WHITE RICHARD DYER

WHITE

Richard Dyer

London and New York

First published 1997
by Routledge
11 New Fetter Lane, London EC4P 4EE

Simultaneously published in the USA and Canada
by Routledge
29 West 35th Street, New York, NY 10001

Typeset in Galliard and Gill by Keystroke, Jacaranda Lodge, Wolverhampton
Printed and bound in Great Britain by Butler and Tanner, Frome, Somerset

British Library Cataloguing in Publication Data
A catalogue record for this book is available from the British Library.

Library of Congress Cataloging in Publication Data
A catalogue record for this book has been requested.

ISBN 0–415–09536–0 (hbk)
ISBN 0–415–09537–9 (pbk)

Contents

Plates

Black and white plates

Colour plates

The colour plate section falls between pp. 144–5

Acknowledgements

I should like to thank Kobena Mercer, who first responded so encouragingly to the idea that I might write on this topic, as well as the following, who have provided ideas, examples and debate during the writing of this book: Mary Alemany-Galway, José Arroyo, Christine Battersby, Avtar Brah, Joe Bristow, Charlotte Brunsdon, Anthea Callen, Luciano Cheles, Ling-Yen Chua, Gerry Cousin, Jenny Cousins, Tony Cryer, Paul Darke, Tom DiPiero, Richard Fung, Jane Gaines, Ann Gray, Larry Gross, Stuart Hall, Mary Hamer, Miriam Hansen, Sylvia Harvey, Michael Hatt, Lisa Henderson, Paul Hills, Hilary Hinds, Ann Kaplan, Liam Kennedy, Al LaValley, Chris Looby, Tommy Lott, Paul McDonald, Sarita Malik, Giorgio Marini, Angela Martin, Darrell Moore, John Osborne, Victor Perkins, Michael Piret, Murray Pratt, Ian Rashid, Femi Shaka, Jackie Stacey, Helen Taylor, Ginette Vincendeau, Tom Waugh, Ann Wilson and Janet Wolff.

Parts of this book have been presented in various forms in a number of contexts, including Edinburgh (Filmhouse), London (Institute of Contemporary Arts) and Toronto (Euclid Arts Centre), and at the following universities: Birmingham, Bristol, Champaign-Urbana, Chicago, Dartmouth, Davis, East London, Galway, Gothenburg, Harvard, Keele, Leuven, Naples, Northwestern, Oxford, Reading, Salzburg, Santa Cruz, Saragossa, Siegen, Stanford, Stockholm, Stony Brook, Turku and Warwick. I should like to thank both the organisers for inviting me and those who came and discussed the issues with me.

A short version of Chapter 3 appeared in *Filmhäftet* 87 and Marie-Luise Angerer (ed.) *The Body of Gender. Körper. Geschlechter. Identitäten* (Vienna: Passagen Verlag, 1995), of Chapter 4 in Harry Stecopoulos and Michael Uebel (eds) *Race and the Subject of Masculinities* (Durham NC: Duke University Press, forthcoming) and of Chapter 5 in *Screen* 37 (3), 1996.

Finally, I should also like to thank all those institutions (and the individuals with whom I dealt) which gave permission for the reproduction of images in their care and whose names appear in the list of plates. Whilst every effort has been made to contact owners of copyright material reproduced in this book, we have not always been successful. In the event of a copyright query, please contact the publishers.

Introduction

This book is a study of the representation of white people in white Western culture. The issues and problems – personal, political, methodological, conceptual – of such an undertaking are themselves the subjects of much of the book. Here I want to say something briefly about the fact that it is about representation and to indicate the way in which it is organised.

My focus is representation. Thus, on the one hand, what follows is not directly about how white people really are, how we feel about ourselves, how others perceive us. These concerns have been addressed by other writers[1] on whom I draw, but they are not the direct topic of this book. This is about how white people are represented, how we represent ourselves – images of white people, or the cultural construction of white people, to use two standard formulations for such work. On the other hand, how anything is represented is the means by which we think and feel about that thing, by which we apprehend it. The study of representation is more limited than the study of reality and yet it is also the study of one of the prime means by which we have any knowledge of reality. This book is then a study of what is available to us, all of us, to make sense of white people – and I emphasise both the making involved, the production of ideas of peoples, and the full affective, sensuous weight of the word *sense* as well as its more cerebral one. Thus, while I want to be sure no reader expects to find what is not here, interviews with people of whatever colour about white people, for instance, or analysis of the historical and sociological patterns of existence of white people, I also want to insist that what follows is not therefore 'merely' about representation.

To this should be added two points. The study refers to white makings of whiteness within Western culture, because white people have had so very much more control over the definition of themselves and indeed of others than have those others. Second, I am primarily, though not exclusively, concerned with visual (principally photographic) representations. However, sight has been a privileged sense in Western culture since the middle ages, and since the mid-nineteenth century the photographic media have become central and authoritative means of knowledge, thought and feeling. Thus,

again, there is nothing 'mere' about the limitation of focusing on the visual and photographic.

The book is organised in a movement from the most general to the most particular. Chapter 1 ('The matter of whiteness') considers some of the general methodological and conceptual issues involved. I start with the in fact highly particular topic of my own relationship to the subject, in order to situate what follows in the particularity of the person who is writing it. I do not intend thereby to collapse whiteness into my own subjectivity, nor to claim to speak for all white people; but nor do I believe that knowledge exists independently of actual people knowing. Moreover, the position of speaking as a white person is one that white people now almost never acknowledge and this is part of the condition and power of whiteness: white people claim and achieve authority for what they say by not admitting, indeed not realising, that for much of the time they speak only for whiteness. The impulse behind this book is to come to see that position of white authority in order to help undermine it. It seems only proper then that I start by talking about *this* white person's position.

Thereafter in Chapter 1 I deal with more genuinely general frameworks: political and methodological issues and some key concepts underpinning the analysis of the rest of the book. I organise these around a notion of 'embodiment', the idea of an exercise of spirit within but not of the body in a mode that, as inflected by Christianity, 'race' and imperialism, comes to define the visible white person. Chapter 2 ('Coloured white, not coloured') narrows the focus to a particular aspect of white representation, namely the use of a colour to signify a social group and what it means that this colour, white, is used to represent this particular group. Chapter 3 ('The light of the world') is also still concerned with the general frameworks through which we see, think and feel about white people, but concentrated here on a particular medium, photography and film, and its historical development in relation to the white face. While chapters 1 and 2 address topics that themselves draw attention to the fact of whiteness, 'The light of the world' looks at an aesthetic technology – a particular medium and its habitual use – that offers itself as neutral with regard to social difference but is in fact profoundly, though not irremediably, shaped by it.

Case studies – particular texts and groups of texts – are used throughout the above, but it is only in the two penultimate chapters that they become the focus of attention. These are, in Chapter 4 ('The white man's muscles'), a grouping of films (adventure films with muscleman stars), itself divisible into further genres or cycles (the Tarzan and Rambo films and especially the Italian 'peplum' films of the late 1950s and early 1960s), and, in Chapter 5 ('"There's nothing I can do! Nothing!"'), one, albeit very long (fifteen-hour) text, the television serial *The Jewel in the Crown*.

In a work of this kind, there must always be an interaction between generalisations and specific instances, between the theoretical and empirical.

Theory needs checking against the particularity and the sheer intractable messiness of any given example; but equally, no cultural production is ever apprehended except through the frameworks that are brought to bear on it, of which theoretical constructs are only a particularly self-reflexive and elaborated kind. I have tried to be explicit about selection: why was this case chosen? Of what is it a case? The instances in the final chapters were indeed selected because they seemed prima facie to enable the exploration of issues raised in the more general chapters, but they also represent particular modes of cultural production and consumption. I approach both, broadly speaking, in terms of genre; that is, traditions of cultural production wider than one particular text and known, albeit differentially, by producers and consumers alike. Chapter 4, however, treats a genre (and a particular sub-genre), homing in on particular texts as exemplars, whereas Chapter 5 focuses on one text, using generic reference to inform the reading of it. The genres in question also suggest other cultural constructions to do with both class and gender. I hope I still see the whiteness that cuts across these particularities, while also registering the fact that whiteness never exists separately from specific class, gender or other socio-cultural inflections.

The gradual narrowing of focus as the book proceeds is stemmed somewhat in the final chapter ('White death') by opening out not to an overall conclusion but to a theme that runs throughout the book, the association of whiteness and death. Methodologically, this Chapter is rather different from the rest, in that it is more a reading of a number of films than either a theoretical disquisition or a case study. It is a reading prompted by what has gone before and developed in relation to the detail of the films themselves, but less culturally and historically grounded. It tries to identify a feeling surfacing in moments of white contemporary popular culture, a sense of the dead end of whiteness.

The matter of whiteness

Racial[1] imagery is central to the organisation of the modern world. At what cost regions and countries export their goods, whose voices are listened to at international gatherings, who bombs and who is bombed, who gets what jobs, housing, access to health care and education, what cultural activities are subsidised and sold, in what terms they are validated – these are all largely inextricable from racial imagery. The myriad minute decisions that constitute the practices of the world are at every point informed by judgements about people's capacities and worth, judgements based on what they look like, where they come from, how they speak, even what they eat, that is, racial judgements. Race is not the only factor governing these things and people of goodwill everywhere struggle to overcome the prejudices and barriers of race, but it is never not a factor, never not in play. And since race in itself – insofar as it is anything in itself – refers to some intrinsically insignificant geographical/physical differences between people, it is the imagery of race that is in play.

There has been an enormous amount of analysis of racial imagery in the past decades, ranging from studies of images of, say, blacks or American Indians in the media to the deconstruction of the fetish of the racial Other in the texts of colonialism and post-colonialism. Yet until recently a notable absence from such work has been the study of images of white people. Indeed, to say that one is interested in race has come to mean that one is interested in any racial imagery other than that of white people. Yet race is not only attributable to people who are not white, nor is imagery of non-white people the only racial imagery.

This book is about the racial imagery of white people – not the images of other races in white cultural production, but the latter's imagery of white people themselves. This is not done merely to fill a gap in the analytic literature, but because there is something at stake in looking at, or continuing to ignore, white racial imagery. As long as race is something only applied to non-white peoples, as long as white people are not racially seen and named, they/we function as a human norm. Other people are raced, we are just people.

There is no more powerful position than that of being 'just' human. The claim to power is the claim to speak for the commonality of humanity. Raced people can't do that – they can only speak for their race.[2] But non-raced people can, for they do not represent the interests of a race. The point of seeing the racing of whites is to dislodge them/us from the position of power, with all the inequities, oppression, privileges and sufferings in its train, dislodging them/us by undercutting the authority with which they/ we speak and act in and on the world.

The sense of whites as non-raced is most evident in the absence of reference to whiteness in the habitual speech and writing of white people in the West. We (whites) will speak of, say, the blackness or Chineseness of friends, neighbours, colleagues, customers or clients, and it may be in the most genuinely friendly and accepting manner, but we don't mention the whiteness of the white people we know. An old-style white comedian will often start a joke: 'There's this bloke walking down the street and he meets this black geezer', never thinking to race the bloke as well as the geezer. Synopses in listings of films on TV, where wordage is tight, none the less squander words with things like: 'Comedy in which a cop and his black sidekick investigate a robbery', 'Skinhead Johnny and his Asian lover Omar set up a laundrette', 'Feature film from a promising Native American director' and so on. Since all white people in the West do this all the time, it would be invidious to quote actual examples, and so I shall confine myself to one from my own writing. In an article on lesbian and gay stereotypes (Dyer 1993b), I discuss the fact that there can be variations on a type such as the queen or dyke. In the illustrations which accompany this point, I compare a 'fashion queen' from the film *Irene* with a 'black queen' from *Car Wash* – the former, white image is not raced, whereas all the variation of the latter is reduced to his race. Moreover, this is the only non-white image referred to in the article, which does not however point out that all the other images discussed are white. In this, as in the other white examples in this paragraph, the fashion queen is, racially speaking, taken as being just human.

This assumption that white people are just people, which is not far off saying that whites are people whereas other colours are something else, is endemic to white culture. Some of the sharpest criticism of it has been aimed at those who would think themselves the least racist or white supremacist. bell hooks, for instance, has noted how amazed and angry white liberals become when attention is drawn to their whiteness, when they are seen by non-white people as white.

> Often their rage erupts because they believe that all ways of looking that highlight difference subvert the liberal belief in a universal subjectivity (we are all just people) that they think will make racism disappear. They have a deep emotional investment in the myth of

'sameness', even as their actions reflect the primacy of whiteness as a sign informing who they are and how they think.

<div align="right">(hooks 1992: 167)</div>

Similarly, Hazel Carby discusses the use of black texts in white class-rooms, under the sign of multiculturalism, in a way that winds up focusing 'on the complexity of response in the (white) reader/student's construction of self in relation to a (black) perceived "other"'. We should, she argues, recognise that 'everyone in this social order has been constructed in our political imagination as a racialised subject' and thus that we should consider whiteness as well as blackness, in order 'to make visible what is rendered invisible when viewed as the normative state of existence: the (white) point in space from which we tend to identify difference' (Carby 1992: 193).

The invisibility of whiteness as a racial position in white (which is to say dominant) discourse is of a piece with its ubiquity. When I said above that this book wasn't merely seeking to fill a gap in the analysis of racial imagery, I reproduced the idea that there is no discussion of white people. In fact for most of the time white people speak about nothing but white people, it's just that we couch it in terms of 'people' in general. Research – into books, museums, the press, advertising, films, television, software – repeatedly shows that in Western representation whites are overwhelmingly and disproportionately predominant, have the central and elaborated roles, and above all are placed as the norm, the ordinary, the standard.[3] Whites are everywhere in representation. Yet precisely because of this and their placing as norm they seem not to be represented to themselves *as* whites but as people who are variously gendered, classed, sexualised and abled. At the level of racial representation, in other words, whites are not of a certain race, they're just the human race.

We are often told that we are living now in a world of multiple identities, of hybridity, of decentredness and fragmentation. The old illusory unified identities of class, gender, race, sexuality are breaking up; someone may be black *and* gay *and* middle class *and* female; we may be bi- , poly- or non-sexual, of mixed race, indeterminate gender and heaven knows what class. Yet we have not yet reached a situation in which white people and white cultural agendas are no longer in the ascendant. The media, politics, education are still in the hands of white people, still speak for whites while claiming – and sometimes sincerely aiming – to speak for humanity. Against the flowering of a myriad postmodern voices, we must also see the countervailing tendency towards a homogenisation of world culture, in the continued dominance of US news dissemination, popular TV programmes and Hollywood movies. Postmodern multiculturalism may have genuinely opened up a space for the voices of the other, challenging the authority of the white West (cf. Owens 1983), but

it may also simultaneously function as a side-show for white people who look on with delight at all the differences that surround them.[4] We may be on our way to genuine hybridity, multiplicity without (white) hegemony, and it may be where we want to get to – but we aren't there yet, and we won't get there until we see whiteness, see its power, its particularity and limitedness, put it in its place and end its rule. This is why studying whiteness matters.

It is studying whiteness *qua* whiteness. Attention is sometimes paid to 'white ethnicity' (e.g. Alba 1990), but this always means an identity based on cultural origins such as British, Italian or Polish, or Catholic or Jewish, or Polish-American, Irish-American, Catholic-American and so on. These however are variations on white ethnicity (though, as I suggest below, some are more securely white than others), and the examination of them tends to lead away from a consideration of whiteness itself. John Ibson (1981), in a discussion of research on white US ethnicity, concludes that being, say, Polish, Catholic or Irish may not be as important to white Americans as some might wish. But being white is.

The rest of this chapter provides a series of contexts for looking at whiteness and for the chapters that follow. I begin with a consideration of my own relation to whiteness, my sense of myself as white. It has become common for those marginalised by culture to acknowledge the situation from which they speak,[5] but those who occupy positions of cultural hegemony blithely carry on as if what they say is neutral and unsituated – human not raced. As I shall argue later, there is something especially white in this non-located and disembodied position of knowledge, and thus it seems especially important to try to break the hold of whiteness by locating and embodying it in a particular experience of being white.

The section after this may be considered as notes on the politics of studying whiteness. I suggest both why it is something that needs to be done – the project of 'making whiteness strange' – and the risks involved. I consider the question of language, especially of what term to use in a study of whiteness to refer to people excluded from and oppressed by the category 'white'. This is followed by a discussion of some methodological issues. The chapter ends with a longer section, presenting a general perspective on whiteness, organised around a concept of embodiment, traced through Christianity, notions of race and enterprise and imperialism.

As a white man

In an article considering the whiteness of sexual politics, and referring to an earlier article of mine, Helen (charles) observes: 'I have often wondered whether white people *know* they are white. I know that Richard Dyer does' (1993: 99; see also (charles) 1992).

Her remark set me thinking. Why was *I* trying to write about whiteness? I embarked on it because I thought it needed doing and, when I started, thought nobody else was doing it. Yet this does not of itself explain what (charles) identifies as the prerequisite for doing it, the awareness of being white. Given that, in the West, being white is not an issue for most white people, not a conscious or reflected on part of their sense of who they are, how come it was for me?

I won't pretend to come up with a total explanation of this, since it must be caught up in individual particularities so particular as to be of little general interest. However, if I try to trace the personal/cultural coalescence which goes some way towards accounting for my sense of myself as white, I can sum it up as follows. I seem from a very early age to have had a feeling for non-white people, a feeling something like kinship; yet there were moments when, for some reason or other, I suddenly realised that I really was not kin, and it was thus that I really realised I was white.

My mother recently told me a story about myself that she had never retailed before. I was brought up in a suburb of London, in a period (the late 1940s and early 1950s) in which there were relatively few non-white people in Britain. I went to a nursery school. One day a black boy came to class and was teased unmercifully by the other children. I, however, took his side, told the teachers that I would be his friend and took him home to tea. Since I don't myself remember this incident, I cannot claim to know what feelings I had at the time, but I cannot help speculating. I remember being very happy at nursery school, but I knew that I was regarded as a funny little boy, chiefly because I preferred playing with dolls and flowers to guns and cars. Perhaps I felt an affinity between myself and another boy who was funny because, albeit for a different reason, he too was not like the other boys.

This is to read back into an incident I don't recall something that I only consciously formulated in late adolescence. The key figure here was a Jewish boy at school, whom I'll call Danny Marker. I used to visit him and his family in Golders Green, a Jewish neighbourhood of London. I knew by then that I was a homosexual and I envied Danny and his family – they too were an oppressed minority, whom, like queers, you could not always spot; but, unlike us, they had this wonderful, warm community and culture and the wrongfulness of their oppression was socially recognised. I now believe that there are intellectual and political problems with making an analogy between Jews and queers, between ethnic and sexual discrimina-tions, but I am trying to say how it felt then. I envied Danny's ethnicity and wanted to be part of it, indeed felt at home with it – except that there were always those moments, when I was offered some specially bought ham, for instance, or when Danny couldn't come out because it was the Sabbath, moments that made me realise that I was not a Jew, was not in fact at home.

I think at that stage I would have said that it was merely because I was a queer, not because I was a gentile or white. That came later, but I need to say something more here about the sexual dimension. I had a crush on Danny. My feeling for non-white people has sometimes taken an erotic form. There is a discourse of white bawdy, not much different in its straight or gay versions, that posits an elemental attraction of some white people to non-white people, the 'you're only interested in blacks because you like big cocks' kind of thing. The sexualisation of my feeling for some non-white men has undoubtedly lent intensity and poignancy to my awareness of race, but I do believe that it is an eroticisation of a much wider feeling, expressed not least in friendships with non-white women and men as well as in many aspects of my cultural life. It is the felt connection between gays and ethnic minorities that is important here, as much as romantic and sexual encounters with non-white men.

The fact that Danny did not reciprocate my crush on him perhaps defended me from imagining I could be more integrated into his world than I was; my feeling remained envy. It was later that, through involvement in a mixed-race gay political group and a relationship with an African-American man, that I experienced most strongly both the desire to be at one with non-white people and the recognition that I would never be exactly that, because I was white. The moment that crystallised it had to do with dancing. Living in New York at the time (1980), I went out dancing a lot with black friends to black venues; I had a black music radio station on all the time; I could not have been more into it. At one mixed-race social event, we all started dancing in a formation copied from the TV series *Soul Train*, two lines facing each other, which we took it in turns to dance down between. For all my love of dancing and funk, I have never felt more white than when I danced down between those lines. I know it was stereotypes in my head; I know plenty of black people who can't dance; I know perceptions of looseness and tightness of the body are dubious. All I can say is that at that moment, the black guys all looked loose and I felt tight. The notion of whiteness having to do with tightness, with self-control, self-consciousness, mind over body, is something I explore below. I felt it, and hated it, dancing between the lines – and hated it not for itself, but because it brought home to me that, in my very limbs, I had not the kinship with black people that I wanted to have.

This then perhaps says something about why I was sensitised to myself as white. It does not however say how I feel about it. If anything, it says too much, implies that I hate and resent it. But this is not the case and never has been. For one thing, I have also always known which side my bread is buttered on. I know I won't be stopped for long at immigration controls; I know I'll be respectfully served in shops, banks and restaurants; I know that, with class and gender also on my side, it is not really surprising that I now have a good job and a nice house and I certainly don't scorn to have

such things. And, while my love of Jewish, black and also Indian cultural forms remains as strong as ever, my cultural tastes certainly happily embrace very white things too, not least some things discussed in this book: the incandescent white faces of the movies, glisteningly muscular white male bodies, the touchingly awkward white melancholia of *The Jewel in the Crown*.

Nor am I immune to white racism. It comes unbidden, when I am off guard. Most commonly it's when I am driving, when, that is, I am both most tense (driving is dangerous to the point of insanity) and most distracted (the mind wanders and the music plays). If someone suddenly pulls out or blinks their lights for me to get out of the way when I myself am already driving at or over the speed limit, then at such moments self-righteous scorn and despair at the human race well up, uncensored. If I catch sight of the driver, then up pops a correlation between race, and gender, and bad driving. I'm shocked by it each time, by the fact that the correlation is so very readily to hand, but it doesn't stop it from coming along the next time.

Two things need to be said about this. The first is that I make a correlation whatever the race and gender of the person. Indeed, my contempt for bad white male drivers is far stronger than for any other category of person, partly because I am less likely instantly to correct it in my mind. I am not ashamed to think white masculinity a menace. Equally, I suspect that if I could tell the person's sexuality, I'd make something of that, including blaming bad driving on the feather-brained silliness of gay men. Second, I don't believe that such thoughts are a 'real me' lurking behind a facade of anti-racism. I did not invent racist thought, it is part of the cultural non-consciousness that we all inhabit.[6] One must take responsibility for it, but that is not the same as being responsible, that is, to blame for it. The shock of its arrival, however, in the context of the feelings of kinship that I have described, further forces upon me my sense of being, after all, white.

As my discussion of racism suggests, how one thinks and feels is at once lived as intensely personal, yet made up of matters that in themselves are not unique to one. I have so far spoken mainly in personal terms, attempting to reconstruct the processes of feeling that both account for and situate the fact that I am writing, that this white man is writing about the representation of whiteness. Yet this itself can be placed in two wider contexts: gay culture and identity politics.

Though I experienced making the connection between being gay and being Jewish or black as a purely individual perception, a glance at gay culture suggests that it is not a surprising one to make. Disco music is rooted in black funk. Camp and Jewish humour have many affinities of irony and self-deprecation. Gay, Jewish and even a surprising amount of black storytelling returns repeatedly to the passing (for straight, for gentile,

for white) narrative. Even the complex, far from unproblematic relations of talismanic white gay men like André Gide or E. M. Forster with Arab and Indian men may be understood in terms of mutual recognition and discovery as well as sexual tourism and exploitation (cf. Bakshi 1994).

Second, it is striking that the recent writings by white people about whiteness arise predominantly out of feminism (Frye 1983, McIntosh 1988, Ware 1992, Frankenberg 1993), labour history (Saxton 1990, Roediger 1991, 1994) and lesbian and gay studies (Hart 1994, Davy 1995, the present work), in other words, what has come to be called identity politics. Each of these is founded on an affirmation of the needs and rights of a group defined in terms of, respectively, gender, class and sexuality. Crucial to such affirmation is the construction of a sense of oneness with a social grouping: women, the working class, lesbians and gay men. It is most recognisable in the opening phrases 'As a woman . . . ', 'As a working class person . . . ', 'As a lesbian . . . ', which often serve to authenticate the truth of the view that follows by claiming it as a group view. The history of identity politics has however been marked by the increasingly strong and heard voices of, for instance, non-white and working-class women, lesbians and gay men, who do not entirely recognise themselves in these 'As a . . . ' claims. Many such claims have come to be seen as having been all along the claims of white women, the white working class, white lesbians and gay men. The effect of this has been to force white people in these movements back on to our racial particularity, thus making possible white reflections on whiteness.

The politics of looking at whiteness

I can turn on the television or open to the front page of the paper and see people of my race widely represented.

If I want to, I can be pretty sure of finding a publisher for this piece on white privilege.

Whether I use cheques, credit cards or cash, I can count on my skin colour not to work against the appearance of financial reliability.

I can swear, or dress in second-hand clothes, or not answer letters, without having people attribute these choices to the bad morals, the poverty or the illiteracy of my race.

I am never asked to speak for all the people of my racial group.

The above is a selection from a list drawn up by Peggy McIntosh of forty-six

special circumstances and conditions I experience which I did not earn but which I have been made to feel are mine by birth, by citizenship,

and by virtue of being a conscientious law-abiding 'normal' person of goodwill.

(McIntosh 1988: 5–9)

This happens because white people are systematically privileged in Western society, enjoy 'unearned advantage and conferred dominance' (ibid.: 14). It is this privilege and dominance that is at stake in analysing white racial imagery.

McIntosh starts from the recognition that white people don't see their white privilege, which acts like 'an invisible weightless knapsack of special provisions, assurances, tools, maps, guides, codebooks, passports, visas, clothes, compass, emergency gear and blank cheques' (ibid.: 1–2). The invisibility of these assets is part and parcel of the sense that whiteness is nothing in particular, that white culture and identity have, as it were, no content. This is one of the feelings most commonly expressed by the white women interviewed by Ruth Frankenberg in her study of white identity. She notes that 'many of the women said that they "did not have a culture"' (Frankenberg 1993: 192): culture, distinctive identity, one might say colour, tended to be felt as add-ons to an identity that is not itself distinctive or coloured, that lacks 'flavour' (ibid.: 197). As one woman (Cathy Thomas) vividly and wittily put it, 'To be a Heinz 57 American, a white, class-confused American, land of the Kleenex type American, is so formless in and of itself' (ibid.: 191).

Having no content, we can't see that we have anything that accounts for our position of privilege and power. This is itself crucial to the security with which we occupy that position. As Peggy McIntosh argues, a white person is taught to believe that all that she or he does, good and ill, all that we achieve, is to be accounted for in terms of our individuality. It is intolerable to realise that we may get a job or a nice house, or a helpful response at school or in hospitals, because of our skin colour, not because of the unique, achieving individual we must believe ourselves to be.

But this then is why it is important to come to see whiteness. For those in power in the West, as long as whiteness is felt to be the human condition, then it alone both defines normality and fully inhabits it. As I suggested in my opening paragraphs, the equation of being white with being human secures a position of power. White people have power and believe that they think, feel and act like and for all people; white people, unable to see their particularity, cannot take account of other people's; white people create the dominant images of the world and don't quite see that they thus construct the world in their own image; white people set standards of humanity by which they are bound to succeed and others bound to fail. Most of this is not done deliberately and maliciously; there are enormous variations of power amongst white people, to do with class, gender and other factors; goodwill is not unheard of in white people's

engagement with others. White power none the less reproduces itself regardless of intention, power differences and goodwill, and overwhelmingly because it is not seen as whiteness, but as normal. White people need to learn to see themselves as white, to see their particularity. In other words, whiteness needs to be made strange.

There is a political need to do this, but there are also problematic political feelings attendant on it, which need to be briefly signalled in order to be guarded against. The first of these is the green light problem. Writing about whiteness gives white people the go-ahead to write and talk about what in any case we have always talked about: ourselves. In, at any rate, intellectual and educational life in the West in recent years there have been challenges to the dominance of white concerns and a concomitant move towards inclusion of non-white cultures and issues. Putting whiteness on the agenda now might permit a sigh of relief that we white people don't after all any longer have to take on all this non-white stuff.

Related to this is the problem of 'me-too-ism', a feeling that, amid all this (*all* this?) attention being given to non-white subjects, white people are being left out. One version of this is simply the desire to have attention paid to one, which for whites is really only the wish to have all the attention once again. Another is the sense that being white is no great advantage, what with being so uptight, out of touch with our bodies, burdened with responsibilities we didn't ask for. Poor us. A third variant is the notion of white men, specifically, as a new victim group, oppressed by the gigantic strides taken by affirmative action policies, can't get jobs, can't keep women, a view identified and thus hardened up by a *Newsweek* cover story on 5 September 1993 on white male paranoia.

The green light and me-too-ism echo the reaction of some men to feminism. There is a lesson here. My blood runs cold at the thought that talking about whiteness could lead to the development of something called 'White Studies', that studying whiteness might become part of what Mike Phillips suspects is 'a new assertiveness . . . amounting to a statement of "white ethnicity", the acceptable face of white nationalism' (1993: 30)[7] or what Philip Norman (1992) identifies as a 1990s fascist chic observable in Calvin Klein and Häagen-Dazs ads as well as the rise of neo-fascist parties in Europe and North America. I dread to think that paying attention to whiteness might lead to white people saying they need to get in touch with their whiteness, that we might end up with the white equivalent of 'Iron John' and co, the 'men's movement' embrace of hairiness replaced with strangled vowels and rigid salutes. The point of looking at whiteness is to dislodge it from its centrality and authority, not to reinstate it (and much less, to make a show of reinstating it, when, like male power, it doesn't actually need reinstating).

A third problem about talking about whiteness is guilt. The kind of white people who are going to talk about being white, apart from conscious racists

who have always done so, are liable to be those sensitised to racism and the history of what white people have done to non-white peoples. Accepting ourselves as white and knowing that history, we are likely to feel overwhelmed with guilt at what we have done and are still doing.[8] Guilt tends to be a blocking emotion. One wants to acknowledge so much how awful white people have been that one may never get around to examining what exactly they have been, and in particular, how exactly their image has been constructed, its complexities and contradictions. This problem – common to all 'images of' analyses – is a special temptation for white people. We may lacerate ourselves with admission of our guilt, but that bears witness to the fineness of a moral spirit that can feel such guilt – the display of our guilt is our calvary.[9]

A political problem of a different order has to do with what term to use to refer to (images of) people who are not white. In most contexts, one would not want to make such sweeping reference to so generalised a category, but in the present context of trying to see the specificity of whiteness it is sometimes necessary. I have opted for the term non-white. This is problematic because of its negativity, as if people who are not white only have identity by virtue of what they are not; it is not a term that I would want to see used in other contexts. However, the two common alternatives pose greater problems for my purposes. 'Black', the term preferred by many theorists and activists, has two drawbacks. First, it excludes a huge range of people who are neither white nor black, Asians, Native Americans (North and South), Chicanos, Jews and so on. Second, it reinforces the dichotomy of black : white that underpins racial thought but which it should be our aim to dislodge. Black is a privileged term in the construction of white racial imagery and I shall examine it as such, but where I need to see whiteness in relation to all peoples who are not white, 'black' will not do. The other option would be 'people of colour', the preferred US term (though with little currency in Britain). While I have always appreciated this term's generosity, including in it all those people that 'black' excludes, it none the less reiterates the notion that some people have colour and others, whites, do not. We need to recognise white as a colour too, and just one among many, and we cannot do that if we keep using a term that reserves colour for anyone other than white people. Reluctantly, I am forced back on 'non-white'.

Politics also inform more evidently methodological questions. When I first started thinking about studying the representation of whiteness, I soon realised that what one could not do was the kind of taxonomy of typifications that had been done for non-white peoples. One cannot come up with a limited range of endlessly repeated images, because the privilege of being white in white culture is not to be subjected to stereotyping in relation to one's whiteness. White people are stereotyped in terms of gender, nation, class, sexuality, ability and so on, but the overt point of such typification

is gender, nation, etc. Whiteness generally colonises the stereotypical definition of all social categories other than those of race. To be normal, even to be normally deviant (queer, crippled),[10] is to be white. White people in their whiteness, however, are imaged as individual and/or endlessly diverse, complex and changing. There are also gradations of whiteness: some people are whiter than others. Latins, the Irish and Jews, for instance, are rather less securely white than Anglos, Teutons and Nordics; indeed, if Jews are white at all, it is only Ashkenazi Jews, since the Holocaust, in a few places.

The individuated, multifarious and graded character of white representation does not mean that white culture has succeeded in imagining in white people the plenitude of human potential and is only at fault for denying this representational range to non-white people. There is a specificity to white representation, but it does not reside in a set of stereotypes so much as in narrative structural positions, rhetorical tropes and habits of perception. The same is true of all representation – the taxonomic study of stereotypes was only ever an initial step in the study of non-white representation. However, stereotyping – complex and contradictory though it is (cf. Perkins 1979, Bhabha 1983, Dyer 1993a) – does characterise the representation of subordinated social groups and is one of the means by which they are categorised and kept in their place, whereas white people in white culture are given the illusion of their own infinite variety.

For a long time, the multiplicity of white representation led me to feel that any generalisation I made about images of white people could always be countered by other, various and opposite images of them, that the image of the pure white woman discussed in Chapter 3, for instance, is easily placed alongside that of the wicked or the merely venial white woman, that the muscleman heroes of Chapter 4 were, if anything, less typical of whiteness than the average white guys of major stars like James Stewart, Harrison Ford or Tom Hanks. Moreover, going against type is a feature of white representation. At the level of textual form, it is the foundation of both psychological realism – when we don't get superheroes or obvious stereotypes, we feel we're getting the real – and of novelty and transgression, where the bounds of the typical are exceeded. At the level of social mores, the right not to conform, to be different and get away with it, is the right of the most privileged groups in society. However, going against type and not conforming depend upon an implicit norm of whiteness against which to go. It is that norm which is my concern in this book.

Equally, given the variety of whiteness, I have sometimes thought that what I am really writing about is the whiteness of the English, Anglo-Saxons or North Europeans (and their descendants), that this whiteness would be unrecognisable to Southern or Eastern Europeans (and their descendants). For much of the past two centuries, North European whiteness has been

hegemonic within a whiteness that has none the less been assumed to include Southern and Eastern European peoples (albeit sometimes grudgingly within Europe[11] and less assuredly without it, in, for instance, the Latin diaspora of the Americas). It is this overarching hegemonic whiteness which concerns me, one to which Northern Europeans most easily lay claim but which is not to be conflated with distinctive North European identities.

As others have found, it often seems that the only way to see the structures, tropes and perceptual habits of whiteness, to see past the illusion of infinite variety, to recognise white *qua* white, is when non-white (and above all black) people are also represented. My initial stab at the topic of whiteness (Dyer 1988) approached it through three films which were centrally about white–black interactions, and my account above of how I may have got into thinking about the topic at all also emphasises the role of non-white people in my life. Similarly, Toni Morrison in her study of whiteness in American literature, *Playing in the Dark* (1992), focuses on the centrality, indeed inescapability, of black representation to the construction of white identity, a perception shared by the very influential work of Edward Saïd (1978) on the West's construction of an 'Orient' by means of which to make sense of itself. This is more than saying that one can only really see the specificity of one's culture by realising that it could be otherwise, in itself an unobjectionable human process. What the work of Morrison, Saïd *et al.* suggests is that white discourse implacably reduces the non-white subject to being a function of the white subject, not allowing her/him space or autonomy, permitting neither the recognition of similarities nor the acceptance of differences except as a means for knowing the white self. This cultural process justifies the emphasis, in work on the representation of white people, on the role of images of non-white people in it.

Yet this emphasis has also worried me, writing from a white position. If I continue to see whiteness only in texts in which there are also non-white people, am I not reproducing the relegation of non-white people to the function of enabling me to understand myself? Do I not do analytically what the texts themselves do? Moreover, while this is certainly the usual function of black images in white texts,[12] to focus exclusively on those texts that are 'about' racial difference and interaction risks giving the impression that whiteness is only white, or only matters, when it is explicitly set against non-white, whereas whiteness reproduces itself as whiteness in all texts all of the time. As a product of enterprise and imperialism, whiteness is of course always already predicated on racial difference, interaction and domination, but that is true of all texts, not just those that take such matters as their explicit subject matter. Similarly, as I argue later in this chapter, there is implicit racial resonance to the idea, endemic to the representation of white heterosexuality, of sexual desire as itself dark, but in Chapter 3 I deliberately show this in relation to white couples in white contexts rather than looking at texts about inter-racial sexuality. The point is to see the

specificity of whiteness, even when the text itself is not trying to show it to you, doesn't even know that it is there to be shown.[13] I do make reference to non-white in my analyses in order to clarify the specificity of white, and I do look at texts with implicit (the peplum) or explicit (*The Jewel in the Crown*) colonial structures, since colonialism is one of the elements that subtends the construction of white identity. But I have eschewed a focus on non-white characters as projections of white imaginings, as the Other to the white person who is really the latter's unknown or forbidden self. This function, as the work of Morrison and others makes abundantly clear, is indeed characteristic of white culture, but it is not the whole story and may reinforce the notion that whiteness is only racial when it is 'marked' by the presence of the truly raced, that is, non-white subject.

The embodiment of whiteness

I have tried so far in this chapter to sketch some of the personal, political and methodological starting points for what follows. I turn now to a particular aspect of white representation, the notion of embodiment, that underpins and generates the particular forms and texts examined in the rest of this book.

To represent people is to represent bodies. In the chapters that follow I consider particular aspects of the bodies of white people in representation: skin colour (Chapter 2), how such bodies are rendered by the aesthetic technologies of light (3), the muscular white male body in adventure fictions (4), the narrative (in)capacities of the white feminine body (5) and the deathliness of the white body (6). Here what I want to suggest is that all of these involve a wider notion of the white body, of embodiment, of whiteness involving something that is in but not of the body. I approach this through three elements of its constitution: Christianity, 'race' and enterprise/imperialism. These do not just provide the intellectual foundations for thinking and feeling about the white body, but also their forms and structures, the cultural register of whiteness.

Christianity (and the particular inflection it gives to Western dualist thought) is founded on the idea – paradoxical, unfathomable, profoundly mysterious – of incarnation, of being that is in the body yet not of it. This provides a compelling cosmology, as well as a vivid imagery and set of narrative tropes, that survive as characteristics of Western culture. All concepts of *race*, emerging out of eighteenth-century materialism, are concepts of bodies, but all along they have had to be reconciled with notions of embodiment and incarnation. The latter become what distinguish white people, giving them a special relation to race. Black people can be reduced (in white culture) to their bodies and thus to race, but white people are something else that is realised in and yet is not reducible to the corporeal,

or racial. It is in this context that I look at a third element of whiteness: *imperialism*. At some point, the embodied something else of whiteness took on a dynamic relation to the physical world, something caught by the ambiguous word 'spirit'. The white spirit organises white flesh and in turn non-white flesh and other material matters: it has *enterprise*. Imperialism is the key historical form in which that process has been realised. Imperialism displays both the character of enterprise in the white person, and its exhilaratingly expansive relationship to the environment. These then are the elements I use to structure the rest of this chapter.

Embodiment: Christianity

The European feeling for self and the world has been shaped by Christianity, a religion whose sensibility is focused on the body. If Christianity as observance and belief has been in decline in Europe over the past half-century, its ways of thinking and feeling are none the less still constitutive of both European culture and consciousness and the colonies and ex-colonies (notably the USA) that it has spawned. Many of the fundamentals of all levels of Western culture – the forms of parenting, especially motherhood, and sex, the value of suffering, guilt, the shock of post-Enlightenment materialism – come to us from Christianity, whether or not we know the Bible story or recognise the specific items of Christian iconography. The Christian structures of feeling are realised in concrete images and stories, for that itself is in the nature of Christianity, and those images and stories centre on the body, or rather, on embodiment.

The body is the basis of Christian imagery, notably in the two great set pieces of the birth and death of Christ, the nativity and the crucifixion, brought together, as Elaine Scarry notes (1985: 216), in the pietà, the dead Christ stretched across his mother Mary's lap, an image simultaneously of cradling and death. These basic figures have been endlessly remade in Western culture, in painting, sculpture, theatre (notably school nativity plays), cinema and television. The basic symbol of Christianity, the cross, is a shape that works itself ineluctably into the fabric of Western design and performance, the shape of an object whose significance is the body that was nailed to it. Such imagery forms the nodal points of the Christian sensibility: its sacred texts, calendar and rituals. While Christ himself and the books of the New Testament do sometimes deal in abstractions, the heart of Christianity is concrete storytelling: Christ's life and the parables, the stories that he himself told. What the sacred texts are most memorably about is people doing things, birth and death but also working and feeding: Christ as carpenter and as shepherd; Christ drinking and offering his body in the form of food and wine; miracles of bodily transformation and corporeal nourishment, water into wine, a few loaves and fishes feeding five

thousand. These in turn provide the basis for Christianity as a lived religion. The Christian calendar is organised to echo the narrative structure of the gospel, peaking at Christmas and Easter but with other incidents registered throughout the year. The ritual sacraments of Christianity take place on the believer's body, most re-enacting, albeit gesturally, the story of Christ's body: baptism (water on the body), confirmation (laying on of hands), communion (ingesting wine and wafers), penance (scourging the body), extreme unction (oil on the body), holy orders (laying on of hands) and marriage (rings on fingers).

Christianity is then very concrete, physical and body-minded. The particularity of this is evident if one compares it to the two other major world monotheistic religions, Judaism and Islam (with both of which, despite historic and often brutal antagonisms, it has much in common). Neither of these has a comparable iconography and sacramental system of the body and, most strikingly, Islam expressly forbids representation of the Prophet. Christianity by contrast is obsessed with Christ's body. Yet, rightly, we think of Christianity as an anti-body religion.

For all the emphasis on the body in Christianity, the point is the spirit that is 'in' the body. What has made Christianity compelling and fascinating is precisely the mystery that it posits, that somehow there is in the body something that is not of the body which may be variously termed spirit, mind, soul or God. This is the distinctive inflection that Christianity gives to Western dualistic philosophy (Hodge 1975). It also underlies many of the grand narratives of European Christianity: the Apostolic Succession (that is, the notion of an unbroken chain of laying on of hands in ordination to the priesthood that constitutes, typically in a bodily act, the passing on of the spirit that came upon the apostles after Christ's death), the Divine Right of Kings (the doctrine that kings ruled by virtue of a direct relation to God, a doctrine itself contesting, from within the secular realm, the Papacy's similar claim), and the Lutheran emphasis on each individual's personal relationship to God and on individual conscience, the voice of God within, as a guide to behaviour (discussed in relation to whiteness by Kovel (1988: 124–5)). While the Enlightenment's largely atheistic shift away from God to Man as the centre of human endeavour and consciousness felt like a drastic break with Christianity, it was in many ways a continuation of the same way of thinking and feeling, simply breaking with the sense of the divinity, but not the presence, of the spirit within.

Christianity maintains a conception of a split between mind and body, regarding the latter as at the least inferior and often as evil. Yet it reproduces such dualistic thought only, magically, incomprehensibly, to transcend it in the spirit-in-the-body of Mary and Christ.

The gender ideals promoted by these two figures derive from the different relations of their bodies to the spirit. Mary is a vessel for the spirit; she does nothing and indeed has no carnal knowledge, but is filled with

16

God; her purity (of which her virginity is only one aspect) is a given of her nature, not something achieved. Christ on the other hand is God, or rather he is simultaneously, again incomprehensibly, fully divine and fully human. The signs of his humanity are his appetites, his temptations and his suffering. Both Mary and Christ provide models of behaviour and being to which humans may aspire. In women these are of passivity, expectancy, receptivity, a kind of sacred readiness,[14] motherhood as the supreme fulfilment of one's nature, all of this constituting a given purity and state of grace (and, where these are absent, the memory of the other, pre-Christian female archetype, Eve); in men the model is of a divided nature and internal struggle between mind (God) and body (man), and of suffering as the supreme expression of both spiritual and physical striving.

Mary and Christ are ambiguous models. They are both exemplary and exceptional human beings. It would be presumptuous – and lacking in Christian humility and hence the very virtuousness after which one strove – to identify with Christ or Mary. They are what one should aspire to be like and yet also what one can never be. This sets up a dynamic of aspiration,of striving to be, to transcend, and to go on striving in the face of the impossibility of transcendence. Such striving (which in women must also be passive) is registered in suffering, self-denial and self-control, and also material achievement, if it can be construed as the temporary and partial triumph of the mind over matter. These constitute something of a thumbnail sketch of the white ideal.

I am not arguing that Christianity is of its essence white. Given that Christianity developed initially within Judaism, that one of its foundational thinkers was the North African Augustine, and that it is now most alive in Africa, South America and the black churches of Europe and North America, it is by no means clear that whiteness is constitutive of it. Yet not only did Christianity become the religion, and religious export, of Europe, indelibly marking its culture and consciousness, it has also been thought and felt in distinctly white ways for most of its history, seen in relation to, for instance, the following: the persistence of the Manichean[15] dualism of black:white that could be mapped on to skin colour difference; the role of the Crusades in racialising the idea of Christendom (making national/ geographic others into enemies of Christ); the gentilising and whitening of the image of Christ and the Virgin in painting; the ready appeal to the God of Christianity in the prosecution of doctrines of racial superiority and imperialism.

Throughout this book I give all this its due in examining the representation of whiteness, yet what I want to underline here is not so much these contingent and reversible aspects of Christianity but the underlying motif of embodiment. To be able to think at all of bodies containing different spiritual qualities, or of some having such qualities and others not having them (a trope of white racism), of bodies containing that which

controls them and then extends beyond them to the control of others and the environment (a trope of enterprise and imperialism), all this requires the first conceptual leap represented by the bodies of Christ and Mary, the sacraments, observances and theologies that rework them and the distinctive European culture founded upon all of this.

Embodiment: race

Before the middle of this century, few white people seem to have hesitated to call themselves white and to speak of belonging to the white race. This leaps out at one now, since in our time it is only extreme right and racist discourse that has an acknowledged and clear concept of a white race. Eighteenth- and nineteenth-century philosophers and politicians, however, have no compunction about detailing the innate quality of white people. A fiercely anti-racist text like *Uncle Tom's Cabin* (1852) is no less full of statements about the nature (far from wholly admirable) of the white race than is a colonialist adventure tale celebrating white prowess, such as *King Solomon's Mines* (1886) or *She* (1887). Even in the Tarzan films, touched on in Chapter 4, not only does Tarzan's body display the evidence of his racial superiority, but, until the 1950s, characters explicitly talk about it. Now, however, to talk about race is to talk about all races except the white.

Yet the ways in which white people were once racially talked about still inform the ways we are now imagined, not least because the cultural production of the past few centuries still provides much of the image vocabulary of the present. Within that legacy, there is, sometimes more strongly, sometimes less, a notion that white people have a peculiar relationship to race, of not being quite contained by their racial categorisation. It is the ideas of whites as a race and the ways in which race is conceptually different in their case that I want to explore in this section.

Even before we arrive at concepts of race *per se* we need to note the first intellectual moves that had to be made, and upon which it is founded. The first has already been described: the perception of a link between the body and spirit as revealed in Christian culture. The second is produced in the characteristic development of Europe[16] up to, say, the sixteenth century, a history of rulers simultaneously identifying terrain over which centralised control can be maintained (to do with geographical givens and the stage of development of military, political and bureaucratic organisation), dominating it and putting boundaries around it. In this process, populations come to be identified as those within and those without the boundaries, populations that it can then seem logical to represent in terms of bodily and/or temperamental characteristics. It is with the incursion of the European nations into territories outside Europe, whose populations are more markedly physically different, that the conflation of body and temperament –

a full concept of race – comes into being, but the idea of populations apparently defined by intrinsic difference was already in place before this.

Elaborated concepts of race began to be developed in the eighteenth century and to take hold in the nineteenth. These were made up of developments in science as well as deeper rooted ideas of embodiment, of populations and (as is explored in Chapter 2) of skin colour itself. They flourished by virtue of their political effectivity, a point developed in the US context by recent historical studies by Theodore Allen, David Roediger and Alexander Saxton.

Allen *et al.* argue that a sense of being white, of belonging to a white race, only widely developed in the USA in the nineteenth century as part of the process of establishing US identity. The appeal to a common white-ness addressed Europeans settlers, on the one hand over and against the indigenous reds and the imported blacks, and on the other over and above the particularities of the different European nations from which they had come. You might be British, you might even be Irish, Polish or Greek, but you were also white, not red or black. Equivalent histories of white consciousness in European countries have not been undertaken (as opposed to the histories of race ideas that I draw on later), but need to be. They may help to explain patterns of popular investment in imperialism, the effective jingoism of the appeal to working-class sacrifice in the First World War, for instance, or the Scottish involvement in British imperialism, noted by Tom Nairn (1968: 13) as a way of asserting a common white British identity without having to become English, a motif of national-regional inclusion within an imperial project that may well be identified in many other countries.

Whiteness has been enormously, often terrifyingly effective in unifying coalitions of disparate groups of people. It has generally been much more successful than class in uniting people across national cultural differences and against their best interests. This has been strengthened by two instabilities that such a coalition produces. On the one hand, it creates a category of maybe, sometime whites, peoples who may be let in to whiteness under particular historical circumstances. The Irish, Mexicans, Jews and people of mixed race provide striking instances: often excluded, sometimes indeed being assimilated into the category of whiteness, and at others treated as a 'buffer' (Allen 1994: 14)[17] between the white and the black or indigenous. On the other hand, whiteness as a coalition also incites the notion that some whites are whiter than others, with the Anglo-Saxons, Germans and Scan-dinavians usually providing the apex of whiteness under British imperialism, US development and Nazism. As both these aspects of whiteness – where it begins and ends, notions of degrees of whiteness – are especially articulated in relation to notions of colour I will leave further discussion of them to Chapter 2. Here I want to note their social and political effectivity. A shifting border and internal hierarchies of whiteness suggest that the

category of whiteness is unclear and unstable, yet this has proved its strength. Because whiteness carries such rewards and privileges, the sense of a border that might be crossed and a hierarchy that might be climbed has produced a dynamic that has enthralled people who have had any chance of participating in it.

I turn now to the concepts of race and the white race that developed in the late eighteenth and through the nineteenth century, that shored up the sense of a category worth getting into if you could.

All concepts of race are always concepts of the body and also of hetero-sexuality. Race is a means of categorising different types of human body which reproduce themselves. It seeks to systematise differences and to relate them to differences of character and worth. Heterosexuality is the means of ensuring, but also the site of endangering, the reproduction of these differences. I look first at race as a means of categorisation and then at the consequences of its being realised through heterosexuality.

We may distinguish between two broad ways of categorising race: one genealogical, concerned with origins and lineages of reproduction, the other more statically biological, concerned with identifying and securing difference on and/or in the body itself.[18] I shall consider them in this order, chiefly because the biological seems to have eclipsed the genealogical in recent times. I am not, however, suggesting that the genealogical comes before the biological, broadly conceived – indeed, the simple identification of bodily differences between populations almost certainly predates constructing different lineages for them.

Whites figure in both the genealogical and biological traditions, though more uncomfortably in the latter. This is partly because to have a history is one splendid thing; to be defined by one's body is quite another – the former accords with the white concept of self, but the latter is uneasy with it. It has also to do with the nature of the intellectual operations involved. The archaeological and historical work of genealogy was bound up with Europeans' quest for forbears: white people saw themselves in what they were investigating. Biology, on the other hand, has traditionally been based upon a model of scientific knowledge as separate from that which it inves-tigates. It is thus not surprising that the biology of race should sometimes seem to have written whites out of the account, for whites are those who have such knowledge, but are themselves less readily the object of it.

Racial genealogy tells histories of populations, generally winding up in the mists of time, to show how environment and tradition have moulded the appearance and character of the people in question. White genealogy has focused on the Aryans or Caucasians. The former are posited as the ancient inhabitants of what is now North West India and Pakistan. The term, which came to prominence in the early nineteenth century, is taken from a Sanskrit word meaning 'of noble birth', and the Indian ancestors of the Aryans (when acknowledged at all) were identified as the Brahmins, the highest

caste in Indian society. It was posited that the Aryans had emigrated to the West and been the founding people of Europe. The Caucasian (a term coined by the natural historian J. F. Blumenbach in 1795) was a variant of this theory, since it was through and from the Caucasus mountains that the Aryans came to Europe. The Caucasian variant both stressed the Caucasus mountains themselves as a determinant factor on white racial formation and enabled the Aryan myth to be severed, most notably at the hands of Nazism, from its Asian associations.

The Aryan/Caucasian myth established a link between Europeans and a venerable culture known to pre-date Europe's oldest civilisation, ancient Greece. It is Martin Bernal's thesis that the myth's function was to provide a white (that is, European-like) origin for ancient Greek society. Before the early nineteenth century, it was widely accepted that Greece had been conquered by the Egyptians and Phoenicians, from whom the characteristics of ancient Greek culture derived. However, argues Bernal, in an age of imperialism, such an idea was intolerable. Greece was seen as the cradle of Europe, but something had given birth to Greece, and that had to be compatible with the European sense of self and could not therefore be located in Africa.

The Aryan and the Caucasian model share a notion of origins in mountains. Bernal notes the admiration of the Romantics, by whom such notions were especially promulgated, for 'small, virtuous and "pure" communities in remote and cold places: Switzerland, North Germany and Scotland' (1987: 209). Such places had a number of virtues: the clarity and cleanliness of the air, the vigour demanded by the cold, the enterprise required by the harshness of the terrain and climate, the sublime, soul-elevating beauty of mountain vistas, even the greater nearness to God above and the presence of the whitest thing on earth, snow. All these virtues could be seen to have formed the white character, its energy, enterprise, discipline and spiritual elevation, and even the white body, its hardness and tautness (born of the battle with the elements, and often unfavourably compared with the slack bodies of non-whites),[19] its uprightness (aspiring to the heights), its affinity with (snowy) whiteness. Such notions did not apply only to forbears. They can still be found in, for instance, nineteenth- and early twentieth-century notions of Canadian identity, where the experience of the cold North is claimed to have moulded in the white settler people a distinct white national character (cf. Berger 1966), and in the German *Bergfilm* (mountain film) of the 1920s and 1930s (cf. Rentschler 1990), in which white men and women pitted and found themselves exultantly against mountain heights and whiteness. Both cases are instructive: explicit racial reference was not always made and both were to do with progress and modernity not genealogy, not looking back to a mountain origin, yet both mobilised a similar rhetoric and imagery of the cold to suggest the distinctiveness of a white identity.

The quest for Aryan/Caucasian roots was not always in the first instance about the white race. There are two separable projects, both having to do with ideas of racial purity. One is indeed to locate and define the white race and its origins. In this context, the white race was one pure race among other pure races, indubitably superior in character but not in degree of racial purity. Linnaeus, perhaps the first to categorise the races of humankind (in his *Systema naturae* (1735)), did not consider the inferior Americanus rubesceus, Asiaticus luridus or Afer niger less racially pure than the superior Europaeus albus (Poliakov 1974: 160–1). However, genealogical research was also at other points motivated by the search for the origins of humankind *tout court*. In this perspective, white people represent the only sub-race that has remained pure to the human race's Aryan forbears (and has even perhaps purified that inheritance via the Caucasus). Non-whites then become seen as degenerative, falling away from the true nature of the (human) race. This notion goes back at least to Johan Boemus, who in 1521 proposed that all humans were descended from Ham, Shem and Japeth, the sons of Noah, but those who descended from Ham degenerated into blackness, whereas the civilised, who remained white, were descended from Shem and Japeth (Fredrickson 1981: 10); more 'scientific' and Aryan variants were proposed in the eighteenth century (Poliakov 1974: 163ff.).

In the quest for purity, whites win either way: either they are a distinct, pure race, superior to all others, or else they are the purest expression of the human race itself. What is interesting in either version is the emphasis on purity, and of the special purity of whiteness, for (as is discussed in Chapter 2) this is a theme central to what is implied and mobilised by this group being called 'white'.

We may also note here the affinity of the genealogical with another model of the place of humans (and specifically white ones) in the scheme of things, one with considerable currency in the eighteenth century, that of the Great Chain of Being (Lovejoy 1936). This proposed that all of creation was connected in a hierarchy that proceeded from the lowest to the highest, the latter being God. Black people were placed only just above apes (a notion taken over into corruptions of Darwinism and often surviving in the quest for the 'missing link' between humans and apes). White men (sic) were placed at the highest point of earthly creation, linked via the angels to God. This was not an historical notion, it was an essentially static model of the order of things, but it does echo the genealogical sense of the higher and purer nature of white humankind. The idea of the closeness of white men to angels is especially suggestive in relation to the representation of white people in terms of light, as discussed in Chapter 3.

The Aryan model was argued principally on the basis of linguistics (the similarities of (some) Indian and European languages); the Caucasian model, however, drew upon natural science. Linnaeus extrapolated from

his work on the classification of species to make his racial distinctions; Blumenbach based his distinctions on comparisons of skull shape and size. From this flowed the mania for measurable biological distinctions in so much subsequent racial thought, from phrenology, craniology and anthropometry to genetics.[20] What seems remarkable here (although a new look at the source material might contradict this) is the apparent lack of interest in the biology of the white race. The many different studies of the racial differences in skulls, facial features, body shape and posture, genitals, blood and eventually genes do include whites, but more as a norm not itself in need of investigation.

It is hard not to see biological race research as an arm of imperialism and domestic control, whose aim is to know, fix and place the non-white rather than, as the genealogical approach does, to establish the characteristics of whiteness. From the point of view of the present study, the significance of biological approaches to race is precisely their disinterest in, and even perhaps unwillingness to consider, the racial character of white people, for that would be to understand white people as, like non-whites, no more than their bodies. Thus while biological approaches to race do seek to pin down the racial characteristics of white people too, a countervailing discourse has stressed that which cannot be scrutinised, that little something more that makes whites different.

A clear expression of this can be found in the work of Houston Stewart Chamberlain, whose *Die Grundlagen des XIX Jahrhunderts* (*Foundations of the Nineteenth Century*) of 1899 expounded on the nature of the German people as the Aryan race. As George Mosse observes, Chamberlain did believe in blood, cranial measurement and anthropological methods, but 'as not all Germans possessed the outward appearance proper to Aryans, it seemed best to retreat to the race-soul which they did share' (1978: 105–6). Intangibilities of character, energy and high (sic) mindedness come to constitute the white race-soul and distinguish white people from all others. As the Brazilian literary critic Alcides Bezerra put it in 1919, the 'Aryan race' is the 'lord and master of the world by virtue of its enviable spiritual qualities' (quoted in Skidmore 1974: 63).

It is not the case that non-white peoples were always assumed not to have souls. Indeed, many whites – most notably Harriet Beecher Stowe – have considered that blacks were more spiritual and had, as later generations would say, more soul. It is not spirituality or soul that is held to distinguish whites, but what we might call 'spirit': get up and go, aspiration, awareness of the highest reaches of intellectual comprehension and aesthetic refinement. Above all, the white spirit could both master and transcend the white body, while the non-white soul was a prey to the promptings and fallibilities of the body. A hard, lean body, a dieted or trained one, an upright,[21] shoulders back, unrelaxed posture, tight rather than loose movement, tidiness in domestic arrangement and eating manners, privacy in

relation to bowels, abstinence or at any rate planning in relation to appetites, all of these are the ways the white body and its handling display the fact of the spirit within. But that spirit itself cannot be seen.

Genetics has likewise often been used to prove, albeit by final reference to an attribute of the body, that white people are more intelligent than black (the inconvenient finding that yellow people are even more intelligent than white tends not to make the headlines or else to be dismissed in terms of an unnerving, wily, in some sense unnatural hyper-intelligence). Genetics has also sometimes granted a bodily superiority to non-white people, for instance, attributing black sports prowess to superior musculature, powers of endurance and inborn fleetness of foot. What genetics also does is to locate race in parts of the body that cannot be seen. Ideas of racial blood had already done this, for while blood, unlike genes, is itself immediately visible, few maintained that the naked eye could see the difference between types of racial blood.[22] The concept of racial blood came to dominate definitions of race by the end of the nineteenth century in the USA, just as genetics has in the twentieth. 'Blood' and genes have been said to carry more of the purely mental properties that constitute white superiority. In these dis-courses, all blood and genes carry mental properties, but, invisibly, white blood and genes carry more intelligence, more spirit of enterprise, more moral refinement. Thus our bodily blood or genes give us that extra-bodily edge.

Biological concepts of race appear more stable and grounded than genealogical ones, especially in a scientific age, yet they actually created problems for the representation of white people. On the one hand, they reinforced the notion of the inescapable corporeality of non-white peoples, while leaving the corporeality of whites less certain, something that fed into the function of non-white, and especially black, people in representation of being a kind of definite thereness by means of which white people can gain a grounding in materiality and 'know who they are' (a point touched on elsewhere). At the level of representation, whites remain, for all their trans-cending superiority, dependent on non-whites for their sense of self, just as they are materially in so many imperial and post-imperial, physical and domestic labour circumstances. Such dependency could form the basis of a bond, but has more often been a source of anxiety. On the other hand, the emphasis on whites being distinguished by that which cannot be seen, whether spirit or merely genetically conceptualised intelligence, means that it is complicated to represent white people visually. In a culture that at the same time places a great weight on the visible, this is a liability. This problem runs through my considerations of white representation in chapters 2 and 3.

Concepts of race are concepts of different kinds of bodies. What makes whites different, and at times uneasily locatable in terms of race, is their embodiment, their closeness to the pure spirit that was made flesh in Jesus,

their spirit of mastery over their and other bodies, in short their potential to transcend their raced bodies. There is, however, before we turn to embodiment in relation to imperialism, a further dimension to whiteness and race, one implicit in the concepts of race just discussed and in the oddness of whites in relation to them. This is heterosexuality.

If race is always about bodies, it is also always about the reproduction of those bodies through heterosexuality. This is implicit in notions of genealogy (the chain of sexual reproduction leading back to the origins of the race), degeneration (the bad chain of such reproduction) and genetics (the way we now understand the passing on of characteristics through reproduction), something the 'gene' root of all these terms indicates. It can be made surprisingly explicit, as in a campaign against venereal disease by the American Social Hygiene Association in 1922, which sought, as John D'Emilio and Estelle Freedman put it, 'to channel sexuality into marriage and reproduction', with separate posters for blacks and whites, promoting sex as something both inspiriting and racial: 'To both boy and girl, sex gives a new joy in living, a desire for a career, a longing to do great things for the race'.[23] Though race here could refer to the human race, accompanying pictures and the readiness in the period to talk of one's particular race as 'the race' suggest otherwise. The centrality of reproduction to heterosexuality can also be sensed in the extraordinary anxiety surrounding inter-racial sexuality, something explicit to the point of psychosis in earlier texts but still betrayed by the fact that a film like *Jungle Fever* (1991) can be regarded as controversial and one like *The Bodyguard* (1992) as daring. Neither of these films is 'about' sexual reproduction, and the fact of reproduction does not necessarily, nor perhaps even usually, enter directly into the representation of inter-racial sexuality, yet it is what is at stake in it. Inter-racial heterosexuality threatens the power of whiteness because it breaks the legitimation of whiteness with reference to the white body. For all the appeal to spirit, still, if white bodies are no longer indubitably white bodies, if they can no longer guarantee their own reproduction as white, then the 'natural' basis of their dominion is no longer credible.

If races are conceptualised as pure (with concomitant qualities of character, including the capacity to hold sway over other races), then miscegenation threatens that purity. Given the actual history of inter-breeding in the imperial history of the past few centuries, it is not surprising that various means have been found to deal with this threat to whiteness. In the US South, elaborate tabulations of degrees of blackness (mulatto, quadroon, octoroon) were developed, while in many states the 'one-drop' definition was promulgated, suggesting that even as much as one drop of black blood was enough to make a person black.[24] These measures focused on blackness as a means of limiting access to the white category, which only the utterly white could inhabit. In Brazil, in contrast, miscegenation was until quite recently positively encouraged on the grounds that the population would

gradually become whiter and the black and native elements would be bred out (Skidmore 1974). Both approaches make the same assumptions: that it is better to be white and that sexual reproduction is the key to achieving whiteness.

The recurrent motif of rape in white race fiction makes sense in this perspective. The form that rape takes in these fictions, of white women by non-white men, not only displaces attention from the routinised misuse of non-white women by white men. It also threatens white men's control over their property, in two senses: their women as their chattels, and their control over their wives as the means of ensuring their other possessions are passed on to those who should properly inherit them (sons, or if need be daughters, whom they can be sure are their own offspring).

Rape is by definition horrific. As Jenny Sharpe (1993) points out (in the context of Raj fictions), it has not always characterised colonial fiction and when it does appear can be seen as an expressive response to threats to colonial authority. She notes its emergence in India only after the 1857 rebellion and we may similarly observe its importance in post-civil war fiction in the USA. Rape can then be seen as a way of registering, and demonising rather than heeding, the threat of non-white resistance and empowerment. However, rape is not just any motif, nor is it important just because it strikes at the heart of white reproduction in the sense already suggested. It also, in the way it is imagined, exposes and threatens white heterosexuality itself.

Inter-racial (non-white on white) rape is represented as bestiality storming the citadel of civilisation – but this often implies that sexuality itself is bestial and antithetical to civilisation, itself achieved and embodied by whites. What is disclosed by this is the conundrum of sexuality for whites, the difficulty they have over the very mechanism that ensures their racial survival and purity, heterosexual reproduction. To ensure the survival of the race, they have to have sex – but having sex, and sexual desire, are not very white: the means of reproducing whiteness are not themselves pure white. This is the logic behind the commonly found anxiety that the white race will fade away. It may be presented as just a matter of numbers. Benjamin Franklin was already worrying in his *Observations Concerning the Increase of Mankind* (1751) that 'the number of purely White People in the World is proportionately very small' (quoted in Jordan 1977: 143) and Joseph Gobineau, writing in 1848, believed that the 'white species will disappear henceforth from the face of the earth' because of so many 'mixtures and . . . attenuations' of blood (quoted in Poliakov 1974: 237). The theme of outnumbering has been a mainstay of white racial politics, becoming the organising principle of British post-war debate, moving from discussion of 'overcrowding' (especially in relation to housing) to the language of 'flooding' and 'swamping' used respectively by Enoch Powell and Margaret Thatcher (Fryer 1984: 381ff.; Miles and Phizacklea 1984: 20ff.). These might be posed in terms of numbers migrating into Britain, but the notion

of breeding was never far behind. Powell argued that it was not enough – as both Labour and Conservative administrations had – to limit numbers coming into the country, for 'the numbers of "coloured immigrates" continued to increase . . . because of the children born to these migrants in Britain' (ibid.: 66). Shoring up this perception are the stereotypes of non-white reproduction: the endlessly extended Asian family, the fatherless West Indian family living off welfare, the teeming Oriental hordes.

In the face of this, white discourse has often emphasised the importance of white reproduction and especially of white women's responsibility in its regard. Marilyn Frye notes this in Ku Klux Klan and other explicitly racist pronouncements: the anxiety over the threat to the extinction of the white race, the worry about the lowness of the white birth-rate (1983: 122–3). She goes on to note the subtle ways in which such thinking informs apparently less racially coded thought. Feminists have noted the role of compulsory heterosexuality in keeping women in their place, but have less often considered that 'the pressures of compulsory motherhood on white women are not just pressures to keep women down, but pressure to keep the white population up' (ibid.: 123).[25] Similarly, when white people start challenging lesbian feminism (and committedly childless people of any sexuality or sex) with the taunt that 'if we had our way, the species would die out', Frye suspects such remarks 'confuse the white race with the human species':

> The demand that white women make white babies to keep the race afloat has not been overt, but I think it is being made over and over again in disguised form as a preachment within an all-white context about our duty to keep the species afloat.
>
> (ibid.: 124).

The problem is that whites may not be very good at it, and precisely because of the qualities of 'spirit' that make us white. Our minds control our bodies and therefore both our sexual impulses and our forward planning of children. The very thing that makes us white endangers the reproduction of our whiteness.

This problem of whiteness and sexuality is represented differently for men and women. In the West heterosexuality implies gendered sexualities, the idea that sex is different for men and women (often, it seems, incommensurably so). Gender difference underpins male:female power difference and is realised in and through heterosexuality. In turn, the relation of white men and white women to sexuality is of a piece with Christian iconography and other aspects of white gender roles.

White men are seen as divided, with more powerful sex drives but also a greater will power. The sexual dramas of white men have to do with not being able to resist the drives or with struggling to master them. The

drives are typically characterised as dark. This forms part of the symbolic function of dark peoples in relation to white identity already touched on. As Sander Gilman (1985) among others suggests,[26] projection of sexuality on to dark races was a means for whites to represent yet dissociate themselves from their own desires. But there need not be explicit or even implied racial reference, it is enough that there is darkness. This furnishes the hetero-sexual desire that will rescue whites from sterility while separating such desire from what whiteness aspires to. Dark desires are part of the story of whiteness, but as what the whiteness of whiteness has to struggle against. Thus it is that the whiteness of white men resides in the tragic quality of their giving way to darkness and the heroism of their channelling or resisting it.

The divided nature of white masculinity, which is expressed in relation not only to sexuality but also to anything that can be characterised as low, dark and irremediably corporeal, reproduces the structure of feeling of the Christ story. His agony is that he was fully flesh and fully spirit, able to be tempted though able to resist. In the torment of the crucifixion he experienced the fullness of the pain of sin, but in the resurrection showed that he could transcend it. The spectacle of white male bodily suffering typically conveys a sense of the dignity and transcendence in such pain.

The presence of the dark within the white man also enables him to assume the position as the universal signifier for humanity. He encompasses all the possibilities for human existence, the darkness and the light. The gradations of whiteness complicate this. Lower-class and Latin whites of both sexes may also have the darkness, but it is less certain that they have the will to struggle against it. The really white man's destiny is that he has further to fall (into darkness) but can aspire higher (towards the light). There is a further twist. *Not* to be sexually driven is liable to cast a question mark over a man's masculinity – the darkness is a sign of his true masculinity, just as his ability to control it is a sign of his whiteness – but there can be occasions when either side discredits the other, the white man's masculinity 'tainting' his whiteness or his whiteness emasculating him. These contradictions constitute the fertile ground for the production of stories and images of a white masculinity seen as exemplary of the human condition.

The potential for white men to 'fall' suggests the Bible story (and images of Adam in the West have, like those of Christ, long been unsemitic). One of the terms that, in Victorian times, most suggested an association of white women with sexuality was that of the 'fallen woman' (cf. Nead 1988). Yet the construction of white female sexuality is different from that of the male. The white man has – as the bearer of agony, as universal subject – to have the dark drives against which to struggle. The white woman on the other hand was not supposed to have such drives in the first place. She might discover that she did and this is the stuff of a great deal of Western

narrative, but this was a fall from whiteness, not constitutive of it, as in the case of the white man's torment. The model for white women is the Virgin Mary, a pure vessel for reproduction who is unsullied by the dark drives that reproduction entails.

There are special anxieties surrounding the whiteness of white women *vis-à-vis* sexuality. As the literal bearers of children, and because they are held primarily responsible for their initial raising, women are the indispensable means by which the group – the race – is in every sense reproduced. Women are also required to display the signs, especially the finery, of the social group to which they are bonded in heterosexuality, be it class or race.

White women thus carry – or, in many narratives, betray – the hopes, achievements and character of the race. They guarantee its reproduction, even while not succeeding to its highest heights. Yet their very whiteness, their refinement, makes of sexuality a disturbance of their racial purity. It's no surprise that Frye should find Ku Klux Klan discourse the most explicit about the threat posed to the white race by the problems of its own reproduction, since the Klan invested so strongly in a mode of representation that etherealised white women to the point that to imagine them having sex and being delivered of children is scandalous and virtually sacrilegious. It is white women's duty but it is what white women are least able to do and still be white. Klan imagery only pushes to its crazed logical conclusion an instability long implicit in normative imagery of white women's sexuality.

White women's role in reproduction makes them at once privileged and subordinated in relation to the operation of white power in the world. As bearers of whiteness, it is fitting that they may exercise power over non-white people of both sexes. We see this most evidently in colonial texts, where, as Ella Shohat (1991: 63) has noted, white women

> can be granted an ephemeral 'positional superiority'. In a film like *The Sheik* (1921), the 'norms of the text' . . . are represented by the Western male but in the moments of His absence, the white woman becomes the civilising centre of the film.

It may also be evident in expressions of white female transgression, notably at the level of sexuality. bell hooks considers the case of Madonna, who has been much celebrated for her 'somebody's got to be in charge side'. hooks suggests that, fun as it might be to see her giving the likes of Warren Beatty and Kevin Costner the run-around, this 'in charge' side is 'most expressed in her interaction with non-white folks, heterosexual and gay, and gay white folks' whom she 'publicly describes as "emotional cripples"'. Madonna, hooks observes, 'is not breaking with any white supremacist, patriarchal status quo; she is endorsing and perpetuating it' (1992: 163). Similarly, Kate Davy instances the still more deliberately transgressive example of the

WOW Café, a women's theatre group whose performances often produced a 'bad girl' image of women, in revolt against both traditional respectability and radical feminist ideas. Davy suggests that such performances 'have been enormously productive, but at the same time as they challenge white womanhood, they depend on it and once again circumscribe and consign to erasure those [non-white] bodies white womanhood has nullified historically and continues to negate' (1995: 199). In these examples, whether acting as civilising centre, being in charge or in revolt against good (white) girls, white women are privileged and oppressive *vis-à-vis* non-white people.

However, white women do not have the same relation to power as white men. Shohat stresses their always temporary occupation of the position of power. Davy argues that the archetypal role of white women has been to foster individualism in white men while denying it to themselves, 'reproducing a construction of white womanhood that allows white women to signify and enact . . . whiteness . . . without inhabiting the subject position reserved for the white men' (ibid.: 197). One result of this, in colonial texts centred on women such as *The Jewel in the Crown* (explored in Chapter 5), is that white women simultaneously stand for white power and yet are shown to be unable either to exercise it effectively or to change what they perceive to be its abuses.

Race and gender are ineluctably intertwined, through the primacy of heterosexuality in reproducing the former and defining the latter. It is a productively unstable alliance. The idea of race, discussed in the first part of this section, locates historical, social and cultural differences in the body. In principle this means all bodies, but in practice whites have accorded themselves a special relation to race and thus to their own and other bodies. They have more of that unquantifiable something, spirit, that puts them above race. This is a badge of superiority, yet it also creates an instability for whites at the hidden heart of the notion of race, namely heterosexual reproduction and its attendant sex roles. Whites must reproduce themselves, yet they must also control and transcend their bodies. Only by (impossibly) doing both can they be white. Thus are produced some of the great narrative dilemmas of whiteness, notably romance, adultery, rape and pornography.

Embodiment: enterprise and imperialism

The ideal white man was one who knew how to use his head, who knew how to manage and control things and get things done. Those whites who were not in a position to perform these functions nevertheless aspired to them.

Eldridge Cleaver: *Soul on Ice* (1969: 80)

In *Uncle Tom's Cabin*, Harriet Beecher Stowe expresses very clearly and unembarrassedly what she takes to be the nature of white men: they are, a word she uses repeatedly, 'enterprising'. From this flows their daring (another favoured term) and steadfastness, their capacity to organise, their hardness and also their rapacity. Ruth Frankenberg (1993: 83) similarly evokes the 'dazzle, brilliance, the spirit of adventure in the entrepreneurial world, good use of good training' expected of upper-class white men over a century later. 'Enterprise' is an aspect of both spirit itself – energy, will, ambition, the ability to think and see things through – and of its effect – discovery, science, business, wealth creation, the building of nations, the organisation of labour (carried out by racially lesser humans). Stowe deplores its unrestrained exercise (and gives to women the task of such restraint), especially insofar as it fails to recognise the humanity, and rights, of those not so endowed, specifically 'negroes', yet she also admires its accomplishments and conveys the appeal of its dynamism and confidence.

Enterprise as an aspect of spirit is associated with the concept of will – the control of self and the control of others. John Hodge (1975) identifies this as a central value in Western culture, tracing it back to Plato. Will is literally mapped on to the world in terms of those who have it and those who don't, the ruler and the ruled, the coloniser and the colonised. Hodge and Struckman trace such dualism from the Greeks through Manicheism, Augustine and up to Freud, the latter considering that 'the leadership of the human species' had fallen upon the 'great ruling powers among the white nations' ('Reflections upon War and Death' 1915; quoted in Hodge and Struckmann 1975: 182). The idea of leadership suggests both a narrative of human progress and the peculiar quality required to effect it. Thus white people lead humanity forward because of their temperamental qualities of leadership: will power, far-sightedness, energy. These were the very qualities that Lamarck had posited as characteristic of the white race (Poliakov 1974: 215).

The most important vehicle for the exercise and thus the display of this dynamism, this enterprise, is imperialism (of which, of course, the world of *Uncle Tom's Cabin* is a part). This gave to enterprise an unprecedented horizon of expansion, of dangers to face, of material – goods, terrain, people – to organise. Edward Saïd (1993) has shown how profoundly imperialism structures Western literary culture, to the point that many canonical works with no apparent interest in imperialism none the less assume and depend on the existence of empire for the life style of the characters, the assumptions they make, for plot reversals and resolutions. The same is more widely true of the way space and time are imagined in white culture.

The history of colonialism as popularly imagined and promulgated could be conveyed in terms of the excitement of advance, of forward movement through time, and of the conquest and control of space. Robert

Miles and Annie Phizacklea evoke this in their account of the history of British imperialism:

> The very existence of Empire was viewed [as] the outcome of the struggle between superior and inferior 'races', an outcome in which the labour of the inferior 'races' had been appropriated not only to ensure 'their' advancement towards 'civilisation' but also, and especially, 'our' advancement to the position of *Great* Britain, workshop of the world.
>
> (1984: 12–13)

A similar conflation of race, history and narrative time and space is suggested by Walter Benn Michaels in his summary of US colonialist ideas:

> Anglo-Saxons . . . were not only capable of self-government, as a 'race of empire-builders' [Albert J. Beveridge 1899[27]], they were biologically destined to govern others as well: 'The breed to which the Southern white man belongs,' wrote Thomas Dixon in *The Clansman*, 'has conquered every foot of soil on this earth their feet have pressed for a thousand years'.
>
> (1989: 185)

The temporal, spatial and racial story of history is a product of the same template of enterprise and imperialism as the more evidently fictional, escapist and entertainment forms.

The Victorian adventure story is one major instance of the latter, but I want to take another which is very close to it, namely the Western. Though no longer the central genre of popular culture it once was, the Western (novels, shows, comics, advertising and television as well as films) was one of the most successful, influential and beloved imaginative constellations for the greater part of this century. Many of the best-known films and stars throughout the world have been Western; the genre has been widely imitated internationally (the novels of the German Karl May and the English J. T. Edson, Hindi, Australian and European, notably spaghetti, Western movies) and widely held to provide the basis for many other films (from the work of Akira Kurosawa to Vietnam movies and *Star Wars*); in dress (above all, jeans) and music (notably the growth of country music), the Western continues to leave its mark on the international imagination. Beyond this, it is also one of the founding myths of the USA,[28] a country which has (for about the same span as the Western itself) symbolised the direction, the hopes and fears of the world (only countervailed by the communist dream, whose national exemplar, the USSR, seldom seized the imagination as did the USA and the Western).

Though I shall discuss briefly in a moment what is more commonly taken to be the content of the Western, including its imperialist design, what I

want to stress first is the Western as an imaginative form which purveyed the experience, the thrill and exhilaration, of the exercise of enterprise. It is in the visceral qualities of the Western – surging through the land, galloping about on horseback, chases, the intensity and skill of fighting, exciting and jubilant music, stunning landscapes – that enterprise and imperialism have had their most undeliberated, powerful appeal.

These textual pleasures are made possible by the imaginary world in which they are grounded. The Western is set at a point in history when the project of the creation and settlement of a new society was underway but had been neither completed nor abandoned. When exactly that is, whether it ever was, is not the issue; what matters is the possibility of imagining that moment on the brink of making a society. It is carried by signs of pastness and a geographical location, whose imprecision in no way diminishes the mobilisation of an historical imagination.

The narrative energy of this moment is suggested by the phrase 'Manifest Destiny', coined in 1845 by John L. Sullivan, who wrote of 'our manifest destiny to overspread the continent allotted by Providence for the free development of our yearly multiplying millions' (quoted in Buscombe 1988: 180–1). Implicit in this, as in every Western, is a teleological narrative (a destiny), energetically and optimistically embraced, in the name of race (breeding, heterosexual reproduction) (cf. Horsman 1981). All this is dynamically crystallised in the image of the frontier. This is both a temporal and a spatial concept, not only in the sense of being the period and the place of establishing presence, but also in suggesting a dynamic that enables progress, the onward and upward march of the human spirit through time, that keeps pressing ahead into new territory (and eventually outer space, of course, 'the final frontier'). Moreover, it signals a border between established and unestablished order, a border that is not crossed but pushed endlessly back.

The border is also of course between white and red peoples, which in turn specifies the nature of this border, namely that it establishes a border where there was none before. This is so not because there was no confrontation between white and red before this, but because the reds were borderless people, who had no concept of boundaries and of the order and civilisation that this bespeaks in the white imagination. From the first, the properness of the white occupation of the North American continent (and indeed of other territories to be colonised) was argued in terms of the fact that the indigenous people did not cultivate the land, did not order it and therefore did not realise the true human (but we will now say white) purpose towards creation.[29] White cultivation brings partition, geometry, boundedness to the land, it displays on the land the fact of human intervention, of enterprise. The frontier, and all the drama and excitement its establishment and maintenance entail, is about the act of bringing order in the form of borders to a land and people without them.

33

A whole series of tropes of whiteness proceed from this, widely noted in cultural history though not always named as white. Richard Slotkin's influential formulation, 'regeneration through violence', suggests why the characteristic violence of Westerns is so satisfying (for those for whom it is satisfying). Bar room brawls, seeing off the encircling Indians, man-to-man confrontation in the street shoot-out, such key moments, pleasures we expect when we go to a Western, resonate with the sense that an act of violence can sort things out, can raze the world of mess and encumbrances (like intractable land, recalcitrant indigenes, and bad elements within whiteness), can regenerate (a term with such a racial reproductive echo) the land, often by making of the desert a *tabula rasa* for the establishment of white society (Slotkin 1973, 1988).

Jane Tompkins uses the term *tabula rasa* to characterise another pleasure of the genre, the look and feel of the landscape. This 'blankness of the plain', she suggests,

> implies – without ever stating – that this is a field where a certain kind of mastery is possible, where a person (of a certain kind) can remain alone and complete and in control of himself, while controlling the external world through physical strength and force of will.
>
> (1992: 75)

Thus too the land, as imagined, calls forth qualities of character, themselves carried in physiognomy – the body of the white male (the person 'of a certain kind' whom Tompkins refers to), lean, sinewy, hard, taut, the cowboy as white male ego ideal. These figures in this landscape are intrinsic to the appeal of the Western:

> The desert flatters the human figure by making it seem dominant and unique, dark against light, vertical against horizontal, solid against plain, detail against blankness. And the openness of the space means that domination can take place virtually through the act of opening one's eyes, through the act, even, of watching a representation on screen.
>
> (ibid.: 74)

The Western is not all white exhilaration and glorification. It has elements that challenge optimism, that drag at the sense of energy and freedom, that complicate any idea of the white man as the citadel of right. The excitement of the Western can be accompanied by harshness and, as Tompkins stresses, a sense of death. The notion of 'manifest destiny' seems to lay the land out before the white gaze, so beautiful, so new, but it is not to be possessed without effort, suffering and loss. In many Westerns, it is true, the land is little more than a playground for white boys to let off steam,

34

but in many others the sense of heat, grime, hunger, pain and death is keenly felt. This, though, only makes the conquest nobler, an agony of the will defining, as I have already suggested, white (male) identity. Similarly appearing to dim the image of the white West, the greatest threat in most Westerns comes not from the native peoples or Mexicans but from within, from bad whites. This does not however tarnish the white project. To make non-whites the greatest threat would accord them qualities of will and skill, of exercising spirit, which would make them the equivalent of white people.[30] It is, besides, part of the genre's realism to acknowledge the variation in white people; that is, the ways in which some white people fail to attain whiteness. Bad whites in Westerns are often associated with darkness, either in the iconography of black and white costuming (in early films, especially, but still evident in, for instance, *Warlock* (1959) or *The Man Who Shot Liberty Valance* (1962)) or in their association with non-white Others, going native with Indian women, hanging about in Mexican bars and so on. The Western expunges such darkly coded bad apples the better to celebrate the struggle for whiteness.

The West constitutes a myth of origins for the USA, for a hundred years the leading edge of the white world. It stands in contrast to another such myth, the South. The West shows the construction of a (white) national identity centred on men and in the face of an indigenous ethnic other, whereas the South shows the construction of one centred on women and in the face of a forced immigrant other. This is realised spatially in the contrast between openness in the West and enclosedness in the South, wide open spaces rather than low down shrub and jungle, the exhilaration of the great outdoors rather than the claustrophobia of the mansion, and, in film, greater use of long and medium shots as opposed to close-ups; it is realised temporally in the overall contrast between movement and stasis, in the performance of broad and achieved actions as against restricted and blocked ones, in narratives of change and transformation as opposed to circularity, entrapment and stagnation, in strong camera movement as against a still or unobtrusively moving camera, and cutting on action rather than cutting on stillness.

This contrast is between two genres of national origins, but one, the Western, is a success genre, the other a failure. The first involves a people massively destroyed by white imperialism, guilt for which only developed as the genre itself declined, whereas the second involves a people forced to be on North American soil, the guilt for which was far more widely felt by white people, for whom African-Americans were a constant presence, in the major cities, on the railroad network, as domestic servants. The West shows success in conquering a land and establishing an order upon it, incorporating the indigenous people into the sweep of that history; the South is a failure to do with labour. In the West, despite some books and films that deliberately addressed the issue of miscegenation, the purity of

whiteness is largely maintained. This is not least because it is a profoundly homosocial, unheterosexual form, often focusing on a world without women, one whose primary and foundational relationships are between men; only at the end may the hero settle with a woman to ensure that his place in the land is reproduced. In the South, however, founded as it is on breeding (of slaves and of white dynasties), troubled by the most extreme expression of the contradiction, touched on above, between the need for white ladies to reproduce and the requirement of their extreme bodily refinement, the question of sexuality and lineage, of white purity, is always more complex. I have argued elsewhere (Dyer 1995) that even in as whole-heartedly white supremacist a text as *The Birth of a Nation* (1915), there is a suspicion that the South is not truly white enough to found the white nation of the film's title: it recurrently has recourse to Northern imagery, characters, stars (Lillian Gish) and even light (see Chapter 3) to regener-ate the doubtfully pure white South. In short, the South seems to be the myth that both most consciously asserts whiteness and most devastatingly undermines it, whereas the West takes the project of whiteness for granted and achieved.

The comparison of the myths of the West and the South suggests that a female-centred representation of white imperialism will deal in stasis and failure, a theme discussed in Chapter 5; but at the same time male impe-rialism is presented as done for white women as, at any rate, the literal and socialising reproducers of the race. In a discussion of Claude Lévi-Strauss' analyses of tribal mythologies, Cleo McNelly relates the gendered placing of white people in imperialism in relation to the kind of binaristic thinking touched on elsewhere in this book. She suggests that imperialism (and anthropology) are represented in the motif of the journey, which is posited on a notion of '*here* and *there*, home and abroad' (1975: 9), which in turn reproduces two figures, 'the white woman at home and her polar opposite, the black woman abroad' (10). The geographical structure of imperial narrative confirms the binarism discussed above, the white woman as the locus of true whiteness, white men in struggle, yearning for home and whiteness, facing the dangers and allures of darkness. This naturalises white gender difference not so much in givens of the body but in the psychic structures produced in the imperial encounter with the world.

The Western as (man-led, woman-inspired) success myth allows us to experience a sense of white historical mastery of time and space. Typically, narrative unfolds in unentangled, linear story-lines leading to a happy ending, and we return repeatedly to an uninterrupted view of the land. The latter draws on a tradition of seeing the land developed in Western[31] painting since the seventeenth century. The idea of a landscape, framed and perspectively organised, suggests a position from which to view the world, one that is distant and separate. Moreover, the very grasping and ordering of the land on canvas or in a photograph suggests a knowledge of

it, bringing it under human control. Even the wildest, most dwarfing land-scapes may also suggest Western man's heroic facing up to the elements or at any rate, in his apprehension of their sublimity, making him aware of his special perception of the divine.[32] Some of the most successful landscape traditions have in any case not stressed awesomeness but manageability. A typical example, such as Jens Juel's *The Ryberg Family Portrait* (1796–7) (colour Plate 1) shows a land fully possessed by those who own it (their home is at the centre of the image, the vigorous male gesturing to both the land and his wife), who none the less are not in it, but stand before it as before a painted backdrop; moreover, the land has not obviously been submitted to the geometry of modern agriculture or continental European gardening traditions – it is mastered, but through subtle knowledge of how to possess it, rather than through inappropriate imposition. In a more evidently colonial context, Ella Shohat (1991) has discussed the importance of the figure of the explorer/scientist in film who gives the spectator knowl-edge of land of which he is emphatically not a part, and the role of images of maps and globes in fixing this within a comprehensive, scientific ambit. Similarly, Martin Stollery discusses the development in British documentary in the 1930s of a genre of aerial film, in which the sense of encompassing the world imperial is reproduced in films that take the (implicitly white) viewer on trips to exotic lands. A particular editing trope of this genre shows a native person looking up at the sky, shading his or her eyes from the sun, trying to see the plane they can hear, followed by a cut to a shot taken from an aircraft looking down on the land, visual master of all that it surveys (Stollery 1994: 310–27, 334–5).

Such representations of the land presuppose an aesthetic (and not even necessarily a literal) distance from it, wittily evoked in a passage about landscape in Jane Austen's *Northanger Abbey* (1818), where the heroine, Catherine, takes a walk on the hills outside Bath with the Tilney family:

> The Tilneys . . . were viewing the country with the eyes of persons accustomed to drawing; and decided on its capability of being formed into pictures, with all the eagerness of real taste. . . . Catherine . . . confessed and lamented her want of knowledge; declared that she would give anything in the world to be able to draw; and a lecture on the picturesque immediately followed, in which [Henry's] instruc-tions were so clear that she soon began to see beauty in everything admired by him; and her attention was so earnest, that he became perfectly satisfied of her having a great deal of natural taste. He talked of foregrounds, distances and second distances; side-screens and perspectives; lights and shades; and Catherine was so hopeful a scholar, that when they gained the top of Beechen Cliff, she voluntarily rejected the whole city of Bath, as unworthy to make part of a landscape.
>
> (Austen 1985: 125–6)

What is especially interesting in this passage, in addition to the account of a particular sense of how to order nature into a landscape and the role of the man in defining this, is the idea that Catherine learns what is then judged to be an unlearned ('natural') taste – by conforming to a male (and, my argument is, white) conception of things she attains to a fundamental state of human perception. This is an instance of what David Lloyd calls the narrative of aesthetic judgement, itself in eighteenth-century philosophy constitutive of the idea of a 'public sphere', a 'disinterested domain of culture' whose historical development is seen 'as the ethical end of humanity itself' (Lloyd 1991: 64).

Lloyd argues that Immanuel Kant in his *Critique of Judgement* (1790) implies a narrative of human development, in which the senses are organised to move beyond particular, local sensations to a recognition of universal forms, a move which can only be made if a human attains to a position of disinterest, becomes what Lloyd terms a 'Subject without properties' (ibid.). This narrative applies equally to the individual and to the human race as a whole – but non-white peoples are presumed to be still, and perhaps forever, at the stage of 'particular, local sensations', not having made the move to disinterested subjecthood. What is involved is not the ascription of racial inferiority, much less evil, to non-whites but their not being deemed subjects without properties. They are particular, marked, raced, whereas the white man has attained the position of being without properties, unmarked, universal, just human. Lloyd indicates two stages of this in the history of colonialism. First, the subject without properties is

> the philosophical figure for what becomes, with increasing literalness throughout the nineteenth century, the global ubiquity of the white European. His domination is virtually self-legitimating since the capacity to be everywhere present becomes an historical manifestation of the white man's gradual approximation to the universality he every-where represents.
>
> (ibid.: 70)

Second,

> in the post-colonial era, immigration from former colonies is a source of especial ideological scandal not least because it upsets the asymmetrical distribution of humanity into the local (native) and the universal.
>
> (ibid.)

Following Lloyd's account, racial theories as such and even the aspirational structure of enterprise and imperialism are less crucial to the development of white identity than the attainment of a position of disinterest – abstraction,

distance, separation, objectivity – which creates a public sphere that is the mark of civilisation, itself the aim of human history. It is that position which interests me here. It provides the philosophical underpinning of the conception of white people (and, as I explore in Chapter 2, the colour white itself) as everything and nothing. It suggests the sense in which the viewpoint of a text (how, in its formal organisation, it sees its subject matter) may legitimately be characterised as white (as well as male and upper or middle class). It is a position of such notable, albeit catastrophic, success in the world that it is one that many people neither white, male nor middle class, may aspire to take up.

Yet it also suggests two problems. First, in a visual culture, the position of being without properties is also an odd one. It is after all not the case that only women and non-white men are shown in paintings, plays, photographs and films – if anything, rather the contrary. Moreover, the appearance of white people in colonialism, what Mohanty calls 'the white man as spectacle', is very much part of the way authority is maintained through its display, just as the dominance of US media has kept the white man at the centre of global representation. The subject without properties – very much the subject rather than the object of scientific, including racial, investigation (as discussed above) as well as the addressee of much of Western art and media – none the less has to be seen, which means being represented as having some properties or other. This is negotiated by various means – the pattern of looks in cinema, for instance, which tends to make the dominating look that of the white male,[33] the production of stars who are at once special and ordinary, the assumption of universality in the muscleman films discussed in Chapter 4 – but its successful negotiation cannot be taken for granted, and constitutes an instability at the heart of the representation of whiteness.

Second, Lloyd's discussion suggests the degree to which whiteness aspires to *dis*-embodiedness. To be without properties also suggests not being at all. This may be thought of as pure spirit, but it also hints at non-existence, or death. This is explored as colourlessness in the next chapter, as dissolving transcendence in Chapter 3, as a narrative impotence in Chapter 5 and as death in the final chapter.

White identity is founded on compelling paradoxes: a vividly corporeal cosmology that most values transcendence of the body; a notion of being at once a sort of race and the human race, an individual and a universal subject; a commitment to heterosexuality that, for whiteness to be affirmed, entails men fighting against sexual desires and women having none; a stress on the display of spirit while maintaining a position of invisibility; in short, a need always to be everything and nothing, literally overwhelmingly present and yet apparently absent, both alive and dead. Paradoxes are fascinating, endlessly drawing us back to them, either in awe at their unfathomability or

else out of a wish to fathom them. Paradoxes provide the instabilities that generate stories, millions of engrossing attempts to find resolution. The dynamism of white instability, especially in its claims to universality, is also what entices those outside to seek to cross its borders and those inside to aspire ever upwards within it. Thus it is that the paradoxes and instabilities of whiteness also constitute its flexibility and productivity, in short, its representational power.

2

Coloured white, not coloured

Plate 2.1 Sandy Huffaker 'White is a flesh colored band aid', from Preston Wilcox (ed.) White Is (New York: Grove Press, 1970)

41

White people are neither literally nor symbolically white. We are not the colour of snow or bleached linen, nor are we uniquely virtuous and pure. Yet images of white people are recognisable as such by virtue of colour.

This chapter considers the implications of a particular group of people being categorised by means of the colour white. This does not mean that I consider colour to be the prime cause of racial distinction and racism,[1] but it is part of the way that racial identity is thought and felt about, and is of particular significance in a culture so bound up with the visual and visible.

Colour is not the only visible physical characteristic that is used to designate white people as white, something that will be touched on in the next section. Moreover, to apply the colour white to white people is to ascribe a visible property to a group that thrives also on invisibility. I discuss this on pages 44–5. None the less, I am focusing on colour. The fact that we are called and call ourselves white suggests the centrality of notions of colour to white representation. Other things may designate us as white and we may not be literally white, yet a colour term, white, is the primary means by which we are identified.

The colourless sources of racial colour

A person is deemed visibly white because of a quite complicated interaction of elements, of which flesh tones within the pink to beige range are only one: the shape of nose, eyes and lips, the colour and set of hair, even body shape may all be mobilised to determine someone's 'colour'. For instance, it has been customary in the West to call the complexion of Chinese or Japanese people yellow, yet it is by no means clear that their complexions are so distinct from that of white Westerners; it is generally the shape of the eyes that is critical in deciding whether someone is 'white' or 'yellow'. Colour may actually be perceived by virtue of other physiognomic features: Sander Gilman (1991: 173–4) argues that Jews were perceived as black in the nineteenth century (and before) because certain features (notably the nose) were seen as being like Africans' and thereby Jews became seen, literally, as markedly dark and swarthy. In passing-for-white dramas, crinkly hair or large (compared to a supposed European average) lips may be taken as the tell-tale sign that someone is 'black' (or it may be betrayed by body language or adornment: an inability to resist the beat of the bongos or a yen for brightly coloured clothes, for instance[2]). In the realm of glamour, a mouth or nose may be perceived as insufficiently attractive in terms that obviously, though not explicitly, declare it is not white enough. Lena Horne, in her stage show *The Lady and Her Music* (1981–3), told of her early days in Hollywood when producers, hoping to pass her off for white, told her to 'sing prettily' by not opening her mouth too wide. Marlene Dietrich recounted that Josef von Sternberg had worked out a way to deal

with her 'broad Slavic nose': a line of silver make-up down her nose and a tiny spotlight placed directly above it. This was a technique used with other women stars who had the same 'problem': Claudette Colbert, Ginger Rogers, Hedy Lamarr, Barbara Stanwyck and 'many others' (Westmore and Davidson 1976: 69–70). The importance of factors other than colour in identifying someone as white is also evident in some of the art produced in Africa, Asia and the Americas in response to the coming of white people: our pointy noses and round eyes have evidently been as much a source of merriment and fascination as our skin colour (Plates 2.2, 5.1; cf. Malbert 1991, Dikötter 1991).

Of these supplementary features, two have to do with colour: hair and eyes. Unlike skin colour, where there is a limited colour range which can be deemed racially white, white people's hair and eyes run the gamut of human coloration. They can have brown, red or black hair and green or brown eyes

Plate 2.2 Figure of a European wearing a cap and blazer, Sotho, Transvaal, c.1900 (Ipswich Borough Council Museums and Galleries)

43

without ceasing to be white. I once heard such hair and eye colour variations used to argue for the greater diversity of white people; they can also function to show that some white people are demonstrably whiter than others. This is most obviously carried in the notion that two specific variants, blond hair and blue eyes, are uniquely white, to the degree that a non-white person with such features is considered, usually literally, to be remarkable.

For all the significance of other physical features in identifying white people as white, I none the less concentrate here on colour. This is after all the accepted term. Even though an alternative, 'Caucasian', is available,[3] it is little used in everyday speech. In job application forms in Britain, if ethnic monitoring is used, 'white' is given as an alternative to a range of other terms, all of which are geographical rather than coloured (Afro-Caribbean, Indian, Chinese, etc.). In some political contexts for some periods, black has been an acceptable term, but those who do not feel included under either black or white have seldom been happy with red, yellow or brown as alternatives, preferring instead national or geographic terms. But whites are always whites.[4]

It would probably be a better world if we didn't use colour terms at all to designate groups of people. Failing that, it might well be better if we used other terms, like pink, olive and grey, to refer to what we now call white people, partly because they are less loaded, partly because this would break up the monolithic identity, whiteness. But we do use the one term and its loading and its designation of a group not ineluctably tied to geographical origin are crucial to our understanding of white people's hold on privilege and power. This is why I am concentrating on white people's whiteness in this chapter.

Colour, visibility, invisibility

In a visual culture – that is, a culture which gives a primacy to the visible as a source of knowledge, control and contact with the world (cf. Lowe 1982) – social groups must be visibly recognisable and representable, since this is a major currency of communication and power. Being visible as white is a passport to privilege; in colonial contexts,[5] as Satya Mohanty points out, the white man as spectacle is a crucial aspect of white rule, for 'eminent visibility [is] the ability to command respect and fear in the subject race' (1991: 315). Visual culture demands that whites can be seen to be whites.

Yet there are problems with such visualisation. As Chapter 1 suggests, whiteness also needs to be not visible. The claim to racial superiority resides in that which cannot be seen, the spirit, manifest only in its control over the body and its enterprising exercise in the world. Moreover, the ultimate position of power in a society that controls people in part through their visibility is that of invisibility, the watcher. Detailed cases, for instance, about

perspective and film editing, have been made for how this expresses itself in cultural forms. Perspective places the individual spectator as the addressee of an image and yet keeps him or her out of the image – we are the spatially privileged observer who is none the less not 'in' the picture. Similarly, one of the building blocks of filmic storytelling, the point of view shot, where the camera takes up the position of a character's eyes, is far more often that of a white male character scrutinising, appraising and savouring black and/ or female characters than vice versa. Looking and being looked at reproduce racial power relations. Jean-Paul Sartre (1949: 229) comments in the Introduction to an anthology of négritude poetry on the shock of finding himself, as a white man, being seen; bell hooks discusses the punishment of black people who look at whites (1992: 168); Mohanty (1991: 331) stresses the invisible perception of others as a means of colonial knowledge and manipulation.

Whites must be seen to be white, yet whiteness as race resides in invisible properties and whiteness as power is maintained by being unseen. To be seen as white is to have one's corporeality registered, yet true whiteness resides in the non-corporeal. The paradox and dynamic of this are expressed in the very choice of white to characterise us. White is both a colour and, at once, not a colour and the sign of that which is colourless because it cannot be seen: the soul, the mind, and also emptiness, non-existence and death, all of which form part of what makes white people socially white. Whiteness is the sign that makes white people visible as white, while simultaneously signifying the true character of white people, which is invisible.

Being deemed white, given what white connotes, is white people's greatest asset and it is this that I shall explore next. We are seen, we do not (and could not possibly) actually inhabit the realm of the unseen, observing subject without properties – but because we are seen as white, we characteristically see ourselves and believe ourselves seen as unmarked, unspecific, universal. How this comes about I explore through the conceptualisation of the colour white in Western culture as also the absence of colour. Yet it does have more specific connotations than absence, to do with beauty and virtue. In the final section I look at these issues, but argue that even here, the conceptualisation of white beauty and white virtue emphasises absence. It is this sense of absence that also proves white peoples' greatest weakness, for in it lies the desolate suspicion of non-existence.

Senses of colour

There are three senses of whiteness as colour, three ways in which it is felt and understood. First, white is a category of colour or *hue*,[6] an observable distinction in the tints of the world, just like red or green. Second, white is a category of *skin* colour. Third, white, like any other hue, has *symbolic*

connotations. Each of these discourses of colour is itself unstable, as is the relation between them. Characteristically, these instabilities, far from weakening the representational hold of white, strengthen it.

Hue

White as a hue is an unstable category in two senses. First, like all colour categories, it is part of a system of dividing the seamless spectrum of colour into discrete units. Paint manufacturers who offer a large and finely graded range of colours often present them in an orderly progression, blue giving way gradually to green and so on. When we look we no doubt have a sense of where the centre of blue or green is, but in the cross-over area it is more difficult – at what point is blue no longer blue and has green really become green? White (though, significantly, it often does not figure in paint charts) is no different. Anyone who has ever tried to match whites in, say, fabrics or tiles will know how many whites there are. Second, though, white is different from other hues in that it is not necessarily thought of as a hue at all. The 1933 *Oxford English Dictionary* and the 1992 *Collins English Dictionary* both give 'colourless' as one of the meanings of white.

White may not be deemed a colour, yet in practice it is also difficult to treat it as if is not one. We do after all choose white as a colour for a room or clothing. On this matter Leonardo da Vinci in his 1492 *Treatise on Painting* was pragmatic:

> The first of all simple colours is White, though philosophers will not acknowledge either White or Black to be colours; because the first is the cause, or the receiver of colours, the other totally deprived of them. But as painters cannot do without either, we shall place them among the others.
>
> (Quoted in Sloan 1991: 6)

The painter Roland Rood provided an explanation for why we have difficulties accepting white as one hue among many. White is a colour, he argued, but because it is the colour of light[7] and we see light all the time, we don't see *its* colour.

> [L]ight without any quality attached is merely light of no, or neutral quality. And light which is neutral is white, of necessity, because white is the only neutral of which we can conceive. . . . [But] whiteness is naught but an idea . . . the idea of the predominant ever-present medium in which all other colour is sunk, and as the light of the sun remains fairly constant, we never have occasion to change our idea of white and we come to regard it as being equally constant with the law

46

of causality. But it is not. There is nothing farfetched in my reasoning. Our other senses act in the same manner. Air has no odour and water no taste only because the stimulation is ever-present.

> (*Colour and Light in Painting*, written *c.*1912–27, published
> 1941; quoted in Sloan 1991: 100–1)

The idea of whiteness as neutrality already suggests its usefulness for designating a social group that is to be taken for the human ordinary.

As just noted, white is often not included in paint colour charts. It is often treated as something you add to another hue to make it paler. There are those who say of a room painted entirely white, 'don't you think you need a bit of colour?', or who complain of the dullness of Western men's fondness for white shirts and underwear in terms of their avoidance of colour. A sheet of white paper is blank; white light is just light, only meriting a colour appellation when distinctly yellow, red or some other hue. There is a further paradox to all this, in that standard school science teaches that white is made up of all colours fused together:[8] white is no colour because it is all colours.

The paradox of whiteness, that it both is and is not a colour, is and is not a tangible sign, is suggested by a comparison with blackness in painting, as discussed by Albert Boime. He argues that there 'probably never was a time when artists used black without symbolic or ethnic significance' (1990: 5). This is partly because of a long association (Boime traces it to ancient Egypt) of black with the soil and because the source of black as a pigment was the earth and its products (soot, vegetables, burned animal material) (ibid.), and partly due to the theory of humours, the notion that the emotions resided in bodily fluids which coloured the skin in a way which betrayed a person's temperament – bile, associated with melancholy, passion and emotional expressivity, gave the skin a swarthy appearance, hence dark-skinned people could be seen as more emotional. Leaving aside qualifications to Boime's argument,[9] what is striking is how difficult it would be to make the same argument for white. White pigment is not literally made of light (though, as we will see Chapter 3, the photographic arts are, with significant consequences) and while the white body humour, phlegm, does have some of the connotations of whiteness (self-possession and coolness, for instance) and could be observed in a 'chalky' appearance,[10] it does not flatter white people in the way that 'white' should.

Thus, white as a hue is, like all others, not as determinate as we tend to think, and we are not always sure that it is a hue anyway. This way of conceptualising white as a hue, apparently the most objective aspect of colour, provides a habit of perception that informs how we think and feel about its other aspects. The slippage between white as a colour and white as colourlessness forms part of a system of thought and affect whereby white people are both particular and nothing in particular, are both something and non-existent.

White as a designated hue has come to have one other remarkable quality: it has an opposite, black. Of no other colours is this so: green is not the opposite of red, nor blue of yellow. This perception is shored up by the notion that Leonardo and Rood (and most Western theorists of colour) refer to, namely that white is light and black its absence. The idea of absolute colour opposites, apparently given by nature and of a piece with dualistic thought, is especially important when conjugated with ideas of whiteness as skin and symbol.

Skin

White as a skin colour is also a category that is internally variable and unclear at the edges. For much of history, many white people have sought to make themselves look white of hue and I shall give an account of this first. However, not being really of one hue means that whiteness may also be seen as multiplicitous and expressively dynamic. It also, as I go on to argue, makes it amenable to being, within bounds, a matter of ascription – white people are who white people say are white. This has a profoundly controlling effect.

Michel Chevreul, whose work on colour is among the most elaborated in Western culture, wrote at length (in his 1839 *De la Loi du contraste simultané des couleurs*) of the effect of clothes of different hue on white women's colouring and in the process specified a huge range of 'white skins' that had to be taken into account, including 'more red than rosy', 'a tint of orange mixed with brown', 'more yellow than orange', 'a little blue' and so on (in Sloan 1991: 27–8). Such variability has however been resisted by many white people, especially the royal, aristocratic and wealthy.

Much of the history of Western make-up is a history of whitening the face. Marina Warner (1994: 368) notes the legend of Cleopatra bathing in asses' milk to whiten her skin and recipes for bleaching hair and whitening the complexion in Gianbattista Della Porta's chapter on 'How to Adorn Women, and make them Beautiful' in his *Natural Magick* (1658). One of the most strongly, and probably to us now startlingly, white cosmetics, in use from the time of the ancient Greeks until the early nineteenth century, was ceruse (white lead), which both made the wearer look matt white and poisoned the skin. Ceruse was replaced by rice powder in the nineteenth century, which was intended actually to whiten (not just cover) the skin. The success of Helena Rubinstein's cosmetics was based on her own appearance, described as both milky and like alabaster, which was supposedly the product of the creams she used (Angeloglou 1970: 109).

Painters and photographers have often rendered white people entirely or in large part literally white. The convention of both line drawing and black and white photography depends upon a readiness to take the literally white

graphic face as a rendering of the socially white face, and even oil painting and colour photography may use white in one form or another (pigment, exposure, retouching, for instance). Whistler's *Symphony in White No 3* (1865–7) (colour Plate 2), with its barest suggestion of pinkness to the skin offsetting the whites of dress and setting, might even be an ironic comment on a work like Reynolds's *Portrait of a Lady* (*c*.1767–9) (colour Plate 3), where the woman's skin really is barely less white than either her clothes, hat and pearls or the effects of light in which she is bathed. There is of course nothing exceptional or extreme about either work.

Just as there is a history of skin white people having tried to make themselves hue white, so, more recently, there is a history of white people darkening themselves through tanning. It seems that this phenomenon only occurs in relation to white women in the twentieth century, and even before that time, tanned white male skin was only sometimes prized as a sign of manliness, of vigour and enterprise, since it was also associated with peasants and working-class labour. In the twentieth century, tanning became a cosmetic: even when caused by the sun, it generally involved any amount of ointments, and it can in practice be achieved through artificial rays as well as creams and pills. The most conscious association of tanning is with health-iness, a belief in the beneficence of the sun's rays (doing for the skin what they do for the fruits of the earth), of the outdoor life, fresh air, exercise. It is also associated with leisure, with time not devoted to work and the necessities of life, with travel and living away from home, and therefore, in connection with all of these, with money. Much less consciously – and quite possibly often not at all – does it have to do with non-white peoples (or, more precisely, the colour range encompassed by Latin, Arab, South Asian and African peoples, since becoming 'red' or 'yellow' has never, yet, been widely prized by whites). In becoming darker, white people may wish to take on some of the imputed characteristics of dark people, characteristics themselves related to the associations of such people in some discourses with healthiness and leisure. Thus dark people work the land and are somehow more natural, dark people have the sensuality and fun sought in leisure and so on. The desire 'to be black' – vividly expressed in white people's relationship to black music and dance – may well inform the fashion for tanning, but the point about tanning is that the white person never does become black. A tanned white person is just that – a white person who has acquired a darker skin. There is no loss of prestige in this. On the contrary, not only does he or she retain the signs of whiteness (suggesting, once again, that skin colour is not really just a matter of the colour of skin), not only does tanning bespeak a wealth and life style largely at white people's disposition, but it also displays white people's right to be various, literally to incorporate into themselves features of other peoples.

Black people's use of skin lighteners are not so positively viewed. Like tanning, these are harmful, but unlike tanning their harmfulness is stressed

as a terrible warning to black people who try to be various. As with tanning, a black person who uses lighteners does not succeed in passing him or herself off as a member of another race – but unlike tanning, this is presumed to be the aim of their use, and the failure to achieve this aim is a source of ridicule. (This itself is a familiar trope of white fiction, the fun made of the black or native character who tries to behave like a lady or gentleman.)[11] Few things have delighted the white press as much as the disfigurement of Michael Jackson's face through what have been supposed to be his attempts to become white.

As the example of tanning suggests, variability of hue within a none the less socially guaranteed whiteness is as much a characteristic of the discourse of white skin colour as attempts to make it literally white. For some, the white face has inherently more variation than any other, not just in the kind of range of hues described by Chevreul, but in expressive colour alterations, so that it is redolent of the enterprising white values of dynamism, flexibility and the capacity to change. Thus Thomas Jefferson wrote (in *Notes on the State of Virginia* (1781–2)):

> Are not the fine mixtures of red and white, the expressions of every passion by greater or less suffusions of colour in the one [race], preferable to that eternal monotony, which reigns in the countenances, that immovable veil of black which covers all the emotions of the other race?
>
> (quoted in Jordan 1977: 458)

Similarly, in 1840 the translator (Charles Locke Eastlake) of the *Farbenlehre* (1810) qualifies Goethe's statement that whites are the most beautiful people because they are of no particular colour by saying that the same could be said of blacks and that what it 'would be safer to say' is 'that the white skin is more beautiful than the black, because it is more capable of indications of life, and indications of emotion' (Goethe 1840: 416).

Variation and alteration, whether in whitening and tanning or the effect of the emotions, indicate that whiteness is more an ascription than a fixed given. One of the earliest instances of the term white to designate a social group (as given by the *OED*) simultaneously registers that it can be inappropriate in terms of colour:

> There may be about 2000 Whites (or I should say Portuguese, for they are none of the whitest) and about treble that Number of Slaves.
>
> (*Adventures of Captain Robert Boyle* (1726))

White people are socially categorised as white because of what white means (here, not being a slave) rather than because that is the most accurate term to describe our skin colour.

There are many examples of the ascription of whiteness. Both Nazi Germany and apartheid South Africa, for instance, gave the Japanese the status of 'honorary whites' (Bernal 1987: 403–4 and Goldberg 1993: 165, respectively). Hitler despised the dark Italians yet made common cause with Mussolini in championing the Aryan race, while Italian fascist propaganda produced an ideal type of the Italian male who looked little like the average Italian (Plate 2.3). Even away from such examples, and to speak appropriately in the language of stereotypes, a red-haired, red-cheeked Irish colleen, a blue-eyed, flaxen-haired, snow-bronzed Scandinavian and a dark-eyed Latin lover may all be deemed white.

Maybe. For the relative fluidity of white as a skin colour functions in relation to the notion of whiteness as a coalition, with a border and an internal hierarchy (as discussed in Chapter 1). Whiteness can determine who is to be included and excluded from the category and also discriminate among those deemed to be within it. Some people – the Irish, Latins, Jews – are white sometimes, and some white people are whiter than others.

As already noted, white is virtually unthinkable except in opposition to black. This has been as true of skin as of hue white. As Mary Hamer (1996) points out, in nineteenth-century racial thought, notably the writings of John Knox, there is a profoundly felt need for an absolute racial distinction between black and white. One function of the exaggerations of blackface,[12] and the film stereotypes of African-Americans in large measure drawn from it,[13] was to make very clear and sharp the difference between black and white races.

Plate 2.3 A count palatine representing the 'tipico biondo di razza italiana' ('typical blonde of the Italian race'), *La difesa della razza* (The Defence of the Race) (journal) c.1938

Yet only Caucasians and Negroes have been felt to fit comfortably into these polarities. Other groups cannot be so tidily accommodated by the schemum. That is its strength. If there are only two colours that really count, then which you belong to becomes a matter of the greatest significance. Theodore Allen (1994: 154) quotes a commentator in *The Richmond Observer* of 4 May 1832, to the effect that poor whites at this time had 'little but their complexion to console them for being born into a higher caste'. As Allen shows, they did have one or two other privileges but nothing to speak of in terms of property or economic security. Yet their complexion, it seems, was consolation enough. A white complexion is a kind of promise to the bearer that he or she may have access to privilege, power and wealth (not to mention, in the context, as here, of the US South, of access to jobs in the rapidly industrialising North).

Given the overwhelming advantage of being white, in terms of power, privilege and material well-being, who counts as white and who doesn't is worth fighting over – fighting to keep people out, to let strategic groups in, fighting to get in. Two examples of peoples who have counted as white under particular historical circumstances are the Irish and the Jews. In both cases, their treatment has involved an appeal to 'colour'.

For much of British history, the Irish have been looked down on as black (cf. Lebow 1976). Liz Curtis (1984: 55) instances the work of the nineteenth-century physician John Beddoe who

> invented the 'index of nigrescence', a formula to identify the racial components of a given people. He concluded that the Irish were darker than the people of eastern and central England, and were closer to the aborigines of the British Isles, who in turn had traces of 'negro' ancestry in their appearances.

Curtis also supplies an illustration from *Harper's Weekly*, visually demonstrating the 'African' looks of the Irish (Plate 2.4). With the rise of the Fenian movement for Irish liberation, British representation of the black Irish intensified, notably through a comparison of the Irish with chimpanzees and gorillas, the first live specimen of the latter being brought to London in 1860 with great public success. The idea that the Irish could be looked on as the 'missing link' between apes and humans ran through both written and visual satire of the period. L. Perry Curtis Jr. (1971) speaks of a 'process of simianizing Paddy's features between 1840 and 1890', which did not die out until the mid-1920s and was as much used in the USA as in Britain. In one 1881 *Punch* cartoon (Plate 2.5), a stiffly upright, unblemished, white-faced Britannia is cast in the classic imperial role of protecting the good native (a straight-haired, white-limbed girl) against the hairy, gesticulating ape-like rebel native, while in an 1876 *Harper's Weekly* (Plate 2.6), black and Irish are both equated in the US context as members

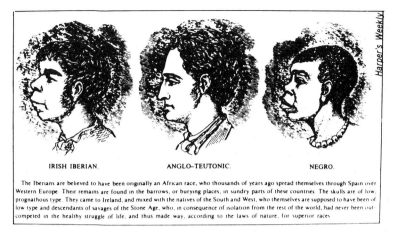

IRISH IBERIAN. ANGLO–TEUTONIC. NEGRO.

The Iberians are believed to have been originally an African race, who thousands of years ago spread themselves through Spain over Western Europe. Their remains are found in the barrows, or burying places, in sundry parts of these countries. The skulls are of low, prognathous type. They came to Ireland, and mixed with the natives of the South and West, who themselves are supposed to have been of low type and descendants of savages of the Stone Age, who, in consequence of isolation from the rest of the world, had never been out-competed in the healthy struggle of life, and thus made way, according to the laws of nature, for superior races

Plate 2.4 'Irish Iberian, Anglo-Teutonic, Negro' (*Harper's Weekly* mid-nineteenth century)

of what might today be called the political underclass. *Puck* 1880 shows both John Bull and Uncle Sam consulting over what to do with the marauding Irish ape (Plate 2.7).

Yet in other circumstances, the Irish could be seen as white, something stressed by both David Roediger (1991: 133ff.) and Theodore Allen (1994) in their histories of whiteness in the USA. There in the nineteenth century, in a country not in the same exploitative relation to Ireland as Britain was, the Irish were the sector of the immigrant working class who might be hailed as white as against the Native Americans, African slaves and even some other European migrants – the project of democracy and the common man could fasten on the (Northern European, famously Christian) Irish as evidence of an openness and including-in which did not need to extend beyond this white boundary.

Throughout Western history, the Jews have been in what Michael Lerner calls 'a position of structural instability'. They have

> repeatedly been offered a devil's deal by European societies: You can move out of the position of the 'most oppressed' if you become the public face of oppression to the rest of society, the middle men (and, increasingly, women) who will represent the elites of wealth and power to the powerless.
>
> (1993: 33)

Not least because of their role in the Christ story – Christ was a Jew, but the Jews rejected him; they could have been, perhaps still could be, white – the Jews have constituted the limit case of whiteness. Their racial visibility

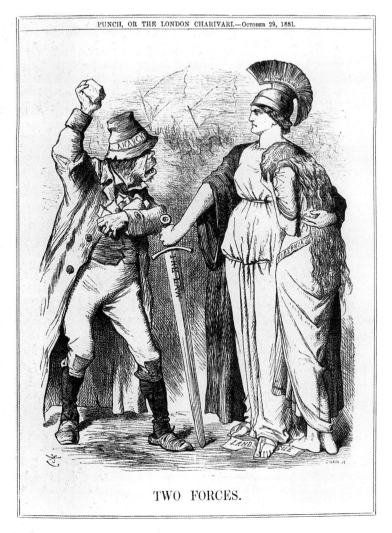

PUNCH, OR THE LONDON CHARIVARI.—October 29, 1881.

TWO FORCES.

Plate 2.5 John Tenniel 'Two Forces' (*Punch* 29 October 1881)

was long thought to be indisputable. Sander Gilman details the tradition of representing Jews in terms of physiognomic difference, including skin, eye and hair colour. However, as he notes, there was a countervailing tendency, which argued that Jews in fact varied in appearance according to geography. Scientists began to demonstrate that Jews were 'the adaptive people par excellence' (1991: 177). Already in 1787 Samuel Stanhope had argued thus: 'In Britain and Germany they are fair, brown in France and in Turkey, swarthy in Portugal and Spain, olive in Syria and Chaldea, tawny or copper-coloured in Arabia and Egypt' (quoted in ibid.).

54

Plate 2.6 Thomas Nast 'The Ignorant Vote: Honors Are Easy' (*Harper's Weekly* 9 December 1876)

Plate 2.7 James A. Wales 'The Simian Irish Celt' (*Puck* 3 November 1880)

This description still tries to fix Jewish colour geographically, not according it the rich flux and variation of whiteness – it is adaptation, not inclusive colourlessness. None the less, it does suggest a conceptual closeness between Jewish and really white colouring. It is a closeness that has only sometimes worked to Jews' advantage. Adaptability could easily be viewed as the capacity to infiltrate, passing for gentile as a kind of corruption of whiteness. The uncertainty over their colour means that at different times Jews may be fully assigned to one or other side of the black:white divide. In Nazi Germany, Jews were regarded as black; in contemporary New York, most would be surprised to find themselves so categorised.

The instability of white as skin colour is not only a means for policing who at any given historical moment is going to be included in or out of the category, but also to differentiate within it, even among those whose racial identity is not in question. In representation, white men are darker than white women. On Greek vases the men are darker than the women,[14] in Western painting (since the Middle Ages) Adonis is darker than Venus, Adam than Eve, indeed any male lover is darker than his female beloved (for the sake of illustration, take Titian's *The Three Ages of Man* (1512) (colour Plate 4) or Jens Juel's *The Ryberg Family Portrait* (1796–7) (colour Plate 1)). Whites may also be hue differentiated according to class. Working-class and peasant whites are darker than middle-class and aristocratic whites. Two portraits by the nineteenth-century Birmingham photographer Benjamin Stone, one (1896) of a charcoal burner (significantly enough, unnamed) and one (1905) of a Mr Smith, clearly a gentleman (Plates 2.8 and 2.9), show very clearly how much darker the working man is, something almost certainly true of the subject himself but enhanced by exposure, development and light (the natural light creates shadows on the charcoal burner, whereas in the studio these can be eliminated). In Chapter 4, I consider the way that, as befits an Everyman figure, the white muscleman hero's body is darker than that of upper-class men but lighter than that of native peoples.

Colour distinctions within whiteness have been understood in relation to labour. To work outside the home – literally out of doors but also away from the values of domesticity – is to be exposed to the elements, especially the sun and the wind, which darken white skin. In most hierarchical social systems, however much the toiler may be lauded in some traditions, the very dreariness and pain of their labour accords them lowly status: thus to be darker, though racially white, is to be inferior. Gender differentiation is crossed with that of class: lower-class women may be darker than upper-class men; to be a lady is to be as white as it gets.

In sum, white as a skin colour is just as unstable, unbounded a category as white as a hue, and therein lies its strength. It enables whiteness to be presented as an apparently attainable, flexible, varied category, while setting up an always movable criterion of inclusion, the ascribed whiteness of your skin.

Plate 2.8 Benjamin Stone *Old Charcoal Burner, Worcestershire* (1896)
(Benjamin Stone Collection, Birmingham Reference Library)

Symbol

Despite some national and historical variation, the basic symbolic connotation of white is fairly clear. Its most familiar form is the moral opposition of white = good and black = bad. *The Oxford English Dictionary* gives as the seventh meaning of white both 'morally and spiritually pure' and 'free from malignity . . . esp. as opposed to something characterised as black', with examples from the tenth century ('Hwylc is of us Drihten baet haebbe swa

Plate 2.9 Benjamin Stone *Mr. Smith in Grotesque Leather Chair* (1905) (Benjamin Stone Collection, Birmingham Reference Library)

hwite saule swa beos halize Marie?' (the *Blickling Homilies*, 971)) to the nineteenth century ('It is I whose duty it is to see that your name be made white again' (Anthony Trollope, *Orley Farm*, 1862)).

This moral symbolism is used to differentiate between characters who belong to the same social skin group, without any apparent racial connotation. Skin hue *per se* may not be adduced: for instance, Marina Warner draws attention to the contrast between an always golden-haired Cinderella and the red, dark and raven-coloured hair of her sisters and stepmother (1994: 366). Dark-haired and swarthy white characters are routinely more often

wicked and/or sensual than fair-haired and light-complexioned ones. John Hodge (1990: 106) provides an example from children's toys:

> Recently (1987) a fast-food restaurant that caters to children and is known throughout the world distributed toy robots to accompany one of its food offerings. The leader of the good robots was predominantly yellow. The bad robots were described as wicked and lazy. Their leader was the darkest of the robots, a dark bluish grey close to black.

The opposition can also work with non-white people. In *Dances with Wolves* (1990), a film self-consciously seeking to right the wrongful imagery of Native Americans in the Western, the bad Pawnee people are none the less of distinctly darker complexion than the good Sioux.

With the basic contrast in place, endless variations can be played. One of the traditional *English and Scottish Popular Ballads* collected by Francis James Child and published in 1882–4 is 'The Twa Sisters', in which a 'dark' older sister kills her 'fair' younger one. The latter has goaded the older in ways which, as Child says, may 'qualify our compassion for' her, as for instance, when she declares

> Wash all day, and you will be no whiter than God made you,
> Wash as white as you please, you will never get a lover.
>
> (Child 1965: 120)

(We may note here the motif of washing and whiteness, something discussed further below.) Richard Jenkyns (1980: 146) points to the contrast in George Eliot's *Middlemarch* (1871–2) between the plain, 'brown' Mary Garth and beautiful Rosamond Vincy, 'a sculptured Psyche' (white like a statue and suggesting spiritual values). However, it is Mary who is the good woman, who prefers the simple country life, whereas Rosamond is a social climber with little interest in morality. The contrast remains – white is beautiful and striving, dark is plain, placid, grounded, unadventurous. The dark:fair contrast is still in place in the already deviant context of a lesbian romance film like *Desert Hearts* (1985), in which uptight, intellectual, traditionally moral and straight Vivian is pale and fair, while raunchy, physical, artistic, promiscuous and lesbian Cay is dark (Plate 2.10) (cf. Stacey 1995: 104–5).[15]

White as a symbol, especially when paired with black, seems more stable than white as a hue or skin tone. It remains firmly in place at the level of language – most people find themselves saying things like 'everything has its darker side', 'it's just a little white lie' and 'that's a black mark against you'. Though we might mock the black and white hats for the villains and heroes respectively in early Westerns, for instance, the use of the oppositions in pictorial representation remains surprisingly widespread.

Plate 2.10 Desert Hearts (USA 1985): Cay (Patricia Charbonneau) and Vivian (Helen Shaver) (BFI Stills, Posters and Designs)

Slippages

There are thus three theoretically distinct senses of white. There does not have to be any slippage between them. The opposition of black and white need not carry racial or moral implications. Jordan (1977: 7) gives an example from Thomas Percy's *Reliques of Ancient English Poetry* (1765):

> Everye white will have its blacke,
> And everye sweete its sowre.

Unless sour is necessarily seen as a bad quality and is aligned (as it is in terms of word placement) with black, this seems merely to be making a point about opposites. Yet an example given by the *OED* of white meaning the opposite of black (and, in the *OED*'s terms, without other inference) suggests how readily slippage may occur:

> I think they have striven if not to make an Ethiopian white, yet an Egyptian to speak truth concerning his own country.
>> (Edward Stillingfleet, *Origines sacrae; or a rational account of the grounds of the christian faith as to the truth and divine authority of the scriptures* (1662))

Here we can see clearly how one register slips into another. The first clause might be neutral enough: you cannot cause a person with black skin to acquire white skin – this both deploys the clear distinction of hue (black and white) and makes a statement of epidermal fact. Yet the second clause clearly refers to the lack of virtue of another race (dishonesty, chauvinism). Lay the two clauses on top of each other and it is easy to see how questions of colour elide with questions of morality. In theory, an Ethiopian (a black person) could represent virtue, but the Ethiopian and the Egyptian occupy the same grammatical position in their respective clauses (and both are non-white people). Neither of them can be made good (symbolically white) nor fair (hue white).

An example of such slippage occurs visually in the film *Beyond the Forest* (1949), in which Bette Davis plays the unrelievedly wicked – and sensual – central character, Rosa Moline (murderous, adulterous, selfish, deceitful, spiteful). She has jet black, shoulder-length hair, a signifier of evil that shrieks at one on the head of a star well known to have light brown hair. Of itself, this need involve no racial connotation but Rosa has an 'Indian' (Native

Plate 2.11 Beyond the Forest (USA 1949): Jenny (Doña Drake) and Rosa (Bette Davis)
(BFI Stills, Posters and Designs)

American) cleaner, Jenny (Doña Drake). Like Rosa, Jenny is a reluctant domestic; she comes to work in a check shirt and trousers, garb for which Rosa upbraids her but which later in the film, she, Rosa, herself adopts; and both of them, in the very WASP little town where the action takes place, have the same shoulder-length, jet black hair. Thus the wickedness of Rosa is signified not only by recourse to a moral black:white antinomy but also by her suggested affinity with a racial inferior (Plates 2.11 and 2.12).

When I began thinking about the significance of white people being coloured white, I was resistant to too quick a conflation of hue, skin and symbol, and especially the idea that because we have a moral vocabulary such that white = good and black = bad we thus necessarily equate white people with goodness and black with evil. Any simple mapping of hue, skin and symbol on to one another is clearly not accurate. White people are far from being always represented as good, for instance. Yet I am now persuaded that the slippage between the three is more pervasive than I thought at first, to the extent that it does probably underlie all representation of white people. For a white person who is bad is failing to be 'white', whereas a black person who is good is a surprise, and one who is bad merely fulfils expectations.

Plate 2.12 Beyond the Forest (USA 1949): Rosa and husband (Joseph Cotten) (BFI Stills, Posters and Designs)

63

Bastide provides a striking example: 'In America, when a Negro is accepted, one often says, in order to separate him from the rest of his race, "He is a Negro, of course, but his soul is white" (1967: 315). However profoundly mixed up and various the actual representations of black and white people are, the underlying regime of dualism is still in play.

Many of the uses of the word 'white' illustrate the slippage between white as hue, skin and symbol. Caroline Spurgeon, in a study of Shakespeare's use of symbols (1958), draws attention to his consistent use of white to suggest beauty and purity (and if I use Shakespeare here it is because, precisely because of its canonical status, his work has so profoundly shaped patterns of thought and feeling in the English language). Typically, something that is indisputably white is used figuratively to suggest a quality of something that barely is, most often white women's complexions. So in *Venus and Adonis*, Venus is said to be 'Teaching the sheets a whiter shade than white' (note again the suggestion of degrees of whiteness, true of the hue and the race), while *Cymbeline* has the lines:

> Cytherea,
> How bravely thou becomest thy bed! fresh lily!
> And whiter than the sheets!

It is, hardly unexpectedly, in *Othello* that the racial equation is most strongly made. Iago's use of racist imagery to unsettle the reception of Othello is well known, but more revealing are Othello's own words, when he becomes convinced of Desdemona's treachery:

> Her name, that was as fresh
> As Dian's visage, is now begrimed and black
> As mine own face.

Here explicitly the value association of black is joined to the skin colour, perhaps as a conceit (especially given that it is put into the mouth of a black man of noble character), but revealing how easily such slippage can occur.

The conflation of symbolic and racial colour became most conscious (and unembarrassed) in the nineteenth century. The *OED* gives the following examples of white referring to light-complexioned people:

> A good fellow is Rayner; as white a man as ever I knew.
> (Sir Walter Besant and James Rice, *The Golden Butterfly*, 1877)

> There ain't a whiter man than Laramie Jack from the Wind River Mountains down to Santa Fe.
> (*The Century Magazine*, February 1890)

Well – this is white of you.

> (Edith Wharton, *The Custom of the Country*, 1913)

I mean to act white by you.

> (ibid.)

To be white is to be at once of the white race and 'honourable' and 'square-dealing'.

The persistence of such slippages and the ground they provide for variation is not confined to the verbal. Albert Boime (1990: 3–4) discusses Edouard Manet's painting *Olympia* (1863), scandalous in its time because it took the noble subject matter of the female nude and showed a naked woman who was very evidently a prostitute. As Boime suggests, those who commented on the presence of a black maid in the painting generally did so in terms of the way her hue made a formal contrast with the main subject, but her blackness is also racially expressive: she is a domestic servant, her head-dress identifies her as West Indian, her relationship to the white nude figure literally embodies imperialism. Yet sexuality is explicitly associated here with the white woman. The presence of the asexual black woman, typically rendered elsewhere in terms of her sexuality, only serves to heighten the outrage of Manet's statement about the white female image – but it can do that because the black:white moral and racial antinomies are in place.

Or take the *Star Wars* trilogy (1977–83), whose unself-conscious antinomies of white/good versus black/evil have been discussed by Clyde Taylor. The basic confrontation is between Luke Skywalker (played by blond Mark Hamill), whose name identifies him as 'a WASP of ancient, biblical lineage' (Taylor 1988: 101), and Darth Vader, whose name may suggest 'dark invader' (ibid.: 100) and who is clad from head to toe in shiny black armour (as discussed in Chapter 3, the shininess may be as racially signi-ficant as the colour). The 'symbolic pawn' in this battle is Princess Leia (Carrie Fisher), an image of 'divinely inspiring, pure white Victorian womanhood' (ibid.). Yet, as Taylor shows, this opposition is complicated, and perhaps thereby partially obscured, by other factors. Luke Skywalker's name also has 'a hint of Native American blood legitimacy' (ibid.: 101) and Darth Vader turns out to be his father, which Taylor relates to such white narratives as the fall from grace and the fear of the enemy within, communism (a potential meaning not lost on Ronald Reagan, who, as Taylor reminds us, took from *Star Wars* the term 'the evil empire' to describe the Soviet Union), and which we might also relate to white fears about the darkness within. Similarly, the casting of the African-American actor Billy Dee Williams as one of the good guys in the second and third parts of the trilogy not only bears witness to how widely perceived 'the first film's iconography and . . . all-white demographics' were among African-Americans (a disproportionately large sector of the US box office), but

also relates to the way the various worlds involved are realised in images drawn from the stereotyping of the Third World. In this context, the casting of Williams 'fits a pattern current in Hollywood movies of those years – separating North American blacks from the demonology that would be directed to Third World people depicted as terrorists' (ibid.: 102–3). In such ways, the reductive dualism of black:white as hue, skin and symbol figures as both a remarkably flexible ground on which to play variations and yet also the bottom line on colour.

The earliest example given by the *Oxford English Dictionary* of the word 'white' being used to refer to a race of people was in 1604,[16] and both Jordan (1977: 95) and Bernal (1987: 201) locate the emergence of the term in the American colonies. Yet grafting morality through hue on to the skin of the person was already in place in painting and literature by then, even where no developed notion of race was explicitly in play. It is in the Christian tradition.

The history of Western painting discloses a shift in flesh colourisation in painting between the medieval and Renaissance periods.[17] In the medieval period there seems to be no interest in flesh differentiation; everyone looks pinky-yellowy. Yet as one moves into the Renaissance, different skin colours begin to be registered. The most obvious is that of the black Magi Balthasar, one of the three wise men who visited Christ in the manger. This visit is only recorded in a few verses of Matthew's gospel, where there is no reference to complexion. The notion that one of the Magi, Balthasar, was black (usually understood to be a Moor) only developed in the Middle Ages, where the three men were taken to represent the three then known continents (Balthasar thus representing Africa). The registering of this in the dark skin of one of the Magi occurs, according to Gertrud Schiller's exhaustive study, only 'sporadically from the twelfth century onwards' but 'frequently in the fifteenth' (especially in North European art) (1971: 96, 112), to become routinised thereafter. Boime (1990: 9) suggests that Balthasar's presence, in an age of developing European exploration and expansion, represents 'a wish fantasy':

> Instead of missionaries and slavers invading the black man's lands and plundering its wealth and subjugating its people by force, a noble and 'wise' black ruler comes of his own volition to the white man's land and lays down his wealth and his power at the feet of the Christ child.

He goes on to note (as does Bastide (1967)) that, even so, Balthasar is generally placed behind the other two kings or further away from the holy infant.

Marking of otherness by skin colour is also present in the depiction of Christ and the Virgin Mary. Increasingly, they are rendered as paler, whiter, than everyone else. This is most evident in the two set-pieces of Christian art,

the nativity and the crucifixion. In the former, Christ and Mary are so white that they give off light which illuminates the darker coloured faces of the shepherds, Magi and even Joseph, none of whom have the transcendent whiteness of Christ and Mary. In crucifixion paintings Christ's body may also give off light, but it may also be less glowingly, more cadaverously white. All those around, except Mary, are darker, though not necessarily uniformly.

A most striking example of flesh colouring is a study of *Madonna and Child with John the Baptist and Ste. Elizabeth* (*c.*1490–5) by Giovanni Bellini (colour Plate 5), in which Christ and Mary are almost purely white while John and Elizabeth (his mother) are much darker. John is especially dark and his black hair falls in ringlets (whereas Christ's and Mary's hair is straight and fair). Historically speaking, all these people are Jews, but Christ and Mary are enlightened, saved Jews, that is, Christians, whereas John and Elizabeth, key witnesses to the coming of Christianity, are none the less pre-Christian, perhaps even unsaved. While this may be an anachronistic perception, the difference between John/Elizabeth and Christ/Mary resembles that between Sephardic Jews (Arab in appearance) and Gentiles (white ones, that is).

The immediate explanation of such skin–symbol colour consciousness is not only European expansionism, but specifically the Crusades (cf. Miles 1989: 13, 17ff). The beginnings of wide and increasing travel beyond Europe involved an encounter with peoples darker in appearance than Europeans, especially North Europeans (who were the first to develop the image of a black Balthasar in painting). Such darkness, in any case not always so distinct from Southern European complexions, did not need to be registered, perhaps at all, and certainly not in terms of a difference at once moral and 'racial'. This is what the Crusades accomplished. Whatever the real motives for them, the primary terms in which the Crusades were and have subsequently been understood is as a struggle of Christianity against the non-Christian (and specifically against the Islamic powers in possession of the Holy Land). The struggle was thus not for possession or expansion but for transcendent, spiritual purposes. Even this does not of itself account for the colourisation of the struggle, but Christianity brought a tradition of black:white moral dualism to bear on an enemy that could itself be perceived as black. The Crusades were thus part of a heightening awareness of skin colour difference which they further inflected in terms of moral attributes.

This explanation can be supplemented by another, which I derive from the argument put forward by Leo Steinberg in his study of the representation of Christ's sexuality in Renaissance art (1983). Steinberg argues that from around the beginning of the thirteenth century, there was an increased 'humanation' in the representation of Christ, an increased emphasis upon his having been human as well as divine, with the result that imagery becomes specific about his human attributes. As he was human, he must, for instance, have been of one sex or the other and must correspondingly have

had the appropriate genitals. Steinberg argues that in this period, contrary to subsequent received perception, painting did depict Christ's genitals, indeed displayed them as a sign of his complete humanity. Following Steinberg, if Christ's humanity was to be fully depicted, then not only must the difference of his sex be represented but so also, in an age of increasing 'racial' awareness, must the difference of his skin colour.

Steinberg also notes a paradox: the Circumcision became increasingly popular as a subject for painting in the Renaissance and yet Christ is never shown to have a circumcised penis – the event is shown but not its bodily effect. Steinberg explains this as a contradiction between a readiness to depict the Circumcision because of its theological importance and a desire not to show Christ as in any way imperfect, that is, unwhole. However, may it not also be because to show him circumcised would have been to show him Jewish (and, indeed, in this particular like the other infidel, Muslim)? Christ's human perfection, in the rendering of his genitals as also of his skin colour, was ineluctably gentile and white.

The gentilising and whitening of Christ was achieved by the end of the Renaissance and by the nineteenth century the image of him as not just fair-skinned but blond and blue-eyed was fully in place. Bastide discusses the significance of the whole socially white ensemble:

> His hair and his beard were given the colour of sunshine, the brightness of the light above, while his eyes retained the colour of the sky from which he descended and to which he returned.
>
> (1967: 315)

The most successful painter of Christ in the twentieth century, the US American Warner E. Sallman, whose *Head of Christ* has been reproduced more than 500 million times, consistently depicted Christ with flowing, wavy, fair hair and a light complexion (and with the backlighting discussed below in Chapter 3) (Grimes 1994). Such popular imagery is still readily obtainable in Christian shops (colour Plate 6 and Plate 2.13).

Christ's whiteness is also that, in painting, of martyrs and beautiful young men.[18] The Virgin Mary's whiteness is that of all truly feminine – womanly, motherly, ladylike – white women. Such hue and skin whitening of the appearance of the indubitable exemplars of white as moral symbol constitutes a slippage that also encapsulates the alluring, culturally intrinsic instabilities of white hue and flesh. Christ and Mary are both human and holy, present and non-existent, which is to say, hue white and uncoloured, skin white and universal.

Hue, skin and symbol bear three senses of whiteness as colour. The high moral value attached to white as symbol permits a slippage associating white hue and skin with such value. However, though I am going to explore this

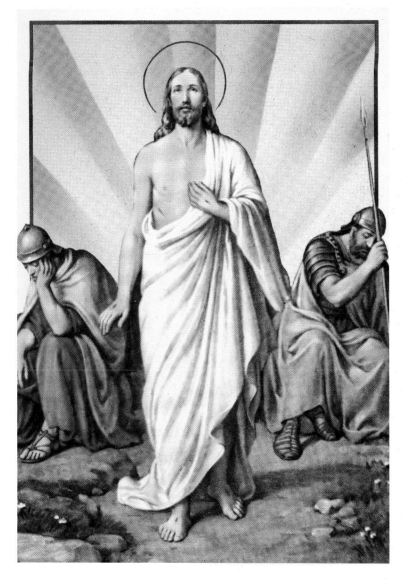

Plate 2.13 Anonymous *Christ with Sleeping Soldiers* (n.d.; postcard bought at Genoa Cathedral, 1996)

further in the next section, it is the least of the work colour designation does in securing and maintaining white power. The wide application of white as symbol, in non-racially specific contexts, makes it appear neutral: white as good is a universal abstraction, it just happens that it coincides with people whose skin is deemed white. The uncertainties of whiteness as a hue, a colour and yet not a colour, make it possible to see the bearers of white skin as non-specific, ordinary and mere, and, it just so happens, the only people whose colour permits this perception. The fuzzy edges and minute gradations of skin whiteness itself make it a richly rewarded social category into which you might be admitted or up which you might climb. To name and to sense white people as white (especially in contradistinction to racially or geographically based terms, such as Negro or Indian) has proved a breathtakingly effective means of maintaining our non-particular, particular power.

White as explicit ideal

Though the power value of whiteness resides above all in its instabilities and apparent neutrality, the colour does carry the more explicit symbolic sense of moral and also aesthetic superiority. It is evidently the case that white people are not invariably represented as good and beautiful – therein lies our diversity, our all-encompassing particularity; yet the moral and aesthetic resonance of whiteness can and often has been mobilised in relation to white-skinned people. It is this that I want to explore here, arguing that the particular way in which this superiority is conceived and expressed, with its emphasis on purity, cleanliness, virginity, in short, absence, inflects whiteness once again towards non-particularity, only this time in the sense of non-existence.

The superiority of whiteness has been felt in terms of beauty as well as morality. Goethe's *Farbenlehre* provides a link between the perception of white as non-particular and as beautiful, since for him white people are beautiful precisely because their colouring is the least particular. Goethe asks himself whether all human 'forms and hues are not equally beautiful', acknowledging that it may be just local prejudice that prefers one over another. Yet he continues:

> We venture, however . . . to assert that the white man, that is, he whose surface varies from white to reddish, yellowish, brownish, in short, whose surface appears most neutral in hue and least inclines to any particular and positive colour, is the most beautiful.
>
> (1840: 265.)

Implicit in this is the sense that white people's whiteness enables them to inhabit without visual contradiction the highest point in the Enlightenment's

understanding of human development, that of the subject without prop-
erties; the beauty of their skin, just because it is nothing 'particular and
positive', is the beauty of this intellectual ideal.

Even without this philosophical gloss, white people have long considered
themselves the most beautiful of people, especially white women. The gallant
term for women in general, 'the fair sex', has a distinct skin colour sugges-
tion. Marina Warner (1994: 363ff.) details the ways in which blondness and
beauty are synonymous in Western myth and fairy-tale. Significantly, the
one exception to this is Snow White, who is dark-haired, but then she has
the name and complexion to make up for it. Winthrop Jordan (1977: 8)
instances the identification of whiteness with beauty in sixteenth-century
England, especially in connection with Queen Elizabeth. Charles White's
influential treatise on race in 1799, crossing phrenology with the idea of the
Great Chain of Being, averred:

> Ascending the line of gradation, we come at the last to the white
> European; who being most removed from the brute creation, may, on
> that account, be considered the most beautiful of the human race. . . .
> Where shall we find, unless in the European, that nobly arched head
> . . . those rosy cheeks and coral lips? Where that erect posture and noble
> gait? In what other quarter of the globe shall we find the blush that
> overspreads the soft features of the beautiful women of Europe, that
> emblem of modesty, of delicate feelings, and of sense? Where that nice
> expression of the amiable and softer passions in the countenance; and
> that general elegance of features and complexion? Where, except on the
> bosom of the European woman, two such plump and snowy white
> hemispheres, tipt with vermilion?
>
> (quoted in Jordan 1977: 501–2)

Nineteenth-century racialist thought repeatedly intertwined science and
aesthetics, defining Aryans or Caucasians as the pinnacle of the human race
in every respect, and therefore including beauty (cf. Mosse 1978, Poliakov
1974).

The notion of lighter or paler skin being more beautiful has also often
applied to non-white people. When the narrator of Rider Haggard's *King
Solomon's Mines* (1885) first meets Umbopa, the Zulu who is to lead him
to the treasure, he praises his appearance thus: 'I never saw a finer native.
Standing about six feet three high, he was broad in proportion, and very
shapely. In that light, too, his skin looked scarcely more than dark.' (1958:
42). bell hooks notes that even in 'the black community the fair-skinned
black woman who most nearly resembled white women was seen as the
"lady" and placed on a pedestal while darker-skinned black women were
seen as bitches and whores' (1982: 110). Until recently, major African-
American women stars have all been pale: Lena Horne, Diahann Carroll,

Diana Ross, Whitney Houston (and major African-American male stars, like Sidney Poitier and Denzel Washington, have had what are seen as relatively Caucasian facial features). What is most striking about the breakthrough of Naomi Campbell as a supermodel is the darkness of her complexion (and even she has flowing, nut-brown hair).

The history of representations of Cleopatra provides one of the clearest instances of the conviction that whiteness is the pinnacle of human beauty. Cleopatra became a byword for feminine beauty in European culture, but in the process she had to be represented as white. As Lucy Hughes-Hallett (1990: 253) puts it, her

> reputation for beauty, though unsupported by any historical evidence, was unassailable, but it was not consonant with the possibility of her being any other than a light-skinned European lady, for in fiction beauty (as distinct from sexual magnetism) has traditionally been the prerogative of social and ethnic élites . . . the vast majority of pre-nineteenth-century writers and artists simply circumvented [this problem] by abolishing Cleopatra's foreignness and changing her appearance to suit their own ideals.

Hughes-Hallett provides many literary and visual examples, including a 1578 poem by Guillaume Belliard, 'Les Delitieuses Amours de Marc Antoine et de Cléopâtre', in which 'her whiteness is said to outshine the whitest ivory', and Tiepolo's 1746 fresco *Cleopatra's Banquet* (Palazzo Labia, Venice), in which Cleopatra 'in common with dozens of others, has strawberry blonde curls, glass-blue eyes and nacreously glimmering neck and breasts' (ibid.: 254).[19] In one nineteenth-century painting, *Cleopatra's Arrival in Cilicia* (1821) by William Etty (Plate 2.14), Cleopatra is black-haired but has the whitest of white face and limbs (one breast is bared and the diaphanous garment reveals the colour of the rest of the body) and she is surrounded by similarly white maidservants and cherubs. On the shore, light-skinned men are looking away, attending to practical matters, but perched on the prow of the barge with his back to us is a black-skinned man, clearly looking directly at Cleopatra. He is placed in the painting so that his skin stands in sharp contrast to Cleopatra and the other women (bar one crouching black maidservant), and he is the only man looking at her – he stands in for the male spectator, whose gaze at this erotic feminine beauty is thus coded as black, the dark look of masculine desire.

In Western tradition, white is beautiful because it is the colour of virtue. This remarkable equation relates to a particular definition of goodness. All lists of the moral connotations of white as symbol in Western culture are the same: purity, spirituality, transcendence, cleanliness, virtue, simplicity, chastity. In a study of 'heathen' Germanic texts, Francis Gummere (1889) shows that this was by no means securely in place before the Renaissance,

Plate 2.14 William Etty *Cleopatra's Arrival in Cilicia* (1821) (the Board of Trustees of the National Museums and Galleries of Merseyside, Lady Lever Art Gallery, Port Sunlight)

but since then it has become so commonplace as to be presented as inevitable, universal and natural. Thus Giovanni Paolo Lomazzo asserts in his *Trattato dell'arte della pittura, scultura e architettura* (1584) that white (the hue) 'signifies and represents innocence, purity' (in Sloan 1991: 8), while Hiroshi Wagatsuma (1967: 422), four centuries later and in the context of skin colour, tells of two Japanese college students in California who dated only Caucasian boys because, they said, 'white skin meant to them purity, advanced civilisation and spiritual cleanliness'. P. J. Heather (1948: 170), drawing on the Bible and Greek and Latin classics, speaks of 'the tendency to associate whiteness with honour, holiness and innocence' and then (178), surveying classic English literature, proverbs and sayings, observes that 'ideas of purity and innocence are . . . intimately present in the minds of our people and in the imagery of poets when white is introduced'. Kenneth Gergen (1967: 397), summarising classic works on colour by Matthew Luckiesh, Walter Sargent and Faber Birren, states that white is associated with 'triumph, light, innocence, joy, divine power, purity, regeneration, happiness, gaiety, peace, chastity, truth, modesty, femininity, and delicacy'. Interestingly he relegates to a footnote something that I discuss in Chapter

6, the association with death, since this refers, as it were, merely 'to the pallor sometimes accompanying death and to the spiritual domain related to the theme of the hereafter' (ibid.: 405). Arrah Evarts, writing in *The Psycho-analytic Review* in 1919, begins by suggesting that white, being as a hue 'the synthesis of all colours, combines in itself the symbolism of all colours' (129), but then proceeds to detail its much more restricted symbolism, derived in this account from it being 'the colour of God' and therefore of eternity, purity, chastity. As with many such accounts of the meanings of colour, to which Gage (1993) is a corrective, and not unconnected to working within the then still fledgling psychoanalytic tradition, Evarts offers these meanings as universal (and for much of the time unconscious), but none the less lays out what are certainly the habitual, unreflected upon (in this sense un-conscious) associations of whiteness in Western tradition. Two of Evarts's elaborations are particularly interesting. One is the account of the derivation of chastity from whiteness, because white is 'pure and untouched' and there-fore redolent of sexual untouchedness. As will be discussed below, defining whiteness through negation and absence is fundamental to understanding it as symbol. Second, Evarts does suggest that sexuality can be positively valued in terms of whiteness, although this is 'repressed into the unconscious' (131). There is an example analysed by Herbert Silberer in *Problems of Mysticism and its Symbolism*, in which a wanderer slays a lion and becomes possessed of its blood and then encounters 'a most beautiful maiden arrayed in white satin'. Evarts concludes from this (132):

> As the parable unfolds the woman clothed in white satin for her bridal becomes the sister-mother-wife of the wanderer, or again the universal female principle as he was the universal male principle.

As discussed elsewhere, the identification of women with whiteness, and men as searchers after whiteness, is central to the construction of skin white people.

The Virgin Mary is the supreme exemplar of this feminine whiteness. Her fair hair[20] and complexion, often white robes and association with lilies and doves all constitute her undisputed virtue in terms of white hue and skin (cf. Bernard 1987, Kovachevski 1991). Mary is an image of motherhood without intercourse (thus unstained by sex). She is never seen pregnant. She goes even further than the most refined white lady: she reproduces without sex.

The case of Mary discloses what is at the heart of the conception of whiteness as virtue, namely absence. This is evident in the way Lomazzo set out the conventional wisdom concerning the symbolism of the colours in 1584, saying of white that it

> signifies and represents *innocence*, *purity*, and in man it represents old age. In the seasons it follows autumn, among the virtues, being an

immaculate colour, it signifies justice. Among the elements it represents water, among metals, silver, and among theological virtues, hope,
which must be *pure* and *impeccable*.

(Sloan 1991: 8–9; my emphases)

While the specific connotations of justice and hope may be lost to us now,
the wider affective ones of purity and so on have remained powerful. The
use of negative terms (innocence,[21] immaculate, impeccable) is interesting as
is the reference to water, since all imply not so much a quality as an absence
of quality, of any thing in particular (and compare the quote from Rood
above, likening white's supposed colourlessness to water's equally doubtful
tastelessness). Many usages of the term white similarly suggest absence:
white languages as, in a genealogical perspective, unadulterated (Bernal
1987: 200); Roland Barthes' notion of écriture blanche, a writing without
character (1965: 68); 'mariage blanc' as a Victorian term for an unconsummated marriage (Hall 1991: 115);[22] white sex itself as vanilla, nothing
added, 'sexual blandness and rigidity' (Bright 1993: 34).

What is absent from white is any *thing*, in other words, material reality.
Cleanliness is the absence of dirt, spirituality the absence of flesh, virtue
the absence of sin, chastity the absence of sex and so on. The cleansing
metaphor of baptism is central. Sin is seen as a stain which water washes
away. Baptism unites cleanliness and goodness. A more sinister, recent and
racially explicit appropriation of the metaphor is to be found in the 'ethnic
cleansing' of Bosnia-Herzegovina.

Joel Kovel, in his study *White Racism*, first published in 1970, makes
dirt central to his account of white attitudes towards non-white people,
from which we may extrapolate attitudes towards whiteness itself. 'Dirt',
he argues, 'is the fate of the sensuousness lost to the world' in the regime
of whiteness (Kovel 1988: c). Kovel argues that, by the late Middle Ages,
the Church, as both the mediator between the individual and God and the
source of moral authority and order in Europe, was increasingly fragmented
and corrupt; Luther stood against the Church by insisting on the individual's direct relation to God. 'His central insight was that a principle
of God was within man himself' (ibid.: 124), something involving both
abstraction, God as a symbol not a being, and an accentuation of the
mind:body split. If God, and all that is of worth, is abstract, then everything
that is concrete, and *a fortiori* the body, is worthless or worse. Kovel stresses
the importance of images of dirt in Luther's work and suggests that out
of this emerges a disdain and disgust for the body and everything bodily:
'the body is dirty; what comes out of the body is especially dirty; the material
world corresponds to what comes out of the body, and hence it is also
especially dirty' (ibid.: 132).

It is in this context that Kovel makes his most vivid argument about race.
Non-white people are associated in various ways with the dirt that comes out

of the body, notably in the repeated racist perception that they smell (but also, notably in a British context, that their food smells, that they eat dirty foods – offal, dogs, snakes – and that they slaughter it in direct and bloody forms). Obsessive control of faeces and identification of them as the nadir of human dirt both characterise Western culture: to be white is to be well potty-trained. Kovel stresses the colour of excrement:

> the central symbol of dirt throughout the world is feces, known by that profane word with which the emotion of disgust is expressed: shit . . . when contrasted with the light colour of the body of the Caucasian person, the dark colour of faeces reinforces, from the infancy of the individual in the culture of the West, the connotation of blackness with badness.
>
> (ibid.: 87)

To be white is to have expunged all dirt, faecal or otherwise, from oneself: to look white is to look clean.

Whiteness, we have come to believe, shows the dirt with unique clarity and certainty. In particular, it shows the dirt of the body. This is why it has such a privileged place in relation to things which are kept close to the body – bed sheets and clothes, especially underwear and shirts – and why whiteness is so central to advertising the cleansing power of detergents. Bridal wear is a symbolically explicit case: it bespeaks the absence of sex, a dirt that is at once literal (sweat, semen, secretions and, in fantasies about virgins, blood) and moral; it also bespeaks the cleanliness of wifely endeavour, the sign that the woman does not bring dirt in to the household and that she will ensure its absence in the performance of her role. Other body-related connotations may be less obvious and routinised yet cover much the same ground. The importance of white for men's underwear and shirts may have to do with a sense that men are less clean than women and thus must strive more to be clean (as they must strive to be white), to show that they are clean, not to be discovered (in the proverbial road accident) to be unclean, and also that they have mothers or wives who ensure they are clean. But the importance of whiteness in underwear is certainly not confined to heterosexual imagery. Steven Maynard discusses the rise of designer men's underwear, whose marketing deploys homoerotic imagery. He notes the way that the Bruce Weber photographs used to advertise Calvin Klein underwear (by far the most successful of all the designer labels) show only white men, only in white underwear (though other colours are sold), use exclusively black and white photography (which 'functions to emphasise, sometimes to almost illuminate, the whiteness of the fabric' (1994: 8)) and draw on both classical Greek imagery and Weimar German photographic styles (both strongly white), so that 'homoeroticism comes to be defined as white' (ibid.). The association of coloured and patterned sheets, underwear and shirts with the

young, the lower classes and the non-white, in part to do with the time and expense involved in achieving white laundry, has also to do with the place of older, socially elevated whites in the pecking order of true whiteness.

It is however not only the whiteness we come into contact with but our own flesh's whiteness that is at issue. The cult of virginity expressed an idea of unsullied femininity (not dirtied by sex), which was held to be visible in the woman's appearance. It could be intensified by the cult of fasting (common still among young women, if seldom now for strictly religious reasons), which makes the person look paler and signifies lack of corporeal engagement with the world, the body not dirtied by having had matter stuffed into it. Marina Warner suggests a further dimension of this in the image of Mary. Virginity was important for the Fathers of the Church not only because it signified absence of knowledge of sex but because it meant that the body was pristine and whole, as God had made it.

> The biblical images the Fathers applied to the birth of Christ reveal that they conceived of a virgin's body as seamless, unbroken, a literal epiphany of integrity. The Virgin Mary is a 'closed gate', a 'spring shut up', a fountain sealed'. . . . The virgin body was natural and integral, and as such the foremost image of purity.
>
> (Warner 1976: 73–4)

This wholeness is evident in Mary's face. Virtually never – not even in the first days after Christ's birth, not even thirty years later as she attends her son's execution – is her face only partially seen (by being in profile, in shadow or cut across by objects), blemished by wrinkles or even streaked with tears (let alone marked by moles, pimples and so on). The infant Jesus is often given lines of age to express his wisdom, whereas his mother almost never has them.

Since the nineteenth century, cosmetics have sought to make rather than paint white skin whiter. At the end of the nineteenth century, the new creams and soaps were founded on the notion that by becoming really, deep down clean, a woman could become truly beautiful, because she would *look* so clean. Pears' Soap gained its ascendancy in the market in a campaign emphasising its efficacy in producing a clean skin: 'Nothing adds so much to personal appearance as a bright *clear* complexion' (1890s advertisement reproduced in Angeloglou 1970: 102; my emphasis). Similarly, Elizabeth Arden promoted its cleansing creams on the following basis:

> The most elaborate *toilette* can be marred by tiny faults of your skin – cheeks that shine, blemishes that flaunt an angry red, coarseness, wrinkles. But each of these faults can be overcome. Not hidden, mind you, but removed!
>
> (reproduced in ibid.: 123)

The reference to shine is especially interesting, for two reasons: first, shine connotes sweat, something inappropriate to ladies, that is, really white women, and also an instance of the body's dirt; second, as will be discussed in Chapter 3, dark skin, especially under strong light, and notably in photography, often has shiny highlights, thus associating shininess with non-white people.

The racial dimensions of cosmetic advertising are brought home, partly by the invariability of having white faces in illustration, partly by the vocabulary of alabaster, milkiness and so on in the copy. Sometimes the rhetoric seems yet more insistent. Jackie Stacey (1994: 3–5) discusses a 1955 advertisement for Lux Toilet Soap (published in *Picturegoer*), which uses Susan Hayward and a sculpted head to promote the purity of both the product and its effect (Plate 2.15). The sculpted head is both white (possibly made of soap) and evokes classical (that is, socially white) ideals; Hayward's face and shoulders rhyme with this doubly white icon (even though Hayward is herself dark-haired). Moreover, as Stacey points out, the word 'white' is used four times, emphasised still more by an italicised superlative (Susan has 'never wavered in her choice of the *whitest* soap') and an (again italicised) link to the special virtue of whiteness: 'It's the snowy, white look of Lux Toilet Soap that tells you worlds about its *purity.*' In short, cultural symbol (classical antiquity), product and effect are all linked by the idea of whiteness as, in Stacey's words, 'purity, cleanliness, beauty and civilised culture' and by the attainment of ideal (therefore implicitly white) feminine beauty.

One of the most famous lines in Shakespeare is also, on the face of it, one of the least memorable: Lady Macbeth's 'Will these hands ne'er be clean?' Perhaps it has lodged in the compendium of sayings because of the way it mobilises the cleansing metaphor. Lady Macbeth's part in her husband's rise to power is bloody and ruthless; in her mind, she seeks to rid herself of the taint of the real means by which her (and other white) power has been achieved. If she can just be clean, she will be free of taint. But – and this is what is most vivid about the line – her terror is that she never will or can be. Clean how one may (even with Lux Toilet Soap), one can never be white enough.

Whiteness, really white whiteness, is unattainable. Its ideal forms are impossible. In Shakespeare (as noted above), Venus must be 'a whiter shade than white', Cytherea in *Cymbeline* must be 'whiter than the sheets'. The Ku Klux Klan must dress in white sheets, because, as Walter Ben Michaels points out, 'their bodies aren't as white as their souls, because *no* body can be as white as the soul embodied in the white sheets' (1989: 190). The most celebrated blondes (Harlow, Monroe, Bardot) were not true blondes, but peroxided to within an inch of their lives.[23]

Whiteness as an ideal can never be attained, not only because white skin can never be hue white, but because ideally white is absence: to be really, absolutely white is to be nothing. This is revealed in the function non-white

How do you see Susan?

HERE'S SUSAN HAYWARD as the sculptor saw her — sweet and fresh as a spring morning.

But you'll be seeing her as one of the hardest women in history — playing Messalina in her latest film!

However much Susan may change character, one thing remains familiar: that fabulous *complexion*. Why? Because she's never changed her mind about what's best for beauty. That means she's never wavered in her choice of the *whitest* soap — Lux Toilet Soap — to keep the lovely sparkle in her skin.

It's the snowy, white look of Lux Toilet Soap that tells you worlds about its *purity*. You can be sure that it is mild, is gentle — and that every day of Lux Toilet Soap care proves your first impression right!

When 9 out of 10 film stars use it, you can be sure that pure, white Lux Toilet Soap lives up to its appearance!

"DIVINELY FRAGRANT!" Film star Susan Hayward sings the praises of Lux Toilet Soap's exciting perfume, which lingers so deliciously on the skin. In the new French handly-shaped, and easy to hold tablet for long-lasting economy, as well as the familiar size.

SUSAN HAYWARD sees her usual charming self, captured in sculpture. You'll see her in another guise, as wicked Messalina in the new 20th CENTURY FOX FILM "DEMET-

9 out of 10 film stars use pure, white Lux Toilet Soap

Plate 2.15 Advertisement for Lux toilet soap (*Picturegoer* 22 January 1955)

peoples have had in white fictions, notably explored in the US context by Toni Morrison. She argues that white US literature has consistently returned to darkness – of actual black characters but also, intertwined with this, imagery of darkness in its use of language – as a way of dealing with the aspects of the self that the white enterprise of constructing US identity could and can not deal with, everything seen as chaotic, savage, ungovernable. She suggests that this is very much part of the Enlightenment project which has fuelled US development and that it was precisely the presence on North American soil of enslaved people called black that enabled them to be used as the symbol of both what was not civilised and yet, crucially, also of what whites knew in their bones was part of their own humanity. Thus these qualities, inimical to the project of 'America', were by no means only intensely despised, they were intensely desired as well, to the point that they, that dark qualities, seemed to be the only real, palpable qualities:

> images of blackness [in US literature] can be evil *and* protective, rebellious *and* forgiving, fearful *and* desirable – all of the self-contra-dictory features of the self. Whiteness, alone, is mute, meaningless, unfathomable, pointless, frozen, veiled, curtained, dreaded, senseless, implacable. Or so our writers seem to say.
>
> (Morrison 1992: 59)

Through the figure of the non-white person, whites can feel what being, physicality, presence, might be like, while also dissociating themselves from the non-whiteness of such things. This would work well were it not for the fact that it also constantly risks reminding whites of what they are relinquishing in their assumption of whiteness: fun, 'life'. Ralph Ellison identified the function of blacks in US culture as that of being 'a marker, a symbol of limits' that will enable white people to know 'who they really are' (quoted in Trost 1975: 81). The problem, however, is that in doing that they may also remind us of what we really aren't, and moreover that being nothing, having no life, is a condition of whiteness. The purity of whiteness may simply be the absence of being.

The ideal of whiteness makes a strong appeal. It flatters white people by associating them with (what they define as) the best in human beauty and virtue. The very idea of a best and of striving towards it accords with the aspirational structure of whiteness. There is an ecstasy to be felt in the luminescent representation discussed in the next chapter, a luminescence that makes sense in the context of the idea of whiteness as transcendence, dissolution into pure spirit and no-thing-ness. Equally, the ideal of white as absence may be confounded with the wider representational mode discussed above: being nothing at all may readily be felt as being nothing in particular, the representative human, the subject without properties.

Yet the lure of the ideal is also, often imperceptibly, haunted by mis-giving, even anxiety. Not only is whiteness as absence impossible, it is not wholly desirable. To relinquish dirt and stains, corporeality and thingness, is also to relinquish both the pleasures of the flesh and the reproduction upon which whiteness as racial power depends. To be nothing is to be dead, something in some circumstances devoutly to be wished (as I suggest in relation to *The Jewel in the Crown* in Chapter 5), but also, especially in a secular age, dreaded (as discussed in Chapter 6).

Besides, whiteness as an ideal not only raises the spectres of absence, it also foregrounds whiteness as whiteness. It is, as was discussed in the first part of this chapter, the colour's propensity *qua* colour to stay in the back-ground, its potential to seem to express diversity and non-particularity that constitutes its greatest power in the representation of white people.

3

The light of the world

A television company is about to shoot a panel discussion before a studio audience. The producer, from the control room, is discussing with the floor manager in the studio how the audience looks in his monitor. The producer says something about the number of black people at the front of the audience. 'You're worried there are not too many whites obviously there?', asks the floor manager. No, says the producer, it's nothing like that, a mere technical matter, a question of lighting – 'it just looks a bit down'.

This exchange occurred in the preparation of a programme about the street fighting that took place in Handsworth, Birmingham, in September 1985, fighting that was largely understood to be about race and which was the most vivid and controversial of many such incidents throughout Britain that year. The exchange was recorded by the Black Audio Film Collective and included in their film *Handsworth Songs* (1987),[1] which explores the cultural construction of 'race riots'. That construction is embedded in part in the professional common sense of media production, two items of which are registered in this exchange.

One item, which is less germane to the subject of this chapter, is that of 'balance'. The floor manager cannot at first understand what the producer is getting at. Is it perhaps the racial composition of the audience in numerical and representative terms? The topic of the programme has been constructed as race riots, and to have 'balance' one has to thinks in terms of sides and ensure that equal numbers on each side are represented. This lies behind the floor manager's remark about there perhaps not being 'enough white people obviously there', and the producer understands what he is getting at. However, it is not what concerns him or us here, whereas the second notion at play in the exchange goes straight to the heart of the matter.

For the producer it is a purely aesthetic matter. The image looks 'down': dull, dingy, lacking sparkle. There is no reason to presume he is saying this because he finds black people dislikeable or uninteresting. He is, in the terms of professional common sense, right: shoot the scene in the usual way with the usual technology with that audience and it will look 'down'. The corollary is that if you do it the usual way with a white audience, it will look

'up', bright, sparkling. What I want to explore in this chapter is how this comes to be and what it signifies.

What is at issue is an aesthetic technology. The producer is making a statement about the formal quality, the look, of a set-up. The technology he is using and the habitual ways of using it both produce a look that assumes, privileges and constructs an image of white people.

All technologies are at once technical in the most limited sense (to do with their material properties and functioning) and also always social (economic, cultural, ideological). Cultural historians sometimes ride roughshod over the former, unwilling to accept the stubborn resistance of matter, the sheer time and effort expended in the trial and error processes of technological discovery, the internal dynamics of technical knowledge. Yet the technically minded can also underestimate, or even entirely discount, the role of the social in technology. Why a technology is even explored, why that exploration is funded, what is actually done with the result (out of all the possible things that could be done with it), these are not determined by purely technical considerations. Given tools and media do set limitations to what can be done with them, but these are very broad; in the immediacy and instantaneity of using technologies we don't stop to consider them culturally, we just use them as we know how – but the history, the social inscription, is there all the same.

Several writers have traced the interplay of factors involved in the development of the photographic media (e.g. Altman 1984, Coleman 1985, Neale 1985, Williams 1974) and this chapter is part of that endeavour. I am trying to add two things, in addition to the specificity of a focus on light. The first is a sense of the racial character of technologies, supplementing the emphasis on class and gender in previous work. Thus just as perspective as an artistic technique has been argued to be implicated in an individualistic world view that privileges both men and the bourgeoisie, so I want to argue that photography and cinema, as media of light, at the very least lend themselves to privileging white people. Second, I also want to insist on the aesthetic, on the technological construction of beauty and pleasure, as well as on the representation of the world. Much historical work on media technology is concerned with how media construct images of the world. This is generally too sophisticatedly conceptualised to be concerned with anything so vulgar as whether a medium represents the world accurately (though in practice, and properly, this lingers as an issue) but is concerned with how an ideology – a way of seeing the world that serves particular social interests – is implicated in the mode of representation. I have no quarrel with this as such, but I do want to recognise that cultural media are only sometimes concerned with reality and are at least as much concerned with ideals and indulgence, that are themselves socially constructed. It is important to understand this too and, indeed, to understand how representation is actually implicated in inspirations and pleasures.

The aesthetic technology at issue in this chapter is light and lighting. This is fundamental to all photographic media; why this is so and what it involves are discussed in the next section ('Light and the Photographic Media'). Mainstream cinema (above all, Hollywood) developed a particular style of lighting that may be called 'movie lighting', and this will be described in the same section. Both the technology of lighting and the specific mode of movie lighting have racial implications. The third section of the chapter ('Lighting for whiteness') discusses these in historical and current practice, looking at the way the aesthetic technology of light has a tendency to assume, privilege and construct an idea of the white person. The fourth section ('A culture of light') traces the development of the technology and its implication in white ways of seeing whiteness. The argument there is that the photographic media are centrepieces in a whole culture of light that is founded on two particular notions, namely that reality can be represented as being on a ground of white, and that light comes from above; these notions have the effect not only of advantaging white people in representation and of discriminating between and within them, but also of suggesting a special affinity between them and the light. In the final section ('The glow of white women'), I take a particularly striking example of the use of light in white representation, namely the glow of the woman within the construction of white heterosexuality.

Light and the photographic media

Photography and film are media of light. Writing about them frequently asserts this. Consider these titles, chosen from what comes to hand as I write: 'Painting with Light' (Milner 1930, about film lighting), *Painting in Light* (Alton 1949, about cinematography), *Printed Light* (Ward and Stevenson 1986, about early photography), *Narration in Light* (Wilson 1986, about point of view in film and not dealing specifically with light at all); or these statements:

> Lighting is the very essence of the motion picture. Figuratively it is the palette of the art director and occupies the same relation as pigment does to painting. It is the medium.
>
> (Ihnen and Atwater 1925: 27)

> As writers work with words, and directors with players, [the camera-man] works with a more elusive medium: light.
>
> (Hoadley 1939: 52)

> [P]hotography is building with light; light is the medium, a medium of infinite plasticity.
>
> (De Maré 1970: 55)

Basically, the visual part of the illusion we call the motion picture is nothing but the accurate control of light.

(Handley 1967: 120)

Films are light.

(Federico Fellini, quoted in Malkiewicz 1986: 1)

Such titles and statements are not metaphors: photography and film really are technologies of light. A photographic image is the product of the effect of light on a chemically prepared surface (the stock); a single frame of a projected film is one such surface with light shining through it on to a screen. No light, no photos or films.

The apparatus of light does not only concern stock and projection. Schematically, the following are involved.

- The light thrown at the subject of the image, in this sense the *lighting*. This may simply be the available light in the location, be it natural or artificial, which may be assisted (e.g. by reflectors and other kinds of bouncing) or controlled (e.g. by filtering sunlight though muslin or glass). It may equally involve a wide array of kinds of lighting apparatus, produced by a variety of means, using various lenses, reflectors and so on, all with different qualities of light.
- The properties of the *subject*. Objects (including people) reflect and absorb light differently, as well as being of different colours.
- The *stock*. Different kinds of stock are sensitive to different kinds and intensities of light.
- *Exposure*. The length of time the photographic stock is exposed to the light and the size of the aperture through which light passes both affect how light is registered on the stock and therefore how it looks when developed and projected.
- The *development* of the stock, during which many adjustments and transformations in light qualities can be achieved.
- *Projection*. Different kinds of projectors produce different qualities of light, and of course film seen on video is different again.

All these elements are in play in the history and practice of the photographic media, including film. A change in stock to register certain colour and textural qualities entails changes in, say, lighting and make-up, which in turn call for modifications in developing procedures and eventually the stock itself. The introduction of sound and colour were particularly intense periods of such alteration, but the technology has never stayed still.[2] Nor was this a purely internal, technical history, since it is entwined with issues of economics, fashion, social pressure and aesthetics.

The history of light technology, even if we just confine ourselves now to film, is highly intricate. Yet through it one can see operating a fairly

consistent sense of what light in film should be, which acted as both bench-mark and goal for most innovations and variations. This is embodied in a style of lighting developed by the 1920s[3] which became and remains so widespread that it can be referred to as, for instance, 'cinema lighting' (Coutard 1966: 9) or the 'film look' (Malkiewicz 1986: 100). I shall call it 'movie lighting' and will draw examples principally from Hollywood films, since by the 1920s they had come to dominate and set standards for most other film production.

Although this lighting style involves all the elements described above as contributing to the medium's technology of light, it is most easily described in relation to the light thrown at the subject, 'lighting' in this sense. Its guiding principal is controlled visibility. At a very basic level, movie lighting wants to ensure that what is important in a shot is clearly visible to the audience. This may seem laboriously elementary but, on the one hand, simply shooting in available light may not achieve this (as all casual photo-graphers know) and, on the other, what constitutes importance in a shot is not a given, but a matter of the film-makers' choices. It may certainly not be story clarity in any obvious sense. In a mystery film, it may be important that the audience cannot see something. In a star vehicle, seeing the star to best advantage may outweigh other narrative considerations. In a drama in which no character is supposed to take precedence over the others in the audience's sympathies, equal visibility for all concerned may be required, something that is quite hard to achieve (given the way natural, and normal domestic, light fall). It is in relation to such problems of film expression that the elaborately controlled method of movie lighting evolved.

Movie lighting nearly always considers people to be the most important element in a shot. In practice, this means lighting people so that they are clearly separated from their surroundings, and do not appear to merge with the scenery. Most often, lighting is set up in two stages, once for the overall setting, once for the people in it, with the latter referred to as the 'figure lighting'. It is common in movies for there to be a perceptible difference between the figure lighting in a long or medium shot and that in a close-up. This is so even in films as early as *Hearts of the World* (USA 1918) and *Way Down East* (USA 1920) (both directed by D. W. Griffith), where the full panoply of light technology was not yet in place. In the former, there is a scene where the heroine (Lillian Gish) is menaced by a German officer (Eric von Stroheim). The lighting in the shots of them together is an even, overall illumination. However, in the close-ups of her, cringing from his advances against a wall, she is lit slightly from below, with no light on the wall – the light catches her wide eyes and the whiteness of her face is emphasised by the contrast with the darkness of the wall. Such a change in light for expressive purposes between mid and close shots is unnaturalistic but wholly within the convention of movie lighting. In *Way Down East*, when the hero and heroine (Robert Harron and Lillian Gish) first meet, the

long and medium shots of them are taken in unassisted sunlight, with only the placing of the performers ensuring that at least each face is visible. However, the close-ups of Harron and Gish use a variety of techniques (soft focus, gauzes, placement against plain white backgrounds, side lighting) to make them special; editing in combination with lighting makes them stand out, as befits both their role as the lovers and their star status. Both these examples also construct the characteristic glow of white women, contrasted especially in the first case with a dark masculine desire that, under the pressure of war propaganda, would also have been felt as racially other.

Figure lighting is the main concern of this chapter, since what is at issue is the image of people. Movie figure lighting ensures the proper visibility of each performer (according to the needs of narration, star status and so on) by a use of several lights, classically in a three-point system consisting of a primary light (the *key*), giving general illumination of the figure, a second, softer light (the *fill*), eliminating some of the shadows created by the key and other set lighting, and *backlighting*, which serves to keep the figure separate from the background as well as creating, when wanted, the rim and halo effects of heroic and glamour lighting.

In practice, movie lighting is a good deal more complex and flexible than this. Three lights for figure lighting is minimal and the picture is always complicated by the infinite range of placements possible for all three positions and by their relationship to other lighting in the scene and to all the other elements that constitute light in film. Nor was the pattern of lighting fixed in the 1920s to remain utterly unchanged ever since. Hollywood, the paradigm of movie style, was influenced by, for instance, both 1920s German ('expressionist') lighting styles, with their much greater emphasis on chiaroscuro effects cutting across the figure (as in, especially, film noir and the horror film), and the bright, bounced, overall white light of the French new wave, less concerned with picking out the figures in a hierarchy of importance.[4] Yet such influences modified movie lighting rather than displacing it, and I have been struck while writing this chapter how extraordinarily pervasive the style remains, in ordinary television as much as in contemporary art cinema and still overwhelmingly in Hollywood movies.

The film *Mauvais sang* (France 1986),[5] for instance, is lit in a bright, hyper-realist style, combining yellowish tungsten with white quartz light; light sources visible on screen often appear to be the source for the lighting overall, characters often step into or out of light without reference to either dialogue or narrative; in short, *Mauvais sang* has a very modern, contemporary look, quite different from classic Hollywood. Yet on inspection many of the norms of movie lighting are in place. Take a scene in which the central character, Alex, visits two men, Marc and Hans. The room he finds them in is lit by fluorescent lighting hung over a billiard table. At first glance, one takes this to be the whole source of lighting for the scene, but in fact lighting at a 45° angle from above screen left illuminates the tops of the men's heads.

A woman, Anna, is introduced into the scene and there are shots of her and Alex, establishing his interest in her. Both are shot in head and shoulders close-up, but cropped at the top and placed slightly to one side of the image, unconventional framing by movie norms. In her case, the framing cuts off the very top of her head, though much of her hair is visible. There is a relatively strong, warm light on her face from screen left (slightly to the front of her face), a less strong light from screen right, creating highlights as well as eliminating the shadows from her neck (shadows cast by the main light), and some light catching what we can see of her hair. As with movie figure lighting, this has little to do with the visible light source in the scene. Lighting so clearly from sides and top is different from the characteristic positions of movie lighting, yet it is none the less a form of three-point lighting. Alex also has the key and fill, more fully to one side and the other of his head, but, as the top of his head is cropped at his brow, it is hard to tell whether he is lit from above. The difference in the lighting between Anna and Alex is gender-related: she is more glowingly and he more harshly lit. The blending of the three-point lighting in her case creates a softer, more unified look; the greater (relative) severity of the lighting on him creates a degree of contrast. Such gender differentiation also has to do with whiteness: she inhabits (albeit principally in his perception) a space of transcendence, whereas he is a body seeking transcendence.

Even in a smart, postmodern film like *Mauvais sang*, the basic qualities of movie lighting remain: ensured visibility, figures lit quasi-independently of setting, and codes that are gendered and white-related. This is even more evidently true of contemporary Hollywood and television, and not only drama[6] but quiz and chat shows and even documentary and news. Indeed, as I have been writing this, I have become riveted by watching light catch the hair and ensure the outlined contours (without going so far as haloing or rimming) of newscasters and TV weather reporters. The sense of the normality of this is still pervasive. A current 'leisure know-how' guide on how to *Make Better Home Videos*, the kind of basic, common-sense, 'no point of view' paperback you can buy in a supermarket, offers exactly the same three-point lighting plan as simply how to light a person (Owen 1993: 104–7).

This chapter focuses on movie figure lighting, and above all face lighting. This is principally because my concern is with how images of (white) people are constructed, but it is also in line with photographic and film practices themselves. The face is seen as both the most important thing in an image and also, as a consequence, the control on the visual quality of everything else. At the point of shooting, a standard photography manual recommends use of an exposure meter: 'Take a reading off the most important part of your subject, e.g. face or person' (and uses a white face in illustration) (Greenhill *et al.* 1977: 48). At the point of development, Raoul Coutard observes of colour film: 'As the film stock is unstable, the laboratories need

something to use as a fixed point from which to work in re-establishing the true colours; and what they work from are the actors' faces' (Coutard 1966: 11). At the point of reception, I well recall the advice that first-time purchasers of colour television were given about how to adjust their sets: get the people's faces right and everything else would fall into place. This is good advice, as long as you take the white face as the norm and don't mind non-white faces looking odd.

Movie lighting of the face is at the heart of ordinary production. The next section looks at its relation to whiteness in general terms before tracing the source of this and its implications in the historical development of a culture of light.

Lighting for whiteness

The photographic media and, *a fortiori*, movie lighting assume, privilege and construct whiteness. The apparatus was developed with white people in mind and habitual use and instruction continue in the same vein, so much so that photographing non-white people is typically construed as a problem.

All technologies work within material parameters that cannot be wished away. Human skin does have different colours which reflect light differently. Methods of calculating this differ, but the degree of difference registered is roughly the same: Millerson (1972: 31), discussing colour television, gives light skin 43 per cent light reflectance and dark skin 29 per cent; Malkiewicz (1986: 53) states that 'a Caucasian face has about 35 percent reflectance but a black face reflects less than 16 percent'. This creates problems if shooting very light and very dark people in the same frame. Writing in *Scientific American* in 1921, Frederick Mills, 'electrical illuminating engineer at the Lasky Studios', noted that

> when there are two persons in [a] scene, possibly a star and a leading player, if one has a dark make-up and the other a light, much care must be exercised in so regulating the light that it neither 'burns up' the light make-up nor is of insufficient strength to light up the dark make-up.
>
> (1921: 148)

The problem is memorably attested in a racial context in school photos where either the black pupils' faces look like blobs or the white pupils have theirs bleached out.

The technology at one's disposal also sets limits. The chemistry of different stocks registers shades and colours differently. Cameras offer varying degrees of flexibility with regard to exposure (effecting their ability to take a wide lightness/darkness range). Different kinds of lighting have different colours and degrees of warmth, with concomitant effects on different skins.

However, what is at one's disposal is not all that could exist. Stocks, cameras and lighting were developed taking the white face as the touchstone. The resultant apparatus came to be seen as fixed and inevitable, existing independently of the fact that it was humanly constructed. It may be – certainly was – true that photo and film apparatuses have seemed to work better with light-skinned peoples, but that is because they were made that way, not because they could be no other way.

All this is complicated still further by the habitual practices and uses of the apparatus. Certain exposures and lighting set-ups, as well as make-ups and developing processes, have become established as normal. They are constituted as the way to use the medium. Anything else becomes a departure from the norm, or even a problem. In practice, such normality is white.

The question of the relationship between the variously coloured human subject and the apparatus of photography is not simply one of accuracy. This is certainly how it is most commonly discussed, in accounts of innovation or advice to photographers and film-makers. There are indeed parameters to be recognised. If someone took a photo of me and made it look as if I had olive skin and black hair, I should be grateful but have to acknowledge that it was inaccurate. However, we also find acceptable considerable departures from how we 'really' look in what we regard as accurate photos, and this must be all the more so with photography of people whom we don't know, such as celebrities, stars and models. In the history of photography and film, getting the right image meant getting the one which conformed to prevalent ideas of humanity. This included ideas of whiteness, of what colour – what range of hue – white people wanted white people to be.

The rest of this section is concerned with the way the aesthetic technology of photography and film is involved in the production of images of whiteness. I look first at the assumption of whiteness as norm at different moments of technical innovation in film history, before looking at examples of that assumption in standard technical guides to the photographic media. The section ends with a discussion of how lighting privileges white people in the image and begins to open up the analysis of the construction of whiteness through light.

Innovation in the photographic media has generally taken the human face as its touchstone, and the white face as the norm of that. The very early experimenters did not take the face as subject at all, but once they and their followers turned to portraits, and especially once photographic portraiture replaced painted portraits in popularity (from the 1840s on), the issue of the 'right' technology (apparatus, consumables, practice) focused on the face and, given the clientele, the white face. Experiment with, for instance, the chemistry of photographic stock, aperture size, length of development and artificial light all proceeded on the assumption that what had to be got right was the look of the white face. This is where the big money lay, in the everyday practices of professional portraiture and amateur snapshots. By

the time of film (some sixty years after the first photographs), technologies and practices were already well established. Film borrowed these, gradually and selectively, carrying forward the assumptions that had gone into them. In turn, film history involves many refinements, variations and innovations, always keeping the white face central as a touchstone and occasionally revealing this quite explicitly, when it is not implicit within such terms as 'beauty', 'glamour' and 'truthfulness'. Let me provide some instances of this.

The interactions of film stock, lighting and make-up illustrate the assumption of the white face at various points in film history. Film stock repeatedly failed to get the whiteness of the white face. The earliest stock, orthochromatic, was insensitive to red and yellow, rendering both colours dark. Charles Handley, looking back in 1954, noted that with orthochromatic stock, 'even a reasonably light-red object would photograph black' (1967: 121). White skin is reasonably light-red. Fashion in make-up also had to be guarded against, as noted in one of the standard manuals of the era, Carl Louis Gregory's *Condensed Course in Motion Picture Photography* (1920):

> Be very sparing in the use of lip rouge. Remember that red photographs black and that a heavy application of rouge shows an unnaturally black mouth on the screen.
>
> (316)

Yellow also posed problems. One derived from theatrical practices of make-up, against which Gregory inveighs in a passage of remarkable racial resonance:

> Another myth that numerous actors entertain is the yellow grease-paint theory. Nobody can explain why a performer should make-up in chinese yellow. . . . The objections to yellow are that it is non-actinic and if the actor happens to step out of the rays of the arcs for a moment or if he is shaded from the distinct force of the light by another actor, his face photographs BLACK instantly.
>
> (ibid.: 317; emphasis in original)

The solution to these problems was a 'dreadful white make-up' (actress Geraldine Farrar, interviewed in Brownlow 1968: 418) worn under carbon arc lights so hot that they made the make-up run, involving endless retouching. This was unpleasant for performers and exacerbated by fine dust and ultraviolet light from the arcs, making the eyes swollen and pink (so-called 'Klieg eyes' after the Kliegl company which was the main supplier of arc lights at the time (Salt 1983: 136)). These eyes filmed big and dark, in other words, not very 'white', and involved the performers in endless 'trooping

down to the infirmary' (Brownlow 1968: 418), constantly interrupting shooting for their well-being and to avoid the (racially) wrong look.

It would have been possible to use incandescent tungsten light instead of carbon arcs; this would have been easier to handle, cheaper (requiring fewer people to operate and using less power) and pleasanter to work with (much less hot). It would also have suited one of the qualities of orthochromatic stock, its preference for subtly modulated lighting rather than high contrast of the kind created by arcs. But incandescent tungsten light has a lot of red and yellow in it and thus tends to bring out those colours in all subjects, including white faces, with consequent blacking effect on orthochromatic stock. This was a reason for sticking with arcs, for all the expense and discomfort.

The insensitivity of orthochromatic stock to yellow also made fair hair look dark 'unless you specially lit it' (cinematographer Charles Rosher, interviewed in Brownlow 1968: 262). Gregory similarly advised:

Yellow blonde hair photographs dark . . . the more loosely [it] is arranged the lighter it photographs, and different methods of studio lighting also affect the photographic values of hair.

(1920: 317)

One of the principal benefits of the introduction of backlighting, in addition to keeping the performer clearly separate from the background, was that it ensured that blonde hair looked blonde:

The use of backlighting on blonde hair was not only spectacular but *necessary* – it was the only way filmmakers could get blonde hair to look light-coloured on the yellow-insensitive orthochromatic stock.

(Bordwell *et al.* 1985: 226; my emphasis)

Backlighting became part of the basic vocabulary of movie lighting. As the cinematographer Joseph Walker put it in his memoirs:

We found [backlighting] necessary to keep the actors from blending into the background. [It] also adds a halo of highlights to the hair and brilliance to the scene.

(Walker and Walker 1984: 218)

From 1926, the introduction of panchromatic stock, more sensitive to yellow, helped with some of the problems of ensuring white people looked properly white, as well as permitting the use of incandescent tungsten, but posed its own problems of make-up. It was still not so sensitive to red, but much more to blue. Max Factor recognised this problem, developing a make-up that would 'add to the face sufficient blue coloration in proportion to red

. . . in order to prevent excessive absorption of light by the face' (Factor 1937: 54); faces that absorb light 'excessively' are of course dark ones.

Colour brought with it a new set of problems, explored in Brian Winston's article on the invention of 'colour film that more readily photographs Caucasians than other human types' (1985: 106). Winston argues that at each stage the search for a colour film stock (including the development process, crucial to the subtractive systems that have proved most workable) was guided by how it rendered white flesh tones. Not long after the introduction of colour in the mid-1930s, the cinematographer Joseph Valentine commented that 'perhaps the most important single factor in dramatic cinematography is the relation between the colour sensitivity of an emulsion and the reproduction of pleasing flesh tones' (1939: 54). Winston looks at one such example of the search for 'pleasing flesh tones' in researches undertaken by Kodak in the early 1950s. A series of prints of 'a young lady' were prepared and submitted to a panel, and a report observed:

> Optimum reproduction of skin colour is not 'exact' reproduction . . .
> 'exact reproduction' is rejected almost unanimously as 'beefy'. On
> the other hand, when the print of highest acceptance is masked and
> compared with the original subject, it seems quite pale.
>
> (David L. MacAdam 1951, quoted in Winston 1985: 120)

As noted above, white skin is taken as a norm but what that means in terms of colour is determined not by how it is but by how, as Winston puts it, it is 'preferred – a whiter shade of white' (ibid.: 121). Characteristically too, it is a woman's skin which provides the litmus test.

Colour film was a possibility from 1896 (when R. W. Paul showed his hand-tinted prints), with Technicolor, the 'first entirely successful colour process used in the cinema', available from 1917 (Coe 1981: 112–39). Yet it did not become anything like a norm until the 1950s, for a complex of economic, technological and aesthetic reasons (cf. Kindem 1979), among which was a sense that colour film was not realistic. As Gorham Kindem suggests, this may have been partly due to a real limitation of the processes adopted from the late 1920s, in that they 'could not reproduce all the colours of the visible spectrum' (1979: 35) but it also had to do with an early association with musicals and spectacle. The way Kindem elaborates this point is racially suggestive:

> While flesh tones, the most important index of accuracy and
> consistency, might be carefully controlled through heavy make-up,
> practically dictating the overall colour appearance, it is quite likely that
> other colours in the set or location had to be sacrificed and appeared
> unnatural or 'gaudy'.
>
> (ibid.)

As noted elsewhere, accurate flesh tones are again the key issue in innovation. The tones involved here are evidently white, for it was lighting the compensatory heavy make-up with sufficient force to ensure a properly white look that was liable to make everything else excessively bright and 'gaudy'. Kindem relates a resistance to such an excess of colour with growing pessimism and cynicism through the 1930s as the weight of the Depression took a hold, to which black and white seemed more appropriate. Yet this seems to emphasise the gangster and social problem films of the 1930s over and above the comedies, musicals, fantasies and adventure films (think screwball, Fred and Ginger, Tarzan) that were, all the same, made in black and white. May it not be that what was not acceptable was escapism that was visually too loud and busy, because excess colour, and the very word 'gaudy', was associated with, indeed, coloured people?

A last example of the operation of the white face as a control on media technology comes from professional television production in the USA.[7] In the late 1970s the WGBH Educational Foundation and the 3M Corporation developed a special television signal, to be recorded on videotape, for the purpose of evaluating tapes. This signal, known as 'skin', was of a pale orange colour and was intended to duplicate the appearance on a television set of white skin. The process of scanning was known as 'skinning'. Operatives would watch the blank pale orange screen produced by tapes prerecorded with the 'skin' signal, making notes whenever a visible defect appeared. The fewer defects, the greater the value of the tape (reckoned in several hundreds of dollars) and thus when and by whom it was used. The whole process centred on blank images representing nothing, and yet founded in the most explicit way on a particular human flesh colour.

The assumption that the normal face is a white face runs through most published advice given on photo- and cinematography.[8] This is carried above all by illustrations which invariably use a white face, except on those rare occasions when they are discussing the 'problem' of dark-skinned people. Kodak announces on the title page of its *How to Take Good Pictures* (1984) that it is 'The world's best-selling photography book', but all the photo examples therein imply an all-white world (with one picture of two very pink Japanese women); similarly, Willard Morgan's *Encyclopedia of Photography* (1963), billed as 'The complete photographer: the Comprehensive Guide and Reference for All Photographers' shows lack of racial completeness and comprehensiveness in its illustrative examples as well as its text (even under such entries as 'Lighting in Portraiture' (Lewis Tulchin 2116–2127), 'Portrait Photography' (Edward Weston 2952–2955), 'Portraiture – Elementary Techniques' (Morris Germain 2955–2965), 'Portraiture Outdoors' (Dale Rooks 2965–2973) or 'Portraiture with the Speedlamp' (Editorial Staff 2973–2977)). Fifteen years after *John Hedgecoe's Complete Photography Course* (1979), *John Hedgecoe's New Book of Photography* (1994) is neither any more complete or new as far as race is concerned (Hedgecoe is

both a bestseller and Professor of Photographic Art at the Royal College of Art in London, in other words a highly authoritative source). Even when non-white subjects are used, it is rarely randomly, to illustrate a general technical point. The only non-white subject in Lucien Lorelle's *The Colour Book of Photography* (1955) is a black woman in what is for this book a highly stylised composition (colour Plate 7). The caption reads:

> Special lighting effects are possible with coloured lamps . . . and light sources included in the picture. Exposure becomes more tricky, and should be based on a meter reading of a key highlight such as the dress.

The photo is presented as an example of an unusual use of colour, to which the model's 'colourfulness' is unwittingly appropriate. The advice to take the exposure meter reading from the dress is itself unusual: with white subjects, it is their skin that is determinant. In Lucille Khornah's *The Nude in Black and White* (1993), nine out of seventy-four illustrations feature non-white subjects – six with parts of the body painted in zebra stripes and two making an aesthetic contrast of black and white skins, all cases which play on skin colour. Only one illustration, a black mother and child, does not seem to be making a point out of the non-white subjects' colour. Some more recent guidebooks randomly do include non-white subjects,[9] but even now there is no danger of excesses of political correctness.

The texts that the illustrations accompany make the same assumption that the human subject is white. Cassell's *Cyclopaedia of Photography* (1911) is clearly destined for a world in which there are only fair faces, whose colour it is important to capture even when nature is not on one's side: 'A common defect in amateur portraits taken out of doors is the dark appearance of the sitters' faces' (Jones 1911: 428).

The most recent edition of the *Focal Encylopedia of Photography* does at least have the grace to be upfront about the matter in the entry on 'Skin Tone':

> When used as a standard for quality control purposes, it is assumed, unless stated otherwise, that the typical subject is Caucasian with a skin reflectance of approximately 36%.
>
> (Stroebel and Richard 1993: 722)

In all this, inventors, commentators and advice-givers are not to be found stating that, if you want to capture the look of the white face correctly, you need to do so and so. They never refer to the white face as such, for to do so would immediately signal its particularity. It is rather in describing facial and skin qualities that the unpremeditated assumption of a white face is

apparent. Josef von Sternberg (1955–6: 109) affirms that 'the skin should reflect and not blot light', something more readily achieved with white skin. Gerald Millerson, discussing the relative light reflectance of skin tones (1972: 35), compares 'light' skin with 'bronzed', as if dark skin is, as it is for a white norm, only sun induced. A much more racially explicit example is provided in Eric De Maré's *Photography*, a much reissued Penguin book 'designed to help and stimulate the amateur photographer' (blurb to the 1970 edition). De Maré discusses the problems of light when shooting out of doors and, inevitably, takes a young (white) woman as the subject:

> [W]e consider her complexion to be at all times of a delicious, peachy pink but, exposing on a sunny day without correction filter to adjust the blue cast from the sky, we shall be *shocked* to find that the colour film has recorded the skin as having a slight indigo tint.
>
> (1970: 295; my emphasis)

The words 'indigo' and 'tint' were widely used with a racial, even racist, meaning in British English.

A major theme in instructional writing is the elimination of shadow. This is taken as a self-evidently and absolutely desirable goal in all but those cases where the aim is a sort of 'arty' expressivity. This obsession with getting rid of shadows established itself early. Victor Fournel, writing in 1858 about contemporary portrait photography practices, noted the already elaborate apparatus to hand to eliminate shadows, observing that 'what frightens the middle classes above everything else are the model's shadows: they can only see in them a blackness which darkens [*rembrunit*] and saddens the figure' (quoted in Rouillé and Marbot 1986: 15).

Shadows on the face are one of the major *Faults in Photography* in Kurt Fritsche's 1966 book; nearly all the advice on lighting in Eugene Hanson's ideologically riveting *Glamour Guide: How to Photograph Girls* (1950) is on avoidance of shadows. In a pair of illustrations to *Photography in Colour with Kodak Films* (Bomback 1957) (colour Plate 8), the superiority of eliminated shadows is affirmed by having the model smile slightly more in the less shadowed versions and adding effects of backlighting, thus emphasising the upbeat quality of the image. As the argument in Chapter 2 might lead one to expect, in all these – and nearly all other – examples, the model (a properly ambiguous term) is a woman, already white and in the light, not struggling towards whiteness and the light.

Elimination of shadow is partly determined by the desire for visibility. The camera lens cannot see into shadows as flexibly as can the human eye and fill lighting compensates for this. Yet even this imperative to see, and to see women, suggests a concern with the visible that has marked the white era, while shadows cut across the association of white people with the light that is explored later in this chapter.

The white-centricity of the aesthetic technology of the photographic media is rarely recognised, except when the topic of photographing non-white faces is addressed. This is habitually conceptualised in terms of non-white subjects entailing a departure from usual practice or constituting a problem. An account of the making of *The Color Purple* (1985) speaks of the 'unique photographic problems that occur when shooting a film with basically an all black cast' and goes on to detail the procedures the cinematographer, Allen Daviau, used to deal with these 'problems', in particular 'having the set interiors and set decorations darker than *normal*' (my emphasis)[10] (Harrell 1986: 54). Cicely Tyson recalled her experience of filming *The Blue Bird* in Russia in 1976, where there was little experience of filming black people. A white woman had been used during the lighting set-ups:

> They light everything for her and then I'm expected to go through the same paces with the same lighting. . . . Naturally, my black skin disappears on the screen. You can't see me at all.
>
> <div align="right">(quoted in Medved 1984: 128–9)</div>

The Moscow crew (at the white centre of the multiracial USSR) assumed that there were just 'faces', which meant that they assumed a universal white face, which in turn obliged Tyson to make a fuss and become constituted as an exception or problem. In 1994, in an interview in the magazine *US* (November: 102), the African-American actor Joe Morton (whose films include *The Brother from Another Planet*, *Terminator 2* and *Speed*) was still having to consider the way he is filmed a problem:

> For black actors, if you're not lit correctly, your skin tone can look very odd. You shouldn't be lit with certain shades of green and yellow. And, lots of black men have broad noses, and that can be exaggerated.

Such examples are not confined to mainstream Hollywood productions. Basil Wright, a leading figure in British documentary in the 1930s, gives an account of shooting in the West Indies and the difficulties of having to film at midday, with the brilliance of the sun which 'kill[ed] all detail'.

> The crux of this *problem* was encountered when negro types [i.e. the normal inhabitants] had to be shot. With bright direct sunlight coming from overhead, it was almost impossible to get a good quality negative and yet retain the negro features. Rubbing the face and arms of the subject with butter or oil only brought up a few highlights, even when aided by reflectors. Finally the problem was solved by staging scenes *in the shade* and using reflectors only.
>
> <div align="right">(Wright 1933: 227; first emphasis mine)</div>

Here, what is more evidently at issue is a still rather inflexible technology, developed and adjusted for the white face; Wright's solution however is very similar to that of Daviau for *The Color Purple* fifty years later.

In Kris Malkiewicz's book *Film Lighting*, based on interviews with Hollywood cinematographers and gaffers, four of the interviewees discuss the question of lighting for black people (Malkiewicz 1986: 141). They come up with a variety of solutions: 'taking light off the white person' if there are people of different colour in shot (John Alonzo), putting 'some lotion on the [black person's] skin to create reflective quality' (Conrad Hall), using 'an orange light' (Michael D. Margulies). James Plannette is robust: 'The only thing that black people need is more light. It is as simple as that.' Even this formulation implies doing something special for black people, departing from a white norm. Some of the others (lotion, orange light) imply that the 'problem' is inherent in the technology, not just its conventional use.

Elsewhere, Ernest Dickerson, Spike Lee's regular cinematographer, indicates (1988: 70) the importance of choices made at every level of light technology when filming black subjects: lighting (use of 'warmer' light, with 'bastard amber' gels, tungsten lights on dimmers 'so they [can] be dialed down to warmer temperatures', and gold instead of silver reflectors), the subject (use of reflective make-up, 'a light sheen from skin moisturizer'), exposure (basing it on 'reflected readings on Black people with a spot meter'), stock ('Eastman Kodak's 5247 with its tight grain and increased color saturation') and development (using 'printing lights in the high thirties and low forties' to ensure that 'blacks will hold up to the release prints'). Dickerson is explaining his choices against his observation that 'many cinematographers cite *problems* photographing black people because of the need to use more light on them' (my emphasis). Much of his language indicates that he is involved in correcting a white bias in the most widely available and used technology: lights are warmer (than an implied cold norm), they are dialled down (from a usual cooler temperature), they are gold not silver, and the stock has more colour saturation. The whiteness implied here is not just a norm (silver not gold) but also redolent of aspects of the conceptualisation of whiteness discussed in previous chapters: coldness and the absence of colour.

The practice of taking the white face as the norm, with deleterious consequences for non-white performers (unless they are consciously taken into account), is evident in films which not only have stars of different colours but also apparently intend to treat them equally. This may be out of a liberal impulse (Sidney Poitier with Tony Curtis in *The Defiant Ones* (1958)), an expression of star power (Eddie Murphy with Nick Nolte in *48 Hours* (1982)) or identification of a box office trend (the Danny Glover-Mel Gibson *Lethal Weapon* series (1987–92)). However, it is rare that the black actor is in fact lit equally. Such films betray the assumption of the white

face built into the habitual uses of the technology and have the effect of privileging the white man; they also contribute to specific perceptions of whiteness. Let me take two examples. The first, *In the Heat of the Night* (1967), makes the white man not only more visible but also more individualised. The second, *Rising Sun* (1993), goes further in privileging and constructing an idea of the white man.

The Sidney Poitier character, Virgil Tibbs, in *In the Heat* is emblematic of the Northern, educated, middle-class black man. His adversary, but fellow cop, Bill Gillespie (Rod Steiger) is, on the contrary, a contradictory character. Tibbs is identified with his home turf (Philadelphia), whereas Gillespie, on whose turf (Sparta, Mississippi) the action unfolds, is in fact from another town and not really accepted by the local force: he is in a certain way more dislocated than Tibbs. He is unthinkingly bigoted but without the obsessive racism of the (white) rest of the town and police. He has a failed marriage in his past. He is an elaborated character, not a representative figure. Much of this is conveyed by dialogue and the two performers' different acting styles: Poitier's stillness and implied intensity, Steiger's busy, exteriorised method acting. It is also conveyed by lighting.

Poitier tends to be posed in profile or near silhouette, emphasising his emblematic presence; Steiger is more often shot face on, in, rather than against the light. Poitier is thus given considerable moral and intellectual authority, but little opportunity to display the workings of individuality on the face. In one scene, Tibbs (Poitier) and Gillespie (Steiger) are sitting talking together in the latter's home. There is a degree of *rapprochement* between them, with each revealing something of himself to the other. In the establishing shot, Poitier is screen left, sitting back in a reclining chair facing screen right, and Steiger is screen right, lying on a couch. The only visible light source is a large table lamp behind Poitier. Poitier is thus profiled and semi-silhouetted, while the light falls full on Steiger's face. As the scene proceeds, most of the shots are close-ups. The table lamp casts both their faces in half light, but this is far more marked with Poitier, whereas Steiger is given some additional fill light, removing most of the shadow from the side of his face away from the lamp. The set-ups for the shots of Poitier remain more or less side-on to camera but, after a few similar shots of Steiger, the camera takes up a frontal position for him, with backlighting and a stronger fill. As a result, not only is Steiger more fully visible to us, but he can display a range of modulations of expression that indicate the character's complex turmoil of feelings and reminiscences. Poitier, by contrast, remains the emblematic, unindividualised, albeit admirable, black man.

Rising Sun (Plate 3.1)[11] is an expensive film involving an experienced director (Philip Kaufman) and often quite elaborate and attractive lighting set-ups (cinematographer Michael Chapman). It has two major stars in it, the black star (Wesley Snipes) having at the time of the film's appearance at least as much cinema box office clout as the white star (Sean Connery).

Plate 3.1 Rising Sun (USA 1993): Sean Connery, Harvey Keitel and Wesley Snipes (BFI Stills, Posters and Designs)

And it is a film that knows about race: a thriller pivoting on questions of American-Japanese antagonisms, it both gives Snipes and Connery, as the detectives on the case, some (black–white) racially conscious dialogue and includes an African-American ghetto sequence to make a point about the Snipes character's roots. In other words, this is a film that has no reason not to light its central male pair so that each comes off equally well (which means, of course, not, in technical terms, lighting them the same). In separate shots they are indeed lit differently, enhancing the character and beauty of their faces to equal effect. Yet in shots featuring both of them, Connery is advantaged. A clear example occurs early on when Snipes and Connery are interviewing a security guard in a building where a corpse has been found. The guard is the most important character in the scene in terms of narrative (what has he seen?) and emotion (he is clearly holding something back for fear of losing his job); Snipes and Connery, as the stars and the investigators, have a different kind of importance, but one is not more important than the other. However, the lighting suggests otherwise. The guard is black. The scene is mostly shot with Connery standing between the guard (screen left) and Snipes (right). The light falls on Connery and is good for his colouring. His equal partner (Snipes) and the crucial witness (the guard), on the other hand, are shrouded in darkness.[12]

This example is caused by the assumption of the white face as a norm (get Connery right and the rest will fall into place); it has the effect of privileging the white performer. It also reproduces a particular construction of whiteness. The light catches Connery's temples, while Snipes and the guard are in darkness. Connery is literally but also figuratively enlightened; the light emphasises his forehead, or, in effect, his brain. Elsewhere, in two-shots where some kind of intermediate light setting has been chosen, not ideal for either star, Snipes' skin shines whereas Connery's disappears in the light – the surface of Snipes' flesh is evident, his corporeality, whereas Connery's flesh is dissolved into the light.

The historical construction of whiteness through light, of which *Rising Sun* is a late product, is the subject of the rest of this chapter. Before moving to that, however, I should like to look at one last recent example, which suggests both that it is not technically impossible to film black people with the same effect as for whites but that it is culturally extremely difficult.

A Few Good Men (1992) concerns two marines on trial for the murder of another. One, Lance Corporal Dawson (Wolfgang Bodison), is African-American, a point to which the film makes neither explicit nor implicit reference. At one point in the trial, it is revealed that Dawson once disobeyed an order (itself a central issue to the marine ethics on which the case turns) by taking food to a marine who was being harshly punished for a trivial mistake by being imprisoned without food; this is a turning point, because it establishes Dawson's high moral character. The shot, of him listening to his attorney Lieutenant Kaffee (Tom Cruise) drawing attention to the moral significance of his disobedience, has strong, hard side and top lighting. Dawson's (Bodison's) hair is shaved at the sides but cut to a flat top. This gives it a relatively open texture which catches the light, creating a glow atop his head, striking in a generally darkly lit scene. His fellow, white, defendant is also in the shot, but his haircut has a rounder shape and the top lighting is less full on his head, though he still benefits from the quasi-halo effect. The lighting on Dawson is more conspicuous, partly because he is the one at issue in narrative terms, but also because there is somewhat more contrast between his bright hair and dark face and because it is so unusual to see an African-American shot like this. It shows that the latter is technically possible, yet not only is the lighting unusually hard and directed, it is also called forth at an expressly ethical moment – white performers benefit habitually from such light at the head, there does not have to be a strong moral point being made.

At the end of the film, Dawson is acquitted of the murder but still dishonourably discharged: the death was the accidental result of obeying an order to rough up a weak and awkward recruit. Dawson realises that he should have disobeyed the order in accordance with a greater moral imperative. The final shot of him is taken at the door to the trial room, as Kaffee/Cruise is telling him that he does have honour because of this

realisation. There is no top lighting and Dawson stands before the dark wood of the door; despite the moral accolade, there is no longer any virtuous light at his head. The film cuts back to Tom Cruise, himself dark-haired but lustrous and tinged with light from above. His character has been much more morally ambiguous throughout, and even at this point his triumph is as much a career success as a sign of moral growth, yet now the white hero has the light no longer accorded the black character. Indeed, the recognition of the latter's virtue is given to Kaffee/Cruise, who tells him that he has honour, since he (Dawson) doesn't know it for himself: the white man, with that touch of light about his head, knows and names virtue in the black man, who now blends in with the darkness of the world.

Movie lighting in effect discriminates on the basis of race. As the rest of this chapter will argue, such discrimination has much to do with the conceptualisation of whiteness. There is also a rather different level at which movie lighting's discrimination may be said to operate. What is at issue here is not how white is shown and seen, so much as the assumptions at work in the way that movie lighting disposes people in space. Movie lighting relates people to each other and to setting according to notions of the human that have historically excluded non-white people.

Movie lighting focuses on the individual. Each person has lighting tailored to his or her personality (character, star image, actorly attributes). Each important person, that is. At a minimum, in a culture in which whites are the important people, in which those who have, rather than are, servants, occupy centre stage, one would expect movie lighting to discriminate against non-white people in terms of visibility, individualisation and centrality. I want however to push the argument a bit further. Movie lighting valorises the notion of the unique and special character of the individual, of the individuality of the individual. It is at the least arguable that white society has found it hard to see non-white people as individuals; the very notion of the individual, of the freely developing, autonomous human person, is only applicable to those who are seen to be free and autonomous, who are not slaves or subject peoples. Movie lighting discriminates against non-white people because it is used in a cinema and a culture that finds it hard to recognise them as appropriate subjects for such lighting, that is, as individuals.

Further, movie lighting hierarchises. It indicates who is important and who is not. It is not just that in white racist society, those who are not white will be lit to be at the bottom of the hierarchy, but that the very process of hierarchisation is an exercise of power. Other and non-white societies have hierarchies, of course; it is not innate to white nature. However, hierarchy, the aspirational structure, is one of the forms that power has taken in the era of white Western society.

Movie lighting also separates the individual, not only from all other individuals, but from her/his environment. The sense of separation from the

environment, of the world as the object of a disembodied human gaze and control, runs deep in white culture. The prime reason for introducing back-lighting in film was to ensure that the figures were distinguished from their ground, to make them stand out from each other and their setting. This was regarded as an obvious necessity, so clearly part of how to see life that it was an unquestionable imperative. Yet it expresses a view of humanity pioneered by white culture; it lies behind its highly successful technology and the terrible price the environment now pays for this.

People who are not white can and are lit to be individualised, arranged hierarchically and kept separate from their environment. But this is only to indicate the triumph of white culture and its readiness to allow some people in, some non-white people to be in this sense white. Yet not only is there still a high degree of control over who gets let in, but, as I want to argue in the rest of this chapter, the technology and culture of light is so constructed as to be both fundamental to the construction of the human image and yet felt to be uniquely appropriate to those who are white.

A culture of light

The aesthetic technology of photography, as it has been invented, refined and elaborated, and the dominant uses of that technology, as they have become fixed and naturalised, assume and privilege the white subject. They also construct that subject, that is, draw on and contribute to a perception of what it means to be white. They do this as part of a much more general culture of light. This has produced both an astonishing set of technologies of light and certain fundamental philosophical, scientific and aesthetic perceptions of the nature of light. White people are central to it, to the extent that they come to seem to have a special relationship to light.

The culture of light is part of the still wider characterisation of modern Western culture as one which privileges seeing above all other senses. In his *History of Bourgeois Perception*, Donald Lowe argues that different epochs are characterised by the primacy given to different senses, embodied in the apparatuses developed to express and extend them. In oral cultures, hearing and touching have primacy over seeing, and even with the introduction of writing, this remains true. It is printing (making the seen word more widespread and available) and perspective (emphasising verisimilitude in imagery and a notion of knowledge through looking rather than from revelation or authority) that begin to move the (bourgeois, Western, white) world towards an emphasis on seeing as the epistemic sense *par excellence*. This is evident in the pervasiveness of sight metaphors about knowledge: seeing is believing, I see what you mean, as far as I can see, the evidence of one's own eyes, taking the long view, a short-sighted decision, she saw right through it, oh I see!

The equation of seeing with knowledge is also one with power. Michel Foucault points to the exercise of power in modern societies through surveillance (literally 'overseeing'), the organisation and control of the social order by means of enhanced and highly elaborated mechanisms of sight. This is realised in the panopticon, in the first instance a prototypical eighteenth-century prison architecture with wardens situated in a high centre and cells ranged all around, thus affording the former a constant view of the latter and instilling in prisoners a constant sense of being surveilled, which becomes internalised as self-surveillance (Foucault 1975). This has been taken as a paradigm of a leading tendency of modern societies, their elaboration of bureaucracies, databanks and surveillance mechanisms, habits of self scrutiny (how do I look? why am I doing this? who will they think I am?) and, not least, both the use of enhanced technologies of light as a form of 'subjection by illumination' (Foucault 1980: 154) and the development of photography and film as modes for recording, classifying and controlling the populace and observing and presenting oneself.

At the technological level, seeing has been enhanced and transformed such that human beings can see better, can record what they see more accurately and can reproduce that record more or less *ad infinitum.* Instruments enabled humans to see ever further (the telescope) and in ever more detail (the microscope). The camera obscura simultaneously reproduced and framed a sight, giving an image that could readily be copied. Photography directly and chemically fixed the image in a camera obscura; film, an exponential multiplication of photographs, caught the image of movement. The photographic media permit the endless reproduction of these fixed and caught impressions.

Such a stress on sight poses a problem, however, in relation to that which cannot be seen. In a humanist culture, the cardinal instance of this is human personality. No amount of looking at someone gives authoritative access to their inner being. Yet just such scrutiny in search of personality has characterised the past two centuries. From the growth of surgery, not least as demonstrated in, literally, theatres of anatomy, through the sciences of phrenology and the rest, Western society has had a positive mania for trying to see what's inside the human being, body and soul (Clair 1994). The photographic media, too, so clearly at the cutting edge in capturing appearances, have also sought to see and show past them. The earliest social success in photography was its use in portraiture, starting around 1840 and rapidly expanding throughout international bourgeois society. Portraiture, whether in Matthew Brady's hugely successful Broadway studios (a must for any mid-nineteenth-century visitor to New York) or Julia Margaret Cameron's intense, private studies of friends and the famous, was founded on the belief that the apparatus could reveal the inner being (or could be made to).

Approaches to camera likenesses, whether made for amateur or commercial purposes, ranged from documentary to artistic, from 'materialistic' to 'atmospheric', but whatever their underlying mode photographic portraits reflected from their origin the conviction that an individual's personality, intellect and character can be revealed through the depiction of facial configuration and expression.

(Naomi Rosenblum, quoted in Lalvani 1993: 447)

Marcus Aurelius Root, an early theorist of photographic portraiture and admirer of Brady's work, described the enterprise thus:

To delineate the human face and figure pervaded by expression, that bids the soul shine glowingly out through the same, is to transcribe the matchless pencillings of the Divine Proto-Artist.

(*The Camera and the Pencil* (1866), quoted in Trachtenberg 1983: 250–1)

By the same token less elevated personalities could be discerned, and photography was soon enlisted in the business of understanding mental illness and criminality, for instance (Tagg 1988), or in the development of anthropology (Green 1984, Edwards 1992).

The racialist possibilities of this concern with the observability of inward features of human beings is evident in phrenology, anthropometry and the rest, already touched on in Chapter 1. Photography's role may be indicated here by two examples. It was a central tool of the eugenics movement, whose focus was the improvement of the human race through control of breeding, a focus for which in practice the white middle class provided the paradigm of improved and improving humanity; photography was the means for both scrutinising human physiognomy and demonstrating variations (and superiorities/inferiorities) in human types (Green 1986). As a second example, Suren Lalvani analyses nineteenth-century photographic portraiture in the USA, connecting its forms to white expansionist ideology:

[T]he arrangements of heads and hands in nineteenth-century bourgeois portraiture are traversed by a physiognomic intention: the need to convey the notion of manifest destiny central to bourgeois ideology: that the world may be civilised by the appropriate combination of head and hand.

(1993: 448)

Nineteenth-century photography provides these confident examples of the possibility of seeing within the human person, but the status of sight as the organ *par excellence* of knowledge about human beings is by no means

secure. On the one hand, the twentieth century has continued to place faith in seeing. To take film alone, both the respect accorded documentary and news film and the intensity and intimacy experienced in relation to movie stars attest to the widespread investment in knowing human beings through seeing them. Yet the same period has also shown an ever increasing suspicion of film's truth. We are all too photo-literate not to know about the camera's deceits, too media-savvy not to know about star hype. Yet the habit of looking for knowledge persists in ever more troubled forms. The routinised charity poster of starving children, the 'is this the face of a killer?' coverage of serial killers, the centrality in the coverage of AIDS, an invisible malady, of giant enlargements of the virus and the display of KS lesions[13] – we go on looking even while we know we are not going to learn.

Western society is characterised by the albeit troubled centrality of vision to knowledge and power. A. D. Coleman (1985) suggests that the development of the technologies of vision (the tele- and microscope, photography) and their centrality to 'the conceptual assumptions' of our period mean that we may speak of ourselves living in 'a lens culture'. I want to suggest that we also live in a light culture.

This too may be characterised in the first place by technologies. These include the photographic media, but they themselves are part of wider developments. Above all, the past two-and-a-half centuries have witnessed (another sight metaphor) an extraordinary development of artificial lighting in everyday life.

We live now, virtually everywhere, in a world that is potentially permanently illuminated, in which it is generally possible to let light be at human will and in which artificial light can reach further and more effectively than the brightest sunshine. Yet before the mid-eighteenth century, the only light supplementing sunlight was firelight, wicks in oil and candles.[14] None gave off strong light, all needed constant tending. To maintain such sources when burning and to have them on a scale sufficient to create strong, bright light entailed fabulous expense. Chandeliers (and even before them crowns of candles) did, from the seventeenth century on, provide bright light over a large space. However, few households, let alone theatres, could either afford them or deal with their inconvenience: they required endless attention as candles guttered and burnt out; for this reason and to provide the best illumination they had to be hung low down, which was bothersome for those below them and irritating, in theatres, for those in the higher seats; their use remained largely confined to some churches and very grand occasions. The world – at night, indoors, in Northern winters – remained dark and light was scarce.

The eighteenth century sees the beginning of a number of transforming innovations in lighting technology, including first improvements in lamp design, using reflectors (réverbères) to enhance city street lighting and glass

to strengthen light for certain types of manual workers, notably lace makers, culminating in 1782–4 in the Argand lamp, which combined a glass chimney with new ways of shaping wicks: 'For the first time since the lamp came within the competence of man there was a device, under excellent control, that could give ten or twelve times the customary light from a single source' (O'Dea 1958: 21). Such developments in the use of reflectors, glass and wicks were supplemented by the invention/discovery of new light sources – limelight (1796), coal gas (1805), electricity (1845), kerosene/paraffin (1860) – and refinements to these (the use of tungsten rather than carbon with electricity, for instance (1911)) and even improvements in candle-making. The adoption of such technologies transformed social and domestic spaces alike. The Argand lamp was adopted for use in lighthouses (with consequent impact on trade) by the end of the eighteenth century. Gas was used to light Lancashire mills for working in 1805 and Pall Mall in London for leisure in 1809. All forms of lighting innovation were introduced by the European nations to their colonies, the only sense in which imperialism brought light to the darkness.

All these developments were in time adopted for theatre lighting (cf. Bergman 1977). This formed part of the transformation of the medium of theatre itself. From the mid-eighteenth century on, theatre lighting no longer aimed to light stage and auditorium equally. Footlights, réverbères attached to the fronts of boxes and galleries and other innovations directed light at the stage, separating it from the audience. The notion of an art based on performance in a brightly lit space at one end of a darkened room, a performance in some sense separated from the spectator, came into view. This notion is part of the definition of cinema.

This had already been anticipated in the magic lantern, another art of light, in this case projected through painted glass or paper. The possibility of doing this had been known since at least the sixteenth century (Remise *et al.* 1979) and Johannes Zahn may even have managed to convey some sense of movement as early as the late seventeenth century, through project-ing a succession of closely related images. In the eighteenth century, magic lantern shows became increasingly popular, and the principle was also used to create special, usually horrifying, effects in the theatre, as with Robertson's *Phantasmagoria* (1798). The idea of taking pleasure and instruction from a light show was thus already well established by the end of the eighteenth century, but the development of intense and steady light sources was needed to provide a strong throw sufficient for large, public spaces. Once this was possible the magic lantern became a major source of public instruction as well as an unusually classless form of entertainment (see Chanan 1980: 13), functions enhanced by the adoption of photographic slides once that became possible.

The new theatre lighting did not only form part of a move towards public performance based on lit spaces watched from unlit ones, but also involved

a change in the use of light in relation to the stage action. Lighting no longer provided 'an indifferent, symmetrical light' (Bergman 1977: 177), illuminating everything and every performer with undifferentiated clarity and intensity. Light, along with other scenic developments, created atmosphere and drew attention to the key players or aspects of the action. Such ways of conceptualising the dramatic use of light were facilitated by the gradual adoption of limelight (providing a metaphor for public appearance, to be 'in the limelight'), gaslight and so on. They underpinned the influential staging methods of the US actor-manager David Belasco, whose productions and writings span the early years of cinema and are a direct source of movie lighting (Baxter 1975: 96–7). Belasco used light to be at once naturalistic (imitating the fall of light in the real world), atmospheric, psychological (so that performance was as much constructed by 'the value of the light in which the character stands' (Belasco 1902, quoted in Bergman 1977: 306) as by what the actor did) and directive (guiding the audience's attention to what mattered and how to see it). So central was light to his approach that he claimed in 1901 that 'the characters present on the stage are really secondary to the lighting effects' (quoted in Baxter 1975: 86).

The technology of lighting thus produced new expectations of everyday life – that it could be assumed to be visible at all times as required – and of dramatic art – that it took place in a separate space flooded with meaning creating light. Both are part of an epistemology of light, at once analytic and metaphorical. Interest in examining the nature of light had been inaugurated in the modern age with Isaac Newton's study of the colour spectrum (1666) and Christian Huygens's *Traité de la lumière* (1690). The eighteenth century saw the development of photometry, the measurement of light, beginning with the work of Pierre Bouguer (1729) and given a considerable fillip with the invention of controllable, constant light sources. The investigation of light became a cornerstone of modern thought, in, for instance, James Maxwell's study of white light and colour vision (1855) as well as the theories of Emanuel Swedenborg,[15] for whom light was, as Rosalind Krauss puts it (1978: 37), 'the conduit between the world of sense impression and the world of spirit'. Concurrently the paintings of such as Turner (1775–1851), Whistler (1834–1903), Monet (1840–1926) and Seurat (1859–91) constitute a kind of systematic analysis of the effect of light.[16]

Metaphors of light in connection with knowledge are time honoured in biblical and liturgical tradition: 'Let there be light' (God's bringing of meaning to the universe in *Genesis*), 'He was a burning and a shining light' (John the Baptist figured, by Christ in St. John's Gospel, as the bringer of the knowledge of Christ's coming), 'To be a light to lighten the gentiles' (spreading the knowledge of God's truth beyond the Jews), 'Lighten our darkness we beseech thee oh Lord' (linking knowledge with relief from suffering in the Book of Common Prayer) and so on; the sacred tradition could be supplemented from the secular, from Dante, Shakespeare, Milton

and so on. The culture of light mobilised such metaphors but also gave them a distinctive and decisive twist. The intense interest in literal light became associated with the human possibilities of knowing and spreading knowledge. It was not merely the adoption of a time honoured metaphor that earned the eighteenth century (in whose wake the following two centuries have been played out) the soubriquet of the Enlightenment, *le siècle des lumières*, *l'illuminismo*, *die Aufklärung*. The association is insisted on in one of the most famous contemporary aphorisms concerning knowledge, coined by Alexander Pope in his *Essay on Man* (1732–4):

Nature and Nature's laws lay hid in night:
God said 'Let Newton be!' and all was light.

The fact that Newton insisted that it was white light that contained all other colours, rather than, as had been believed before, black (Bynam *et al.* 1981: 236), is at the very least ethnically suggestive in this period of buoyant European expansion of knowledge.

To this technology and epistemology of light we can now add photography. As already noted above, photography is properly described as an art of light, and indeed literally means light (photo) drawing (graphy). The effect of light shining through a small hole on to a wall in a darkened room, casting an (inverted) image of what is outside, had long been known – at least as far back as Al Hazen (965–1068) and in the Western modern period since the mid-sixteenth century. It has been claimed that there may have been successful attempts to fix such images chemically by Johannes Torrentius (1589–1644) (Barnouw 1984), but the first generally attested chemical investigations are those of J. H. Schulze in 1727 and C. W. Scheele in 1777 and the first practical realisation that of Joseph Nicéphore Niepce in 1822. The observation of how light works – in casting an image, in altering chemicals exposed to that image – is the basis of photography, enchantingly suggested in the words of another inventor of photography, William Henry Fox Talbot:

[I reflected on] the inimitable beauty of the pictures of nature's paintings which the glass lens of the camera [obscura] throws upon the paper in its focus – fairy pictures, creations of a moment. . . . How charming it would be if it were possible to cause those natural images to imprint themselves durably on paper! . . . And why should it not be possible? . . . Light, where it exists, can exert an action, and, in certain circumstances does exert one sufficient to cause changes in material bodies. Suppose, then, such an action could be executed on the paper; and suppose the paper could be visibly changed by it.

(*The Pencil of Nature* (1844–6); quoted in Ward and Stevenson 1986: 10)

Suppose, in other words and as came to pass, one made pictures using light as the critical medium.

Nadar, among the most commercially successful and formally influential of all nineteenth-century portrait photographers, took Swedenborg's notion of light as a conduit as authorisation for the idea that photography, the art of light, could capture the inner human being. This is why for him the essence of good photography was 'the feeling of light' (Lemagny and Rouillé 1987: 21). It is that feeling, and its potential ethnic implications, that concern me here. I want to focus on two perceptions of light in cultural production, both utterly commonplace to how we now see but both quite remarkable, even in the first case perverse,[17] ways of seeing. The fact of more light in the world, the association of light with knowledge, and photography and film as the exemplary arts of this technical-epistemological configuration, all are shot through with the assumptions that it is possible to see the world as transparent and that light comes from above.

The world is transparent

Life, like a dome of many-coloured glass,
Stains the white radiance of eternity
(Percy Bysshe Shelley: *Adonais* (1821))

When we look at a photograph, we are looking at a translucent world. This is but intensified when we see a slide (magic lantern) show or film. Photographs are normally printed on white paper, slides and films are shown on white screens: the light of the white background shows through the objects and people that we see. It is remarkable that we should so easily accept the representation of the world like this, as if life is, as Shelley avers, like a transparency. It is a form of representation that became fully established in the first half of the nineteenth century (when Shelley wrote these lines). Many arts aspired to the condition of translucence, and yet its very insubstantiality entailed countervailing tendencies that would give apparent substance to translucence. This in turn relates to the peculiar ethnic potential of this mode of representation: light shows through white subjects more than through black, so that they appear indeed illuminated and enlightened, but this is also a problem, since it is capable of rendering the white subject as being without substance altogether.

Representing, and therefore possibly seeing, the world as if it is on a ground of light was already an established convention by the time of photography's invention. Perhaps, had it not been, it would not have been possible to conceive of photography. The effect of the camera obscura, a wraith-like image cast on a white surface, might have seemed merely curious, not usable as the foundation for a new medium.

The light of the world

In her book *Moving Pictures*, Anne Hollander traces the development of a distinctive way of depicting light from fifteenth-century North European painting to the cinema. The painters, she argues, sought 'a jewel-like transparency that made the picture seem to be conducting light through it, rather than reflecting externally applied light from its modelled surface' (1989: 15–16). She finds this both in painting and in the growth of printing and woodcuts, which put in place the convention of black print on white paper and in which, for instance, a white face is in effect a blank, whose palpable existence we only infer from the black that surrounds it and/or forms a background to it. Hollander's location of the start of this development in North European painting is, at the least, suggestive, since this is *par excellence* the territory of white people. This was an art of realism, concerned with depicting the way it was supposed the world looked (rather than depicting received or revealed knowledge). It is reasonable to suggest that fair-skinned people are more liable to make the weird conceptual leap that allows one to see blank white space as a realistic representation of a face.

There was an intensification of such translucent representation in the late eighteenth and early nineteenth centuries. The enormous increase in the magic lantern's popularity has already been mentioned. Equally striking is the rise of stained glass and, especially, watercolour in the period. Both are much older media but coming into their own again (stained glass) or for the first time (watercolour) at this time. The former was known principally in church and, to a lesser extent, aristocratic use and carried such elevated social connotations with it, associating translucence with transcendence. This itself may be a modern perception, since Gage (1993: 70 ff.) suggests that 'luminosity' was not 'the central preoccupation of the early glass-designers' (i.e. in the Romanesque and early Gothic period).

Watercolours only became commonplace and widely valued in the early nineteenth century (Clarke 1981: 14). The mass production of pre-mixed paints, the ever increasing interest in observing and recording (natural history, landscape art, portraiture), the convenience of watercolouring when undertaking the travel associated with observing and recording, the availability of the portable camera obscura as an aid, the role of amateur domestic accomplishment in the development of a middle-class gentility, in short, a number of technological and social developments came together in yet another aspect of the culture of seeing and light. Watercolour anticipates photography in a number of ways (and was to be somewhat displaced by it): use, prestige, availability and, most strikingly, formal properties. Two descriptions of the medium emphasise qualities that, as I've already suggested, also characterise the photographic media:

[in watercolour] light is reflected not only from the uppermost surface but, after penetrating every layer of paint, from the paper itself as well

– hence the use of white paper, on which the layers of paint lie like sheets of coloured glass.

(Koschatzky 1970: 14)

Since the layers of pigment placed on the surface are very thin, light is reflected from the white background through the colour washes to produce the brightness of tone, freshness of colour and luminosity of effect which are the watercolour's characteristic assets.

(Reynolds 1971: 8)

There is a decided echo of Shelley's lines in the first of these descriptions.

The rise of the magic lantern and watercolouring, and the very swift acceptance of photography by the 1840s, are paralleled by developments in theatre lighting that sought to convey a similarly insubstantial quality. Theatre is always flesh and stuff and cannot be translucent in the way film necessarily always is, yet the use of gauzes in scenery, of luminous kinds of make-up and above all of diffused, overlapping, pooled, 'curtained'[18] and other kinds of lighting effect (including magic lantern projection) all constructed an aesthetic of insubstantiality for certain kinds of theatre. Angels, fairies, dreams and visions, as well as sunrises and sunsets, were greatly appreciated features of popular theatrical spectacle. At the end of the nineteenth century, in a more avant-garde context that had a huge influence on twentieth-century theatre, Adolphe Appia's stage design used light with greatly simplified settings to create a look characterised by 'its misty envelopments, its dissolving silhouettes and vaporous distances' (Simonson 1968: 39).

Print, the magic lantern, watercolouring, photography and film were all media which represented people through translucence, and even media not founded on this, like oil painting and theatre, often aimed at something of the quality. It was clearly accepted and valued, yet it was also in a certain measure troubling. The world was rendered transparent, perhaps to the point of non-existence. The development of this perception is a common way of reading the history of modernist painting. To take but one instance: Monet's series of studies (1892–3) of Rouen cathedral in the light of different times of day seems almost to suggest that there is no cathedral, only the play of light. This perception is out of synch with materialist, positivist thought, which still sought to carry forward the project of the Enlightenment, light as a means of seeing not as all there is.

The question of translucence, and related qualities such as diffusion and blur, was already a matter of controversy in relation to photography within a few years of its invention (cf. Seiberling 1986: 26–7). While technological innovators tended to aim for a sharp, detailed, concrete appearance and to take nature and objects as subject matter, users and critics often favoured a slightly out-of-focus look, especially for portraits. Such blurring was held to

catch the essence of a subject, which would be lost in the brutality of hard edges. In practice a difference developed between the blurred, spiritual quality of portraits of the great and the good, a tendency reaching its apotheosis in the work of Julia Margaret Cameron, and the brutal, scrutinising quality of criminal, medical, eugenic and much ethnographic photography.

Diffusion:sharpness distinguishes between subjects and within them. There are appropriately hard-edged, relatively opaque subjects (the lunatic, the felon, the native) and appropriately soft-edged, more translucent ones (angels, fairies, saints and people like them). At the extremes there are the opaque non-white subject and the pellucid white subject, but in between the technology permits the reproduction of whiteness as a differentiated and hierarchised structure. Class as well as such criteria of proper whiteness as sanity and non-criminality are expressed in terms of degrees of translucence, with murkiness associated with poor, working-class and immigrant white subjects.

Photographic history provides striking examples.[19] Jean-Claude Lemagny and André Rouillé (1987: 22) show pre-1850 daguerrotypes depicting an actor, dressed as a tramp, and a blacksmith (Plates 3.2. and 3.3). The actor, despite the role, has a clear white face above his heavy beard and moustache, and this is emphasised by his being posed against a dark backdrop. The blacksmith, on the other hand, has only one or two highlights in a very dark face, whose darkness is reinforced by posing him against a light backdrop. (The actor's aspirational upward-looking face and pose and the blacksmith's direct look at the camera further express the class difference, the former glorified for the camera, the latter submitted to it.) Jacob Riis' influential photo reportage of immigrants, 'How the Other Half Live', published in *Scribner's Magazine* in December 1889, set out to show the link between poverty and environment, opposing the idea that the former is a product of the character and moral turpitude of the poor themselves. Yet, as Lemagny and Rouillé point out, Riis' accompanying text also provides a racial explanation for why some people remain poor, suggesting that, compared to the Chinese, Italians and Jews, 'the families of *Northern* European stock, like Riis himself, are neat, hard-working, and most likely to rise out of the slum'(1987: 64; my emphasis). The photographs use light and dark, blur and sharpness to underline the difference among the poor.

The extremes of this representation are also gendered. A middle- or upper-class aristocratic woman's face might be rendered nearly as white as the paper on which it was printed or the screen on which it was projected, while working-class men would be even darker than working-class women. There is a further gender differentiation for subjects clearly well within the pale of whiteness, again rendered in terms of translucence. White subjects may have the soft and the sharp, the light and the dark, the translucent and palpable warring *within* them. However, this is more often true of white men, portrayed with greater contrasts of light and dark, hard contours but

Plates 3.2 and 3.3 Anonymous
Actor Dressed as a Tramp (n.d.)
and Anonymous *A Blacksmith*
(before 1850); from Lemagny.
(Collection of the Bibliotheque
Nationale, Paris)

areas of translucence, the spirit in the flesh. White women are more liable to be overall translucent, but in ways that may deny their fleshliness altogether, allow it to coexist in a kind of disavowal, or else be presented as a sign of the deceptiveness of the image of woman as spirit. These variations will be further discussed below.

Within the aspirational structure of whiteness, photography's translucence could differentiate between races and within the white race, and even show degrees of translucence within the individual white (usually male) subject. Film reworked the same play on translucence, on letting light through without becoming wholly transparent. Much of the development of movie lighting was intended to counteract the insubtstantiality (and flatness) of the film image, which was heightened by the flickering quality of film's projected light. Early film used diffuse, overall light (generally sunlight, perhaps redirected or supplemented); the gradual adoption (notably from Belasco) of chiaroscuro and more and more artificial light sources permitted both realism (a source for the light is visible on screen) and direction (the hierarchisation of characters already discussed) as well as figure modelling. Backlighting kept the figure separate from the background and gave a sense of depth to the image. Three-point lighting moulded the figure and could bring out the texture of surfaces, of skin and clothes. Thus, paradoxically, lighting could be used to counterbalance the image's inherent translucence. To this should be added two other elements which, not themselves aspects of light, none the less contributed to giving the airy film image an illusion of solidity. First, both continuity editing and the moving camera (in place as conventions by the 1920s) create not only the illusion of three-dimensionality but also encourage the spectator to imagine s/he is *in* that space and surrounded by it.[20] Second, and fundamentally, all photographic images signify that there was a material, palpable reality there in order for there now to be a photograph of it. In a sense, the translucence of the photograph is always already held in check by the guarantee that it is an image of a palpable reality.

Yet film also in fact invested in translucence, in blur and glow, in the *mise-en-scène* of love and the development of the star system. These were cornerstones of film's commercial and cultural success, and will be discussed again at the end of the chapter.

The photographic media hold together translucence and materiality. This provides them with an extraordinarily supple and subtle mode of representation. It also permits a construction of the human person that discriminates between those who have a large amount of light shining through them and those who have next to none – the radiant white face and the opaque black one. However, it is the mix, in the very medium itself, of light and substance that is central to the conception of white humanity.

In this context, chiaroscuro becomes a key feature of the representation of whiteness. Hollander argues that it is used to discipline, organise and fix the image, suggesting the exercise of spirit over subject matter. It also

mobilises the polarity of black:white, which is at the very least consonant with the perceptual/moral/racial slippages of Western dualism discussed in Chapter 2. It also, selectively, lets light through. It allows the spiritual to be manifest in the material. The extreme instance of translucence, discussed in the final section of this chapter, is the angelic white woman. At the other extreme, the criminal, insane, disabled white person, especially if male, is dark and matt. The extremes are rare. It is the combination of translucence and substance – not translucence alone – which really defines white representation.

Light comes from above

While the idea of life as a transparency, though we are habituated to it, represents a remarkable perceptual leap, the idea that light comes from above may seem uninteresting. Surely, after all, in its natural forms – sunlight, moonlight, starlight – it does? This is undeniable, but consider two points. It is only since the eighteenth century – and only commonly since the late nineteenth – that artificial lighting has come from above. And it is only in Northern countries that middle-of-the-day overhead light is regarded as the optimum time for being about; in the South it is the low slanting (but still, granted, overhead) light of morning and evening by which things and people are most often seen. Yet in the movies there is always light from on high.

Kris Malkiewicz, writing in 1986, argues that nowadays cinematographers 'feel more and more uneasy about the key light coming from high above and creating what is considered a "film look" as opposed to the reality of light coming from the window or the practical light sources outside' (1986: 100). It is by no means clear that this is the case. Though much contemporary mainstream cinema does make more marked use of visible and lower light sources, it does not do so to the extent of abandoning light from on high. *Schindler's List* (1993), for instance, given the Academy Award for its cinematography (by Janusz Kaminski), may appear unHollywoodian in its use of black and white and strong, directional light, yet throughout it uses overhead lighting to rim the head or give a light glow to the temples. A striking instance is a sequence in a women's barracks in a concentration camp at night, where one woman is telling the others what she has heard about the gas chambers. She and the other women, in this dingy room at night, are none the less all lit from unobtrusive, ennobling overhead sources. The uneasiness with light from on high that Malkiewicz notes in contemporary cinematographers does not extend to abandonment of it.

Malkiewicz sees light from above as unnaturalistic, yet it was by recourse to exactly the same arbiter, nature, that the theatre began to move towards overhead lighting at the end of the eighteenth century. In 1781 the chemist

Antoine Lavoisier advised the Comédie Française on the use of overhead oil lamps with reflectors, thereby eliminating the old fault 'of presenting objects in a manner contrary to nature by lighting them from bottom to top, when they should, as in the physical order, be lit from top to bottom' (quoted in O'Dea 1958: 161, my translation). What is regarded as natural in any era has to do with what is possible and what is wanted. It was only the new light sources that made certain qualities of light (controllability, great brightness, steadiness) achievable and made it possible for almost anyone to have permanent overhead lighting in their home, street, stage or studio.

Both theatre and photography had, by the end of the nineteenth century, established the use of overhead lighting (though according to Nicholas Vardac it was not until 1917 that Belasco 'managed to eliminate the distortion of footlighting' altogether (1968: 119)). Film adopted the convention. Initially, natural sunlight was used (with interiors shot on open-roofed sets) but this was soon modified (diffused by the use of sheets, gauzes and so on) and/or supplemented by artificial lighting. Up to 1919 the latter were generally placed just above the performer's head (Salt 1983: 141); even this constitutes a relatively high position (compared to footlights or table lamps), but movie lighting proper placed it much higher.

High refers here not so much to the distance as the position above the performer. The distance above did certainly affect the intensity and spread of the light as well as the convenience of working with it (heat, keeping it out of shot), but it was the angle that was most significant. Although this kind of light is sometimes referred to as 'zenith light', this is not strictly true ('The lousiest photography you can get is around high noon when the sun's directly overhead', director Clarence Brown, quoted in Brownlow 1968: 164). A direct overhead position (as it were, high midday) for the key light tends to cast those feared shadows from the eyebrows, nose and chin, requiring too strong and flattening a fill in compensation. Something closer to a 45° angle has come to be preferred, since it enabled modelling of the face without 'disfiguring' shadows.

The light comes from above in a literal sense, but its superior position also carries geographical and ontological connotations, both ethnically suggestive.

Movie lighting drew on nineteenth-century traditions of using and representing light that were explicitly indebted to North European painting, above all to Rembrandt and Vermeer, painting rediscovered in this period (Slive 1962). This had provided, through its emphasis on domestic portraiture as opposed to classical and biblical subjects, a venerable model for photography in its bid for profitable respectability, something very clear in figures who were soon recognised as early masters of photography, such as David Octavius Hill and Robert Adamson (Rembrandt) and Henry Peach Robinson (Vermeer). Similarly in the theatre, Belasco and Appia, even though their work in many ways moved in opposite directions (towards

naturalism and anti-illusionism respectively), had both seen the Dutch and Flemish masters as their masters, and both made extensive use of overhead lighting. Lighting in film, once it was not just using available sunlight, also drew on North European painting, partly through taking over the conventions of photographic portraiture,[21] partly under the influence of Belasco (directly and tellingly on Cecil B. DeMille (Baxter 1975: 101)) and partly in the rather separate development of a film lighting style in the Scandinavian countries (in tune with the flowering of a distinctive style in the arts based on the observation and reproduction of the qualities of Nordic light (see Kent 1987)), a development that was in turn taken up by Hollywood.

From the late 1910s on, it became usual to refer to the ideal for lighting the movies as 'North' or 'Northern' light: 'I've always used his [Rembrandt's] technique of north light – of having my main source of light on a set always coming from the north' (cinematographer Lee Garmes, quoted in Russell 1973: 45). North light is defined by Barry Salt as 'the kind of light that comes into a room in daytime through a large north-facing window, or some arrangement that produces an identical effect with artificial means' (1983: 329). It is soft, white and steeply slanted. Even the move to suffuse sunlight in the early movies can be seen as a wish to reproduce the softness of Northern light, and it is central to the development of three (and more)-point movie lighting. More recently, it may also be achieved by bounced light using quartz or an umbrella light (ibid.: 329–330).

However effected, this light has certain implications. It is, literally and symbolically, superior light. The North, in ethnocentric geography, in the map of the world that became standardised in the process of European expansion, is above the South. It is still most common to think in terms of going up North, being down South and so on. This is also the region of North Europeans, the whitest whites in the white racial hierarchy. As discussed in Chapter 1, the North is an epitome of the 'high, cold' places that promoted the vigour, cleanliness, piety and enterprise of whiteness. White people come off best from this standardised Northern light, such that they seem to have a special affinity with it, to be enlightened, to be the recipient, reflection and maybe even source of the light of the world.

Such an affinity is further suggested in the figure of the ideal Aryan, with blond hair and blue eyes – hair the colour of the sun, eyes the colour of the sky. The supreme embodiment of Western humanity is Christ, whose whitening in Christian iconography was such that his 'hair and his beard were given the colour of sunshine, the brightness of the light above, while his eyes retained the colour of the sky from which he descended and to which he returned' (Bastide 1967: 315).

Light from above is virtuously Northern; it is also, as the last quotation suggests, celestial. Heaven had been seen as a place of light since around the twelfth century (McDannell and Lang 1988: 80ff.) Film was quick to realise

this. Following Belasco, pools of light were used for scenes of spiritual devotion and conversion (Gunning 1991: 182, 187). One of the earliest examples of the expressive use of light in film, that is, going beyond general, overall illumination, is the vision of Eva as an angel in *Uncle Tom's Cabin* (USA, 1903) (Plate 3.4). Both the ray of light in which Eva appears and the 45° slanted light coming through the window are in fact painted on the set. The example – famous as an example of literally painting light and also because of the runaway commercial success of the film – could not be more germane ethnically: Eva is the last word in white purity even before she joins the angels, themselves figures of central importance in the construction of ideal white womanhood.

The celestial connotations of light from above are not confined to its use in explicitly religious or ethereal contexts. I have already discussed the examples of Sean Connery's illuminated forehead in *Rising Sun* and the gleam on Tom Cruise's hair in *A Few Good Men*, and the exceptional example of the black man with glowing hair in the latter. In all these cases the man is not particularly brightly lit overall, but there is this touch of light about this head.

There is a continuity between this way of representing white men and nineteenth-century portraiture. Christine Battersby (1989) has noted the motif of the light of genius at the temples in painted portraits of men in the

Plate 3.4 Uncle Tom's Cabin (USA 1903)

period (Plate 3.5). The same thing runs through photography. It is very striking in Julia Margaret Cameron's work, her studies of Sir John Herschel (1867) (Plate 3.6) and Longfellow (1868), for instance. Cameron also did studies of angels and fairies; she transfers her sense of the spiritual, celestial quality of light to great men touched by heavenly inspiration. Yet it was not confined to the portraiture of the great and the good. The dark clothing of men, especially respectable men, and the upturned face combined with overhead lighting, became the standard way to produce an image of (ideal, privileged) white masculinity that showed it to be touched with a spark of light.

Plate 3.5 James Northcote *Henry Fuseli* (1778) (National Portrait Gallery, London)

Plate 3.6 Julia Margaret Cameron *Sir John Herschel* (1867) (Royal Photographic Society, Bath)

The culture of light makes seeing by means and in terms of light central to the construction of the human image. Light is a defining term and means of the culture and how different groups relate to it profoundly affects their place in society. Those who can let the light through, however dividedly, with however much struggle, those whose bodies are touched by the light from above, who yearn upward towards it, those are the people who should rule and inherit the earth. However, as I have already suggested above, such imagery is also inflected by class and gender, and it is to the second of these, so crucial to the sexual reproductive economy of race, that I finally turn.

The glow of white women

So far I have been arguing that the aesthetic technology of the photographic media, the apparatus and practice *par excellence* of a light culture, not only assumes and privileges whiteness but also constructs it. Finally I want to look at an extreme instance of this, the use of light in constructing an image of the ideal white woman within heterosexuality.

A passage in *Uncle Tom's Cabin* (1852) describes a visual effect that has become standard in photography and film:

> Eva came tripping up the verandah steps to her father. It was late in the afternoon, and the rays of the sun formed a kind of glory behind her, as she came forward in her white dress, with her golden hair and glowing cheeks.

> (Stowe 1981: 401)

Idealised white women are bathed in and permeated by light. It streams through them and falls on to them from above. In short, they glow.

They glow rather than shine. The light within or from above appears to suffuse the body. Shine, on the other hand, is light bouncing back off the surface of the skin. It is the mirror effect of sweat, itself connoting physicality, the emissions of the body and unladylike labour, in the sense of both work and parturition. In a well-known Victorian saw, animals sweated, and even gentlemen perspired, but ladies merely glowed. Dark skin too, when it does not absorb the light, may bounce it back. Non-white and sometimes working-class white women are liable to shine rather than glow in photographs and films.

Cosmetics have been devoted to both glow and the avoidance of shine. The reason for the use of powder in cosmetics was to prevent any suspicion of shine. Elizabeth Arden's cleansing cream promised to remove the fault of 'cheeks that shine'. Helena Rubinstein's fame rested on her claim to have, and through her creams to be able to give others, alabaster skin, that is, a translucent whiteness. An ad in *Photoplay* in October 1938 (Plate 3.7) works on the idea that the purity of the product itself can create true loveliness: Luxor is a powder that 'will bring a new, smooth *transparency* to your skin . . . the *radiance* and bloom of pure beauty' (my emphasis). Ads for skin lighteners for women of African descent claimed that they too could glow (like, by implication, white women). One in *Ebony* in July 1973 (Plate 3.8) is for a skin tone cream actually called Bleach and Glow, promising: 'That glowing complexion . . . it's yours . . . closer than you ever dreamed' – in other words, black women can get close to looking like the feminine ideal, that is, white women. Significantly, another ad in the same issue (Plate 3.9) is for Tawny, 'a new make-up that's made exclusively for coloured girls – at last, someone has realised your skin is different', part of a contemporaneous promotion of black female beauty not modelled on glowing white ideals.

is PURITY important, girls?

HAVE you ever avoided gazing into his eyes . . . because you're afraid of close scrutiny? Ever had the disappointment of donning your favorite hat, and discovering it exposed an unlovely cheek? Do you sometimes hesitate to face the cruel, bright daylight?

Of course, heavy powdering will *cover up* the blemishes. Yet this is the very thing that aggravates your skin. And besides . . . men hate "that powdered look."

You say, "What's a girl to do?" The answer's easy: *Use powder that is pure. Impure powders cause irritations and blemishes. Only powder that is pure can protect your skin.*

And powder that is pure and fine means protection plus beauty. Luxor powder is made in scientific laboratories, of only the purest ingredients. It's sifted through tight-stretched silk to make it fine and soft. It will bring a new, smooth transparency to your skin . . . the radiance and bloom of pure beauty.

Luxor products are not costly: face-powder, 50 cents a box, rouge 50 cents, lipstick 50 cents.

Luxor, Ltd.

Luxor, Ltd., 1355 W. 31st St., Chicago, Ill.
I guess purity *is* important. Here's ten cents for a sample of the pure face-powder. (Check)—Rachel, Flesh, White.
PP-A
Name———————
Address————————

Plate 3.7 Advertisement for Luxor face powder (*Photoplay*, October 1938)

Plate 3.8 Advertisement for Bleach and Glow skin tone cream
(*Ebony* July 1973)

Blonde hair too could give white women that glow. Marina Warner traces the connection of blondness and lightness far back into Christian tradition. Blondness is identified with 'heavenly effulgence. . . . It appears to reflect solar radiance, the totality of the spectrum, the flooding wholeness of light which Dante finds grows more and more dazzling as he rises in Paradise' (Warner 1994: 366). I noted above the development of backlighting in film to ensure that blonde hair looked blonde; it also enabled the production of this effulgent dazzle.

White clothing can also give that glow, no more so than in bridal wear. Weddings are the privileged moment of heterosexuality, that is, (racial) reproduction, and also of women, since they are glorified on what is seen as their day. The ubiquity of white as the colour for wedding dresses was really only fixed as a convention from the mid-nineteenth century (cf. Ginsburg 1981, McBride-Mellinger 1993).[22] The wedding dress, especially the veil and the use of lace (industrially produced from the late eighteenth century), all facilitate a radiant look. Dark-skinned brides may wear white as well, of course, but not only do they seldom have fair hair but their skin colour is likely to contrast strongly with their bridal wear, whereas white women's

Plate 3.9 Advertisement for Tawny make-up (*Ebony* July 1973)

complexions, especially in wedding photography, can seem like the apotheosis of the clothing's whiteness and glow.[23]

The photographic media have further enhanced these aspects of cosmetics and apparel in the use of haloes, backlighting, soft focus, gauzes, retouching and all the other conventions of feminine lighting. The ethnically loaded evils of shadow and shine can be eliminated, the former by the combination of lights in the three- or more point system, the latter by the selection of lights of different intensities, colours and temperatures. The mobilisation of these is often especially evident in close-ups of women in films, exaggerating the difference between overall and figure lighting discussed above.

The development of an image of the glowing human being can be traced in European art. One index of it is the means for representing haloes. In medieval art, these are gold, very material, silhouetting the head; since the Renaissance, they have seemed to radiate from the head, in turn suffusing it with a glow. Rudolph Arnheim discusses the way in which in Rembrandt's work, objects (including people) receive the impact of light from without, but at the same time 'become light sources themselves, actively irradiating

energy. Having become enlightened, they hand on the message' (1956: 314–15). This is the perception that was carried over into movie lighting.

The secularisation and feminine specification of this seems to have been effected through the figure of the woman as angel, enlightened and enlightening. Theologically, angels have no gender, and in the Bible and medieval art they were depicted as male and manly. With the Renaissance, they begin to be depicted either as women or as men with 'feminine' traits (Underhill 1995: 56). Verbal and visual imagery of the angelic begins to be applied to idealised, or just simply adored, women. Edmund Spenser in his *Epithalamion* (1594) evokes the beloved bride arriving in the tellingly coloured accoutrements of hallowed womanhood, which lead him on irresistibly to heavenliness – she is

> Clad all in white, that seems a virgin best.
> So well it her beseemes, that ye would weene
> Some angell she had beene.

By the nineteenth century this had become a doctrine. Notoriously, in Victorian society woman was to be the 'angel in the house', a term derived from the title of an 1854 poem by Coventry Patmore, which invokes her thus:

> Her disposition is devout,
> Her countenance angelical
>
> . . .
>
> A rapture of submission lifts
> Her life into celestial rest.

The term was taken up by John Ruskin in his *Sesame and Lilies* (1865), the white flowers of the title referring to women; in it, he also speaks of such angels providing for men 'a haven in a heartless world', playing on the nearness of the word 'haven', a harbour, to 'heaven'. Similarly, Horace Bushnell, in *Women's Suffrage: The Reform against Nature* (1869), inveighed:

> Why, if our women could but see . . . how they make a realm into which the poor bruised fighters . . . may come in, to be quieted, and civilised and get some touch of the angelic, I think they would be very little apt to disrespect their womanly subordination.
>
> (quoted in Dijkstra 1986: 11)

The persistence and power of this image was not lost on the young Calvin Hernton growing up in the American south years later:

As I grew older, the desire to see what it was that made white women so dear and angelic became a secret, grotesque burden to my psyche. . . . I kept wanting to find out what made white womanhood *white womanhood*; I wanted to unearth the quality that made her angelic and forbidden.

(1969: 61–2)

The touch of the angelic that Bushnell called for and that weighed so heavily on Hernton is Christian not only in drawing on the figure of the angel from its cosmology but also because it is in line with Victorian discussions of beauty which maintained that, while Western ideals of physical beauty were derived from the Greeks, they had been given a decisive inflection by Christianity, which stressed the overwhelming importance of inner beauty (Steele 1985: 102ff). Thus, the anonymous author of *How to be Beautiful* (1866) 'described a girl whose "features were plain in the last degree, her figure and her gait most unlovely," who discovered that "the secret of how to be beautiful was to "let Christ dwell in your heart"' (ibid.: 105). The sign of this was the sense of glow, of something in but not of the body, something heavenly.

The angelically glowing white woman is an extreme representation, precisely because it is an idealisation. It reached its apogee towards the end of the nineteenth century and especially in three situations of heightened perceived threat to the hegemony of whiteness. British ideological investment in race categories increased in response to spectacular resistance to its Empire, notably the Indian Mutiny of 1857 and the Jamaican revolt of 1865 (Miles 1989: 83). The Southern US ideal of womanhood intensified in the period after the Civil War, with the defeat of official racism and slavery and the supposed rise of Negro lawlessness. The celebration of the Victorian virgin ideal in the cinema, in stars like Lillian Gish and Mary Pickford[24] (Plates 3.10 and 3.11), was part of a bid for the respectabilisation of the medium, a class issue but indissociable from ethnicity in the USA in the early years of the twentieth century, in the form of both mass immigration of non-Nordic groups to the USA and the huge internal migration of African-Americans from the scattered, rural South to the concentrated, urban North (May 1983, Hansen 1991).

The white woman as angel was in these contexts both the symbol of white virtuousness and the last word in the claim that what made whites special as a race was their non-physical, spiritual, indeed ethereal qualities. It held up an image of what white women should be, could be, essentially were, an image that had attractions and drawbacks for actual white people. It was always contested: 'Victorian values' were never simply assented to. Even within cinema, even within the very films seemingly promulgating the cult of true womanhood, there were alternative and oppositional views (Hansen 1991: 120 and *passim*). The ideal itself was unstable, at once attracting and

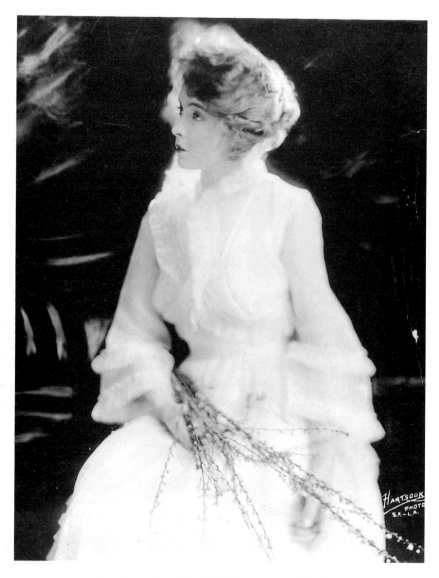

Plate 3.10 Lillian Gish (BFI Stills, Posters and Designs)

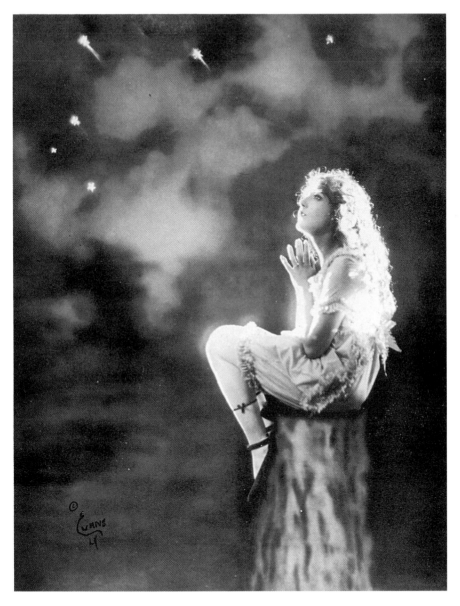

Plate 3.11 Nelson Evans: photograph of Mary Pickford (c.1917) (BFI Stills, Posters and Designs)

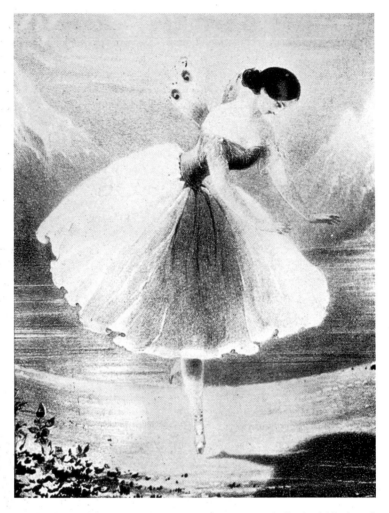

Plate 3.12 N. Currier: lithograph of Fanny Elssler in the 'pas de l'ombre' (shadow dance) from *Ondine, ou la Naiade* (1846)

repelling both women and men. It accorded white women a position of moral superiority and required deference to their needs, yet it was also a trap of moral obligation and unreal moral demands. It provided white men with an object of inspirational devotion, but one which might also provoke resentment of moral superiority and sexual unavailability. The ambiguity of the image is caught in the figure of the ballerina in the Romantic ballet (and the related genres of féerie, pantomime and burlesque), where the soft, flaring gaslight caught and was diffused by the fluffed up, multiple layers of the tutu, introduced in the mid-nineteenth century. Together with scenarios about

sprites and the use of pointe work (ballerinas seeming to dance on the tips of their toes and thus to be weightless), the Romantic ballet constructed a translucent, incorporeal image (Plate 3.12). Yet the ballerina was also always a flesh and blood woman showing her legs. Gustave Doré's lithograph *Les Rats de l'Opéra* (Plate 3.13) perfectly expresses the sexual dynamics of the ballet, the men in the dark box gazing lustfully at these supposedly ethereal figures in the light. The accidental double booking and resourceful amalgamation of a Parisian ballet troupe and a melodrama to produce the entertainment *The Black Crook* in New York in 1866 is widely credited with having simultaneously introduced ballet, the musical comedy and burlesque (striptease) into the US theatre. The Romantic ballet produced both the most ethereal stage aesthetic and the sex show.

As a day-to-day ideal, the image of the glowingly pure white woman no longer has the currency it once had: neither sex expects women to conform to this ideal and few think it would be a good thing if they did. Yet the language of this image remains powerful, and particularly at those radiant moments of adoration: the man's first sight of his first or great love, demure, looking down, luminously sweet; the bride, glowing in the light of her white gown; the young mother, still at heart illuminated with the pure desire of love for children. The history of Diana Windsor (Lady Diana/the Princess of Wales) (Plates 3.14 and 3.15) could be told through this

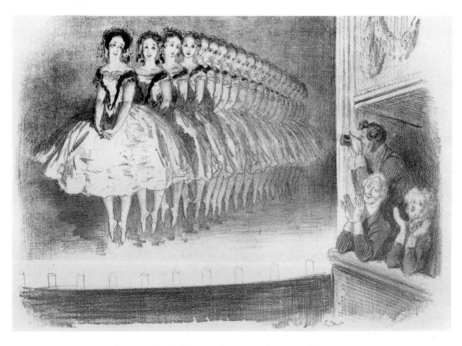

Plate 3.13 Gustave Doré *Les Rats de l'Opéra*

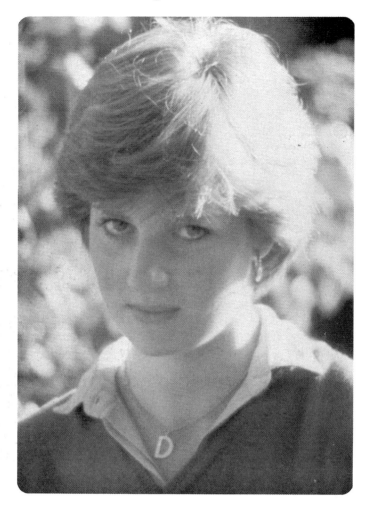

Plate 3.14 Lady Diana Spencer, from *Charles: Present Prince, Future King* (Manchester: World International Publishing, 1981)

imagery, until her fall from grace. Glow remains a key quality in idealised representations of white women – even with a 'feminist' star like Jane Fonda (Plate 3.16) or in the routinised pin-ups of the British tabloid press (Plate 3.17).

The endurance of the image is especially notable in the representation of the white heterosexual couple, the bearers of the race. Here there is a persistent differentiation between men and women in terms of light. In painting, in shots of love scenes in films, in, perhaps supremely, film stills,[25] the man is darker: his clothes are more sombre, his fair body is more covered, what

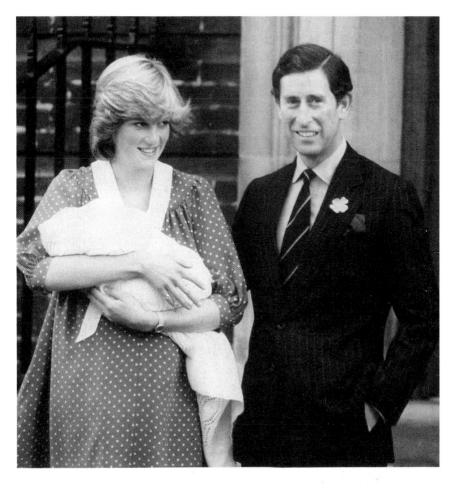

Plate 3.15 The Prince and Princess of Wales and Prince William
(*Majesty* 3(4), August 1982)

is visible of his flesh is darker, light falls less fully on him. There is almost never any departure from this – it is as true of art cinema and pornography as of mainstream movies; Madonna provides a postmodern polarisation in her bleached looks and supporting black studs.

The difference is often subtle enough. In a famous still from *The Big Sleep* (USA, 1946) (Plate 3.18), featuring one of the iconic heterosexual couples of the twentieth century, Lauren Bacall and Humphrey Bogart, he is only somewhat darker; her dress is in fact blacker than his suit and both have overhead lighting and some fill that eliminates quite a lot of shadow (though less than might be the case if it were not a film noir). All the same, she is lighter and whiter. The overhead light catches more of her hair; the key light

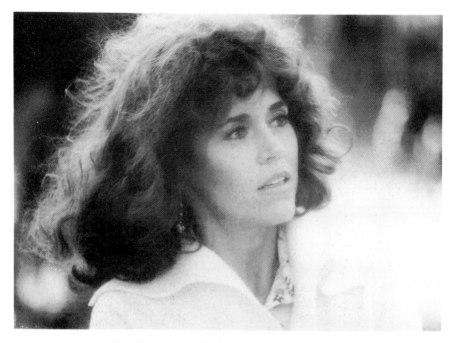

Plate 3.16 Coming Home (USA 1978): Jane Fonda

on her, the make-up and probably some retouching, all make her face the largest, clearest expanse of white in the image. The slight shadow from her nose and across her right cheek is much softer than the sharp, deep shadows round his eyes and distending from his nose. Her darker clothing has the effect of heightening the whiteness of her face, wrist and hands; he is greyer overall, apart from the spark of light at his temples. Most significantly, the light that creates this spark and illuminates in profile the right side of his face (the side turned away from the camera) seems to be the same light that catches the back and top of her hair, so that the light on him comes in some measure from or through her.

It is thus not just a matter of a different disposition of light on women and men, but the way the light constructs the relationship between them. The sense of the man being illuminated by the woman is a widespread convention, established in classic Hollywood cinema – Nazimova and Valentino (*Camille* (1921)), Erich von Stroheim and Maude George (*Foolish Wives* (1921)), Lillian Gish and Lars Hanson (*The Scarlet Letter* (1926)), Greta Garbo and John Gilbert (*Flesh and the Devil* (1926)), Robert Taylor and Jean Harlow (*Personal Property* (1936)), Bette Davis and Henry Fonda (*Jezebel* (1938)) (Plates 3.19 to 3.24) – but still current to-day, from Isabelle Adjani and Vincent Perez (*La Reine Margot* (1994)) (colour Plate 9) to the covers of romantic fiction (colour Plate 10). The woman is more fully in the

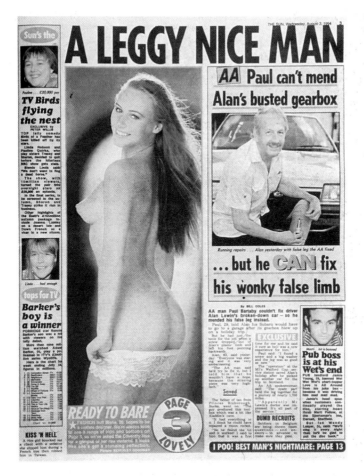

Plate 3.17 'Page 3 Lovely' (*The Sun*, 3 August 1994)

light, the man posed so that he seem to intrude into, yearn towards it; the dark shape of his body rears up into the light of hers; he is dark below and gradually lighter, often from the shirt front or neck up. This is pushed to its logical conclusion in horror film imagery. There is a frightening, disfiguring darkness to the sexuality that, moth to a flame, yearns towards the pure light of desirability.

In film, it is not only within a single image but also in the relationship between shots in a scene that this dynamic is at work. In the example from *Way Down East* discussed on pages 86–7, in the shot:reverse-shot cutting when Barthelmess and Gish first see each other, he, though strongly lit from his right, is against a dark background and within an iris, darkening the surround of the image. She, on the other hand, is against a lighter background,

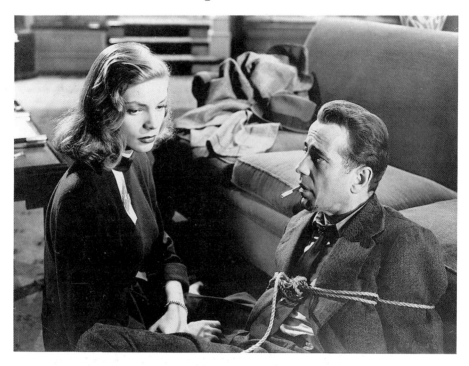

Plate 3.18 The Big Sleep (USA 1946): Lauren Bacall and Humphrey Bogart (BFI Stills, Posters and Designs)

with strong frontal lighting and an overhead light catching the crown of her bonnet, and only a slight darkening of the edge of the image where the light falls off, having the effect of softening the frame. He looks at her from his surrounding darkness; she is seen in a blur of light.

Such contrasts are common in scenes of the first encounter of the hetero-sexual couple. Cinematographer Joseph Walker recalls working on *Mr. Deeds Goes to Town* (1936) and feeling uneasy when setting up sharp lighting for Gary Cooper but diffused lighting for Jean Arthur in close-ups destined to be cross-cut. The director Frank Capra told him not to worry: 'By all means, go ahead with the close-up of Arthur. This is the way he sees her! The man is in love and he sees her . . . softly diffused . . . ethereal . . . beautiful . . . Yes' (Walker and Walker 1984: 220).

In *Broken Blossoms* (USA, 1919), Cheng (Richard Barthelmess), steeped in melancholia, is seated at the counter of his shop looking towards the window; there is strong frontal light on his face and strong overhead light on his head, shoulders, right hand and a pile of goods behind him, yet this light only serves to create a contrast with his dark cap and jacket and the pitch black of his surround. The film cuts (via an inter-title, 'This child with tear-aged face') to what he sees: Lucy (Lillian Gish) looking at the things in

Plate 3.19 Camille (USA 1921): Alla Nazimova and Rudolph Valentino (BFI Stills, Posters and Designs)

the window. The shot starts in near darkness, with just a little light on Gish's right cheek and another catching some of the hair over her left shoulder; she is framed from the chest up and to the right of the image, so that well over half the screen is in darkness. As the shot continues, however, and as Cheng continues to gaze at her, both lights grow stronger and wider until finally most of her face is in light, her body is rimmed with light and parts of the wall behind her are softly lit. The light is the dawning recognition by him of her goodness, which awakens his chaste desire.

In *Gilda* (USA, 1946), Johnny (Glenn Ford) and Ballen (George

Plate 3.20 *Foolish Wives* (USA 1921): Maude George and Erich von Stroheim (BFI Stills, Posters and Designs)

Macready), both darkly dressed and buttoned tightly up to the neck, walk through the latter's mansion from the bright hallway through the dim passages that lead to Ballen's bedroom, from which can be heard soft, female singing. When they reach the threshold of the bedroom, Johnny remains in the dark passage while Ballen stands just inside, a black figure against the bright white of the door. We cut to what they see: a brilliantly lit space, into which a bare-shouldered woman, Gilda (Rita Hayworth), rises up, flinging back her long hair so that it creates a flurry of light. The men look on from darkness at the woman in, and seemingly emanating, the light. In *Some Like It Hot* (USA, 1959), Joe (Tony Curtis) and Jerry (Jack Lemmon), dressed as women, burst into the women's toilet on a train and surprise Sugar (Marilyn Monroe), who is taking a surreptitious swig of brandy. All three wear black dresses, but the men also have black hats in contrast to Sugar's/Monroe's blonde hair which is lit from above, the side and even from below (catching it where it bobs at her nape), so that her head is almost a ball of light. This quality is echoed by the lights that pass behind her outside the train, whereas Joe and Jerry are posed against the interior of the train. In *8½* (Italy, 1963), Guido (Marcello Mastroianni), dressed in a dark suit and wearing black-

Plate 3.21 The Scarlet Letter (USA 1926): Lars Hanson and Lillian Gish (BFI Stills, Posters and Designs)

rimmed sunglasses, is queuing for water at a health spa and musing on the film he is trying to make; suddenly, he imagines he sees his ideal woman (Claudia Cardinale); he lowers his sunglasses, exposing his eyes to the light, and looks off screen: the woman, in a simple white dress, walks on tiptoe and in a sudden silence up some steps into a sun-drenched arena; the film moves, via shots of his darker figure, to an extreme close-up of her, cropped from forehead to chin, against a plain, dazzling white background; finally she bends down to pick something up, leaving the screen entirely blank white.

All the examples I have given of the contrast in the use of light between white men and women within heterosexuality, with the connotations of dark desire for the light, are much more complex, contradictory and even tense than I have so far indicated. In *Broken Blossoms*, it is a Chinese man who looks at the white child-woman. The film is at pains to exalt his goodness compared to the Europeans among whom he lives, and especially the girl's abusive adoptive 'father', while still locating the perverse desire for a child in this ethnic other (cf. Andrew 1981, Lesage 1985). In *Gilda*, the woman looks back, Gilda subjects Johnny to her appraising gaze (cf. Dyer 1978). In *Some Like It Hot*, the woman takes the men for women, creating a whole range of

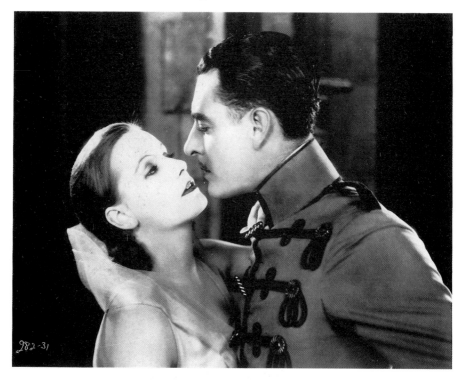

Plate 3.22 Flesh and the Devil (USA 1926): Greta Garbo and John Gilbert (BFI Stills, Posters and Designs)

ambiguities (cf. French 1978). *8½* shows that the man knows that the woman is his fantasy and at the end of the film even has the actress who's going to play the part of the fantasy come and tell him that she is after all just his fantasy.

These variations are a product of the resistances and equivocations with regard to the image of woman as angel that I noted above. They deploy perversity, defiance, self-reflexivity, irony. They suggest both a space for white women to work with and against the image and also the play of resentment, punishment and self-awareness in white heterosexual masculinity. They do not lessen the impact of the image.

Just as the white woman as the idealised creature of light has always been an ambivalent and contested image, so these variations on the image are witness to its hold on imagination. The aesthetic technology of light, perhaps the most characteristic mode of cultural production of the white era, finds its fullest, most flexible and contradictory expression in the cradle of whiteness, heterosexuality.

There is a remarkable watercolour by the eighteenth-century British artist Paul Sandby of a group watching a magic lantern (colour Plate 11). As a

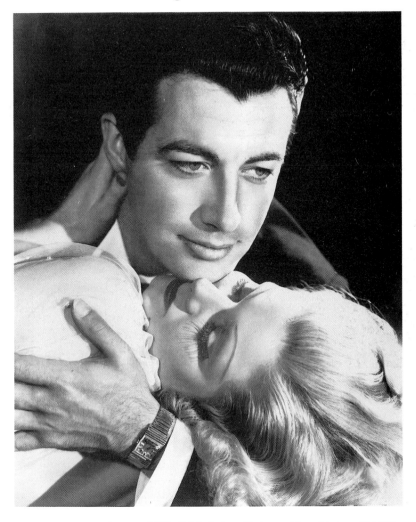

Plate 3.23 *Personal Property* (USA 1936): Robert Taylor and Jean Harlow (BFI Stills, Posters and Designs)

watercolour of a magic lantern this is already fascinating as a translucent representation of translucence. At either side of the image there are two figures of contrast. On the right there is a white woman, a nurse cuddling a baby. The light from the lantern screen barely illuminates those watching it, and she is even further than they from the screen, yet she is luminescent with lighter clothes than everyone else and light from no source above striking the top of her bonnet. She is a figure of (maternal) virtue and/or of desirability. On the left there is a male servant, who looks as if he is of African descent (a common enough practice in wealthy households of the time). He is

Plate 3.24 Jezebel (USA 1938): Henry Fonda and Bette Davis (BFI Stills, Posters and Designs)

completely dark, apart from one dot of an eye and a little illumination from a candle held close to his waist. His left side is silhouetted against the light of the screen, an aesthetic play on his skin/hue and the colour of light. The white woman, albeit lowish in status, has no need of the light to be lit up. The black man, directly in front of the screen and holding a candle, still does not pick up the light, is still opaque. His candle, though, does enlighten a book he is carrying, a treatise on light by a Dr Taylor. The two servants (the white nurse, the black houseboy) do not look at the screen, but across the paper at each other, with desire. The figure of dark, physical, unenlightened desire looks across at the (responsive) figure of illuminated desirability, while the well-to-do whites look on at their slide (a parody of a Parliamentary procession). Such deployment of light and dark, transparency and substance, Caucasian and not-Caucasian, female and male, sex-oriented and sex-indifferent, in the context of an overdeterminedly translucent image from the end of the eighteenth century which makes reference to light epistemology, condenses the theme of this chapter and, in many ways, of this book.

Appendix: Instruction manuals

The following manuals on photography, film and video were consulted for this chapter.

1892 Brothers, A. *Photography: its History, Processes, Apparatus and Materials*, London: C. Griffin.

*c.*1910 *Comment obtenir de Bonnes Photographies*, Paris: Kodak, Société Anonyme Française.

1911 Jones, Bernard E. *Cassell's Cyclopaedia of Photography*, London: Cassell.

1912 Talbot, Frederick A. *Moving Pictures: How They Are Made and Worked*, Philadelphia: J. B. Lippincott.

1920 Gregory, Carl Louis (ed.) *A Condensed Course in Motion Picture Photography*, New York: New York Institute of Photography.

*c.*1924 McKay, Herbert C. *Motion Picture Photography for the Amateur*, New York: Falk.

1929 Wheeler, Owen *Amateur Cinematography*, New York: Pitman.

1936 Deschin, Jacob *New Ways in Photography*, New York: Whittlesey House.

1939 Barton, Fred B. *Photography as a Hobby*, New York: Harper & Brothers.

1948 Archer, Fred *Fred Archer on Portraiture*, San Francisco: Camera Craft Publishing Co.

1950 Hanson, Eugene M. *Glamour Guide: How to Photograph Girls*, American Photographic Publishing Co. (no place given).

1955 Lorelle, Lucien *The Colour Book of Photography*, London: Focal Press. (Translation of *Traité pratique de la prise de vue en couleurs*, Paris: Publications Photo-Cinéma Paul Montel, n.d.)

1957 Bomback, Edward S. *Photography in Colour with Kodak Films*, London: Fountain Press.

1957 De Maré, Eric *Photography*, Harmondsworth: Penguin (reprinted at least five times up to 1970).

1963 Morgan, Willard B. (ed.) *The Encyclopedia of Photography*, New York: Greystoke Press.

1966 Fritsche, Kurt *Das Grosse Fotofehlerbuch*, Leipzig: VEB Fotokinoverlag. (Published in translation as *Faults in Photography: Causes and Corrections*, London/New York: Focal Press, 1968.)

1972 Millerson, Gerald *The Technique of Lighting for Television and Motion Pictures*, London: Focal Press.

1977 Greenhill, Richard, Murray Margaret, and Spence Jo, *Photography*, London: Macdonald Educational.

1979 Hedgecoe, John *John Hedgecoe's Complete Photography Course*, New York: Simon & Schuster.

1981 Craven, John and Wasley, John *Young Photographer*, East Ardsley: E P Publishing.

1984 Kodak *How to Take Good Pictures*, London: Collins. (A revised edition of *The World's Bestselling Photography Book*.)

1985 Busselle, Michael *The Manual of Male Photography*, London: Century Hutchinson.

1987 Haines, George *Go Photography*, London: Hamlyn. (Reprinted as *Learn Photography*, London: Dean, 1992.)

1988 Blaker, Alfred E. *Photography: Art and Technique*, Stoneham, MA: Butterworth.

1990 Cheshire, David *The Book of Video Photography*, New York: Knopf.

1990 Spillman, Ron *The Complete Photographer*, Surbiton: Fountain Press.

1992 Langford, Michael *Learn Photography in a Weekend*, London: Dorling Kindersley.

1992 Thomas, Philip *Photography in a Week*, London: Hodder & Stoughton.

1993 Khornak, Lucille *The Nude in Black and White*, New York: Amphoto.

1993 Freeman, Michael *Collins Photographer's Handbook*, London: HarperCollins.

1993 Owen, David *Make Better Home Videos*, Slough: Foulsham.

1993 Freeman, Michael *Collins Complete Guide to Photography*, London: HarperCollins.

1993 Freeman, Michael *Amphoto Guide to Photography*, New York: Amphoto.

1993 Stroebel, Leslie and Zakia, Richard (eds) *The Focal Encyclopedia of Photography* (3rd edn), Boston: Focal Press.

1994 Hedgecoe, John *John Hedgecoe's New Book of Photography*, New York: Dorling Kindersley.

1994 London, Barbara and Upton, John *Photography*, New York: HarperCollins (fifth edn).

This list was arrived at by consulting the relevant sections of bookshops and both university and public libraries, and also checking shelves at, for example, supermarkets, airports, railway stations. It is in this sense random. As a result, the works constitute a cross-section including publications from specialist presses, leading houses and small publishers, relatively technical as well as introductory and simplifying texts, and general as well as focused (children, the nude) books. Only Buselle (1985), Freeman (1993) (*Collins Complete Guide*), Greenhill *et al.* (1977), Khornak (1993), Langford (1992) and London and Upton (1994) use non-white subjects in illustration.

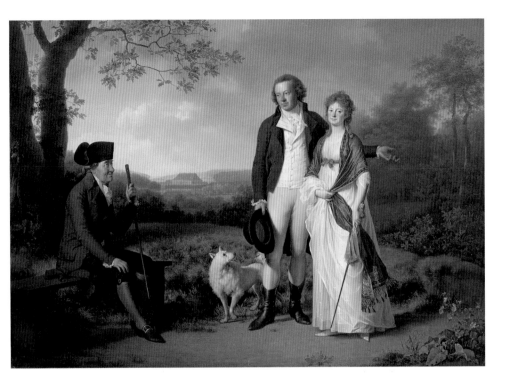

Plate 1 Jens Juel *The Ryberg Family Portrait* (1796–7) (Statens Museum for Kunst, Copenhagen)

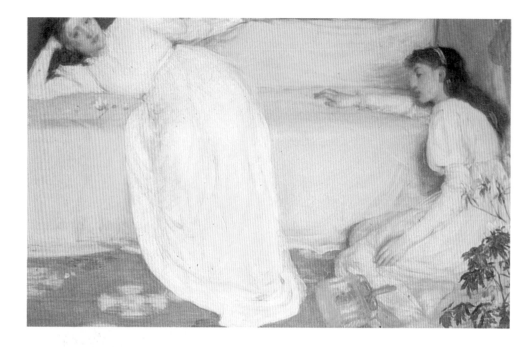

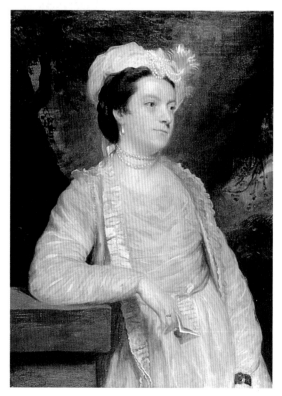

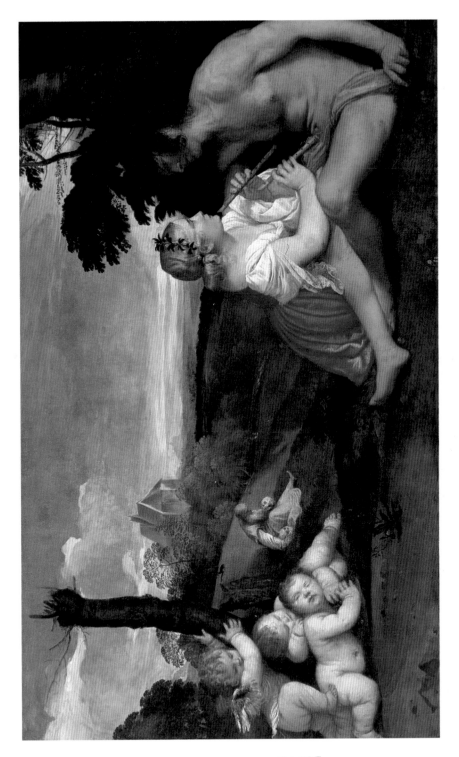

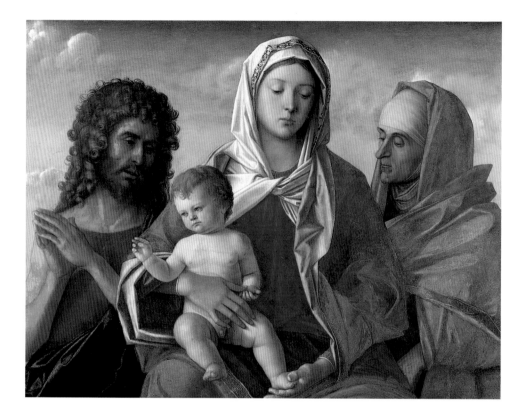

▲ *Plate 5*
Giovanni Bellini *Madonna and Child
with John the Baptist and Ste. Elizabeth*
(c. 1490–5) (Städelsches Kunstinstitut,
Frankfurt-am-Main)

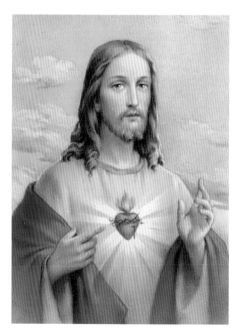

◄ *Plate 6*
Anonymous *Christ with Bleeding Heart*
(n.d.; postcard bought at Genoa
Cathedral, 1996)

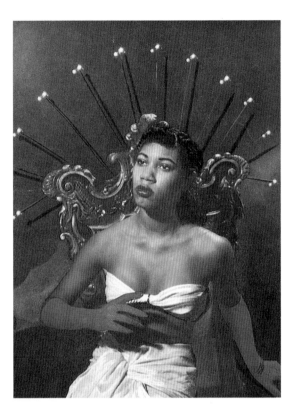

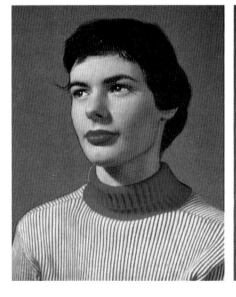

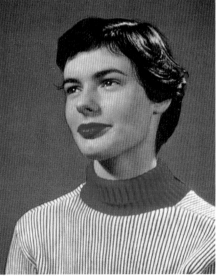

◄　　*Plate 7*
Ektachrome photograph by
L. Burrows illustrating 'special
lighting effects', from L. Lorelle
*The Colour Book of
Photography* (London: Focal
Press, 1955)

▼　　*Plate 8*
Two 'portraits of girl'
illustrating high (left) and
low (right) contrast lighting,
from Edward Bomback
*Photography in Colour with
Kodak Films* (London:
Fountain Press, 1957)

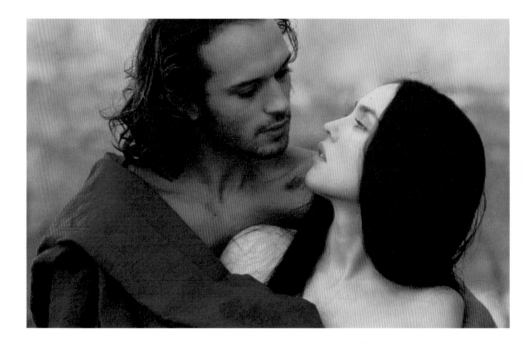

Plate 9 La Reine Margot (France/Germany/Italy 1994): Vincent Perez and Isabelle Adjani (L. Roux/Sigma)

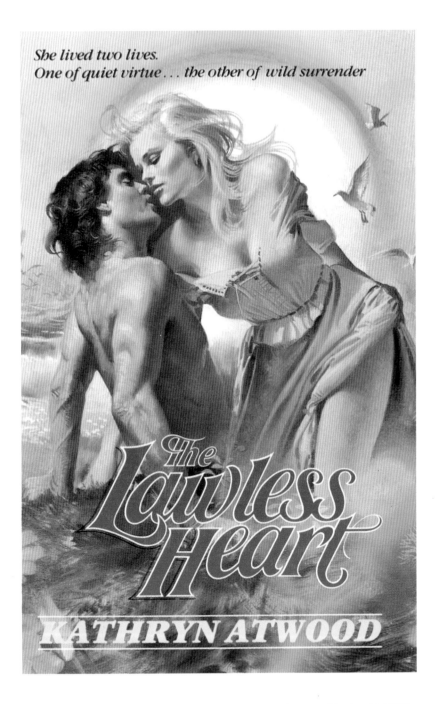

*She lived two lives.
One of quiet virtue . . . the other of wild surrender*

The
Lawless
Heart

KATHRYN ATWOOD

Plate 10 Cover of Kathryn Atwood *The Lawless Heart* (London: Macdonald, 1988)

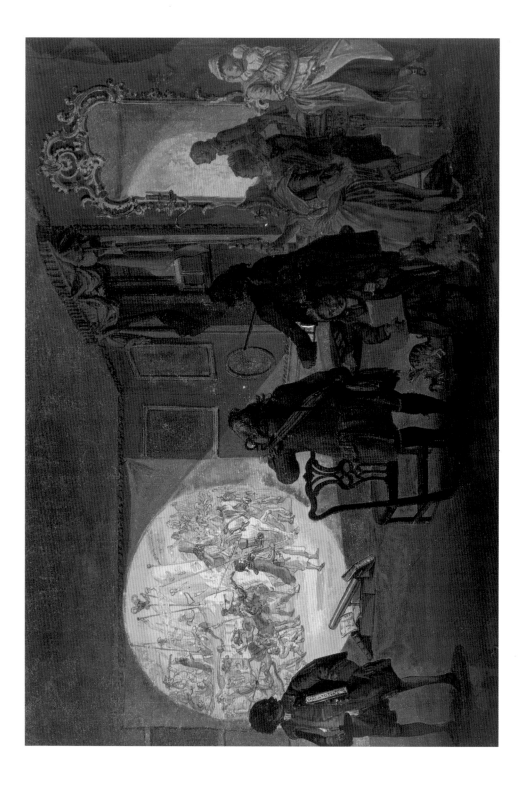

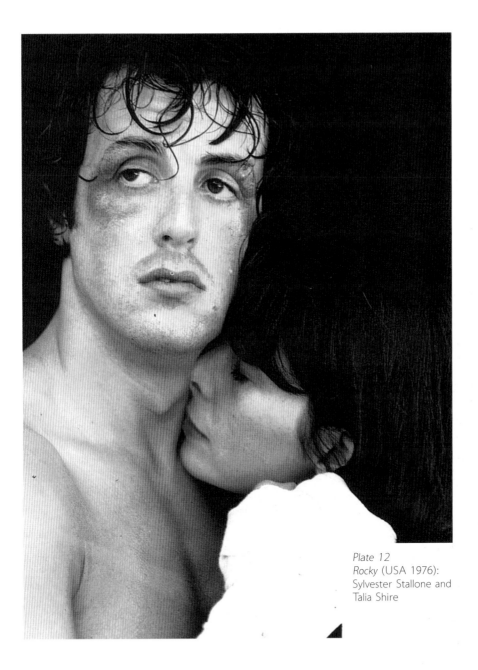

Plate 12
Rocky (USA 1976):
Sylvester Stallone and
Talia Shire

◀ *Plate 11*
Paul Sandby *The Magic Lantern* (c.1757–60) (British Museum)

◄ *Plate 13*
Robert Abbett: cover for
Tarzan the Invincible
(New York: Ballantine Books,
1964)

◄ *Plate 14*
Robert Abbett: cover for
Tarzan and the Lion Man
(New York: Ballantine
Books, 1964)

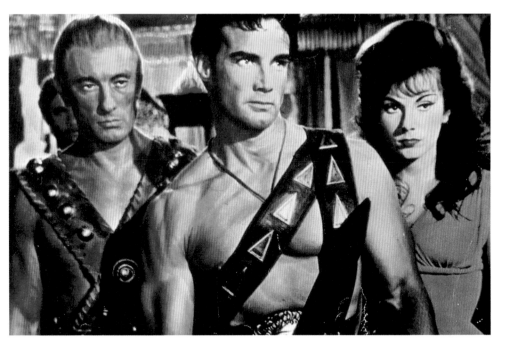

Plate 15 Il figlio di Spartacus (Italy 1962): Jacques Sernas, Steve Reeves and Gianna Maria Canale (BFI Stills, Posters and Designs)

Plate 16 The Jewel in the Crown (Granada Television 1984): Barbie Batchelor (Peggy Ashcroft) (BFI Stills, Posters and Designs)

4

The white man's muscles

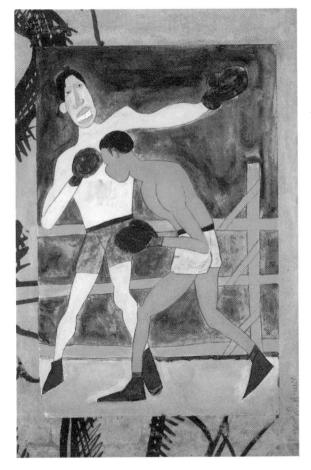

Plate 4.1 William H. Johnson *Joe Louis and Unidentified Boxer* (c.1939–42) (National Museum of American Art, Smithsonian Institution)

Until the 1980s, it was rare to see a white man semi-naked in popular fictions. The art gallery, sports and pornography offered socially sanctioned or cordoned-off images, but the cinema, the major visual narrative form of the twentieth century, only did so in particular cases. This was not so with non-white male bodies. In the Western, the plantation drama and the jungle adventure film, the non-white body is routinely on display. Dance numbers with body-baring chorus boys (up to and including Madonna's videos) most often used non-white (including 'Latin') dancers. Paul Robeson, the first major African-American acting star (as opposed to featured player), appeared torso-naked or more for large sections in nearly all his films, on a scale unimaginable with white male stars. The latter might be glimpsed for a brief shot washing or coming out of a swimming pool or the sea (at which point they instantly put on a robe), but a star like Rudolph Valentino (in any case Latin and often cast as a non-white) or a film like *Picnic* (1955) stand out as exceptions,[1] together with two genres: the boxing film (not really discussed here) and the adventure film in a colonial setting with a star possessed of a champion or built body.

This latter form is found in three cycles. One is the Tarzan films, beginning in 1912 with *Tarzan of the Apes,* continuing through forty-six further features, along with two television series and several Tarzan lookalikes (e.g. *King of the Jungle* (1927 and 1933) and Bomba the Jungle Boy (1949–)).[2] A second is the series of Italian films produced between 1957 and 1965 centred on heroes drawn from classical antiquity played by US bodybuilders, a cycle that has come to be known as the peplum.[3] Third, since the mid-1970s, there have been vehicles for such muscle stars as Arnold Schwarzenegger, Sylvester Stallone, Claude Van Damme and Dolph Lundgren.[4]

The two common features of these films – a champion/built body and a colonial setting – set terms for looking at the naked white male body. The white man has been the centre of attention for many centuries of Western culture, but there is a problem about the display of his body, which gives another inflection to the general paradox, already adumbrated, of whiteness and visibility. A naked body is a vulnerable body. This is so in the most fundamental sense – the bare body has no protection from the elements – but also in a social sense. Clothes are bearers of prestige, notably of wealth, status and class: to be without them is to lose prestige. Nakedness may also reveal the inadequacies of the body by comparison with social ideals. It may betray the relative similarity of male and female, white and non-white bodies, undo the remorseless insistences on difference and concomitant power carried by clothes and grooming. The exposed white male body is liable to pose the legitimacy of white male power: why should people who look like that – so unimpressive, so like others – have so much power?

At the same time, there is value in the white male body being seen. On the one hand, the body often figures very effectively as a point of final

explanation of social difference. By this argument, whites – and men – are where they are socially by virtue of biological, that is, bodily superiority. The sight of the body can be a kind of proof. On the other hand, the white insistence on spirit, on a transcendent relation to the body, has also led to a view that perhaps non-whites have better bodies, run faster, reproduce more easily, have bigger muscles, that perhaps indeed 'white men can't jump', a film title that has both a literal, basketball reference and an appropriately heterosexual, reproductive connotation. The possibility of white bodily inferiority falls heavily on the shoulders of those white men who are not at the top of the spirit pile, those for whom their body is their only capital. In the context particularly of white working-class or 'underachieving' masculinity, an assertion of the value and even superiority of the white male body has especial resonance (cf. Walkerdine 1986, Tasker 1993). The built body in colonial adventures is a formula that speaks to the need for an affirmation of the white male body without the loss of legitimacy that is always risked by its exposure, while also replaying the notion that white men are distinguished above all by their spirit and enterprise.

I will look first at the connotations of this kind of body and then at the colonial setting, before discussing the relation between them. In the final part of the chapter I look in more detail at the particular instance of the peplum, bringing the class address of colonial muscularity into focus and opening up the latter's relation to an avowedly white form of politics, fascism.

Tarzan, Hercules, Rambo[5] and the other heroes of the films in question here are all played by actors with champion and/or built physiques. The first Tarzans, and the stars of an earlier (*c*.1912–26) Italian muscle cycle, were drawn from the strong man acts of the variety stage. Thereafter, however, sports proper generally provided the performers. Of the Tarzans, James Peirce (1926) was an All-American centre on the Indiana University Football Team, and Frank Merill (1928 and 1929) a national gym champion; Johnny Weissmuller (twelve films between 1932 and 1948) had five Olympic gold medals for swimming; Buster Crabbe (1933) was also an Olympic swimmer, Herman Brix (1935 and 1938) an Olympic shot putter, Glenn Morris (1938) an Olympic decathlon champion, Denny Miller (1960) a UCLA basketball star and Mike Henry (three films between 1967 and 1968) a star line-backer for the Los Angeles Rams. Although Lex Barker (1949–55), Jock Mahoney (1962–3) and Ron Ely (TV 1966–8) were beefy rather than sculpted, Gordon Scott (1955–60) was clearly a bodybuilder, while Miles O'Keefe (1981) and Wolf Larson (TV 1991–3) are manifest creatures of the Nautilus age. The stars of the peplum and recent muscleman films are also obviously gym products. In two notable cases they are explicitly champions of bodybuilding: Steve Reeves (the most famous peplum star) won the Mr America contest in 1947 and Mr Universe in 1950 and Arnold Schwarzenegger was seven times Mr Olympia.

Tarzan since the 1950s, the peplum heroes and Schwarzenegger, Stallone *et al.* have bodybuilt bodies. The bodies of earlier Tarzans were winners, and hence amenable to being understood in terms of white superiority, but the heightened muscularity of the built body carries further connotations of whiteness.

Bodybuilding as an activity has a relatively good track record in terms of racial equality. From the 1950s on, non-white men – and especially those of African descent – became major figures in bodybuilding competitions.[6]
Yet the dominant images of the built body remain white. Kenneth Dutton (1995: 232) points out that black bodybuilders are rare on the cover of *Muscle and Fitness*, the bodybuilding magazine now most responsible for establishing and promulgating the image of the sport. They feature inside, as, given their pre-eminence in the field, they must, but a cover fixes an image of the world evoked by a magazine, even for those who don't buy it – the covers of *Muscle and Fitness* tend to define built bodies as white. The treatment of non-white bodybuilders by the movies is no better. There is no king of the jungle of African descent, no really major non-white muscle stars.[7] The peplum used two spectacularly built black bodybuilders, Paul Wynter and Serge Nubret, the latter now one of the best known figures in bodybuilding, but they were never the heroes, only, as I discuss below, helpers or foes.[8]

Bodybuilding in popular culture articulates white masculinity.[9] The body shapes it cultivates and the way it presents them draw on a number of white traditions. First, bodybuilding makes reference to classical – that is, ancient Greek and Roman – art (cf. Doan and Dietz 1984:11–18, Wyke 1996). Props or montages often explicitly relate body shape and pose to classical antecedents (cf. Plate 4.2), as does writing about bodybuilding.[10] The standard posing vocabulary was elaborated at the end of the nineteenth century in conscious emanation of the classic statuary then so prized in the visual culture. Eugen Sandow, the first bodybuilding star, affirmed for himself a lineage back to the Greeks and Romans in his 1904 manual *Body-building, or Man in the Making*.[11] By this time, the Caucasian whiteness of the classical world was taken for granted, down to the pleasure taken in the literal (hue) whiteness that its statues now have (the Victorians were scandalised to be told that Greek statues were once coloured (Jenkyns 1980: 146–54)). Second, bodybuilding now more often invokes a US, and *a fortiori* Californian, life style, with a characteristic emphasis on ideas of health, energy and naturalness. Dutton (1995: 17) locates bodybuilding's US-ness in its concatenation of labour and leisure, pain and consumerism:

> The combination of an affluent consumer society and the Protestant work ethic has been reflected in activities which paradoxically combine disciplined asceticism on the one hand and narcissistic hedonism on the other.

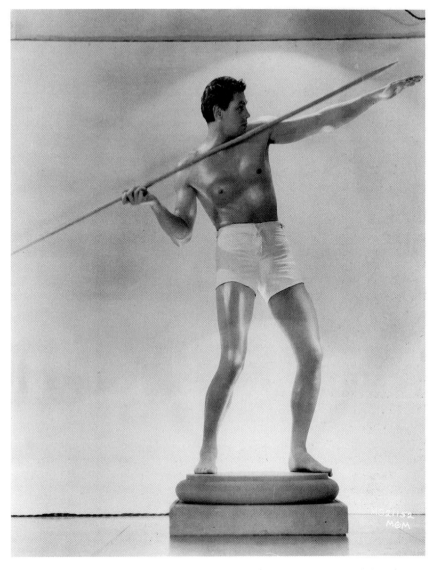

Plate 4.2 Johnny Weissmuller, 1930s (BFI Stills, Posters and Designs)

The USA is of course a highly multiracial society, but the idea of being an 'American' has long sat uneasily with ideas of being any other colour than white. Third, bodybuilding has sometimes adopted the image of the barbarian, drawn principally from comic books. Schwarzenegger's earliest vehicles were *Conan the Barbarian* (1982) and *Conan the Destroyer* (1984), and there is a host of largely straight-to-video movies based on this theme, including *The Barbarians* (1987) starring the Paul brothers (Plate 4.3),

who called themselves the Barbarians for their bodybuilding performances. The primitivism and exoticism of this – to say nothing of the fact that 'the barbarians' are generally credited with the destruction of classical civilisation – might suggest that this is a rather non-white image. However, not only is the casting (and in the comics the drawing) of the hero always white, it very often mobilises a sub-Nietschian rhetoric of the Übermensch[12] that, however inaccurately, is strongly associated with Hitlerism and crypto-fascism. Finally, bodybuilding does also sometimes draw on Christian imagery. The activity itself involves pain, bodily suffering, and with it the idea of the value of pain. This may be echoed in film in images of bodybuilders crucified. Leon Hunt has discussed the importance of crucifixion scenes in epic films, combining as they do 'passivity offset by control, humiliation offset by nobility of sacrifice, eroticism offset by religious connotations of transcendence' (1993: 73). Though infrequent, the recourse to crucifixion can be a key moment in establishing the moral superiority of not specifically Christian characters: Conan in *Conan the Barbarian*, Rambo in *Rambo II* (1985) (Plates 4.4 and 4.5).

Classicism, Californianism, barbarianism and crucifixionism are specific, strongly white representational traditions. Equally, many of the formal properties of the built body carry connotations of whiteness: it is ideal, hard, achieved, wealthy, hairless and tanned.

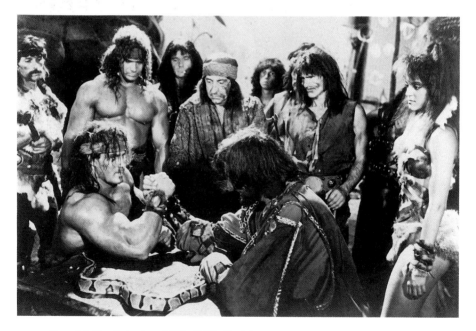

Plate 4.3 The Barbarians (USA 1987): David and Peter Paul (BFI Stills, Posters and Designs)

The built body presents itself not as typical but as ideal. It suggests our vague notions of the Greek gods and the Übermensch. Organised as competition, bodybuilding encourages discussion of the best body. Kenneth Dutton's study of the tradition roots it in a characteristically Western investment in perfectibility, in the possibility of humans developing themselves here on earth. In *Pumping Iron* (1976), Schwarzenegger describes bodybuilding as 'the dream of physical perfection and the agonies you go through to attain it'. Whiteness, as I argued in Chapter 1, is an aspirational

Plate 4.4 Conan the Barbarian (USA 1982): Arnold Schwarzenegger (BFI Stills, Posters and Designs)

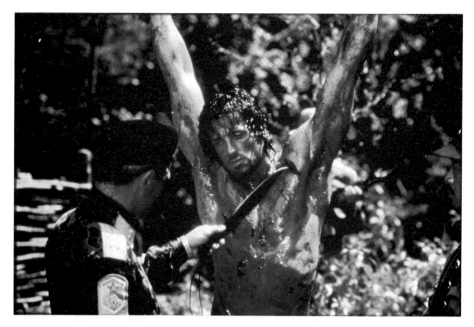

Plate 4.5 Rambo: First Blood II (USA 1985): Sylvester Stallone (BFI Stills, Posters and Designs)

structure, requiring ideals of human development. All the rhetoric of body-building is founded on this and most vividly seen in the aspirational motifs of the posing vocabulary, bodies forever striving upwards (Plate 4.6).

The built body is hard and contoured, often resembling armour. Body-building has three goals: mass (muscle size), definition (the clarity with which one muscle group stands out from another) and proportion (the visual balance between all the body's muscle groups). The first two of these present a look of hardness: the skin stretched over pumped up muscle creates a taut surface, the separation of groups seems, as bodybuilding jargon has it, to 'cut' into the body as into stone. Definition and proportion also emphasise contour, of individual muscle groups and of the body as a whole. Posing conventions, maximising size, tightening for definition, relating muscle groups to one another, further highlight these qualities; the use of oil (or often in films water or sweat) on the body emphasises it as a surface and hence its shape; relatively hard, three-quarter angle lighting brings out muscle shape; posing against cycloramas or shooting against skylines (Plate 4.7) presents the overall body contour.

Looking like a statue again invokes the classical; men against the horizon are a cliché of aspirational propaganda. Moreover, a hard, contoured body does not look like it runs the risk of being merged into other bodies. A sense of separation and boundedness is important to the white male ego. Klaus

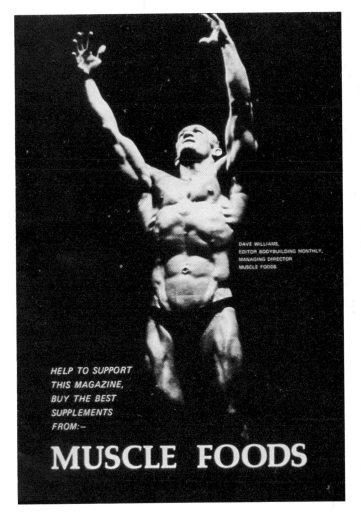

DAVE WILLIAMS,
EDITOR BODYBUILDING MONTHLY,
MANAGING DIRECTOR
MUSCLE FOODS

HELP TO SUPPORT
THIS MAGAZINE,
BUY THE BEST
SUPPLEMENTS
FROM:-

MUSCLE FOODS

Plate 4.6 Dave Williams in advertisement for Muscle Foods, 1980s

Theweleit's study (1987) of the German Freikorps suggests a model of white male identity in which anxieties about the integrity and survival of the self are expressed through fantasmic fears of the flooding, invading character of women, the masses and racial inferiors. Only a hard, visibly bounded body can resist being submerged into the horror of femininity and non-whiteness.

The built body is an achieved body, worked at, planned, suffered for. A massive, sculpted physique requires forethought and long-term organisation; regimes of graduated exercise, diet and scheduled rest need to be worked out and strictly adhered to; in short, building bodies is the most literal triumph of mind over matter, imagination over flesh. Some pepla (e.g. *La*

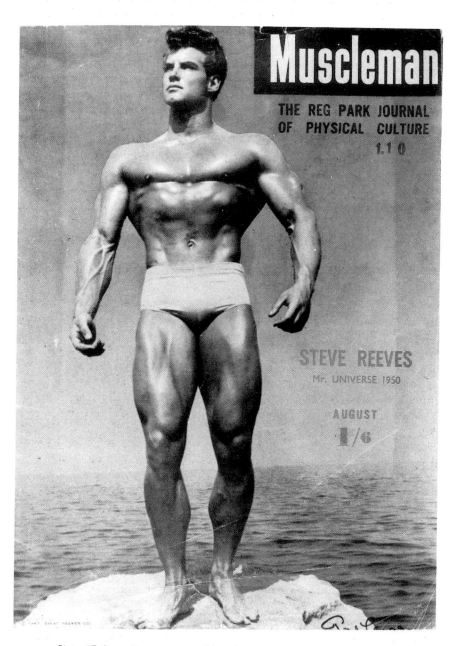

Plate 4.7 Steve Reeves, cover of *Muscleman* (c.1950; photo dated 1947)

schiava di Roma, La guerra di Troia, La battaglia di Maratona),[13] and many contemporary muscleman films, include sequences showing such disciplined physical preparation. They are especially common in Stallone's films, notably *Rocky IV* (1985), which intercuts Rocky's down-home, improvisatory training routines with his Soviet opponent's hi-tech, body-as-machine processes. Schwarzenegger's films contain nothing so agonised, and he has been cast as a machine in the *Terminator* films (1984 and 1991) rather than as a machine's opponent. Schwarzenegger, as a multiple Mr Olympia winner, is always already a champion physique; Stallone's body is not so certified, his narratives involve him in proving himself physically. Schwarzenegger's body is simply massive, his characteristic facial expression genial, his persona one of Teutonic confidence; Stallone's muscles look tortured into existence, with veins popping out and strained skin, his eyes and mouth express vulnerability, iconic images have him bruised (*Rocky*) (colour Plate 12) or scarred (Rambo).[14] Schwarzenegger and Stallone are variations on achievement. Their bodies, like those of all muscle heroes, carry the signs of hard, planned labour, the spirit reigning over the flesh.

The built body is a wealthy body. It is well fed and enormous amounts of leisure time have been devoted to it. The huge, firm muscles of Gordon Scott, Steve Reeves or Arnold Schwarzenegger make the simplest contrast with the thin or slack bodies of the native peoples in their films. Such muscles are a product and sign of affluence.

Finally, bodybuilders have hairless (shaved when not naturally so) and tanned bodies. Both of these are done in order to display the muscles more clearly, but they have further connotations. Body hair is animalistic; hairlessness connotes striving above nature. The climax of *Gli amori di Ercole* has Hercules fighting a giant ape, who has previously behaved in a King Kong-ish way towards Hercules's beloved Dejanira, stroking her hair and when she screams making as if to rape her; close-ups contrast Hercules's smooth, hairless muscles with the hairy limbs of this racist archetype.[15]

The modern bodybuilder tans. Although Sandow used white powder to make his body look more Greek sculptural, contemporary bodybuilding guru Robert Kennedy advises: 'To stand out on stage at a physique event, one must be really well tanned' (1983: 139). Tanning, which only white people do, connotes typically white privileges: leisure (having the time to lie about acquiring a tan), wealth (buying that time, acquiring an artificial tan or travelling to the sun) and a healthy life style (the California/Australia myth that no amount of melanoma statistics seem to dim).

These bodies with their white connotations are on display in colonialist adventure films. Few are about the settlement in and maintenance of rule over foreign lands. Yet the heroes are also not usually indigenous inhabitants of the land in which the action takes place. They relate to it as a post-colonial.

Muscle heroes are not indigenous. Tarzan, though he lives in the jungle, is not of the jungle. The peplum heroes, initially located in ancient Greece or Rome, soon roamed very far and wide in time and space. The widespread use of a widely recognised 'Vietnam' iconography (lush, glistening, dense jungle, camouflage gear, hi-tech hand weaponry, napalm-style fire) (Plate 4.8)[16] in 1980s muscle films (e.g. *Commando* (1985) and *Predator* (1987), both with Schwarzenegger, Stallone's Rambo films, Chuck Norris's work,[17] the *American Ninja* series 1985– with Michael Dudikoff, *Sword of Bushida* (1990) with Richard Norton, *Men of War* (1994) with Dolph Lundgren) invokes the most vividly remembered fighting in a foreign land of recent Western history. This invocation, associating the muscle image with the Vietnam experience, is carried over into other contemporary muscle films.

In all cases, the hero is up against foreignness, its treacherous terrain and inhabitants, animal and human. The latter are quite often his adversaries, but by no means always. There are good and bad, instinctual and wily, stupid and wise, primitive and orientalist natives, in any combination. The colonialist structure of the heroes' relation to the native is aid as much as antagonism: he sorts out the problems of people who cannot sort things out for themselves. This is the role in which the Western nations liked to cast themselves in relation to their former colonies. The claim that had always

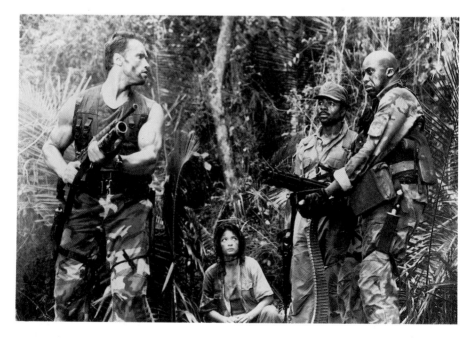

Plate 4.8 Predator (USA 1987): Arnold Schwarzenegger, Elpidia Carrillo, Carl Weathers and Bill Duke (BFI Stills, Posters and Designs)

been made, that imperial possession brought, and was even done in order to bring, benefits to the natives, informed policy since the 1950s, headed by the idea of the USA as world policeman, sharpened by cold war rivalry over political/economic influence. Aid is the watchword alike of foreign policy towards the Third World and the muscleman hero.

The three groups of films offer markedly different variations on this. I will look briefly here at Tarzan and Rambo *et al.*, leaving discussion of the peplum's probably rather less familiar colonialism to the final section of the chapter.

The Tarzan films are clearly rooted in colonialism, but with a twist. Very many involve a journey of white people from without into Africa. The difficulty of the terrain, its unfamiliarity and its dangers (savage beasts, precipitous mountain passes, tumultuous rivers, thick jungle) provide the opportunity for the exercise of the white spirit, indomitable, organised. The native people may have some specialised knowledge useful to the whites, but otherwise are either serviceable to carry things or else one more aspect of the land's perils. All this is the familiar basis for the thrills of the jungle adventure story. But Tarzan is already in the jungle. Apart from the Elmo Lincoln films and *Greystoke, the Legend of Tarzan* (1984), which tell the story of how he comes to be there (born of Scottish parents who die soon after), it is simply a given that Tarzan lives in the jungle. Sometimes he helps the whites, but very often he defends the jungle against them, for they have come to find treasure or, most often, despoil nature (for example, killing elephants for tusks, capturing animals who are Tarzan's helpers). Politically, Tarzan is a green.[18] Not infrequently, he defends native people against whites whose actions would destroy their way of life.

Tarzan, then, is identified with the jungle. He is at one with the animals. In his unadorned near-nakedness, he is natural man. Some of the comic strips, and the Weissmuller films especially, show him merging with the shapes and shadows of the jungle (Plates 4.9 and 4.10). Yet he is also superior to nature, he is king of the jungle. Just as elephants and chimpanzees come to the rescue at his call, or even because they sense instinctually that he is in peril, so too are lions and crocodiles swiftly despatched at his hands. Likewise, he is a friend to good natives (though never going so far as to live with them), but an invincible enemy of the bad, and in either case, he is physically, mentally and morally their superior.

The theme of nature, Tarzan's greenness, is not a mere mask for this colonialist relation. The treatment of nature is a central aspect of colonial enterprise. The latter is understood to involve mastery and ordering, but also a depredation that distances the white man from nature. A lament for a loss of closeness to nature has run through a very great deal of white culture. With Tarzan, however, one can have colonial power and closeness to nature. Tarzan is indubitably white – even those who do not know the story of his Scottish aristocratic parentage and the notion of heredity so important in the

Plate 4.9 Allen Saint-John: Tarzan illustration, c.1920s

novels (cf. Newsinger 1986, Bristow 1991: 213–18) will register his white-
ness in the films in his sports- or gym-created body, its contrast to the other,
darker native male bodies and, very often, the unabashed reference to him
as a 'white ape'. Yet this white man is more in harmony with nature than
the indigenous inhabitants. With Tarzan, the white man can be king of the
jungle without loss of oneness with it.

Tarzan films effect an imaginary reconciliation between the enjoyment of
colonial power and the ecological price of colonialism. The Rambo films do
something similar, only more torturously. As Yvonne Tasker has pointed out
(1993: 98ff.), the films themselves are greatly at variance to the wider image

Plate 4.10 Johnny Weissmuller, 1930s (BFI Stills, Posters and Designs)

of Rambo as a straightforward gung ho American patriot. Rather, he is a patriot without, it seems, a country. The first film has him returning, much decorated, from Vietnam, to find himself rejected as an uncouth trouble-maker. The film is set in the US North West, but as Rambo is pursued into the forest it begins to look as if it is Vietnam. Rambo wins against the enemies in this foreign land – but it is his home country. In the first sequel, he rescues soldiers missing in action in Vietnam after the war, actions revealed to be against actual (as opposed to declared) policy; the actions of the military bureaucracy not only seek to undermine his success but put Rambo himself at risk. He is a product of their finest training yet is none the less expendable. In *Rambo III* he is a one-man intervention in the Soviet

occupation of Afghanistan, doing the job (of destroying the arch enemy of US ideals, communism) that the US government should be doing. Thus he repeatedly upholds basic American values against the actuality of America.

Equally significant as this structural pattern is the way he dresses and fights. His spirit is evident in both his resourcefulness, that is, the intelligent, improvisatory use of his environment, and his endurance, his capacity to withstand pain and torture. Rambo's actions, as well as Stallone's tortured muscles, both express this. Yet the resourcefulness also involves him in adopting non-white techniques. Like Tarzan, he becomes more absorbed into nature than the locals, most memorably in *Rambo II*, where he sinks himself deep into a mud bank, only his eyes visible, before rearing out to kill one of the US marines set on his trail. His fighting attire includes a ritualistically donned headband, suggesting his half-Native American parentage, while his weapons of choice include a huge serrated knife and a powered bow and arrow (Plate 4.11). The latter also invoke Native Americans, though in hi-tech versions. Rambo repeatedly and explicitly espouses a love of America, yet he dresses and fights for America by going generically native (that is, conflating Native American with, in the second and third films, the know-how of good Orientals). 'America' can only be redeemed through bypassing the historical reality of the white USA, by returning to what can be conceptualised as coming before and without the USA. The Rambo films

Plate 4.11 Rambo: First Blood II (USA 1985): Sylvester Stallone (BFI Stills, Posters and Designs)

leave off at the impossibility of redemption by such contradictory means, ending with Rambo in tears (*First Blood*), Rambo walking off into a barren landscape (*Rambo II*), Rambo driving off screen, leaving the camera to dwell on the people he has saved (*Rambo III*).

The Rambo films have qualms, to a degree rare, I think, in other 1980s and 1990s muscle films. In other of the Vietnam iconography films, the misgivings, let alone the impossible knot of contradictions in loving a country that doesn't exist, are not present, although the theme of being at once emotionally central – male, white, heterosexual, powerful – and yet betrayed by bureaucrats and politicians is still very much in evidence.

Tarzan, Hercules, Rambo and the rest show us ideal, hard, achieved, wealthy, hairless and tanned white male bodies set in a colonialist relation, of aid as much as antagonism, to lands and peoples that are other to them. This body in this setting constructs the white man as physically superior, yet also an everyman, built to do the job of colonial world improvement.

The body is distinguished from those around it: hard not slack, well-fed not emaciated, cut not indulgently fat, aspirationally posed not curved over or hanging back. It does sometimes happen that the built white hero is pitted

Plate 4.12 Tarzan and the Great River (USA 1967): Mike Henry and Rafer Johnson (BFI Stills, Posters and Designs)

against a built non-white body, but, since the former invariably wins, this only affirms the ultimate superiority of the white man's body. At the climax of *Tarzan and the Great River* (1967), Tarzan (Mike Henry) fights Barcuna (Rafer Johnson), the black leader who wants to control the country's main water supply (a key issue in the politics of development) (Plate 4.12). Johnson has a fine physique, but less cut, less evidently worked at, than Henry's. In cross-cutting, the latter is shot from below, Johnson from above, a standard aggrandising/diminishing rhetoric. Tarzan/Henry wears a tailored loincloth (and is earlier seen in a Western suit), whereas Barcuna/ Johnson wears a leopard skin and mumbo-jumbo adornments. In other words, not only does the outcome of the confrontation prove Tarzan's bodily superiority, but casting, shooting and dress bespeak it throughout. The same contrast of attire is often found in the peplum. In *Maciste nella terra dei ciclopi*, Maciste (Gordon Mitchell) wears a cloth peplum (suggesting in fabric as well as tailoring an advanced level of human development), as compared to his unnamed black adversary (Paul Wynter), who wears a leopard skin loincloth (attire based on a primitive level of development, hunted not manufactured, draped not tailored). In this case, the adversary, Wynter, a Mr Universe, has a finer physique than the hero, but attire and defeat undercut it.

The hero's body is superior, but his skin colour – tanned white – also signals him an everyman. As discussed in Chapter 2, tanning does not suggest a desire or readiness to be racially black – a tanned white body is always indubitably just that. At the same time, it also implies that white people are capable of attractive variation in colour, whereas blacks who lighten and otherwise whiten their appearance are mocked for the endeavour and are generally held to have failed. The tanned built body affirms whiteness as a particular yet not a restricted identity, something heightened by comparison with the other bodies in the films. Tarzan is lighter than the natives, but darker than other white men; on two book covers by the same artist (colour Plates 13 and 14), he has lighter skin when battling an ape, darker when coming upon a white woman, flexible within these extremes of male darkness and female lightness. The peplum, which does not so often have nonwhite characters, none the less plays on skin colour. The hero is always darker than all white women, whether they be good (and blonde) or bad (and brunette), a fact encapsulated in the common pose of the woman's white hand resting against the broad expanse of the hero's tanned pectorals (Plate 4.13). He is also darker than other white men, especially bad ones, orientalist rulers whose pasty complexions are of a piece with their decadence, primitives whose underground or cave dwellings have kept their skins from sunlight. The hero, so often first seen standing in the sun against the horizon or even, as in *Maciste nella terra dei ciclopi*, apparently born in a ray of sunshine, is the antithesis of this whiteness that shrinks from the lifegiving sun. Even good white men are seldom as dark as the hero. Yet the

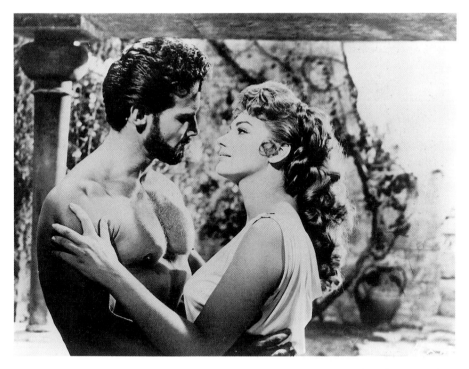

Plate 4.13 Ercole e la regina di Lidia (Italy/France 1958): Steve Reeves and Sylva Koscina
(BFI Stills, Posters and Designs)

hero is never equated with racial blackness: when even good, and physically spectacular, black men are present, the films are at great pains to stress the hero's superiority to them. White male heroism is thus constructed as both unmistakably yet not particularistically white. The muscle hero is an everyman: his tan bespeaks his right to intervene anywhere.

The emphasis in the peplum on the spectacle of the body also represents masculinity and colonialism in terms of relations between bodies. The economic, military and technological realities of colonialism disappear in a presentation of white bodily superiority as explanation of the colonising position. At its simplest this becomes the resolution of colonial conflict as a one-to-one fight between the hero and an antagonist, be the latter the leading warrior of the society, its ruler or a usurper (three versions of embodied power). Whatever the narrative specifics, the hero's better body wins out over the inferior oriental or primitive one. The example given above from *Tarzan and the Great River*, or Arnie's final stripped to the waist confrontation at the climax of *Commando*, reduce the political struggle over, respectively, natural resources or US foreign policy to a contest of bare flesh and may the best body win.

This pattern is often heightened by pitting the hero's body against the

technology of his antagonists. It is they, the object of the hero's colonialist sorting out, who have recourse to elaborate weaponry and massed militia, which the hero confronts with his bare body alone. An especially vivid image of this is the climax of *La battlaglia di Maratona*, where Philippides (Steve Reeves) wears only a white loincloth as compared to the heavy armour of his opponents and where he has only his body to set against their elaborate machineries of war (Plate 4.14). Yet his built white body triumphs over their black-clad, technologically sophisticated ones. The colonial encounter, and white supremacy, is thus naturalised by being realised and achieved in the body.

The built white body is not the body that white men are born with; it is the body made possible by their natural mental superiority. The point after all is that it is built, a product of the application of thought and planning, an achievement. It is the sense of the mind at work behind the production of this body that most defines its whiteness. This makes the white man better able to handle his body, to improvise with what is to hand, to size up situations; no matter how splendid the physiques of non-

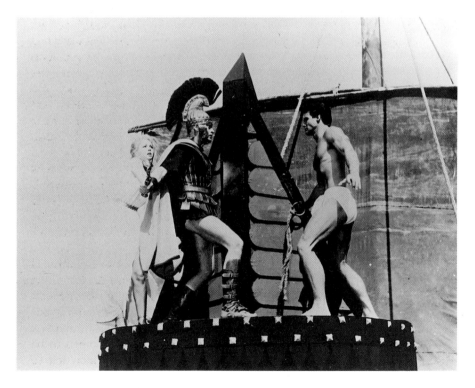

Plate 4.14 La battaglia di Maratona (Italy/ France 1959): Mylene Demongeot, Sergio Fantoni and Steve Reeves

white bodybuilders, they are never granted this quality (and thus the fact that their bodies too were produced ones is forgotten). The hero's physique may be fabulous, but what made it, and makes it effective, is the spirit within.

In short, the built body and the imperial enterprise are analogous. The built body sees the body as submitted to and glorified by the planning and ambition of the mind; colonial worlds are likewise represented as inchoate terrain needing the skill, sense and vision of the coloniser to be brought to order. The muscle hero has landscaped his body with muscles and he controls them superbly and sagely; the lands of the muscle film are enfeebled or raw bodies requiring discipline. The built white male body and colonial enterprise act as mirrors of each other, and both, even as they display the white man's magnificent corporeality, tell of the spirit within.

The peplum

I end this chapter by exploring the 1957–65 Italian peplum cycle in more detail, focusing on both its class address and its relation to an explicit politics of whiteness: fascism. The cycle draws on the image of the idealised white man, with his spirit-perfected body and capacity to sort out the problems of lesser beings, in a context of a damaged identity: Italian working-class masculinity at a moment of rapid industrialisation and in the wake of a period of nationalist, incipiently imperialist and racist politics, fascism, that had promised working-class men so much. The whole cycle mobilises the white resonances of the body image and the colonialist narrative structures discussed above to negotiate positions for this class audience in this historical moment. The films evidently address anxieties of class and gender, but they do this with recourse, in part, to rhetorics of whiteness. This manoeuvre is complicated by the often explicit rejection of fascism as a politics; in other words, the films have to mobilise whiteness as a balm to a damaged male class identity while also dissociating themselves from a discredited politics of whiteness.

Peplum films are adventure films centred on heroes drawn from classical (including Biblical) antiquity played by US bodybuilders. As characters played by these performers they embody the white past and future: classical antiquity was still unchallenged as racially white and Europeans tend to see the USA as basically a white nation with colourful marginalia. Moreover, classical antiquity, a material presence in Italy, was still also assumed to be the pinnacle of all human achievement, while the USA was widely felt to be the land of the human future.

Most of the peplum heroes figure in ancient texts (Hercules, Spartacus, Ulysses, Samson, Goliath (as hero not villain)), but two of the most

165

important are modern inventions: Ursus, from the novel and thus the films of *Quo Vadis?*, and, most widely used of all, Maciste, created for *Cabiria* in 1914. None of these heroes remain tied to the place and time of their first appearance: Hercules, Maciste and the rest appear in numerous other situations, far removed from their original stories. The whole of the ancient world was drawn upon; new fantasy lands were invented; even the post-classical world was not out of the question, Maciste showing up, for instance, in thirteenth-century Asia (*Maciste alla corte del Gran Khan*), in seventeenth-century Scotland (*Maciste all'inferno*), in China (*Maciste contro i Mongoli*), Arabia (*Maciste contro lo sceicco*) and Russia (*Maciste alla corte dello Zar*) as well as in non-European ancient worlds, for example, Africa (*Maciste nelle miniere del re Salomone*) and Central America (*Maciste il vendicatore dei Mayas*). Such is the freedom of construction in the cycle that the heroes, originally grounded in different eras and textual traditions (legend, history, romance), can be brought together as comrades (*Ercole, Sansone, Maciste ed Ursus gli invincibili*) or antagonists (*Ulisse contro Ercole, Ercole sfida Sansone*). The co-ordinates of space and time get looser still when one recognises sets and costumes that are prehistoric in one film show up in Roman times in another, or when one sees the films in English-dubbed versions, where distributors often randomly substituted the heroes' names for one another.

This exuberant spirit of collage is undoubtedly explicable in terms of both production and consumption patterns. Although some films were expensive by Italian standards, many more were not. Sets tend to look like sets, they and the costumes were reused, rehearsal time was minimal, many of the cast could not understand each other and the voices one hears are not always those of the people one sees (even in the original versions). They were seldom shown in first-run houses (Della Casa 1989: 91); their principal destinations were inner city and rural cinemas and touring film shows, where they were watched, as Christopher Wagstaff (1992) has argued of such *terza visione* exhibition in general, more as television is watched, people dropping in and out of the cinema, moving seats, socialising. The films drew upon popular traditions of the strongman acts in piazzas, circuses, fairs and varietà that were still familiar to this audience (Farassino and Sanguineti 1983). Such conditions of production and consumption do not encourage the kind of finished, developmental forms of 'classical Hollywood cinema', with its premium on coherence of plot, plausibility of character and setting, consistency of tone. Rather what can be done and what works are set pieces of action and display, immediately and vividly recognisable characters and settings, and the principle of variety: feats, dances, playlets, slapstick, speeches, tableaux.

This makes a certain kind of cinema possible. I am not thinking here of the kind of abandonment of reason (plausibility, decorum) that the surrealists so much valued in popular cinema and which informs the early French critical

championing of the genre, so much as certain textual consequences relevant to the question of white masculinity.

Given the hero performers' ignorance (in the main) of Italian, their inexperience as actors and their limited availability, it was clearly often easier to keep them out of filming that involved interaction with others. Thus Philippides in *La battaglia di Maratona* does not join in the land battle half-way through but climbs a hill to throw boulders down on the enemy; Hercules at the liberation of Thebes in *Ercole e la regina di Lidia* is occupied with wrestling a tiger in a pit rather than joining with the other men sacking the city; the climax of *Maciste contro i mostri* consists of a fight between two tribal chiefs with Maciste looking on; the second half of *Le fatiche di Ercole* is devoted to Jason and the Golden Fleece, Hercules going along as indispensable helper but Jason's quest being the one that propels the narrative. The hero is kept to one side of the narrative, whether its detailed unfolding through editing or its larger segmental organisation.

Such narrational devices permit the set pieces of posing that follow on from casting bodybuilders. The latter are not necessarily agile or acrobatic; the point is their size and shape, frozen in moments of maximum tension. Holding a boulder aloft (Plate 4.15), in a clinch with a lion, these and many other set-ups incorporate not only the posing vocabulary of bodybuilding competitions but also the *mise-en-scènes* of such non-narrative forms as physique photography and the strongman acts. The peplum's collage structure showcases the built body and the white values it carries.

Moreover, keeping the hero to one side of the narrative chain is of a piece with the ambiguity of his ontological status. Is the peplum hero human? Hercules is explicitly and traditionally not entirely so – he is half-god, half-human, a status explored in some films (*Le fatiche di Ercole, Ercole e la regina di Lidia, Ercole alla conquista di Atlantide*); Maciste, a slave in the original *Cabiria*, announces that his parents were the sun and the moon in *Maciste contro i mostri*; Crios in *Arrivano i Titani* is a Titan, a demigod. Even when nothing as explicit is suggested, many of the heroes seem not quite human, not least in their capacity to leap time and space to be where they are needed, a capacity that is never explained (Maciste's sudden loinclothed appearance at a Scottish witch burning in *Maciste all'inferno* is the most glorious example). Their introduction into the film often has a magical quality. Frequently the hero is discovered by water – the sea, a waterfall – as if born of it. In *Le fatiche di Ercole* Hercules asks to be deprived of his immortality and the granting of this is symbolised in his being drenched in rain, reborn in water as human (Plate 4.16). The first shot of the hero in *Maciste nella terra dei ciclopi* has him lying on a stone by the sea in a beam of light, in a pose echoing the Adam of Michelangelo in the Sistine Chapel (an image less foreign to anyone who had been through the Italian school system than it might be to others). Such imagery is of course Christian (and white) – baptismal water, Genesis. It insists on the heroes' humanity,

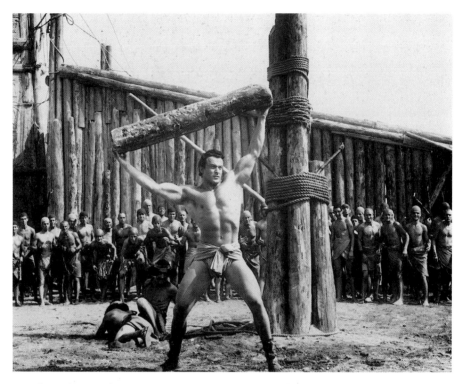

Plate 4.15 Maciste nella valle dei re (Italy/France/Yugoslavia 1959): Mark Forrest (BFI Stills, Posters and Designs)

yet their divine associations, their freedom of movement across time and space, the way they are not fully implicated in the investments of the narrative, also make them superhuman. They are both of humanity and above it, the white man's favourite position.

Such showcasing of male physical strength assumes a particular significance in the culture of the films' original audiences. The strongman image was rooted, as Giuseppe Valperga (1983) shows, in the cultural traditions of rural Italy. In addition to its popularity in entertainments and popular novels, it also had religious and local significance. Veneration and invocation of saints is an important element in Catholic devotion, and in peasant communities there was a special fondness for St Christopher, the giant who in legend carried Christ on his shoulders. Equally, big strong men were important figures in peasant communities: giant boy babies were a source of wide interest, seen as a blessing, not least because their strength was of the greatest economic significance in rural labour. In this context big male bodies were a resource of the first importance and what they could do often suggested props for strongman acts: boulders, tree trunks, carts, chains and so on.

Plate 4.16 Le fatiche di Ercole (Italy 1957): Steve Reeves (BFI Stills, Posters and Designs)

However, the period of the peplum is also a period of mass internal migration in Italy, from the rural South to the industrial North, from labour based on strength to one based on skill with machines (or, failing that, shitwork). In the shift away from rural labour, the value of the big strong body, and the male power that went along with it, was undermined. The peplum celebrates a type of male body for an audience to whom it had until now been a source of economic self-worth. The very emphasis on the simple display of muscle, foregrounded by the films' collage structure, and the heroes' triumphs through their deployment of those muscles, are an affirmation of the value of strength to an audience who was finding that it no longer had such value. The hero is often shown in conflict with machines, winning against elaborate war gadgetry (*La battaglia di Maratona*, *Il colosso di Rodi*), freeing people from giant wheels that have to be endlessly, mindlessly turned by hordes of men (*Nel segno di Roma*, *Sette contro tutti*, *Maciste l'uomo più forte del mondo*). His triumph over the machine by body alone offers the audience a fantasy of triumph over their new conditions of labour in terms of their traditional resources.

Yet these heroes, in many ways down to earth, are also sort of divine characters played by US Americans. If they speak to the realities of their initial audiences and in many particulars seem to be of them, they are also above them. This is one of the structures of feeling that suggests continuities between the peplum and fascism.

Fascism had lasted in Italy over twenty years, twice as long as in Germany; in 1960, when the peplum was at a peak, fascism's demise was only fifteen years past. It was fresh in the memory, though not yet a common theme in cinema. Apart from the brief period of neo-realism, itself born of anti-fascism, it was not until the 1970s that Italy's internationally renowned *autori* (Bertolucci, Cavani, Fellini, Pasolini, Rosi, Wertmüller) started to make films about fascism. Popular cinema, more mindful of the need to address a large national audience where it was at and less inhibited by questions of what the right thing to say was, characteristically did deal with fascism, directly and indirectly in comedy, and in the peplum.

Italian fascism's imagery of masculinity centred on monumentalist imagery and, above all, on Mussolini, il Duce. The regime did produce the kind of massive statuary and painting (especially frescoes and posters) featuring big men in aspirant postures that is also associated with Nazism. The fascist-built sports stadium in Rome, the Foro Italico, is surrounded by statues three times life-size of muscular naked men in white stone (Plate 4.17). Sportsmen, notably 1932 heavyweight champion Primo Carnera (who appears as an antagonist in *Ercole e la regina di Lidia*), were promoted as emblematic of the regime and subject matter for artists, including the

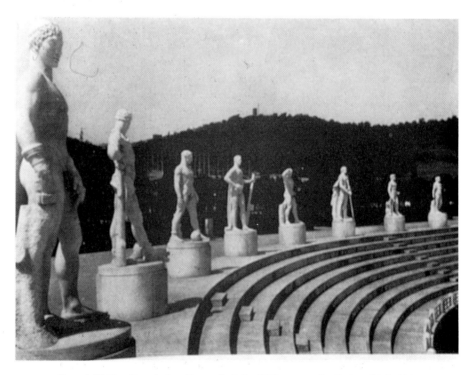

Plate 4.17 The Foro Italico, Rome, built in 1938; statues by Enrico del Debbio

photographer Elio Luxardo (Turroni 1980) (Plate 4.18), and increased sporting facilities and gymnastic displays were important aspects of policy (Felice and Goglia 1982: 184–7; Abruzzese 1983: 65). Yet such imagery, though important, was not saturating and, notably, it was almost absent from the cinema: the one attempt to harness the epic tradition to fascist ends, *Scipione l'Africano* (1937), did not use a muscleman as hero and was not a great success (Hay 1987: 155–61; Dalle Vacche 1992: 27–49). *Scipione* was however, especially in the attendant publicity and reviews, obvious in its reference to Mussolini. For he was the supreme hero figure of the regime. Indeed, as a child wrote in one of the essays elicited by the film journal *Bianco e nero* when *Scipione* first appeared:

> Era bello Scipione sul suo cavallo bianco. Però il Duce è ancora più bello e più bravo di Scipione.
>> (How handsome Scipio was on his white horse. But il Duce is even more handsome and brave than Scipio.)
>>> (Quoted in Brunetta 1975: 77)

Mussolini, as Gian Piero Brunetta (1975) and James Hay (1987) have observed, was the Maciste of fascist Italy. He was so both, as it were, narratively and iconographically. His role in the story of Italy was that of the strongman (physically, morally, temperamentally) who could sort out the country's problems: unemployment, corruption, inefficiency. It was only in the mid-1930s that this became tied up with questions of Italy's greatness measured imperially (realised in the war with Ethiopia) and racially (the passing of anti-Semitic legislation in 1938). Iconographically, as Hay (1987: 227–9) details, Mussolini drew his gestures from silent screen heroes and his emblematic roles (warrior, builder, patriarch) from the fascist repertoire. Most significantly here he promoted these qualities through his body, in his stature and posture (aided by camera angles) when clothed, in the very display of himself when unclothed. He posed for photographs as a swimmer, athlete or bare-chested skier (Felice and Goglia 1983: 82, 88) (Plate 4.19); he appeared stripped to the waist working alongside peasants for photographs (very Maciste-like in Felice and Goglia 1982: 141) and in the newsreel film *Il Duce trebbia il grano nell'Agro Pontino* (Il Duce threshes wheat in the Pontine Fields) (1938); he was the model for the imperative that everyone should have the body of a 20 year old (to the point that he forbade publication of his date of birth (Milano 1982: 32)).

The relation of the peplum to the athletic, Mussolinian image of the male body is complex. A given film may seem to be both denouncing and applauding fascism. *Ercole contro Roma*, for instance, establishes Hercules's Greekness with unusual thoroughness and has him come to the rescue of the ordinary Roman people through the good offices of an Arab merchant-

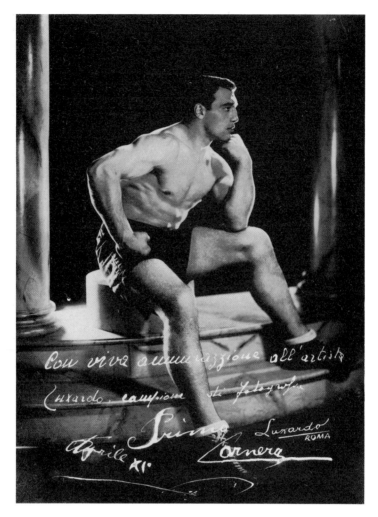

Plate 4.18 Elio Luxardo: photographic study of Primo Carnera, 1930s

cum-messenger; yet the enemy of the people is a usurper called Afro, and what Hercules finally restores is a militaristic regime in which the legionaries elect the leader. He is against Rome in the name of Rome.

Such contradictions are characteristic. In many ways, in explicit allusions and through certain distancing strategies, the cycle is a rejection of fascism, yet in its address and narrative organisation it also shows continuities with fascism. Rather than attempt to side the peplum (and by implication its audience) either with or against fascism, it should be seen as an imaginary working through of the shameful momentousness of the period, shameful because it was fascist or because it was defeated.

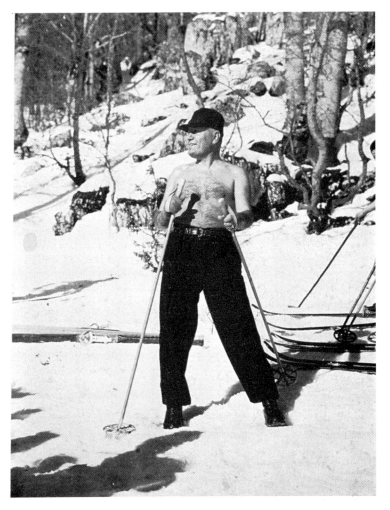

Plate 4.19 Benito Mussolini at Terminillo, 1930s

Where there is explicit reference to fascism in the peplum, it is hostile. This is often expressed iconographically. The obviously fascistic regime of Atlantis in *Ercole alla conquista di Atlantide*, breeding a flaxen-haired master race of men,[19] is emblematised in a vast Atlas-like statue in the queen's underground palace; the giant male statue bestriding the harbour entrance in *Il colosso di Rodi* is an object of hate, serving as a prison for dissidents and aimed at strategic dominance of the Mediterranean; the work camp in *Spartacus e i dieci gladiatori* is reminiscent of Nazi[20] concentration camps. Arena displays make oblique reference to the regime's mass spectacles and references to Rome are often coded references to fascism, because of the

importance of Rome in fascist rhetoric. The emphasis on Rome was both part of fascism's modernising attempt at national centralisation and a bid to suggest continuity with the empire of ancient Rome, which would placed Italy at the forefront of white civilisation.

More generally, peplum societies are characterised by cruel authoritarianism, with rulers who have usurped power by force and trickery while often (by no means always) having the support of the hoodwinked people. Their aims can be avowedly racial: 'Inferior races must be subjugated to us' says the evil ruler in *Maciste il vendicatore dei Mayas*, 'If we do not contaminate the purity of our race,[21] one day we will be masters of the world', says his equivalent in *Sette contro tutti*. It is usual for the hero to restore traditional authority. Significantly, unlike Mussolini, he is never himself a ruler, nor explicitly identified with leadership.

To this conscious if vague anti-fascism, we may add two important points that further seem to distance the peplum from fascism. First, the very absence of Maciste *et al.* from the cinema under fascism, and the revival of these pre-fascist heroes in the late 1950s, would suggest that if there was a harking back to the past it was to a past that Mussolini had displaced. The 'interpretation of fascism as a momentary "perversion" or "deviation", as a parenthesis in Italian history', with real Italianness to be found in earlier cultural continuities, was widely canvassed at the time (Cannella 1973/4: 12) and would accord with this rediscovery of the pre-fascist figures of Maciste *et al.*

Second, the casting of US, or US-seeming, bodybuilders is crucial. It should be stressed that it is not just that these performers were presumed to be US,[22] but that they looked it. The style of the built body was set by US bodybuilders in the post-war period (and especially by Steve Reeves (Sanguineti 1983: 88)) and the peplum stars' haircuts are those of Dean, Brando and Presley. This is sometimes emphasised in the contrast between the hero and his chief helper among the people: in *Ercole contro i figli del sole*, both Hercules (Mark Forrest) and Mytha (Giuliano Gemma), the Incan warrior he befriends, are very well built, but Mytha has straight, shoulder-length hair and a headband whereas Hercules sports the quiff and sheen of a rock star (Plate 4.20). The significance of the heroes' US-ness is above all that they were not Italian. Here was the display of the muscular male body promoted in Italian society only fifteen years previously stripped at a stroke of its fascist connotations. To this one should add the importance of the USA in the popular imagination in Italy, something both exploited by fascism but also a talisman on the left. US soldiers had spearheaded the liberation of Italy from Nazi occupation at the end of the war.[23] The USA was a land of modernity, as evident in these technologically honed, scientifically fed bodies. It was the land of the Common Man. Not least, it was a land of mass Italian emigration.

Yet for all its explicit anti-fascism, its heroes who are not rulers and its use

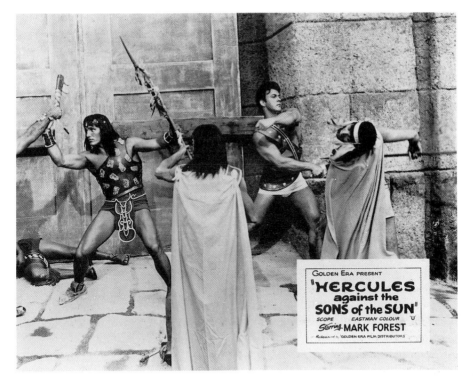

Plate 4.20 Ercole contro i figli del sole (Italy/Spain 1964): Giuliano Gemma and Mark Forrest (BFI Stills, Posters and Designs)

of pre-fascist figures realised in non-Italian bodies, the peplum also deploys fascistic structures of feeling. These were not necessarily invented by the fascists. As Abruzzese (1983: 65) argues, 'the national socialist use of the body has much deeper roots than the Mussolinian exaltation of the athlete', reaching back well into the nineteenth century; Maciste in the 1914 *Cabiria* prefigures the monumental incarnations of Primo Carnera and the regime's statuary. None the less, the regime had access to a repertoire of images very congenial to it and, by the time of the 1957–65 peplum, strongly associated with it. Moreover, though there were no Macistes during the fascist period, the regime had no need of them – it had Mussolini. Key aspects of the peplum – its address, the organisation of its narrative world, to say nothing of the hero's body – all suggest continuities with fascism.

These continuities are evident from a consideration of the regime's one epic, *Scipione l'Africano*, even though Scipio is no muscleman and its avowedly imperialist narrative is seldom found in the cycle. Nevertheless, he is a hero who is never wrong, never greatly in difficulty, and, like Mussolini, like Hercules or Maciste (or Tarzan or Rambo), the only answer to the problems at hand. Moreover, Scipio is not really offered as a figure

for the audience to identify with: for that the spectator has 'common man' figures in crowd scenes, lovers in sub-plots that show the impact of war, or simply the masses. Hay (1987: 152) traces this back to pre-fascist film spectacles, where through 'throngs of extras, mass audiences were given a stake in the films' action' but in terms of a presence 'for whom the central characters acted'. The interests of ordinary people are met, and are only able to be met, by the strongman. This is the structure of the peplum. The way the hero is kept to one side of the narrative reinforces the sense that what is at stake in the narrative are the tribulations of the people, but that they have to be solved by the intervention of the hero: he is not involved in the action, he merely performs the vital resolving actions. The fact that the hero, unlike Scipio or il Duce, is not a ruler is part of the films' rejection of fascist polity even while it replays the appeal of fascism's strongman.

The peplum's contradictory relation to fascism (which, I want to stress, does not mean that the peplum is 'really' fascist but that it is, precisely, contradictory) is embodied in the hero, most explicitly in *Ercole alla conquista di Atlantide*. Here the wicked Antinea, Queen of Atlantis, oversees the breeding of a race of ideal men; when she encounters Hercules she of course realises that here is the ultimate specimen of ideal manhood; Hercules is opposed to this fascist regime but Reg Park's muscles embody its very ideals. The appeal of this body type, especially with renewed force in a period of class upheaval, remains throughout the peplum in tension with the memory of its exaltation in the disgraceful recent past.

The peplum offered its original working-class audience an affirmation of the value of the big strong body; its contradictions work through the problems of that body's association with a discredited recent polity. The implicit whiteness of all this comes to the fore in both the films' colonialist structures and their occasional use of black bodybuilders.

Like other muscleman films, the central narrative motif of the peplum is intervention. The hero arrives in a foreign land and sorts out its problems. This very often means that he fights on the side of an ethnic other. If need be, he will side with them against bad whites. In *Il figlio di Spartacus* (colour Plate 15), the hero, Rando, a Roman, is first won over to the North Africans' plight by seeing a crucified black man and then observing the enslavement of the people. He even goes so far as to observe that 'if Rome is for slavery, then I am against Rome'. Yet the people can only be saved by the intervention of Rando and Vezio, his bleached blond German comrade in arms. Moreover, the people suffer as much from barbarian tribes and Saracens as from Romans, and the latter are seen as corrupt individuals, Rando finally bringing about the restoration of the good Caesar's dominion. Rando, son of Spartacus, the slaves' champion, restores enlightened colonialism.

Pepla are not necessarily set in known historical or mythological nations, but when they are, those that predominate are the most geopolitically close

to Italy and subject of its most 'successful' colonisation (Libya), that is, Arab lands: Egypt (*Maciste nella valle dei re*), Mesopotamia/Iraq (*Ercole contro i tiranni di Babilonia, L'eroe di Babilonia, Golia alla conquista di Bagdad*) or just generically 'Arab' (*Maciste contro il sceicco, Il figlio dello sceicco, Maciste contro il vampiro*). Sub-Saharan, black Africa features only once (*Maciste nelle miniere del re Salomone*), partly because it was not territory of significant Italian migration, tourism and diplomacy, but also because of Italy's imperial brush with black Africa. Mussolini's conquest of Ethiopia in 1935 had been seen as the high point of the regime, the moment at which Italy seemed to enter the league of the great white nations by virtue of having an empire; but it lost it in 1941 (to other imperial powers, the Allies). Ethiopia, and thus black Africa generally, was an embarrassing reference point for Italian colonial adventures, and indeed *Maciste nelle miniere del re Salomone* represents Africa as a world with hardly any black inhabitants, ruled by machinating whites with 'Arab' names.

Whether the film is set in known or newly invented lands, Fanon's black:white 'Manichean delirium' (1970: 183) is strongly in evidence. This is often realised in the most literal way through dress and *mise en scène*. *Maciste contro i mostri* depicts warring (racially white) tribes in a prehistoric world. The bad tribe is black-haired and darker skinned, they wear black clothes, live underground and worship the moon, the symbol of night; the good tribe is fair-haired and light-skinned, they wear white clothes, live in overground dwellings and worship the sun, the daylight. Other pepla are less unrelenting in their antinomies, but such use of dark and light in clothing, skin colour, below/above ground, night and day, bad and good is none the less the rule.

Ethnically different peoples in pepla are generally played by white actors, but the differences signalled by *mise en scène* are those of racial difference in Eurocentric discourse. On the one hand there is a use of architecture, clothing, hair-styles, music and dance gestures to create a broadly oriental ('Arab' or 'Chinese') world, with luxurious court life and devilishly clever modes of torture (Plate 4.21). This is established in the Carthaginianism of forerunners like *Cabiria* and *Scipione l'Africano* and in the depiction of Lidia, all pagodas and tinkling music, in the second film of the cycle, *Ercole e la regina di Lidia*. It is not just a question of geography, but of the widespread use of orientalist motifs in the depiction of vicious rule in invented societies, as in, for instance, *Maciste contro i mostri* and *Maciste l'uomo più forte del mondo*. In contrast, in other films or in the same film, there are the primitives, dressed in skins, living in huts or holes, skulking in the undergrowth, crude in their pleasures, brutal in their violence. In *Le fatiche di Ercole* the tribe that attacks the group on the island of the Golden Fleece are ape-like; in *Maciste contro i mostri*, the bad black tribe is accompanied by 'jungle' music and seen carrying game suspended from sticks, just like natives in Hollywood African adventure films. There can be variations

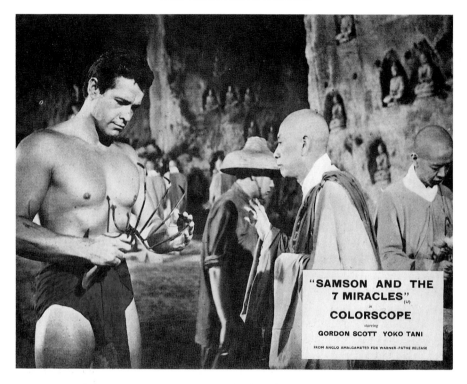

"SAMSON AND THE
7 MIRACLES" (U)
in
COLORSCOPE
starring
GORDON SCOTT YOKO TANI
FROM ANGLO AMALGAMATED FOR WARNER·PATHE RELEASE

Plate 4.21 Maciste alla corte del Gran Khan (Italy 1969): Gordon Scott and Chu-Lai-Chit
(BFI Stills, Posters and Designs)

in the primitives, suggesting degrees of civilisation. In *Maciste il vendicatore
dei Mayas*, the good white tribe is distinguished from the bad black tribe by
wearing cloth not skins, living in a settlement not underground and having
an elaborated belief system not just brute instinct.

The hero, who comes from without, is associated with neither the oriental
nor the primitive, though he comes to the aid of the good or rightful
elements in either. He is superior to both, cleverer than the orientals,
tougher than the primitives. He contains their strengths, yet is not defined
by either cleverness or toughness. On the contrary, often what is explicitly
praised in the film is his 'simplicity'. He is unimpressed by the elaborations
of Atlantis in *Ercole all conquista di Atlantide*; some older men in *Le fatiche
di Ercole* contrast Hercules's admirable simplicity in sport with the current
'fanaticism and cult of the body'. The white man both comprehends
orientals and primitives and yet is sublimely straightforward, not mired in
sophistication nor yet driven by instinct.

Pepla do occasionally cast black bodybuilders, usually as a special case of
primitivism. They are presented as possessed of a slave mentality, realising

that their best and true place is in subservience to the white man. In *Maciste nella terra dei ciclopi*, the unnamed slave (Wynter) stands by as Maciste is tortured by having to hold a rope in each hand at the end of which are teams of men; they pull in a tug of war and whichever loses will fall into a pit of lions; one team is white, the other black and when asked which team will win, the slave says the white one – he instinctively (it does not seem cynically) recognises racial superiority. In *Maciste l'uomo più forte del mondo*, Maciste rescues Banco (Wynter again) from the mole men; as a result Banco says he will be Maciste's slave for ever, for he gave him life; Maciste says that Banco's mother gave him life, that there should be no masters and slaves, yet Banco is unable to accept this and throughout the film acts as a slave. Slavery is thus condemned but shown as what blacks, not whites, crave.

Maciste's refusal of Banco's servitude displays his moral enlightenment. This is often suggested by the hero's behaviour in combat with black men. Marco, the chief hero of *Sette contro tutti*, refuses to kill his black combatant in the arena. In *Arrivano i Titani*, Rathor (Serge Nubret) is at first a snarling slave who has run amok; however, in gladiatorial combat Crios defeats him but gets the king to allow him to spare his life; thereafter Rathor is Crios's devoted helper. In the process he changes character: before he meets Crios in combat, he has despatched another (white) opponent to his death and he smiles at his success, his sweating muscles gleaming in the torch light; after Crios has saved his life we have no more such shots of exultant physicality. When Maciste and the black slave fight in *Maciste nella terra dei ciclopi*, Maciste is at first under the influence of the slave's magic potion; there is a lengthy sequence in which Maciste is viciously beaten by the slave; when the potion wears off and Maciste recovers his superior strength and skill, he despatches the slave very quickly – while the black slave has lingered over the torment, Maciste just acts with maximum efficiency and minimum pain.

When the black man becomes the white man's slave, he is of limited practical help to him. The hero may occasionally need the black man, either as additional support or as sheer force; but the black man needs the hero even more, because of the latter's ability to size up situations, know right from wrong, do the right thing. This motif of brain versus brawn is explicitly commented on in *Arrivano i Titani*, which insists on its racial dimension by casting the very dark Serge Nubret as Rathor against (as Nubret 1964: 61 confirms) bleached blond Giuliano Gemma as Crios. Before they fight, all the gladiators have to choose swords; Rathor muscles his way to the front and picks the biggest, Crios stands nonchalantly by and winds up with the smallest. (White mythology's racial penis size obsessions require comment only in this bracket.) Yet in combat it is Crios's skill, his acrobatic swiftness of foot and eye, that win over Rathor's brute size. When Rathor selected the biggest weapon, Crios shook his head and said: 'Tutti muscoli, niente cervello' (all muscles, no brain). A little later, Crios, now favoured by the

King, watches a contest between a white man and a black bull; the former wins and the Queen comments, 'L'intelligenza trionfa sempre' (intelligence always wins).

There is an extraordinary scene from *Maciste l'uomo più forte del mondo*, which encapsulates many of the characteristics of the peplum. The Queen of the mole people has had Maciste chained with a yoke across his shoulders on to which are lain more and more vast heavy weights; if Maciste buckles under the strain, prongs beneath the yoke will pierce his two companions who are tied down on either side of him. One of them, Banco, tells him not to hold the weights up on his account, thereby displaying both his slavish readiness to sacrifice his life and his lack of broader sense (since if Maciste does not hold the weights up he, Maciste, will be put to death). The Queen looks on and the film cuts to what she sees: close-ups of Mark Forrest's bulged and glistening pectorals and biceps. A point comes at which Maciste threatens to buckle; the weights slip, a prong enters Banco's chest, blood seeps out; by a supreme effort, Maciste pushes up the weight again and then higher and higher until he is holding it aloft above his head; as the music climaxes, a reaction shot of the Queen shows her breathing and gulping with an excitement that it is hard not to read as orgasmic. The set-piece muscle display, the lusting bad woman's point of view, the white man's triumph in the fiendish underground orientalist test, a triumph spurred on by his moral compulsion to save the good black primitive, of such elements, here screwed up to an exceptional pitch of sado-masochistic delirium, is the peplum's construction of the built white male body in colonial enterprise composed.

The peplum validates the image of the physically strong male body. It asserts this through the pleasures of adventure and desirability (everyone admires the hero's strength and women adore it). It negotiates the difficulties of its association with fascism. These difficulties are also being reworked in the films' handling of colonialism and race. Both of these were at issue in Italian fascism, less stridently and apocalyptically than in Nazism, but none the less there. Colonial ambitions and the assertion of Romanness both laid a claim for Italy to be included at the heart of whiteness. Such a claim offers a sense of superiority ('at least I'm not a colonial black') to those at the bottom of the white heap. It is always implicit in the peplum. The oddness of the cycle is that it simultaneously offers figures with whom the imputed audience may identify – the validated strong male body – and takes this away by placing them above the common man, exceptional like il Duce, and not played by Italians. The recourse to more explicit colonial structures, including confrontations with black bodybuilders, may be a strategy to overcome this: 'as a white man, I, an Italian working class man, may not be il Duce or an American, but they act on *my* behalf over against the Third World and racial inferiors.' Such juggling is crucial to the maintenance of white masculinity.

Appendix: Peplum filmography

The first title in brackets is a literal translation; any others are the titles by which the film is known in English language distribution. The final name is the star playing the hero (character name in brackets if not eponymous).

amori di Ercole, Gli (The Loves of Hercules) 1960; Mickey Hargitay.

Arrivano i Titani (Here Come the Titans; Sons of Thunder; My Son the Hero) 1962; Giuliano Gemma (Crios).

battaglia di Maratona, La (The Battle of Marathon; The Giant of Marathon) 1959; Steve Reeves (Filippide).

Cabiria 1914; Bartolomeo Pagano (Maciste).

colosso di Rodi, Il (The Colossus of Rhodes) 1961; Rory Calhoun (Dario).

Ercole al centro della terra aka *Ercole contro i vampiri* (Hercules at the Centre of the World/versus the Vampires; Hercules in the Haunted World) 1962; Reg Park.

Ercole alla conquista di Atlantide (Hercules Conquers Atlantis; Hercules and the Captive Women) 1961; Reg Park.

Ercole contro i figli del sole (Hercules versus the Sons of the Sun) 1964; Mark Forrest.

Ercole contro i tiranni di Babilonia (Hercules versus the Tyrants of Babylon) 1965; Rock Stevens.

Ercole contro Roma (Hercules versus Rome) 1964; Alan Steel.

Ercole e la regina di Lidia (Hercules and the Queen of Lidia; Hercules Unchained) 1959; Steve Reeves.

Ercole sfida Sansone (Hercules challenges Samson) 1964; Kirk Morris (Hercules), Richard Lloyd (Samson).

Ercole, Sansone, Maciste ed Ursus gli invincibili (Hercules, Samson, Maciste and Ursus the Invincible; Hercules, Maciste, Samson and Ursus versus the Universe; Samson and the Mighty Challenge) 1965; Kirk Morris, Red Ross, Nadir Baltimor, Yann Larvor (in eponymous order).

eroe di Babilonia, L' (The Hero of Babylon; Goliath King of the Slaves) 1964; Gordon Scott (Nipur).

fatiche di Ercole, Le (The Labours of Hercules; Hercules) 1958; Steve Reeves.

figlio dello sceicco, Il (The Son of the Sheik) 1962; Gordon Scott (Kerim).

figlio di Spartacus, Il (Son of Spartacus; The Slave) 1962; Steve Reeves (Rando).

gigante di Metropolis, Il (The Giant of Metropolis) 1961; Gordon Mitchell (Obro).

Golia alla conquista di Bagdad (Goliath conquers Baghdad) 1966; Rock Stevens.

Golia e la schiava ribelle (Goliath and the Rebel Slave; Arrow of the Avenger) 1963; Gordon Scott.

guerra di Troia, La (The Trojan War; The Wooden Horse of Troy); Steve Reeves (Aeneas).

Maciste all'inferno (Maciste in Hell) 1962; Kirk Morris.

Maciste alla corte del Gran Khan (Maciste at the court of the Great Khan; Samson and the Seven Miracles) 1959; Gordon Scott.

Maciste alla corte dello Zar (Maciste at the Court of the Czar) 1964; Kirk Morris.

Maciste contro i Mongoli (Maciste versus the Mongols) 1963; Alan Steel.

Maciste contro i mostri (Maciste against the Monsters; Colossus of the Stone Age, Land of the Monsters) 1962; Reg Lewis.

Maciste contro il vampiro (Maciste versus the Vampire; Goliath and the Vampires) 1961; Gordon Scott.

Maciste contro lo sceicco (Maciste versus the Sheik) 1962; Ed Fury.

Maciste il vendicatore dei Mayas aka *Ercole contro il gigante Golia* (Maciste the Mayas' Avenger/Hercules versus the Giant Golia) 1965; Kirk Morris.

Maciste l'uomo più forte del mondo (Maciste the Strongest Man in the World; The Mole Men Battle the Son of Hercules) 1961; Mark Forrest.

Maciste nella terra dei ciclopi aka *Maciste contro le cyclope* (Maciste in the Land of the Cyclops/versus the Cyclops; Atlas in the Land of the Cyclops; Monster from the Unknown World; The Cyclops; Atlas against the Cyclops) 1961; Gordon Mitchell.

Maciste nella valle dei re (Maciste in the Valley of the Kings; Maciste the Mighty; Son of Samson) 1959; Mark Forrest.

Maciste nelle miniere del re Salomone (Maciste in King Solomon's Mines; Samson in King Solomon's Mines) 1964; Reg Park.

Nel segno di Roma (Under the sign of Rome; Sign of the Gladiator) 1959; Georges Marchal (Marco Valerio).

Quo Vadis? 1912; Bruto Castellani (Ursus).

Romolo e Remo (Romulus and Remus; Duel of the Titans) 1961; Gordon Scott (Remo), Steve Reeves (Romolo).

schiava di Roma, La (The Roman Slave Girl; Blood of the Warriors) 1961; Guy Madison (Marco Valerio).

Sette contro tutti (Seven against all) 1966.

sette fatiche di Ali Babà, Le (The Seven Labours of Ali Baba) 1963; Rod Flash Jlush.

Simbad contro i sette Saraceni (Sinbad versus the Seven Saracens) 1965; Gordon Mitchell.

Spartacus e i dieci gladiatori (Spartacus and the Ten Gladiators; Day of Vengeance) 1965; Dan Vadis.

Ulisse contro Ercole (Ulysses versus Hercules; Ulysses against the Son of Hercules) 1962; Georges Marchal (Ulysses), Michael Lane (Hercules).

ultimi giorni di Pompei, Gli (The Last Days of Pompeii) 1959; Steve Reeves (Glauco Leto).

Ursus (Ursus; Mighty Ursus) 1961; Ed Fury.

Ursus e la ragazza tartaruga (Ursus and the Tartar Girl) 1961; Joe Robinson.

5

'There's nothing I can do! Nothing!'

The processes of imperialism express, in representation, white identities. These are forged from the roles and functions of white people in imperialism and the qualities of character that performing them is held to require and call forth. When a text is one of celebration, it is the manly white qualities of expansiveness, enterprise, courage and control (of self and others) that are in the foreground; but when doubt and uncertainty creep in, women begin to take centre stage. The white male spirit achieves and maintains empire; the white female soul is associated with its demise.

Such a stark contrast of identities in the imagination of empire is bound to admit of many exceptions and counter examples. If, outside of the doughty figures of travel writing, women really have figured little in the creation of empire, except as rewards or impediments for the men, still there are many central male characters in end-of-empire fictions. None the less, it is striking how often the latter do centre on women, and most notably in fictions concerning the Indian Raj. The ur-text of these is E. M. Forster's *A Passage to India*, written in 1912–13, published in 1924, adapted for the stage in 1960, adapted for television in 1965, and made into a film in 1984. In this lineage, we may include *Night Falls on Siva's Hill* (novel 1929), *The Rains Came* (novel 1937; film 1940; remake (*The Rains of Ranchipur*) 1956), *Black Narcissus* (novel 1939; film 1947), *The River* (novel 1946; film 1950), *Kingfishers Catch Fire* (novel 1953), *Bowhani Junction* (novel 1954; film 1956), *Heat and Dust* (novel 1975; film 1982) and *The Raj Quartet* (novels 1966–75; TV adaptation 1984). It is on the last of these – the fourteen-episode TV serial *The Jewel in the Crown* – that I concentrate in this chapter.

The representation of white women in such texts relate in quite complex ways to both the traditional view of white woman's place in imperialism and also to feminism. The traditional view has positive and negative variants. The positive is most readily evoked through the idea of white woman's civilising mission. This might be accomplished literally through missionary work (Plate 5.1), but that tended to be unattractively pro-active and spinsterish, and it was rather the memsahibs, the mothers, wives and daughters of the

white officers and administrators, who were to instil civilisation, through the example of their own moral refinement. The straightforwardly negative view of this was the image of the memsahib as more snobbish, and crueller to the natives, than the men, at once morally repressive and, what with the heat and the boredom, more liable to be prey to adultery and worse. As a result, the coming of white women to the empire was often seen as the beginning of the end of British dominion, a notion especially inclined to

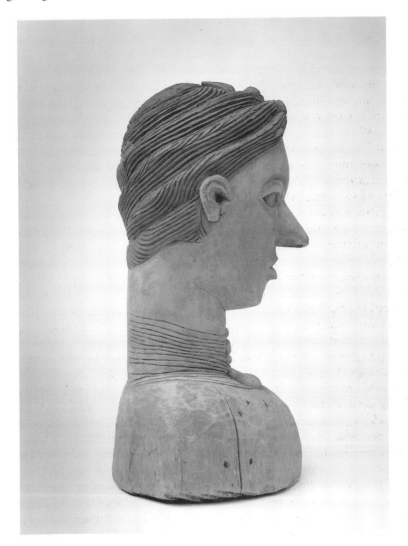

Plate 5.1 Bust of Mary Kingsley, Qua-Ibo, Nigeria, c. late nineteenth, early twentieth century (the Board of Trustees of the National Museums and Galleries on Merseyside, Liverpool Museum)

185

be voiced in sexual imagery. Women, by their very presence, introduced the fact of sexuality; unwittingly, they enflamed the already overheated desires of native men; they sapped their own men's energies or, as already noted, were liable to wind up betraying them. There is another way of interpreting the tendency to represent white women's deleterious effect on the empire in terms of sexuality. The coming of white women disturbed a comfortable pattern of homosociality and native prostitution; they introduced expectations of affect, obligation and mutuality in heterosexual arrangements while also tending to curtail white men's use of native women (cf. Ballhatchet 1980: 5) – in short, in quite another sense than the usual misogynistic portrayal of the memsahib, they really did disturb the sexuality of the Raj.

Threaded through the traditional representations, and informing the broadly more liberal version of white womanhood that is the subject of this chapter, is the influence of feminism. This is evident partly in the awareness of issues of racism, partly in the encouragement of female independence, partly in the connections with the moral purity crusades of the period. The relation of feminism to both missionary work and the memsahib role is thus ambiguous, now validating spinsterish missionary work and moral scrupulousness, now critical of racism and the restrictions of the proper memsahib existence (cf. Midgely 1992, Ware 1992).

Within and sometimes against both the traditional and feminist views, white women in the texts to which *The Jewel in the Crown* is heir are figures of conscience, cause and impotence. They express disapproval of British practice in India, though always at the level of how Indians are treated rather than whether they should be treated at all; they criticise the conduct of empire, not the enterprise itself. This is a logical conclusion of the civilising mission, which did not question the presence of the British in the empire, but did challenge the actual behaviour of the rulers towards the ruled, either in terms of Christian principle or because such rudeness and cruelty itself set a bad example of moral refinement. While being thus the conscience of empire, women were also seen as the cause of its decline. Partly the very expression of conscience undermined the united voice of imperial rule (here the missionaries were an especially dissident element), while the older notions of the presence of women weakening British dominion also persisted, not least in the exploration of both rape and relationships between British women and Indian men. It is the sexuality of Adela in *A Passage to India* and Edwina in *The Rains Came*, or, as we shall see, of Daphne in *The Jewel in the Crown*, that sets in motion the drama of the narrative. If they'd never come to India, none of this would have happened. At the same time, while white women conscientiously criticise and cause the downfall of the Raj, they are also seen as impotent. They may criticise, but they can't do anything to change things: when they try, they fail or even do harm (a theme, for instance, of Rumer Godden's novels, *Black Narcissus* and *Kingfishers Catch Fire*).

In the first three episodes of *The Jewel in the Crown*, the words 'There's nothing I can do!', usually with an echoing 'Nothing!' before or after them, are uttered six times, always by women. The sense of a refrain is reinforced by the unnaturalistic way in which they are both scripted and spoken, so that they stand free of surrounding speech, proclaiming themselves as emblematic (as does much else in the serial). Faintly echoed twice in the next ten episodes, they return forcibly in the final one, whose dialogue moreover focuses repeatedly on the question of what can, and especially what can't, be done. Doing· nothing, and nothingness itself, provide the keynote for the series: the nature of the central characters' lives, the overall feeling of the serial's narrative organisation, the explanatory framework for what it unfolds. Doing nothing, nothing, thus provides the basis for the complex construction of a particular white femininity.

Before addressing this, let me provide a basic account of the serial, both of its narrative content and its televisual status (its success, its female address, its politics).

The Jewel in the Crown was a fourteen-episode, fifteen-hour[1] serial, produced by Granada Television and first shown weekly from 3 January 1984 on ITV (the main commercial channel in Britain) with an immediate repeat a few days later on Channel 4 (seen as a minority, alternative channel). The first screening was at the peak viewing time of 9 p.m. and, for a drama of this kind, performed well in the ratings (averaging just over eight million viewers per episode). More significantly, it was at once acclaimed as the epitome of what great television drama could be,[2] becoming a key reference point in arguments about 'quality television', not least in debates about the deregulation of British television under the post-1979 Conservative government. A programme note for a complete screening at the National Film Theatre in London in March 1990, as part of a television season about deregulation entitled 'Goodbye to All This?', calls *Jewel* the 'title everyone reaches for when asked for a definition of "quality television"'. Charlotte Brunsdon, in her discussion of the notion of quality in relation to television, observes that *Jewel* (and *Brideshead Revisited*) 'have come to figure, within discussion of television's fictional output, as the acme of British quality' (1990: 85). It is both the status of *Jewel* in relation to wider notions of excellence in art, and its success within international, middle-class popular culture, that make it such an important symptomatic text.

The narrative content is too complex to admit of a complete summary here.[3] The key characters and events concern Daphne Manners, Hari Kumar and Ronald Merrick (Plates 5.2, 5.3 and 5.4). What happens to them in the first three episodes hangs over the rest of the series, even though Daphne dies in the third episode and Hari is hardly seen thereafter. The year is 1942, the place Mayapore[4] in India. Daphne is a young English woman newly arrived in India who begins an affair with Hari. He too, though of Indian parentage,

Plate 5.2 The Jewel in the Crown (Granada Television 1984): Daphne Manners (Susan Wooldridge) (BFI Stills, Posters and Designs)

has recently come to India, having been raised and educated in England. During political disturbances (triggered by the imprisonment of Mahatma Gandhi), Daphne and Hari are set upon while making love and Daphne is raped. The local chief of police is Ronald Merrick. He randomly arrests a number of young men for the crime, including Hari. Ronald knows that Daphne and Hari were lovers; moreover, he has himself proposed to Daphne earlier and been refused. His interrogation of Hari is brutal, involving beating and sexual assault. Hari however steadfastly refuses either to confirm or deny that he was with Daphne at the time she was attacked and raped. He is thrown into jail for several months; Daphne dies giving birth to a child. This child, Parvati, is adopted by Daphne's aunt, Lady Manners (Plate 5.8).

There is one other character in the first episodes who should be mentioned at this point, though she is not directly part of the Daphne–Hari story (referred to throughout the serial as 'the Manners case'). This is Miss Crane, a missionary, who, on the same night that Daphne and Hari are assaulted, is herself attacked on the road; the Indian schoolteacher she is travelling with is killed. Daphne comforts her in hospital. Later, Miss Crane sets fire to herself.

Plate 5.3 The Jewel in the Crown (Granada Television 1984): Hari Kumar (Art Malik) and Daphne (BFI Stills, Posters and Designs)

The remainder of the serial deals with a new set of characters, Ronald Merrick providing the one character link. The focus is on the Laytons, an army family living in the hill town of Pankot. Colonel Layton, the commanding officer of the local regiment, is a prisoner of war in Germany. Left behind are his wife, Mildred, and two daughters, Sarah and Susan. The latter marries an army officer called Teddie Bingham, stationed at Mirat. At the wedding, in Mirat, Ronald Merrick, now one of Teddie's fellow officers, acts as best man. He has been dogged by threatening incidents since the Manners case and a stone is thrown at the car taking him and Teddie to the church. Both he and Teddie are soon posted to Burma and Ronald is disfigured when he tries, unsuccessfully, to save Teddie's life in an attack. Some time later, Ronald himself marries Susan, who has had Teddie's child. Ronald is finally killed by unidentified Indians, the revenge for his behaviour during the Manners case at last accomplished.

The Laytons – Mildred, Sarah and Susan – live near Mabel Layton, who is Colonel Layton's stepmother. She lives in a highly desirable residence called Rose Cottage with a retired missionary, Barbie Batchelor (colour Plate 16). The latter is traumatised by the self-immolation of her friend and fellow missionary Miss Crane and comes to lose faith in her own calling. Despised and snubbed by most of the other memsahibs, she is forced to leave Rose

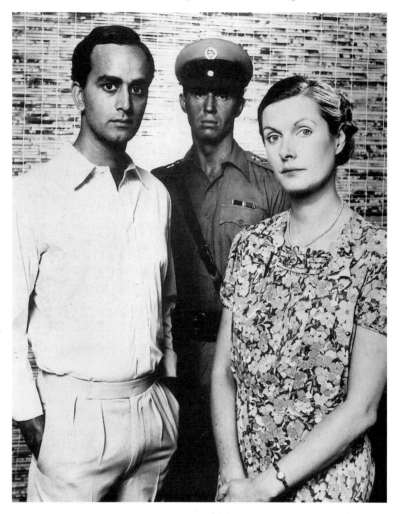

Plate 5.4 *The Jewel in the Crown* (Granada Television 1984): Hari, Ronald Merrick (Tim Pigott-Smith) and Daphne (BFI Stills, Posters and Designs)

Cottage on Mabel's death, is thrown from a tonga during a storm, and dies, refusing to speak again, in a mission hospital.

Barbie's one friend among the Pankot memsahibs is Sarah Layton (Plate 5.5). Sarah is in fact the character most on screen in episodes 3–10, yet, despite a one-night stand during a visit to Calcutta resulting in pregnancy and an abortion, she is the main character to whom least seems to happen. In Mirat, at the time of Susan and Teddie's wedding, she meets Ahmed Kassim (Plate 5.6) and, though he is unwilling to let their relationship become a romance, she does develop a friendship with him over the years. Ahmed is the

Plate 5.5 The Jewel in the Crown (Granada Television 1984): Sarah Layton (Geraldine James) (BFI Stills, Posters and Designs)

son of M. A. Kassim ('MAK'), a Muslim who is a leading member of the predominantly Hindu Congress Party. In the final episode, which takes place a few days before Indian independence, Ahmed travels with Sarah, Susan and some other British people on a train from Mirat to Ranpur. The train is attacked by Hindu guerrillas, who call Ahmed out of the compartment and kill him, along with all the other Muslims on board.

Only one other character need be mentioned at this point: Guy Perron (Plate 5.7). He knew Hari Kumar at school in England. An army sergeant, he is dragooned into working for Ronald Merrick. Through this he meets Sarah Layton, but, though they make love, she makes it clear that she does not want their relationship to go any further than this. He is with her, Ahmed and the others in the train which is attacked by guerrillas. Like Sarah, nothing much happens to him, yet he is a central figure of the episodes in which he appears (10–14).

It will be evident from the above that *The Jewel in the Crown* does not deal exclusively with women, yet there are a number of ways in which it is for the greater part focused on them. First, until episode 10, it is women, Daphne and Sarah, who, as listeners, observers and questioners, provide the

Plate 5.6 The Jewel in the Crown (Granada Television 1984): Ahmed Kassim (Derrick Branche) and Sarah (BFI Stills, Posters and Designs)

perspective on other characters and events. Second, much of the serial can be situated in relation to the television genre most widely seen as for and about women, namely soap opera (indeed, some who disparaged *Jewel* did so by calling it merely a superior soap).[5] *Jewel* eschews action and melodrama; like soaps, it devotes most of its time to talk, talk about personal matters, gossip. Whether validly or not, such talk has often been seen as women's territory, and one of the reasons why soap can be considered a women's genre (cf. Brundson 1981). To this we may add the contribution to *Jewel*'s success of costumes and domestic settings, also areas in which women tend to acquire more expertise and amplified here by the vogue for retro fashion in the early 1980s. Third, two of *Jewel*'s male love objects are figures from romantic fiction: Hari and Ahmed are glowering and difficult, harbouring a pain that the heroine alone can perceive, and, of course, they are exotic. Where *Jewel* differs from romance is in not ending with a heterosexual settling down.

There is another way in which *Jewel* may be seen as a woman-centred text. One of its most striking features, which I discuss further below, is the use of foregrounded symbols. Not only do these all relate especially to women

Plate 5.7 The Jewel in the Crown (Granada Television 1984): Ahmed, Guy Perron (Charles Dance) and Sarah (BFI Stills, Posters and Designs)

characters, but one of the most important is passed on from woman to woman in a lineage that bypasses the mother–daughter descent sanctified by the patriarchal family (which is represented as dysfunctional in the one such instance in the serial, the Laytons). This is some lace with appliqué butterflies (colour plate 16). It has been given to Mabel Layton by her mother on her marriage, to be used as a christening gown for her first child. There are two pieces. Mabel, herself childless, gives one to her *step*-daughter Sarah, who gives it to her sister Susan, who uses it for her fatherless child, in other words, an already tortuous, fragmented patriarchal lineage. The other piece Mabel gives to her friend Barbie, who on her death bequeaths it to Sarah (with whom she may have been in love). Patriarchal relations are bypassed – the chain consists of sisters, stepmothers and female friends and loved ones. A distinctly female lineage is established that binds characters together and is also of primary significance for the audience in following and deciphering the serial – it draws us into a specifically female chain of signification.

There is a further sense in which *Jewel* might be seen as addressing women. This is its liberalism. A liberal position is not necessarily or exclusively feminine, but it very often is and men espousing it are often thought, at the least, unmanly. Such a view is expressed by several characters in the serial, notably Ronald Merrick, who tells Sarah that he thought when he first met

Plate 5.8 The Jewel in the Crown (Granada Television 1984): Lady Manners (Rachel Kempson) (BFI Stills, Posters and Designs)

her that she was one of those English women 'who come over here with a bee in their bonnets about the rotten way we treat Indians', in effect invoking a female type central to the textual tradition to which *Jewel* belongs.

Much contemporary critical response to the serial saw it as a leftish, anti-imperialist text,[6] a view with which a minority, and notably Salman Rushdie (1991), took issue. Quite apart from its overwhelming interest in the British rather than the Indian experience of the Raj, its critique of British imperialism is in terms of the failure, not the validity, of the attempt; it is critical of those British who treated Indians badly and thinks them typical, but it does not really criticise the very presence of the British in India. In both its handling of the idea(l) of the Raj and its explanation of its failure, it is conservative and implicitly racist, and I deal with this next; yet, as I'll go on to argue, there is none the less a sense in which it can properly be deemed liberal.

The Raj as an ideal is represented not so much in the serial's nostalgic tone as in a painting, 'The Jewel in the Crown', shown repeatedly throughout the serial, and the character of Lady Manners. The painting depicts an

Indian prince presenting Queen Victoria with a jewel on the occasion of a royal visit to India. As both Barbie and Miss Crane (who have copies of the painting) insist, the jewel to which the title refers is not the one proffered to Victoria; rather, 'the Jewel is India'. India is the finest possession of all in the British empire. The painting proclaims the ideal of the Raj, the 'hope' or the 'promise' as characters variously call it, something that is never questioned by the characters or the serial as an ideal.

This ideal is explored through the character of Lady Manners (Plate 5.8). She adopts Daphne and Hari's child, Parvati; she arranges for Hari's case to be investigated, which ultimately leads to his release. These acts establish her openness and lack of racial prejudice. Thereafter she appears only three more times in the serial, without speaking and with no clear narrative purpose: Sarah sees her in the street; Barbie sees her come into a church and genuflect before the altar; her car causes that carrying some memsahibs to swerve out of the way. She thus has little narrative role, appears only briefly, says little, and yet her character is highly charged with significance, something heightened by her being played by the distinguished actress, Rachel Kempson.

Lady Manners represents the old Raj. After she has made their car swerve, the women wonder who it was and one of them remarks, 'if I know anything about it, we shan't see them again'. These women represent the current order, who indeed know something about it and have no time for the high ideals represented by Lady Manners. Yet the serial has time for them and Lady Manners embodies them in a positively beatific light. For her last three appearances, she wears a toupee with a cream-coloured veil. When Sarah sees her, she (Lady Manners) steps into a car and sits back, lifting her face to the sun with an ecstatic smile, the veil catching the sunlight in a radiant glow. In the church, she suddenly but noiselessly enters, genuflects to the altar, then leaves again, opening the door so that the sunlight streams on to her face and veil. As she drives away from the memsahibs, dismissed forever from their world if they 'know anything about it', she at last rolls up the veil and beams at Parvati and her ayah. She is the light of the Raj, wise, open, serene.

Along with this glowing view of the good old Raj, *Jewel* also presents a view of the failure of the Raj that discloses a conventionally colonialist view of India and Indians. After the massacre in the final episode, Sarah expresses what might seem like a clear indictment of the Raj: 'After three hundred years of India, we've [i.e. the British] made this whole, damn, bloody, senseless mess.' Yet the idea that communal violence is a product of imperialism, that existing complex patterns of conflict were focused and polarised by successive British administrations (concisely argued in Chandavarkar 1990), is not really pursued by the serial. Its interpretation of history is suggested rather in the notion of Pandora's Box, the title of one episode and an article in the *Ranpur Gazette* discussed in it by Guy and Count Bronowsky.[7]

The article argues that Indian independence will mean 'letting out all the evils that have afflicted India in the past but which until now have been imprisoned under the lid of British power and law'; Guy and Bronowsky agree that it is 'a shrewd comment'. India is a country of endemic, atavistic violence no more than kept at bay under the Raj; the failure of the Raj is the failure to change this, to civilise Indians out of their lethal tribal and fundamentalist loyalties.

Yet for all the above, there is a sense in which *Jewel* can properly be considered liberal, a sense related to the period in which it was made, the early years of the Thatcher administration. The policies and tone of this government were widely felt to inaugurate a major shift in attitudes, one in which liberal values seemed to be discredited as ineffectual, harmful and, somehow most damning of all, really only the indulgence of a comfortably off, educated elite, the so-called 'chattering classes'. One response to the emergence of 'Thatcherism' was to identify it with the rise of a newly affluent working class, steeped in neither the middle-class sense of public service nor the older Tory *noblesse oblige*, a class type who had never before set the social agenda, ambitious, materialistic, insensitive, incipiently racist. This is expressed in the person of *Jewel*'s hate figure, namely Ronald Merrick, lower class, a policeman (a member of a sector seen as allied to the Thatcher sensibility), racist and, most Thatcherite, at once nationalistic and yet scornful of 'soft' traditional values. The liberalism of the series is revealed in the way it sets up as villains those who speak in the language of Thatcherism. It is a liberalism that might be summed up as a lament for the decline of niceness as a ruling principle in public affairs.

One aspect of *Jewel*'s liberalism, which it shares with many other colonial texts of all political hues, is the use of the motif of rape. As Jenny Sharpe points out, in a study of rape in Raj fictions, this is not a continuous or necessary image in the colonial imagination. It is seldom found before the 1857 Indian Mutiny, but thereafter became common, permitting 'strategies of counterinsurgency to be recorded as the restoration of moral order' (1993:6). *Jewel* deploys this motif, but ambivalently. Daphne is raped, yet it is not this that exercises the characters. It is as if the serial's liberalism makes it embarrassed to have deployed the trope of black-on-white rape, endemic to racist fictions, so that it transfers all concern to Ronald's handling of the case. It may be called 'the Manners case', but sympathetic characters like Sarah and Guy worry more about Hari. This transferral away from the rape of the woman is heightened by the fact that Hari is literally raped (by Ronald). However, perhaps because of twitchiness about homosexuality, but also because even Hari, like all Indians, is marginalised by the serial (characters worry endlessly about him, but the serial virtually never shows us his point of view), the possible force of this, rape as a metaphor for imperialism, is muted. At the same time, the complexity of the issues of sexual power in male-on-female rape, especially in imperial contexts, is

evaded. The liberal focus is on the helplessness of nice white people, above all women, in the face of history.

The Jewel in the Crown tells a story of the last days of the British in India, but chooses to do so through white characters who are seen as at once typical of and yet largely marginal to that history. Moreover, its use of television serial form greatly attenuates the usual linear dynamism of that mode. It is these dimensions, of the world of the serial and of narration, that construct white femininity as not doing, as nothing.

The sphere of power and history, of what is seen as really doing something, is in *Jewel* the sphere of men. This is glimpsed from time to time, but, while central to the world the serial refers to, it is not central to it as a text. In other television serials, the world of public power is either (US prime-time soaps) also a world of women or (British soaps) is felt as a kind of irrelevance to the real business of life, which is domestic and communal. In *Jewel*, by contrast, what matters to the central characters is the world of power and the imperial project, 'India', but they themselves are peripheral to it.

They are peripheral above all because most of them are women, but this can be reinforced by other factors, even with major male characters. The two most important Indian characters, Hari and Ahmed, do not 'belong' to India. Hari has been brought up and educated in England and does not speak any Indian languages. Ahmed is a Muslim whose father is a leading figure in a largely Hindu party, who has no interest in politics and feels that he does not belong. Both are linked to English women who, to different degrees, don't belong: Hari, an orphan, is linked to Daphne, also an orphan who moreover chooses to live with Lady Chatterjee, an Indian friend of the family whom she calls auntie; Ahmed is linked to Sarah, seen by the knowing figure of Bronowsky as being like Ahmed in not feeling that she belongs. Other factors may socially marginalise textually central characters: like Hari and Daphne, Ronald and Guy are orphans, adrift from familial connection; Ronald and Barbie are despised by most of the other English characters for their lowly class origins, of which both are conscious; Ronald, Bronowsky, 'Sophie' Dixon[8] and possibly Barbie are homosexual; Bronowsky, Sister Ludmila[9] and Anna Klaus[10] are white but not British.

Until the final episodes, women are the centre of the narrative. There are important male characters, but Hari disappears early on and Teddie is killed. Only Ronald is given as much attention as Daphne, Sarah or Barbie and he is both unremittingly unsympathetic and primarily an object of the other characters' appalled fascination. The serial's focus is women, to whom it allots three narrative possibilities: doing that fails; boredom and bitchiness; or, in Sarah, transfixed listening and observing.

There are two kinds of female doing in the serial, both of which fail. The first takes the form of the role that British imperialism did assign women: the civilising mission, represented here by Miss Crane and Barbie Batchelor.

The former, an entirely emblematic character, is the first to say, 'There was nothing I could do! Nothing!', which Barbie repeats a little later, though with no consciousness that she is echoing it. Both believe that they have failed, that they have not brought any of the children they taught to God, that there may not be a God. Miss Crane sets fire to herself; Barbie goes mad.

The other kind of doing is more radical, but no more effective, and most strongly represented in Daphne. From the start she wants to do something that will change things. When the matron of the hospital to which she is assigned says complacently on her first day that there may be things of which neither of them might approve (in policies towards Indians), Daphne says that they are perhaps things that ought to be changed. Similarly, she conveys to the district commissioner her disapproval that her 'aunt', Lady Chatterjee, as an Indian is not allowed to attend a War Week event. Such gestures are small and not followed through; it is her love for Hari that makes her do more. She speaks quietly to the district commissioner about Lady Chatterjee, but minutes later makes a point of greeting Hari very loudly before her English companions. He, like the men Daphne is with, is an ex-public school boy but, as an Indian, cannot attend the event and is only present as a journalist. Daphne not only speaks to him, in full view and hearing of everyone, but also leaves her companions and walks over to him, enters his space. This spatial transgression is repeated in her readiness to 'cross the bridge' (at once real and metaphorical) to have dinner with him and his aunt (who lives in the 'Indian' part of town) and her getting him to take her to the Hindu temple, a place no English woman has ever asked to see. Above all, though, her transgressive doing consists in going against the advice of Ronald Merrick and ignoring the tight-lipped disapproval of Lady Chatterjee. It is she who invites Hari to dinner, introduces him to the Bibighar gardens,[11] perseveres in the face of his attempt to put her off him, holds on to his hand when he is about to go and draws him down to her to make love. For this she is raped and assaulted, never sees Hari again, causes him to be locked up and himself raped, and dies in childbirth.

Daphne, not least through the touching awkwardness that Susan Wooldridge's performance gives her, is the most engaging, tough-minded and courageous character in the serial. Yet structurally, as in so many Raj fictions, she is the cause of all the trouble. Lady Chatterjee compares her to Pandora. Even before the rape, she has clearly expressed her view – a mixture of anxiety and disapproval – of Daphne's relationship with Hari. Now she says to her:

'I was afraid for you, now I'm afraid for all of us because of you. . . . You don't shrink from anything, even your mistakes, your marvellous mistakes. Like Pandora who bashed off to the attic and opened her blasted box.'

Daphne smiles affectionately at this, yet both the words and the way they are delivered (by Zohra Segal) do not seem to warrant this response. Daphne's transgressive 'mistakes' are to blame for what is about to happen: Hari's arrest, torture, rape and imprisonment.

It is of course unfair to blame Daphne for these events, but the serial gives us licence to do so through Lady Chatterjee's words. The notion of Pandora's Box is picked up much later in the serial, where, as discussed above, it refers to the notion that British rule kept the lid on the simmering evils of India about to be unleashed with British withdrawal. Perhaps it means no more than this, but in a serial so characterised by echoes across episodes, it is hard not to make a connection with Lady Chatterjee's words. The British withdraw because they have failed; and they have failed because of their women, who have weakened the fabric of empire with both their sexuality and their questioning of the enterprise. They may not have caused the evils of India, but they are the reason why the British can no longer keep the lid on the box.

Daphne's doing creates havoc. No woman in the rest of the series dares do anything. Not that most of them show any inclination. What is presented as the typical mode for memsahibs is sitting around with nothing to do but be frightful. A series of cameos reiterates a portrait of women bored, spiteful, silly, snobbish and racist. The most extensive treatments are of Sarah's aunt Fenny, the silly end of the spectrum, endlessly calculating just how pukka people are, and Mildred, seldom seen without a glass in her hand, having sex with her husband's deputy while he, the husband, is in a prisoner of war camp in Germany, vile to vulnerable old women like Barbie, in short, a bitch. The sense of most white women's contemptibly empty lives is suggested especially strongly in the interpolation of a scene between Mildred and her friend Nicky into the middle of the scene of Hari's interrogation after weeks of imprisonment without trial. The seriousness and intensity of the latter contrasts with the brittle snottiness of the former, a disparity especially powerfully suggested in a sound edit of Nicky's laughter heard over the court detailing Hari's particulars.

The run of white women have nothing to do and do it very unpleasantly; those who do try to do something fail, go mad or create havoc. This is the context for the character who provides the continuity for most of the serial from episode 3 on, namely Sarah. She is a character who listens more than she does. Ronald compares her to Daphne, but in order to say that they are not alike, that Sarah 'knows where to draw the line' and is not 'one of those English girls who come over here with a bee in their bonnets about the rotten way we treat Indians'. Sarah replaces Daphne in the serial; she is fascinated by her and what 'the Manners case' represents (an indictment of the Raj) and does, in her relation with Ahmed, seem to be about to repeat Daphne's experience (as Ronald fears). But she does not in fact do so. Ahmed, it is true, resists her, wary of the danger of liaisons with 'English

girls'; but, as we've seen, Hari resisted Daphne, it was she who insisted. Sarah does not insist. She does not repeat Daphne's doing.

This does not mean that she does nothing at all, but there is an over-whelming sense of how constricted this is. She is repeatedly pulled back to the family that she is in so many ways critical of, just when she is about to spread her wings into the world of real doing (as the serial sees it). When she plans to go away to be more useful in the war effort, she 'has' to stay back and look after Susan in her bereavement and confinement; when, after the massacre on the train, she wants to go back to Mirat and tell people about Ahmed's death, she can't because she 'has' to look after her sister and aunt. This last example takes place in the context of the most explicit address to the question of her doing in the serial. At the station that the train draws into after the massacre, she fills water pots; it is, she tells Guy, all she feels able to do, she cannot 'do the other thing', tend to the wounded and dying. A little later, when they talk on the platform now cleared of bodies, she says, 'At that tap, filling those bloody jars, I never hated myself so much as I did then – my brave little memsahib act'. Guy tries to comfort her with 'What else could we have done?', occasioning the strongest repetition of the leitmotiv phrase of the series, when Sarah says, with wretched bitterness, 'Nothing. Nothing we could do'.

Sarah is transfixed and immobilised. She desires Ahmed but gets Guy, whom she then blocks from any further intimacy. She can't go out into the world; she can't go back to Mirat; she can't go beyond filling pots with water. In Geraldine James's performance she moves little, and when she does it can be ungainly, an inability to move which is the literal embodiment of an inability to do. All that is really left for her is to listen and observe. Notably, she listens to those whom other people can't bear or be bothered to listen to: Lady Manners, irritating old Barbie, Susan in her widowhood and madness, even the despicable Ronald. And she really listens, trying to understand the significance of what is being related. Listening in a television serial is a significant position. Given the importance of talk in the form,[12] listener characters often suggest a place for the audience from which to see things. We are in many ways asked to identify with Sarah, with her confused sense of conscience and her frustrated realisation that there is nothing to be done. Yet towards the end of the serial, we are taken away from her impotent position to the partial reassurance of a male listening position, in the person of Guy Perron.

Guy does not appear until episode 10, two-thirds of the way through the serial. His coming signals a shift away from the focus on women in the serial so far, not only through his person as the central listener-observer but also from episode 11 onwards in a considerable increase in scenes between men alone. This goes along with a return of the faster narrative pace of the early episodes, with strong mystery elements and the climactic massacre. It is as if the torpor of female incapacity has finally been displaced by male action.

Guy is not active in any traditional heroic sense, nor is he at the centre of power. Yet he has a marginality that also confers authority: he is a historian. This gives him a reason to be in India other than on imperial service or due to the vagaries of birth: it's not just that his character has the textual function of listener, Guy is also in the serial's fictional world in order to observe it. He has a specialist knowledge of India, its history, its culture. He is able to take an academic's distance. All this distinguishes him from his female textual predecessors. He does not get emotionally involved; he is able to 'do' more (he can go back to Mirat to break the news, he does try to make contact with Hari, not just talk and worry about him); above all it is he, not Sarah, who most nearly puts together the pieces of the puzzle of Hari. Much of the serial is organised around the idea of puzzle-solving, and characters use the phrase 'that fits' three times in discussing things, suggesting a jigsaw or crossword. The last occurs when Guy asks someone who Philoctetes was in Greek myth. This is the *nom de plume* of the author of an article in a Ranpur newspaper. He is told that Philoctetes was one of the Argonauts, who was left behind because he stank but who did finally get to Troy because 'they needed him in the end'. When Guy says that 'that fits', it signals not only that he realises 'Philoctetes' is Hari Kumar, but also that he understands Hari's historical role, the unacceptable Indian who has to be discarded but who will eventually be needed. This moment of knowledge is then backed up by the knowledge Guy gains access to – the file on Hari, the reminiscences of Sophie Dixon and Count Bronowsky, all things that only he gets to know and can therefore piece together.

By the end of the serial, Guy has the assumed the commanding position of knowledge. He has the final words in voice-over, which offer a distanced position of wisdom and hope for the viewer. This position is, like that of Daphne and Sarah, one of impotence in relation to India and the imperial project, but without either the anguish that they experience or the hints of blame, the Pandora associations. Nice white men may not be able to do much, but at least they know; white women don't even have that to be said for them and may very well do harm.

It is not just the place of women in the serial's world, at once typical yet marginal and helpless before events, that constructs white femininity in terms of not doing. It is also the organisation of the narration, specifically its use of television serial form. Two aspects are relevant here. The first is the handling of sequence, the order in which things occur, pace and suspense. The second has to do with connections made across the length of the serial, the way the audience is asked to bring to later episodes its knowledge of earlier ones. If the first of these tends in *Jewel* to create a mood of torpor, the second invites the viewer to turn attention away from the way events unfold to grasp a broader, overall structure of an essentially fixed kind. The combination of sequential torpor and structural fixity realises in the form of the serial itself the feeling of this white femininity.

Three aspects of sequence in *Jewel* are relevant: pace, the order of events and the handling of breaks (between and within episodes). The first has much in common with many classic serials, and especially two that had been highly successful shortly before it was first broadcast, namely *Tinker Tailor Soldier Spy* (1979) and *Brideshead Revisited* (1982): it is slow. This is somewhat less true of the first and last two episodes, but otherwise it very much gives that impression that those who don't like this sort of thing complain of, the impression that nothing happens. In part this has to do with the fact that much of the action consists of dialogue, looks and meaningful silences, a combination of soap opera talk and Chekhovian drama. It also has to do with the handling of the ends of scenes, which very often carry on long after they have served their narrative function. Occasionally this is to extend and intensify the feeling of the scene in a manner common in soap opera (cf. Feuer 1984), but more often there are no feelings to speak of. A typical example occurs late on, when Guy phones Sarah but, as she is out, gets her aunt Fenny instead; Fenny explains Sarah's absence and they have a brief, polite conversation before ringing off; the sequence ends with a lengthy take of Fenny putting down the phone and wandering off. There are no emotions in this sequence to be extended and the shot of Fenny serves no narrative purpose. The use of such *temps mort* ensures that the unfolding of the serial is kept to a snail's pace. This suits its ruminative nature; it also conveys the tempo of a sluggish, aimless existence.

The feeling of a serial that is not getting anywhere is also conveyed by the ordering of events. The overall organisation is chronological, but there is little sense of a drive forward through the narrative; on the contrary, all feeling of momentum is stymied by the serial's concern with looking backwards. This is most obviously realised in the use of flashbacks, deployed to an unusually high degree for television drama. Of the fourteen episodes, only three have no flashback. Sometimes these further characters' understanding of past events, solving a mystery of some kind, but often they have little such function. They hold up the story and remorselessly direct attention backwards.

This is reinforced by the fact that much of the talk is about the past, endlessly raking over what has happened, especially the Manners case. Such repetitive talk is common in television serials: it both acts as a recapitulation for viewers from episode to episode and, in soap operas especially, allows for the dissection of emotional responses to events. The repetition in *Jewel* has these functions, but it is both more cerebral, more an attempt to work out what has happened than exploring feelings about it, and also more futile – the more people talk about the past, the less they fathom it.

This lethargic sequential unfolding is in turn reinforced by the handling of breaks in the serial. It is usual for these to function as cliff-hangers, occurring at moments of maximum suspense, so that the viewer will keep on watching after the ads or the following week (cf. Geraghty 1981). What is remarkable

about *Jewel* is how seldom this obtains.[13] Of the twenty-nine break points, only eleven could be construed as cliff-hangers and of these only one (at the end of the first episode) really has the suspense suggested by the term (it shows Lady Chatterjee, standing on the steps of her house, having just learnt that Daphne is missing in the midst of political unrest).

Typically the breaks in *Jewel* are either desolate or desultory, and often literally empty. Four occur at points of death, five those of madness; neither generate much sense of anticipation of what is going to happen. Closing moments of emotional intensity may convey a character's sense that their life (and consequently the serial's own story) is going nowhere: after Daphne declines Ronald's proposal of marriage, the pre-break shot of them has her looking away in a sort of anger, him looking on in disappointment; after telling her about Miss Crane's self-immolation, Barbie says to Sarah that Miss Crane never answered her letters and a silence falls between them; Sarah helplessly holds Susan's hand in her madness. Often the ending is yet more desultory (Teddie reading an unimportant letter from Susan as he sits on the loo; Sarah, Mildred and Fenny lapsing into silence after an inconsequential exchange at cross-purposes) or disquieting, but without any precise emotional or narrative content (Sarah observing a one-legged patient coming down the corridor as she waits to see Ronald in hospital; the ghostly swinging of Barbie's dressing-gown on the back of the door after Sarah leaves her in the mission hospital). Several breaks in the final episodes simply focus on one of the recurrent symbols discussed below (flames, the butterfly lace, the phrase 'a promise never fulfilled'). Many pre-break shots are also literally empty of people or at any rate significant characters. Often a character simply walks out of frame and the camera is left there: Ronald after the stone thrown at the car taking him and Teddie to the latter's wedding, Sarah waiting for a connection at a station, Guy entering his barracks, Hari disappearing behind a pillar. Repeatedly the viewer is left with no one significant on screen, just a sense of emptiness

Along with the listless, desolate handling of sequence, the serial uses a number of images without narrative function to speak of but which constitute a set of symbols by means of which the viewer is enjoined to grasp the wider significance of the story and characters. These include the painting 'The Jewel in the Crown' and the butterfly lace, and also a circle of fire, seen both in a statuette of the God Shiva, dancing in a ring of fire, but also in literal rings of fire at various points (for example, Miss Crane's self-immolation, a scorpion killing itself when put in a circle of fire, Barbie's death cross-cut with the mushroom cloud of Hiroshima and, in the final shot of the serial,[14] the painting burning up in a ring of fire until it shatters its glass and frame). The handling of these images makes it clear that they are to be treated as symbols. The camera dwells on them; talk and action is held up by them; characters that want to understand (Daphne, Sarah, Guy) are shown in close-up gazing on thoughtfully to emphasise that these things

have meanings that need to be plumbed. Ending episodes with them, usually in a freeze frame, asks the viewer to register their symbolic importance.

The symbols contribute to the serial's lack of momentum and propose that we treat it as a jigsaw or crossword puzzle, to see whether, along with Guy and Sarah, we can work out how things 'fit'. In asking us to treat the temporal, sequential structure of the serial as a fixed, spatial one like a jigsaw or crossword, *Jewel* further undercuts any sense of narrative drive, of characters 'doing'.

Moreover, the symbols are also in part about the problem of doing. The painting depicts a scene of Victoria's visit to India, which, as Miss Crane and Barbie point out, never took place, a promise never fulfilled. It invokes a failure of historical doing. We are repeatedly told that the butterflies sewn on to the lace are 'caught in a web', are 'poor prisoners', clearly symbolising the fate of the characters trapped in a complex situation from which they cannot escape, struggle though they might. We may take this as referring to the British in the last days of the Raj, or even to the human condition, but the most explicit association of the lace (as discussed above) is with the best white women, caring, thoughtful and exquisite, but also helpless and ineffectual, caught up in the complexities of a historical process they can do nothing about and from which they cannot break free.

The circle of fire suggests an end to all this ineffectual doing. Miss Crane's self-immolation is seen as an act of suttee, the practice in which a widow joins her husband on his funeral pyre; she is, as Ronald perceives, a widow to her India, which she realises is now dead, hence the logic of her dressing in white 'like a good Indian widow in mourning' (as Lady Chatterjee remarks) and setting fire to herself. The scorpion that seems to kill itself in the circle of fire is seen by Sarah as doing something brave in a situation where there is 'no way out'. The lace and fire symbolisms are brought together when Susan wraps her baby son in the lace before setting him down in a ring of flames, believing she will thereby set him and the butterflies free; by wrapping her son in the lace, she attempts both to set free the white innocents of the Raj – caring women and not yet corrupted children – and also perhaps to bring the Raj to an end, killing off the next generation.

As these examples suggest, fire as destruction is by no means seen as tragic or horrific; it offers freedom and deliverance. The serial signals this in the gloss it provides to the statuette of Shiva, dancing in a ring of what Sister Ludmila says is 'cosmic fire . . . the circle of creation and destruction, of dark and light, and wholeness', to which Daphne adds that the god's wings give one 'a sort of flying feeling, as if you could leap into the dark with him and not come to any harm'. Suttee too, long considered in the West the last word in Indian barbarism and backwardness, is seen as something positive, a voluntary entering into 'a state of grace', in Daphne's words. The culmination of this imagery, the final shattering of the painting, the idea(l) of doing imperialism, suggests deliverance from the burdens of historical enterprise.

Through its ring of fire imagery, *Jewel* presses an Indian cosmology into providing a framework for dealing with loss of empire. The Raj is dead, its hopes shattered, but it is also over, subsumed in the wider universal and eternal cycle of creation and destruction.

White women have a special relation to such ideas through the notion of nirvana. This is expounded for the serial by Lady Chatterjee early on: 'To a Hindu, life is a struggle towards oblivion, the material world being an illusion.' White women's connection to this, and to the oblivion offered by the ring of fire, is spelt out in a scene between Daphne and Sister Ludmila some time after the rape. When Daphne says to her that, since the authorities will tell her nothing about Hari, nor will his Aunt Shalini speak to her about him, there's nothing she can do, she immediately continues:

It's a sort of silence. I think now it's the silence of India, behind the chatter and the violence. That's why he [Hari] didn't speak, why he told them nothing, because there's nothing you can say, only the silence.

During this speech, there are cuts to Sister Ludmila listening and to the Shiva statuette, before a cut back to a shot that shows all three (Daphne, Ludmila, Shiva) together in the frame. The significance of Shiva, to Daphne and in Hindu philosophy (as glossed by Sister Ludmila), has already been established by this stage. Both the words and the editing link white female non-doing with an 'Indian' view of oblivion, here signified as silence.

This last is a motif associated throughout the series with white women who come to be able to live beyond the fretfulness of British consciousness. Lady Manners does not speak in her final, beatific appearances; Mabel (who donated money to the victims of the Amritsar massacre, not to General Dyer, who ordered it) hardly speaks at all; Susan (who tries to destroy/release her son and the butterflies in a ring of fire) is silent in her madness. Barbie's final lapse into silence most clearly develops the theme. In the hospital, she does not speak but gazes out on the Towers of Silence. This is where, we are told, the Parsees leave the bodies of their dead, to be eaten by vultures. When Sarah and Barbie sit together looking at them circling the Towers, Sarah says, 'You said that God was deaf. Perhaps he hears – in silence', and Barbie puts a hand up to caress Sarah's cheek, accepting this more 'Indian' way of understanding the cosmic order. Silence, oblivion, give to the non-doing of nice white women in the serial, so consciously experienced as agony, the possibility that it is a form of grace. White feminine narrative torpor and nirvana can be the same thing.

As in many colonialist fictions, white women in *The Jewel in the Crown* voice a liberal critique of empire and are in part to blame for its decline. Because of their social marginality and because, when they do do anything, they do

harm, the only honourable position for them, the only really white position, is that of doing nothing. Because they are creatures of conscience this is a source of agony. Yet it is an exquisite agony, stretched out over fifteen languid hours. It bears witness to the greater sensitivity of women and other marginals. It even suggests that there may be an Oriental holiness to be derived from helpless inaction. Women take the blame, and provide the spectacle of moral suffering, for the loss of empire. For this they are rewarded with a possibility that already matches their condition of narrative existence: nothing.

6

White death

I had not intended to write a chapter on whiteness as death, but it was a topic that kept coming back. In the centrality of the image of death in Christianity, in the presence of death (killing, the desert, hardness and silence) in the Western, in the image of a transcendent dissolution in light, in the mayhem and crucifixionism of the muscleman films, in the despair at but glimpsed sense of redemption in nothingness in *The Jewel in the Crown*, the subject of death keeps recurring.

Death may in some traditions be a vivid experience, but within much of the white tradition it is a blank that may be immateriality (pure spirit) or else just nothing at all. This is within the logics of whiteness even if it is not at the forefront of white identity. White people have a colour, but it is a colour that also signifies the absence of colour, itself a characteristic of life and presence. In the transparent representation of the culture of light, the white face has to be read in the blanks on the paper or screen. To be positioned as an overseeing subject without properties may lead one to wonder if one is a subject at all. If it is spirit not body that makes a person white, then where does this leave the white body which is the vehicle for the reproduction of whiteness, of white power and possession, here on earth?

In 1873, Walter Pater wrote of the unsurpassed beauty of Classical Greek sculpture, from which all subsequent art is a falling away. Following the German art historian Johann Winckelmann, Pater discerned in Greek sculpture a quality of abstraction and light:

That white light, purged from the angry, bloodlike stains of action and passion, reveals, not what is accidental in man, but the tranquil godship in him, as opposed to the restless accidents of life.

(Pater 1915: 224)

Here is a condensation of what has been much discussed in this book. Humanity (and probably only 'man') peaked in ancient Greek civilisation, accepted in the Victorian period as unequivocally white. What makes whites

special is the light within, though modern man must struggle to see, let alone regain this. This light, which is white, is dirtied ('stained') by blood, passion, movement, which is to say, isn't it, life. In the wider representation of whiteness, the very struggle for whiteness is a sign of whiteness, but here in Pater, to recapture whiteness is also to shed life, which can mean nothing else than death.

The theme of whiteness and death takes many forms. Whites often seem to have a special relation with death, to yearn for it but also to bring it to others. Death may be conceived of as something devoutly to be wished but also as terrifying. In this chapter, a coda rather than a conclusion, I am going to discuss mainly the fearsomeness of the image, partly because the more welcomed versions, glimpsed in the radiant transcendence of some star imagery and in the notion of nirvana in *The Jewel in the Crown*, are none the less less common in the twentieth century than earlier. Yet it is this emphasis on the fearfulness – sometimes horrible, sometimes bleak – of the white association with death that I have been wary of, that for so long made me resistant to writing separately about it. For it winds up making whites look tragic and sad and thus comes perilously close to a 'me-too', 'we're oppressed', 'poor us' position that seems to equalise suffering, to ignore the active role of whites in promulgating inequality and suffering. Yet, if the white association with death is the logical outcome of the way in which whites have had power, then perhaps recognition of our deathliness may be the one thing that will make us relinquish it.

Within Western art the dead white body has often been a sight of veneration, an object of beauty. While Christ on the cross may often be an image of agony, it is also one of beauty, with the suffering itself part of the trans-cendent beauty. In Victorian times, death – especially that of children, above all girls – was seen as a fit subject for painting and photography that had far more to do with beauty than tragedy (as in, for instance, Henry Peach Robinson's bestseller *Fading Away* (1858) or Margaret Cameron's *The Dead Child* (*c.*1868)).[1] A pure ecstasy of death is conveyed in Eva's demise in *Uncle Tom's Cabin*, using the rhetoric of transcendent vision and light discussed in Chapter 3:

> The child lay panting on her pillows, as one exhausted, – the large clear eyes rolled up and fixed. Ah, what said those eyes, that spoke so much of heaven! Earth was past, and earthly pain; but so solemn, so mysterious, was the *triumphant brightness* of that face, that it checked even the sobs of sorrow. . . .
>
> A *bright, glorious* smile passed over her face, and she said, brokenly, – 'O! love, – joy, – peace!' gave one sigh and passed from death unto life!
>
> (Stowe 1981: 427–8; my emphasis)

The *Oxford English Dictionary* gives 'white death' as a term for tuberculosis around 1910, and both Susan Sontag (1979) and Bram Dijkstra (1986) have discussed the importance of 'sublime pallor' in the nineteenth-century perception of the then fatal disease. The beauty of white death, as well as the romantic longing for it, especially in British and German nineteenth-century poetry, are well attested (Praz 1933).

Some Christian films have explored this feeling. Martyrs in Italian and Hollywood epics (*Quo Vadis?* (1912, 1924, 1951), *The Sign of the Cross* (1914, 1933), *Fabiola* (1917, 1949), *Ben Hur* (1925, 1959), *The Robe* (1953)) go to their death in triumphal, light-strewn, heavenly choir *mise-en-scènes*. Two of Robert Bresson's films end with deaths that are signalled as moments of grace, of God's blessing. In *Au hasard Balthasar* (1966), a donkey, abused throughout its life, dies surrounded by a flock of sheep, milling white symbols of redemption. In *Mouchette* (1967), the equally abused heroine rolls down a slope into a river and drowns; the camera contemplates the river as a redemptive Monteverdi *Magnificat* is heard.

However, the bright beauty of the deathbed seems very remote from us now, while religious epics seem archaic and Bresson is an exceptional figure. All depend on a deep conviction of the reality of transcendence, heaven or grace. Such religious belief has declined in the West, especially among whites. Neither born-again Christianity, with its emphasis on material success with Jesus, nor 'New Age' practices, so caught up in the therapeutic, that is, the here-and-now value of spirituality, seem centrally to embrace death. In the absence of a belief in the glory of white death, whites are thrown back on less comfortable feelings.

It is said that when sub-Saharan Africans first saw Europeans, they took them for dead people, for living cadavers. If so, it was a deadly perception, for whites may not only embody death, they also bring it. bell hooks speaks of 'the way whiteness makes its presence felt in black life, most often as terrorising imposition, a power that wounds, hurts, tortures' (1992: 169).[2] The image of the Ku Klux Klan decked out in white is an image of the bringing of death. When we see the Klan riding to the rescue of the beleaguered whites in *The Birth of a Nation*, it is undoubtedly intended that we should see them as bringing salvation, but it is now hard to see in these great splashes, streaks and swirls of white on a white screen anything but the bringing of death to African-Americans. In some set-ups, as Joel Finler (1995: 23) observes, composition, placing the Klan where the natural light falls and outlining them with billowing white smoke, shows nothing but white death.

This association of whiteness with the bringing of death may reach its peak in the Holocaust. At one level, this may be seen as no more than yet another instance of whites as the bringer of death to non-whites, no more awesome than the histories of genocide and slavery in the making of Australasia and the Americas. Yet the Holocaust has a particular place in the

symbolism of whiteness and death. It seems to represent the bringing to bear of the very thing that whites claim as their special virtue, civilisation, to wholesale human destruction. It was precisely the values of orderliness, systematicity and hidden ugliness that were used to expunge from Europe the Jews and other human 'dirt' (that is, the perceived sullying borders of whiteness). As Lorraine Hansberry put it, 'who else [but whites] could put all those people into ovens *scientifically*?' (quoted in hooks 1992: 170).

The idea of whites as both themselves dead and as bringers of death is commonly hinted at in horror literature and film. Horror as an emotion is surely a universal, even if what stimulates it and how it is articulated are culturally and historically specific. However, horror as a genre does seem, despite some interesting exceptions, to be a white genre in the West: African-American cinema has produced only a handful of horror films compared to its many action, thriller, music and drama films. Horror is licensed to deal with what terrifies us – partly by giving it free reign for the safe length of a movie, partly by being low, dismissible and often risible, partly by providing happy endings in which the horror is laid to rest. It is a cultural space that makes bearable for whites the exploration of the association of whiteness with death.

It is at the heart of the vampire myth. The vampire is dead but also brings death. Because vampires are dead, they are pale, cadaverous, white. They bring themselves a kind of life by sucking the blood of the living, and at such points may appear flushed with red, the colour of life: Hammer films sometimes had the eyes of their engorged vampires glisten with bloody colour; the replete Dracula in Coppola's version is young and, though pale, not so agedly, deathly white (corpse-like skin, spun white hair) as in his unfed state. Just as the vampires' whiteness conveys their own deadness, so too their bringing of death is signalled by whiteness – their victims grow pale, the colour leaves their cheeks, life ebbs away.

The horror of vampirism is expressed in colour: ghastly white, disgustingly cadaverous, without the blood of life that would give colour. The vampire's bite, so evidently a metaphor for sexuality, is debilitating unto death, just as white people fear sexuality if it is allowed to get out of control (out from under the will) – yet, like the vampire, they need it. The vampire is the white man or woman in the grip of a libidinal need s/he cannot master. In the act of vampirism, white society (the vampire) feeds off itself (his/her victims) and threatens to destroy itself. All of this is so menacing that it is often ascribed to those who are not mainstream whites – Jews (see Gelder 1994: 13–17), South East Europeans (Transylvania in *Dracula* and its derivatives), the denizens of New Orleans (Anne Rice's *Vampire Chronicles*). Horror films have their cake and eat it: they give us the horror of whiteness while at the same time ascribing it to those who are liminally white. The terror of whiteness, of being without life, of causing death, is both vividly conveyed and disowned.

The theme of whiteness as death is similarly addressed in the trilogy of horror films on 'the dead' made by George Romero: *The Night of the Living Dead* (1969), *Zombies: Dawn of the Dead* (1978) and *Day of the Dead* (1985). In these films, something has caused the dead to come back to life as zombies, mindless bodies feeding inexorably on the living. The sense that the zombies are whites is suggested in a number of ways. In the first film, they are literally all skin whites; in the other two, they are predominantly so and those who are not none the less have whitened skin by virtue of being dead. In *Dawn*, they are visually rhymed with shop window mannequins, all white, all part of the US suburban consumerist dream that is in principle multicoloured but in practice felt as intrinsically white. Most tellingly, the protagonists able to stand up to and escape the zombies (who by the end of *Day* have virtually taken over the world), are either only blacks (*Night*) or coalitions, of a black man and white woman (*Dawn*) and a white woman and a perhaps gay couple, one Irish, one Caribbean (*Day*); in both the later films, the black man is the crucial enabling figure.

I have discussed this symbolism at greater length elsewhere (Dyer 1993: 157–160). What I want to emphasise here is the way it repeatedly produces startling images of white people as the dead devouring the dead. Much of what we see is just this: white people chomping away at white people. The pitch of horror is screwed up further in the climactic sequences of the first and last of the films. In *Night*, there is an aerial shot of some white figures moving across a field in a straggly line, with slow, terrible deliberation: we assume they are zombies, since this is how they have always been shown in the film; yet, when the film cuts to a ground level shot of these figures, we realise that they are the vigilantes (all of whom are white) come to destroy the zombies. There is no difference between whites, living or dead; all whites bring death and, by implication, all whites are dead (in terms of human feeling). This is then forced home by the grim ending to the film. The focus of the film throughout is a group of people trapped in a small, isolated home-stead; only the black character, Ben, is resourceful and courageous, while the whites around him panic, fall into a catatonic state or wind up devouring one another; Ben, in other words, stands for life. At the end of the film, the white vigilantes shoot him dead. Whites are dead, bring death and cannot stand that others live. *Day* is set in a military compound, one of the last outposts of the living in a world now overrun by zombies. At the end of the film, the white woman and the Irish-Caribbean male couple escape to an island, but before that we see the chief representative of whiteness in the film torn apart by the zombies as they finally invade the compound. As they pull him literally limb from limb, he shrieks with terrible hysterical laughter, as if this is the apotheosis of whiteness: to be destroyed by your own kind.

Anxiety about (as opposed to aspiration to) whiteness as non-existence is not necessarily expressed in the horrified terms of the dead bringing death. It may take a more transfixed or desolate form. One of the most famous

expressions of the terror of whiteness occurs as Chapter 42 of Herman Melville's *Moby-Dick* (1992) (discussed in Kovel 1988: 234–46 and Boime 1990: 4–5). The narrator acknowledges the beauty and virtuousness of white, and explicitly relates this to white skin as well as hue, yet owns that there is also about it 'a certain nameless terror' (Melville 1992: 207). This is not just, he suggests, because white is 'the marble pallor' of dead people which 'appals the gaze' (208), but also because of its blankness and emptiness which evokes meaninglessness and pointlessness:

> Is it that by its indefiniteness it shadows forth the heartless voids and immensities of the universe, and thus stabs us from behind with the thought of annihilation . . . ? Or is it, that as in essence whiteness is not so much a colour as the visible absence of colour, and at the same time the concrete of all colours; is it for these reasons that there is such a dumb blankness, full of meaning, in a wide landscape of snows – a colourless, all colour atheism from which we shrink?
>
> (212)

If this is so, then to be white is to be a thing of terror to oneself, which in *Moby-Dick* is externalised on to an object of depthless irrational loathing, the white whale. As the narrator says, given this, 'Wonder ye then at the fiery hunt?' (ibid.).

Contemporary fiction continues to rework this perception in many different tones. Tom DiPiero discusses the representation of both whiteness and masculinity as not so much identities as 'hysterical responses to a perceived lack of identity' (1994: 117). He looks at the wryly comic construction of confused, 'nice guy' white male protagonists in films like *White Men Can't Jump* (1992) and *Grand Canyon* (1992), arguing that the films 'endorse the position that white men are justified in asking others to determine their identity' (132).[3] I want to look at yet another contemporary mode for approaching white non-existence, from which emerges a desolate and terminal perception. This is the figure of the android in science fiction films, notably the *Alien* films (*Alien* (1979), *Aliens* (1986), *Alien*[3] (1992)) and *Blade Runner* (1982). These have been highly successful films, not only in terms of immediate box office returns, but in terms of both critical attention[4] and shelf life, as video, as a standby of art houses, in the fact of the sequels to *Alien* and the release in 1992 of a 'director's cut' of *Blade Runner*.

The *Alien* films have multiracial casts, but at the centre of each is the confrontation between a white woman (Ripley, played by Sigourney Weaver) and the corporation, a power 'invisible but all-pervasive' (Kuhn 1990: 9), perhaps thus even at this level a metaphor for whiteness. The representatives of the corporation are white men; its goal is to harness the unspeakable, demonic, in the final analysis unharnessable energy and force of the alien, a primitive, protean creature first encountered on a planet far

distant from earth. In *Alien* itself the representative of the company is an android named Ash (something white) – he is a white man who is not human.[5] This is revealed when an African-American crew member pulls off Ash's head: the black man reveals the nothingness of the white man and destroys him by depriving him of his brain, the site of his spirit. The crew bring this severed head back to temporary electronic life to find out how the alien can be destroyed. He tells them that it is indestructible and one of the crew realises that he admires it. 'I admire its purity', he says, adding in a cut to an extreme, intensifying close-up, 'unclouded by conscience, remorse or delusions of morality'. Purity and absence of affect, the essence of the aspiration of whiteness, said in a state of half life by a white man who has never really been alive anyway.

The android as a definition of whiteness, the highest point of human aspiration, is more fully explored in *Blade Runner* (directed, like *Alien*, by Ridley Scott), which seems more pointedly to suggest that to be white is to be nothing. The central protagonist, Deckard (Harrison Ford), is a police-man specialising in tracking down and destroying runaway replicants, robots indistinguishable in appearance and manner from human beings; those Deckard pursues have escaped from acting as slaves in space colonies and are trying to pass for human on earth.

The film's central characters (Deckard, the replicants, the head of the corporation, an inventor) are all white, but its background characters are predominantly 'Orientals' (itself a telling shift away from the centrality of Native Americans in the Western and black people in most of the rest of US culture, related of course to the increasing economic threat posed by the Pacific Rim nations). The film is set in a Los Angeles of the future, marked by cataclysmic pollution: dirt, endless rain, crumbling buildings and, very much part of this pollution, teeming oriental hordes. The opening shot of a pall of industrial waste hanging over the city, produced by vast, belching towers, gives way to a portrait of the belly of the city, as visited by Deckard, layer upon layer of building and neon, ceaselessly washed by rain and peopled almost entirely by people of 'Eastern' descent (although, of course, in terms of proximity, China and Japan are to the West of Los Angeles). Not unfriendly, not the enemy, in the film's terms, they are none the less portrayed within the terms of the racist discourse of the yellow peril: busy with their small enterprises, hard to communicate with, and there in their millions. At one point, Deckard tracks down one of the replicants, Zhora (not herself 'Eastern' looking), who is working as a snake dancer in a sort of bazaar, the exoticism of Orientalism given full reign with Egyptian motifs, ostriches, snakes and so on. There is some explanation for the predominance of orientals in *Blade Runner*'s future world in the book on which it is based, *Do Androids Dream of Electric Sheep?* by Philip K. Dick: all those who can afford to have emigrated from the earth's smog and irreversible spoliation to other planets. Without this explanation, however, it just looks as if

the Orient has taken over in its pullulating, entrepreneurial, ecologically unsound way.

It is against this context that the drama of the white characters is acted out. The yellow human background emphasises the chief protagonists' whiteness. The whitest of hue are the replicants, especially the two most formidable in resisting Deckard, Roy (Rutger Hauer) and Pris (Daryl Hannah), who both have pale faces and bleached blond hair. The casting of Hauer, unmistakably Teutonic, and thus at the top of the Caucasian tree, is especially suggestive, as is the Christ-like imagery during his final confrontation with Deckard, when, naked except about the loins, he drives a nail through his hand giving himself a stigma and then holds a white dove as he expires. Against this most strident expression of whiteness,[6] which is also explicitly the attempt to pass for human, are ranged, on the one hand, the characters responsible for the existence of the replicants, and on the other, Deckard. The former consist of Dr Tyrell (Joe Turkel), head of the corporation which manufactures replicants, and J. F. Sebastian (William Sanderson), who designs them. Both live in isolated (though in Sebastian's case also seedy) splendour, high above the teeming life of the city; both have only non-humans for company, Tyrell his replicant 'daughter' Rachael (Sean Young) and a replicant owl, Sebastian his dwarf mechanical soldiers and other automata; Tyrell is cold and cerebral, Sebastian has a skin disorder that means he is ageing and crumbling, like the building in which he lives. In short, both the representatives of white creativity in the film are pale creatures leading attenuated lives, devoid of human interaction, dead and dying.

Which leaves us with Deckard. The 'director's cut'[7] makes more likely what one might only surmise in the previously released version, namely that Deckard is himself a replicant. This is suggested through two elements that themselves represent Deckard's sense of self: memories and dreams. As inner and very personal human processes these seem to be the touchstone of truly being human, yet both are discredited by the film. Memories are represented by photographs: at one point, Deckard sits at the piano gazing at photos, at his personal history. Yet in this world, photographs, seemingly tangible proof of memories, of a self with a past, are programmed into replicants, precisely to make them more like humans. Leon, the first male replicant we see destroyed, hides photographs among his clothes, talismen of the life he wants to claim he has lived; Rachael, Tyrell's 'daughter', proffers photographs to Deckard as proof of her humanity, yet she, we and Deckard all know that she is a replicant. Leon and Rachael cling on with desperation, with truly felt intensity, to this proof of their being truly alive; they truly desire to be human, but are not. The melancholy of Deckard's gaze at the family photos on his piano could just be nostalgia, but it also hints at the anguish of an identity based upon an illusion of having had a life.

This interpretation is only made clear at the end of the film, in relation to dreaming. Deckard has vivid dreams of a unicorn, something he tells no

one about, perhaps to reassure himself that he must be human because he alone knows of this inner vision. But someone else does know. Deckard has a superior in the force, Gaff (Edward James Olmos), who has a habit of leaving tiny origami model figures behind him which indicate his prior knowledge of events. When Deckard makes his get-away at the end of the film, Gaff leaves a tinfoil unicorn behind, suggesting that he does know the content of Deckard's dream, something he could only know if Deckard is a replicant (to whose programming he would have access). Thus memories and dreams, already wisps of confirmation of being truly human, are illusions, illusions of being truly alive.

The characters of Gaff and Rachael add a further dimension. Both are dark, Gaff Hispanic (with pointy beard and glittery eyes), Rachael with pink rouged cheeks but sculpted jet-black hair. Gaff has knowledge of Deckard; Rachael offers the possibility of developing true emotions (something predicted of all replicants and a major reason for destroying them, since this could challenge their robot/slave status). The two dark 'whites' offer something definite, real, physical to the nothingness of the indifferently fair white man. In the first version, Deckard and Rachael escape, the film ending with a lyrical (if naff) flight away from Los Angeles and perhaps Earth: the dark woman's discovery of true feeling (she weeps) redeems the fair – truly white – man's emptiness. This ending is absent from the 'director's cut'; the dark woman cannot redeem the fair man – all that is left, in a variation of Toni Morrison's discussion of the role of black characters in fiction, is the dark man's knowledge of the fair man. This is not too comforting however: we are known to exist, but known to exist only as empty fabrications.

Deckard is skin white, but he does not look hue white. Though he is relatively heroic (resourceful, compassionate), he is not symbolically white, in the sense of being highly virtuous or even (despite Harrison Ford's nice looks) very beautiful. It is this though that makes him an exemplary white for our times. He's not an oriental, may even be in retreat as they take over the world, but he's not stridently, malignantly white either. He's just ordinary (and, as a man, more ordinarily human than a white woman). This is still his representational strength – he remains the central, representative figure of humanity, even while being specifically white (and male) – but *Blade Runner*'s cult life may also be because it touches on the suspicion that white man, in his retreat from the coloured hordes, has nothing in his self to fall back on.

Implicit in *Blade Runner* as well as vampire and *Zombie* films, and phantasmagorically explicit in the *Alien* trilogy, is the issue of reproduction. Vampires and zombies cannot reproduce themselves, and nor can androids, at any rate sexually as opposed to technologically. Deckard, Tyrell, Sebastian and Rachael are non-reproductive machines or machine-makers set against the pullulating evidence of breeding among the oriental hordes. The alien, on the other hand, is a monster of reproduction, taking protean shape

in both vaginal and phallic forms, able to spawn out of a male stomach in *Alien* and revealed to originate from a vast womb in *Aliens*. It erupts in non-reproducing societies, amid apparently rather asexual space crew in the first two films and on a planet on which there are only men in *Alien³*. The character of Ripley becomes progressively more linked to reproduction through the second and third films. In *Aliens*, she develops a maternal relationship with a girl survivor of the alien's rampage on the space ship and then faces up to the alien mother, as one female to another; in *Alien³*, she is pregnant with the alien and at the end of the film she takes 'her' baby to her breast, throwing herself and it to their deaths in a vast furnace. Reproduction is polarised between the non-reproducing, white and often android-led human world and the terrifying and indeed alien realm of the alien's uncontrollable reproductive energy.

Discussing *Aliens*, Amy Taubin relates such imagery to its historical context, suggesting its racial resonances:

> If Ripley is the protoypical, upper-middle-class WASP, the alien queen bears a suspicious resemblance to a favourite scapegoat of the Reagan/ Bush era – the black welfare mother, that parasite on the economy whose uncurbed reproductive drive reduced hard-working taxpayers to bankruptcy.

> (Taubin 1993: 95–6)

The horror at reproduction is not just, as Barbara Creed (1990) has argued, male paranoiac recoil in the film's undoubtedly 'monstrous-feminine' imagery of engulfment, dripping secretions, gaping holes and nauseating ejections. It is a specifically white, aghast perception of the unstoppable breeding of non-whites, that deep-seated suspicion that non-whites are better at sex and reproduction than are whites, that, indeed, to be truly white and reproductively efficient are mutually incompatible and that, as a result, whites are going to be swamped and engulfed by the non-white multitudes.

By the time of *Alien³* (1992), a good ten years into the highest profile epidemic in Western society, Taubin suggests (1993: 98–9) that

> AIDS is everywhere in the film. It's in the danger surrounding sex and drugs. It's in the metaphor of a deadly organism attacking an all-male community. It's in the iconography of shaven heads. . . . The alien's basement lair, with its dripping pipes and sewage tunnels, represents not only the fear of the monstrous-feminine, but homophobia as well. It's the uterine and the anal plumbing entwined.

The most common aetiology of AIDS in the popular imagination combines uncontrolled African heterosexual appetite with the *ne plus ultra* of white sexual decadence, namely queers: excessive reproductive drive wreaking

havoc on the white world by using its most perversely non-reproductive members. This is the deliriously bleak vision of *Alien³*'s world.

When in *Alien*, as described above, the company android Ash has his head pulled off, it discharges white liquid from its 'veins'. These pulsing ejaculations look like nothing so much as the cum shots of the heterosexual pornography so familiar by the late 1970s. In the extreme close-up of him extolling the 'purity' of the alien, his face is covered with this white ejaculate. In heteroporn, the cum shot is a display of pleasure, which insistently divorces the moment of orgasm from that of procreation. The rise of hetero-porn and the absolute requirement of the cum shot fix the image of sex as non-reproductive, and sexual reproduction in a racialised society is always also something to do with racial reproduction. Heteroporn produces an image of Western sexuality that is racially terminal. In *Alien³*, the android/white man's severed head covered with cum is a grotesque vision of a fruitless display of sexuality at the point of death.

The suspicion of the emptiness of whiteness and also of its terminal repro-ductive line is also crucial to the non-science fiction film, *Falling Down* (1993). I want to end with a discussion of this film, not least because it is a recent, widely seen film explicitly addressing the question of white identity that has attracted some notable analyses in these terms (Clover 1993, Davies 1995a, 1995b, Kennedy 1996, Pfeil 1995, Pratt 1995, Gabriel 1996). Focusing on *Blade Runner* and the *Zombie* and *Alien* films, all to me much more interesting, may suggest that the suspicion of nothingness and the death of whiteness is, as far as white identity goes, the cultural dominant of our times, that we really do feel we're played out. I do think their shelf life and cult status suggests something approaching that, whereas *Falling Down* seems already to be beginning to be forgotten. Cult films cling on to deep-seated, only half-expressible fears and fascinations; they haunt the imagination. *Falling Down*, on the other hand, because rather than in spite of its cultural opportunism and having it all ways, has the fear of white death but also, unresolvedly, the possibility that there's life in us yet.

The film may very easily be read as an allegory of the death of the white man, or at any rate, the white man as endangered species. Its central charac-ter, referred to as D-FENS after his car number-plate and played by Michael Douglas, abandons his car in the middle of a traffic jam on a sweltering day in Los Angeles and decides to walk his way home, across the city to Venice Beach. The journey motif, the resonance of the notion of home, situate the film squarely within white male adventure narrative, and this is reinforced by the obstacles the hero encounters on the way, the sense of jungle suggested not only because this is a well-known cliché about urban America but by the geographical confusion of the terrain and the often lethal hostility of the natives. Yet during the course of the journey we learn that D-FENS has lost all that affirms his identity: his job (made redundant from his white collar defence industry position), his wife (they are divorced), his role in parenting

(there is a restraining order on him and he is forbidden to come to his daughter's birthday party, taking place on the afternoon of the film's action). He is nothing. Moreover, his journey does not take him home. When he reaches Venice, it is not recognisable to him any more (transformed by alien immigrant and New Age developments). When he reaches the house where his wife and daughter live, they have already fled in terror at his coming. He pursues them on to the pier, off land, as far as you can go, the end-point of white Westward expansion, and here he is finally killed by Prendergast (Robert Duvall), the cop who has been pursuing him throughout the film. His death is the only possible logical outcome, not just because Hollywood films still rarely countenance killers getting away with it, but also because there is – literally, figuratively, historically – nowhere else for the story to take him.

The sense of the dead-end, the death, of whiteness, is also suggested in relation to reproduction. In a motif common in thrillers, D-FENS and Prendergast are seen to have much in common, including the fact that both have lost only children, the former through divorce, the latter through the child's death. The fact that in both cases it is daughters, not sons, also suggests the end of a lineage. Here is spoilt and failed reproduction. At the end of the film, when D-FENS draws his gun in a show-down with Prendergast, it is not a powerful tool, not much of a phallus, just something dribbling water, his daughter's water pistol. (I will, however, come back to the fact that Prendergast's tool does work.) Moreover, D-FENS has probably, as Davies argues (1995a: 150), engineered his own death, drawing this fake gun so that Prendergast will despatch him and, as a result, his daughter will receive the pay-out from his life insurance policy. He has done the only decent thing left for a white male begetter in the modern world to do: annihilate himself so that reproduction is taken care of by a corporation.

The reproductive impotence of white masculinity is also suggested in D-FENS's encounter with a neo-Nazi who runs a military surplus store. The man (played by Frederic Forrest) has been listening in on the police radio and not only knows who D-FENS is but thinks he recognises a fellow bigot and principled vigilante. He covers for him when the police come to the store on a search of the area, but when D-FENS abusively rejects the hand of white supremacist solidarity, the store owner turns on him and tries to handcuff him with a view to turning him over to the police, only in turn to be violently despatched by him. As many commentators have pointed out, the evident purpose of this scene is to distinguish D-FENS from white supremacism – he may be white, but he's not a fascist. Yet he is not so neatly distinguishable from the store owner.[8] The latter is not foolish to think he spies a fellow redneck, given what D-FENS has been doing and his rigid bearing, cropped hair and grim expression. And after the confrontation, D-FENS does act more like a vigilante, dressing like a grunt, enacting the rampage the store owner is perhaps too inhibited to perform.

This scene, suggesting whiteness taken to an extreme, is also shot through with homosexuality. There are two evidently gay (white) men in the store, subject to verbal abuse by the store owner to impress D-FENS, who is however indifferent. When the store owner attacks him, he spread-eagles him over a bar and then in effect mounts him, all the while taunting him with the rape he's going to get from black inmates in prison. As Murray Pratt observes, at this point 'the film loses its grip momentarily, shifting focus to a blurred shot of the Nazi's mouth repeating "Give it to me, give it to me"' (1995: 100). No doubt the film wants us to derive a liberal message from all this too: D-FENS is not homophobic, while the store owner's homophobia seems fairly evidently repressed homosexuality. He takes D-FENS into a back room to show him his fascist regalia and a bazooka, phallic excess gone mad, and Pratt suggests there is here an implicit contrast between this crazed assault in a darkened space and the more respectable image of homosexuality in the gay couple seen earlier in the store; a similar point was put to me by Mark Hall,[9] who pressed home the analogy with the gay bar back rooms demonised anew in the era of AIDS.

Yet if the scene seems to separate D-FENS from both gayness and homophobia, indifferent to both, it also binds together violence, whiteness and homoeroticism, with a 'loss of grip' that suggests anything but indifference on the part of the film. The two white gay men are customers, clearly looking for purchases charged with an erotic violence; the more obviously sexually coded one, wearing a torso-revealing singlet, squares up to the owner when he taunts them and then smashes a display unit to the ground as he leaves. After killing the store owner, D-FENS dresses up in the gear from the racks the gay boys were going through and arms himself with the store owner's bazooka. Thus, in both erotic tastes and actual action, gay men seem no less violent than the store owner, who in turn seems no less homosexual, while D-FENS is not so distant from this erotic culture of violence. There is a continuum between violence, asserted whiteness and homosexuality, and between D-FENS, the store owner and the fag customers.

Why is this sequence so obsessively homosexual? Even if the overt aim is to dissociate D-FENS from homophobia, why is it necessary to do this? Homosexuality has acquired an extraordinarily high profile in the 1990s, partly as a result of the success of the gay movement and the gay market, partly as a result of AIDS. It seems to have become a touchstone for Western sexuality quite out of proportion to its incidence. The pervasive use of homoeroticism in consumer culture gives spice to the vanilla of straight sex, but homosex is also the sign of the spectre of sex as death, because of the association of AIDS and also because it is a non-(racially) reproductive form of sexuality. Despite the activism of lesbians and gay men of colour, homosexuality remains obstinately white in popular representations,[10] partly because, as observed before, whiteness colonises even the representation of ordinary deviance, but also because it dramatises the terror of white reproductive

inadequacy. Thus a trope of white culture equates whiteness, homosexuality and sex *tout court*. This is the anxiety that I suspect is buried in *Falling Down*: that white sex is queer sex. This is a triple source of anxiety: it is inherently perverse; it is a bringer of death (in the form of AIDS); and, above all, because so much at the heart of all white anxieties, it is non-reproductive.

Falling Down's tone is highly ambivalent. Is D-FENS offered as an identification figure for the audience or is he too insistently allegorical for that? Is he a representative of the class of the average white male or revealed to have too many neuroses to be taken for that? Are his experiences ones which anyone might have with anyone or are they race- and gender-specific? Are we to take him seriously or, as the film nudges us to at times, to laugh at him? Some of these ambivalences may, as written down, not seem especially paradoxical. Some of us may think that to be neurotic is the condition of the average white male. It is certainly a common strategy of the representation of white males to offer them as at once typical and individualised, and humour about their mistakes and failings can also seem to render them all the more representative of average humanity. The fact that some of the problems D-FENS encounters are indeed 'things that can affect and offend anyone', such as 'the traffic jam, the annoying bumper stickers . . . the general rudeness of all towards all' (Clover 1993: 8), might have the effect, as Carol Clover argues, of disguising the racial and gendered character of many of the other confrontations on his journey (cf. Kennedy 1996). In other words, the ambivalence of the film's tone might seem par for the course for white male representation, its strength residing in just this reconciliation of apparent particularity with embodiment of the human norm.

Yet if we focus on D-FENS, we probably will retain a sense of the film's ambivalence about whiteness itself. On the one hand, his rigid bearing and brutal haircut seem too extreme, the fact that we mainly only know him by the obviously symbolic letters of his car number-plate seems too abstract, and his connection with neo-Nazi white supremacism is too pointedly hinted at. On the other hand, his scenes are the most vivid in the film, he is played by the only big star in the film, his plight (made redundant, divorced, receiving hostile response to his controlled politeness) and even probably his appearance clearly struck chords for many viewers, making the film a box office success and often, it is said, rousing cheers from the audience. Much depends on one's view of Michael Douglas, to me always rather repellent and yet clearly able to carry a central protagonist role in one box office success after another.

Yet D-FENS is not the only representative of whiteness in the film. We have, first, Beth, his wife (Barbara Hershey). Given much less emphasis by the film than either him or Prendergast, she is remorselessly presented in terms of maternity. She is what is at stake in D-FENS's journey: reproduction. If Bill (to give him now his family name) is the end of the male line, just a dribble, she at least is carrying the race forward, if only though a

female line. Despite what Hershey brings to the role, it is a very bare statement of the role of women in whiteness.

We also have Prendergast. As already mentioned, he and D-FENS are seen to have much in common, not just lack of contact with their one, female offspring, but unsatisfactory marriages (one divorced, the other subservient to his wife's neuroses), joblessness (one redundant, the other on his last day at work, taking early retirement from what was anyway pen-pushing, not real policing, and both (not) working for different branches of the defence industry, the police and arms) and ignorance where the 'new', that is, Asian populations are concerned (D-FENS's encounter with a Korean shopkeeper is echoed almost at once by Prendergast's assumption that his Japanese-American colleague will understand what the Korean says). Most of all, Prendergast is able to notice D-FENS, piecing together seemingly random police reports coming in, and to track him down, just by knowing him intuitively, recognising what makes him tick from a sense of common feeling. By the end of the film, Prendergast has become more like D-FENS, standing up to his wife and commander in ways which signal that he has rediscovered his manhood.

All of this suggests that Prendergast is just another version of D-FENS, but what may appear superficial differences – Prendergast's warmth and gentleness, Robert Duvall's more nuanced performance – are important in resecuring the social position of whiteness that D-FENS/Douglas's more extreme character risks undermining. The very unobtrusiveness of Prendergast/Duvall allows him to occupy more comfortably the position of ordinariness that is the white man's prerogative. This is reinforced by the fact that he has the investigator role, a classic version of the subject without properties, seeing and listening but not interrogatively seen and heard. This then makes his shooting of D-FENS all the more significant. It takes a white man to kill a white man, to make the world safe, but (like the tanned muscleman heroes) he must not be too white. He must be taken as ordinary, and it is seldom in the West that anyone other than a white male can take up that position.

Prendergast resecures the centrality – the invisibility, the ordinariness – of the white male. But not definitively. The film does not end with him (let alone with him and his wife, or Beth and a putative husband, the normal conclusion of race-confident stories). It ends with a camera track into Beth's house and on to the TV screen, where a video of Bill, Beth and Adele (their child) is playing. This has been seen earlier, when D-FENS/Bill watches it, momentarily unsure where Beth and Adele have got to. At first, it looks like a reminder of happier times, the white nuclear family at contented play, but then Bill's underlying violence becomes apparent, as he shouts at Beth and insists that Adele, in tears, be made to sit on the rocking-horse she doesn't want to sit on; appalled recognition of himself dawns on D-FENS's face. *Falling Down* ends on this video image, all that is left of Bill, that is

D-FENS, that is the average white guy, a mere image trace of an always incipient violence. Then the screen suddenly goes blank, cutting off before the end of the sequence, even that image finally clipped.

If *Falling Down* is Bill/Douglas's film, then it may be felt to articulate the idea that whiteness, especially white masculinity, is under threat, decentred, angry, keying in to an emergent discourse of the 1990s. If it is Prendergast's, it is resecuring the culturally stronger, but now harder to maintain position of ordinariness, the subject without properties. But if the final images have the last word, it is in line with the much deeper anxieties of the *Zombie* and *Alien* films and of *Blade Runner*, a feeling that deep down whites are nothing and have had their day, that we are, and perhaps always have been, the dead. *Falling Down*'s success may derive from its expression of the state of play in the contemporary construction of whiteness, between a renewedly respectable supremacism, the old everything and nothing-in-particular hegemony and the fear of an annihilation that will be the realisation of our emptiness.

Falling Down contains the representation of both extreme whiteness, ambivalently perceived, and ordinary whiteness, that is, whiteness as ordinariness. The other films discussed in this chapter also contain both. The mesmerisingly excessive vampire is met by his/her normal, dull but decent antagonists. In the *Alien* films, the faceless company and its robotic representatives, dedicated to purity, are part of a future world containing less pure, more workaday white people, of whom one, Ripley, is the chief protagonist. *Blade Runner* makes a distinction within its whites/androids, between the strident, bleached whiteness of Roy and Pris and the more average whiteness of Deckard.

I want to end here with a brief consideration of the function of extreme whiteness in relation to ordinary whiteness and white hegemony. Most white people, and even most representations of white people, are not virginal women glowing in the light, hyper-muscular men sorting out other people's problems or privileged marginals transfixed by the dilemma of doing. The sketch of white characteristics that has surfaced throughout this book, of whites being taut, tight, rigid, upright, straight (not curved), on the beat (not syncopated), controlled and controlling, even this sketch would not describe most images of white people. Yet the extreme, very white white image is functional in relation to the ordinary, is even perhaps a condition of establishing whiteness as ordinary.

Extreme whiteness coexists with ordinary whiteness: it is exceptional, excessive, marked. It is what whiteness aspires to and also, as I've suggested in this chapter, fears. It exists alongside non-extreme, unspectacular, plain whiteness. Non-whiteness, on the other hand, is already peculiar, marked, exceptional: it is always, in relation to notions of the human in Western culture, particular and has no ordinariness. Whites are the one particular

group that can take up the non-particular position of ordinariness, the position that claims to speak for and embody the commonality of humanity.

The extreme image of whiteness acts as a distraction. An image of what whites are like is set up, but can also be held at a distance. Extreme whiteness is, precisely, extreme. If in certain periods of derangement – the empires at their height, the Fascist eras – white people have seen themselves in these images, they can take comfort from the fact that for most of the time they haven't. Whites can thus believe that they are nothing in particular, because the white particularities on offer are so obviously not them. Extreme whiteness thus leaves a residue, a way of being that is not marked as white, in which white people can see themselves. This residue is non-particularity, the space of ordinariness. The combination of extreme whiteness with plain, unwhite whiteness means that white people can both lay claim to the spirit that aspires to the heights of humanity and yet supposedly speak and act disinterestedly as humanity's most average and unremarkable representatives.

Notes

Introduction

1 On white consciousness see, for instance, Frye 1983, McIntosh 1988, Roediger 1991, 1994, Ware 1992, Frankenberg 1993; on non-white perceptions of whites, see, for instance, Malbert and Coates 1991, (charles) 1992, hooks 1992. (These references are given in the bibliography for Chapter 1, 'The matter of whiteness'.)

I The matter of whiteness

1 I use the terms 'race' and 'racial' in this opening section in the most common though problematic sense, referring to supposedly visibly differentiable, supposedly discrete social groupings.

2 In their discussion of the extraordinarily successful TV sitcom about a middle-class, African-American family, *The Cosby Show*, Sut Jhally and Justin Lewis note the way that viewers repeatedly recognise the characters' blackness but also feel that 'you just think of them as people'; in other words that they don't only speak for their race. Jhally and Lewis argue that this is achieved by the way the family conforms to 'the everyday, generic world of white television' (1992: 100), an essentially middle-class world. The family is 'ordinary' *despite* being black; because it is upwardly mobile, it can be accepted as 'ordinary', in a way that marginalises most actual African-Americans. If the realities of African-American experience were included, then the characters would not be perceived as 'just people'.

3 See, for instance, Bogle 1973, Hartmann and Husband 1974, Troyna 1981, MacDonald 1983, Wilson and Gutiérez 1985, van Dijk 1987, Jhally and Lewis 1992 (58ff.), Ross 1995. The research findings are generally cast the other way round, in terms of non-white under-representation, textual marginalisation and positioning as deviant or a problem. Recent research in the US does suggest that African-Americans (but not other racially marginalised groups) have become more represented in the media, even in excess of their proportion of the population. However, this number still falls off if one focuses on central characters.

4 *The Crying Game* (GB 1992) seems to me to be an example of this. It explores, with fascination and generosity, the hybrid and fluid nature of identity: gender, race, national belonging, sexuality. Yet all of this revolves around a bemused but ultimately unchallenged straight white man – it reinscribes the position of those

224

at the intersection of heterosexuality, maleness and whiteness as that of the one group which does not need to be hybrid and fluid.

5 Most notably in feminist theories of 'situated knowledge'. See Harding 1987, Haraway 1990.

6 Frankenberg and Mani similarly discuss the way that colonial imagery still and unconsciously addresses people in contemporary Britain and the USA (1993: 297–300).

7 He makes this point in the context of both a TV documentary about D. W. Griffith and an article by me on Lillian Gish; though I think it is inaccurate to call the latter a 'celebration' (as opposed to a recognition) of the whiteness of her stardom, the general tenor of his remarks is salutary.

8 Pascal Bruckner discusses liberal guilt and 'Third Worldism' in his *Le sanglot de l'homme blanc* (The White Man's Tears) (1983).

9 Alastair Bonnett makes a related point about the discourse of blame in recent studies of whiteness by white people.

> [A]lthough whiteness is subjected to a barrage of unsentimental critique, it emerges from this process as an omnipresent and all-powerful historical force. Whiteness is seen to be responsible for the failure of socialism to develop in America, for racism, for the impoverishment of humanity. With this 'blame' comes a new kind of centring: Whiteness, and White people, are turned into the key agents of historical change, the shapers of contemporary America.
>
> (Bonnett 1996: 153)

10 On the whiteness of queers see Hart 1994, and of disabled people see Cumberbatch and Negrine 1992: 74. Paul Darke argues (in a personal communication) that the overwhelming prevalence of whites in the representation of disability is due not only to the assumption of white as a human norm but to two other factors specific to disability – that it is to be imagined as 'the worst quality of life on earth', which must be most tragic for the most privileged, and that in the overriding representation of whites as individuals, the fact of the social construction of disability is hidden.

11 A schoolboy phrase I remember being taught was that 'wogs begin at Calais'; even the French were not white enough for little Englanders. ('Wog' is British slang for 'nigger'.)

12 An insight explored in a film context in Cameron Bailey's analysis of *Something Wild* (USA 1986), where non-white culture is used as a marker of authenticity and wildness that will give vitality and essence to the garish emptiness of middle-American mass culture, to the point that the 'wild' white woman (played by Melanie Griffiths) who distracts the hero (Jeff Daniels) from the straight and narrow is entirely coded in terms of black culture (Bailey 1988).

13 Lynda Hart's discussion (1994: 104–23) of *Attack of the 50-Ft Woman* and *Single White Female* is an example of an analysis in these terms that I read too late to integrate into the discussion.

14 Liz Stanley (1977) uses the term 'readiness' in her discussion of the female role within heterosexuality.

15 Manicheism is a doctrine based on the ideas of the Persian philosopher Manes, which saw the world as polarised between forces of absolute good and evil, symbolised in the oppositions of light and darkness, black and white. While formally deemed a heresy by the Church, it has provided a moral framework, and not least a powerfully simple symbolism, that has profoundly marked

Christian/Western thought. The use of the term in the context of the analysis of white attitudes to race has been especially influenced by the work of Frantz Fanon (e.g. 1967, 1970); see also JanMohamed 1985.

16 The account in this paragraph is indebted to Robinson 1983.

17 Allen is specifically discussing policy with regard to 'mulattos' in the British West Indian colonies.

18 What follows is a drastically simplified account. Among studies that give a more detailed account, often indicating the slippages between and contradictions within different notions, and which do look at the white race, are Poliakov 1974, Mosse 1978 and Bernal 1987.

19 A comparison still at work in the adventure films discussed in Chapter 4.

20 The role of photography as a tool in these developments has been widely discussed; see, *inter alia*, Green 1984, 1986, Rouillé and Marbot 1986.

21 On 'upward training' in the civilising of the white body, see Vigarello 1989.

22 One who did was a Prussian surgeon, Johann Meckel, who 'dissected some Negroes in 1757 [and] claimed that their brains were of a darker colour than those of Europeans, and that their blood was black, "so black that instead of making the bandages red, as blood normally does, it made them black"' (Poliakov 1974: 161).

23 The first quote is from notes accompanying figures 40–2 in D'Emilio and Freedman 1988; the second quote is from one of the posters illustrated.

24 This view was still upheld in 1983 by the Louisiana Bureau of Vital Records, which, in the case of a descendant of an eighteenth-century white planter and a black slave, declared that anyone with at least ½ of 'Negro blood' in them cannot be deemed white (Omi and Winant 1986: 57).

25 Cf. Lynda Hart's discussion (1994: 112–13, 116–19) of white (men's) involvement in anti-abortion campaigns.

26 Explored recently by, for instance, Young 1995 and McClintock 1995.

27 In fact the original, as quoted in Gossett (1965: 329), Michaels' own source, has 'the kindest and most merciful of the world's great race of *administrators*, the people of the American republic'.

28 This is commonly enough observed of course (Smith 1950), but note especially the discussion of the precise function of the image of the Western hero in facilitating the unification of white settlers as a group against non-whites in Saxton 1990: 321–47.

29 Bernal discusses Locke's belief (in *The True End of Civil Government* (1689)) that 'Africans and [indigenous] Americans did not practise agriculture and, according to him, the only entitlement to land came from cultivation' (Bernal 1987: 203); similarly Fredrickson argues that white thought since the Renaissance has only recognised civilisation in beings who 'practised sedentary agriculture, had political forms that Europeans recognised as regular governments, and lived to some extent in urban concentrations' (Fredrickson 1981: 9–10). See also Parekh 1994.

30 Similarly, the dangerous blacks in *The Birth of a Nation* are led by whites or else mulattos, organisationally superior by virtue of their white blood, while the bravery of black soldiers in the Civil War was often put down to the qualities of the white officers (Saxton 1990: 373).

31 Here of course I mean Europe and its white ex-colonies; the fact that the word Western refers to both a narrow fictional genre and a vast geopolitical formation suggests the centrality of the former in defining the latter.

32 On the sublime see Weiskel 1976; for its connection to whiteness see Coetzee 1988 and to gender see Battersby 1989.

33 Feminist film theory (e.g. Mulvey 1975, Kaplan 1983) argues strongly that the look of the camera, the gaze, is male. More recent discussions have looked at the

high level of exceptions to this (in the look of women at men, in the lesbian/gay gaze) and the way race inflects such considerations (Gaines 1988, Mayne 1993). It is important, however, not to write off 'male gaze' theory under the sign of a free-for-all of gazes, but rather to explore the complex interplay of power in looking and being looked at, above all in terms of who controls these relations, who has the right to look unchallenged, uninterrupted and unembarrassed, who controls the conditions under which they themselves are looked at.

2 Coloured white, not coloured

1 A much debated topic. Gergen (1967), for instance, makes the case that primal colour associations are at the root of racism, a view disputed by Allen (1994: 3ff) in a historiographical context.
2 I have specifically in mind the British thriller *Sapphire* (1959), though these are typical motifs (cf. Young 1996).
3 The term 'European' also offers itself as an alternative; outside of Europe, it is sometimes, and perhaps even increasingly used, but its use within Europe is problematic, since now many Europeans are not white. For a discussion of terminology for whites, see Bonnett 1993.
4 The movement, notably in the USA, to depart from this by adopting originatory terms analogous to African-American (both European-American and Anglo-American, Italian-American, etc.) may succeed in displacing the term white, but not necessarily the visual rhetoric of whiteness that is at issue in this chapter. My sense is that European-American is little used, though Anglo-American, Greek-American, etc. are gaining some ground; the latter are of course not the strict equivalents of African-American (which evokes a continent, not a nation) and evade the issue of the coalition/umbrella nature of whiteness discussed by social historians such as Roediger (see Chapter 1).
5 By which I mean contemporary global culture as well as historical periods and situations specifically designated as colonial.
6 I shall be using this term to mean colour in the sense given here, thereby to avoid the confusion that would result, in a discussion of different aspects of colour, if I used the word colour instead. I mention this because in some usages, hue is a particular attribute of colour or is applicable to any colour other than black or white, rather than being a synonym for colour.
7 Even this, according to Gage, is a perception of post-medieval origin. In classical tradition and medieval art, the colour of light was held to be red (though it could sometimes be represented as blue) (1993: 12–13, 52–3, 58–60). (Still more surprising to modern eyes is Aristotle's statement that 'earth is naturally white' (quoted in Sloan 1991: 2).)
8 This perception, attributed to Newton, was prefigured not only by the second century Gnostics but also in the work of the alchemists, most evidently in one of the texts collected by Albertus Magnus and published in 1659:

> All colours that can be conceived by men in the world appear there [in white] and then they will be fixed and complete the Work in a single colour, that is the white, and in that all colours come together.

Newton acquired a copy of this text in 1669, which suggests that the notion of white being all colours fused together may be more culturally rooted than we necessarily assume (see Gage 1993: 141).

9 As mentioned in note 8, the earth was associated with whiteness in Aristotle, and Gage (1993), in his detailed cultural history of colour, implies that the role of the notion of the humours in the perception of colour was not great.

10 According to A. J. Pernety in his *Dictionnaire Portatif de Peinture; Sculpture et Gravure* (1757); see Gage 1993: 292–3.

11 A classic example is Joyce Carey's novel *Mister Johnson* (1939), made into a film in 1990; see Shaka 1994.

12 As the work of Roediger and others suggests, blackface, especially in minstrelsy, was by no means a simple and straightforward phenomenon. Roediger, for instance, argues that it could express a longing for fun and carnival among white workers that their adoption of a white identity had repressed; in other words, as so many have observed, images of blackness express what is longed for even as it is decried. However, this does not mean that the otherness, and absolute difference, of what is both longed for and decried is not still held in place by the felt colour polarity of black and white skin.

13 I take this observation from Corin Willis's Warwick MA dissertation.

14 This is usually interpreted in terms of labour, namely men working out of doors, respectable women within. Shelley Haley (1994: 26), however, argues that the differentiation has to do with the Egyptian mythic system, associating women with the sky goddess Nut and men with the earth goddess Geb. Its gendered labour significance may then be a subsequent white interpretation of the differentiation.

15 See also Louise Allen's discussion of colour and lesbianism in *Salmonberries* (Canada 1991) (1995: 77–80).

16 'Under the same line . . . lies a part of Peru, and of the new kingdome of Grenado, which . . . are very temperate Countries, . . . and the inhabitants are white' (E. Grimstone's 1604 translation of *D'Acosta's History of the Indies*).

17 This observation is based on systematic visits to the following museums: Amsterdam (Rijksmuseum), Birmingham (Museum and Art Gallery), Chicago (Art Institute), Edinburgh (National Gallery of Scotland), Frankfurt-am-Main (Städelsches Kunstinstitut), Liverpool (Walker Art Gallery), London (National Gallery), Manchester (City Art Gallery), Montreal (Musée des Beaux Arts), New York (Metropolitan Museum of Art), Philadelphia (Museum of Art), Paris (Louvre), Stockholm (Nationalmuseum), Vienna (Kunsthistorisches Museum). This is not a comprehensive survey of the great galleries of European painting; it is, however, random, not pre-selected, based purely on what cities I have been fortunate enough to visit for other reasons while preparing and writing this book. All the galleries have a representative collection of European painting from the Middle Ages to the present day; some are distinguished, others minor. All however were collected under the pressure of the selective tradition of Western painting.

18 I am grateful to Paul Hills for this observation.

19 For a detailed analysis of this and related imagery, see Hamer 1993: 45–76.

20 There is now a tradition of Mary being dark-haired (dark-haired white women friends of mine recall being chosen to play Mary in the school nativity play because of their hair). However, in the tradition of Western painting since the fifteenth century (Warner 1994: 367), Mary, when her head is uncovered (which is only half the time), is far more often goldenly fair than even brown, let alone dark.

21 Literally meaning 'not noxious'.

22 The term is still used in Italian.

23 Bardot had made sixteen films before bleaching her hair and bursting into stardom with *Et Dieu créa la femme* in 1956 (see Vincendeau 1992).

3 The light of the world

1 I'm grateful to Ann Gray for bringing this example to my attention.
2 Overviews of this history can be found in Handley 1967, Salt 1983 and Revault d'Allones 1991.
3 Salt (1983) finds examples as far back as 1909 and traces its variants through the 1910s, suggesting that it probably only became established as a norm around 1917–19.
4 In his study of lighting in film, Fabrice Revault d'Allones distinguishes movie or 'classical' lighting (which can be more highly wrought to the point of becoming 'baroque') from what he terms 'modernist' lighting. The latter does not seek to control meaning or to hierarchise elements in the image; nor does light itself carry meaning (of, for example, darkness being sinister). He takes the example of the film *Thérèse* (France 1986), about the life of a young nun:

> Thérèse may die, but the lighting is the same as when she danced; she may turn out to be a saint, but she looks no more and no less radiant than before: the lighting resists dramatisation and symbolisation, subjectivisation and psychologisation.
>
> (Revault d'Allones 1991: 10)

Revault d'Allones finds this kind of lighting in the work of individual directors at various points in the history of the cinema, but sees it as characteristic of only a brief period of cinema, around the French new wave in the 1960s. In its indifference to (racial) difference, such lighting will reproduce the privileging of the white face discussed in this chapter.
5 Director Léos Carax; photographer Jean-Yves Escoffier.
6 It is remorselessly true of the lighting in *The Jewel in the Crown*, for instance, discussed in Chapter 5.
7 I am grateful to William Spurlin of the Visual and Environmental Studies Department at Harvard University for telling me of this, explaining it and commenting on drafts of this paragraph.
8 This observation is based on analysis of a random cross-section of such books published this century. See Appendix at end of chapter.
9 See Appendix at end of chapter.
10 Film stock registers contrasts less subtly than the human eye, which tends, faced with real life, to compensate for excessive lightness or darkness; a black face against a light background, of set or costume, creates a strong contrast; adequately lighting a black performer's face in such circumstances (that is, directing more light at it than one would at a white person's face) risks bleaching out the sets and costumes.
11 Note that this figure, though illustrating the general point made in this paragraph, is a production still from a different scene to that discussed here.
12 José Arroyo notes Snipes coming off badly through lighting in a more recent vehicle for him (*Money Train* 1995): 'whenever there's a white person in the frame, discerning Snipes' features becomes a matter of eye-strain' (1996: 47).
13 Cf. Grover 1995; one of the key courtroom scenes in *Philadelphia* (1993) turns on the protagonist's display of his lesions.
14 The account of the history of lighting in this and the next paragraph is based principally on O'Dea 1958.
15 Swedenborg died in 1772, but the heyday of his international influence was in the nineteenth century.

16 Paul Hills traces a concern with rendering light in painting back to the early Italian Renaissance. However, he suggests, such a preoccupation is a peculiarity of Western tradition; in other cultures light 'is usually taken for granted as a universal medium of visibility rather than imitated' (1987: 1).

17 Mary Hamer's observation to me in a too brief conversation.

18 As in Steele MacKaye's Luxauleator, patented in 1892, in which a 'curtain of light' blotted out one scene and then allowed another to emerge out of it as it was 'drawn' (Vardac 1968: 143).

19 See also the discussion in Chapter 2 of two portraits by Benjamin Stone.

20 An establishing shot of a scene holds the viewer at a distance, but a cut to a mid- or close-up shot of something within the scene, or a track into it, creates something analogous to the experience of moving through three-dimensional space.

21 Salt (1983: 136) suggests this was a relatively late (c.1919) influence.

22 McBride-Mellinger (1993) finds examples of white wedding dresses from the fifteenth century onwards, but suggests that it is only in the mid-nineteenth century, and above all with the marriage of Queen Victoria in 1840, that it becomes a norm. Only from this point on do fashion and bridal magazines speak of white being used from 'the earliest ages' (*Godey's Lady's Book* 1849) and since 'time immemorial' (*Ladies Home Journal* 1890).

23 Compare also Lynda Dyson's description of the filming of Ada (Holly Hunter) in the racially sensitive context of *The Piano* (1993), 'skin bleached out' and, as she plays the piano, 'her vulnerable spine .. exposed and *elided with the whiteness of her bodice*' (1996: 270–1; my emphasis).

24 On such female star images in this period, see Rosen 1974, Higashi 1978, Tey 1980. Specifically on Gish and whiteness, see Dyer 1993.

25 Stills are not true frame enlargements, which give a rougher finish to the image, but specially posed photographs based on shots from a film and used in promotion; they are important in fixing the idea of a film in public discourse.

4 The white man's muscles

1 On Valentino, see Studlar 1989, Hansen 1991, Dyer 1992 and Leconte 1996; on *Picnic*, see Cohan 1991.

2 On Tarzan films, see Essoe 1968, Lacassin 1982, Nesteby 1982, Torgovnick 1990, Morton 1993 and Fury 1994.

3 The cycle runs from the 1957 *Le fatiche di Ercole* to 1965, with the odd straggler such as *Combate de gigantes* (1966); the most complete account is in Cammarota 1987. The term 'peplum' (plural 'pepla') was coined by French critics in the early l960s; it derives from a Latinised Greek word meaning a woman's tunic but here refers to the short skirt or kilt worn by the heroes. 'Peplum' is generally understood to refer to the 1958–65 Italian cycle, but is also sometimes used to refer to an earlier Italian one, from *Quo Vadis?* (1912) and especially *Cabiria* (1914) to c.1926, or even to all adventure films set in 'ancient times', including Hollywood films such as *The Ten Commandments, Ben Hur, Cleopatra* and *Conan the Barbarian*. Here however 'peplum' refers only to the 1957–65 cycle.

4 Two studies of these films are Tasker 1993 and Jeffords 1994.

5 The Rambo films are *First Blood* (1982), *Rambo: First Blood Part II* (1985) and *Rambo III* (1988). I shall refer to them as *First Blood, Rambo II* and *Rambo III* respectively.

6 Webster (1979: 105) does note that before this there had been a view that 'the high calves of the negro races prevented full and proportionate development', suggesting – as have comparable arguments about ballet – a particular biological discourse aimed at preserving the whiteness of activities concerned with producing body images supposedly founded on 'classical' precedent.

7 The exception is Bruce Lee, significantly, in the US context, Asian not black African.

8 The earlier cycle had introduced (in *Cabiria* (1914)) the character of Maciste, helper to the unmuscular hero, as a Nubian slave (played by an Italian, Bartolomeo Pagano). So popular was he that he became the most loved character of this and the later cycle – but his blackness was forgotten.

9 See Holmlund (1989) for a discussion of the way femininity and blackness are negotiated in the *Pumping Iron* films.

10 Note also that the Tarzan of the books is described in explicitly classical terms; see Holtsmark 1981.

11 On Sandow, see Chapman 1994.

12 Notably in the use in bodybuilding competitions of the opening of Richard Strauss's symphonic poem based on Nietsche, *Also sprach Zarathustra*.

13 See Appendix for translations, dates and stars of pepla discussed in this chapter.

14 On the role of pain in the Rambo films, see Warner 1992.

15 On *King Kong* as a racist archetype, see Lott 1995.

16 The films are not necessarily set in Vietnam. On 'Vietnam' in 1980s action cinema, see Tasker 1993: *passim*.

17 See Williams 1990.

18 This was the subject of an essay by John Tinkler, written for my MA course.

19 This seems in fact more like a reference to Nazism than Italian fascism, something that happens elsewhere in pepla, notably in the Teutonic characterisation of the dictator-led Gauls in *La schiava di Roma*, one of the most pro-Roman films of the cycle. One might note that dealing with fascism in terms of Nazism is also common in many of Italy's most internationally renowned films, from *Roma città aperta* (Rome Open City (1945)) to *Pasqualino Settebellezze* (Seven Beauties (1976)).

20 See note 19.

21 The word used is 'stirpe', most strictly translated as 'stock' and a key term in Italian fascist rhetoric.

22 Most were indeed US – Steve Reeves, Gordon Scott, Gordon Mitchell, Mickey Hargitay – but when not, they had names that could be taken for US. This is not just a question of niceties such as assuming a Canadian (Samson Burke) or a Briton (Reg Park, Joe Robinson) to be US, but of Italians changing their names (Adriano Bellini becoming Kirk Morris, Sergio Ciani Alan Steel) and moreover US bodybuilders adopting, if necessary, more US-sounding, that is, Anglo names, so that even the Italian-American Lou Degni became Mark Forrest while Ed Holovchik became Ed Fury. These name changes suggest the degree to which Americanness was perceived as indubitable whiteness.

23 I am grateful to Luciano Cheles for reminding me of this connection.

5 'There's nothing I can do! Nothing!'

1 Episode 1 was double length.

2 For more discussion of both the ratings and the critical response, see Brandt 1994.

3 For a more detailed, episode-by-episode synopsis, see Granada Television 1983.
4 An invented name, as are Pankot and Mirat.
5 On women and soap opera see, *inter alia*, Geraghty 1991.
6 Critics of Right and Left read it in the same way, only with different amounts of approval; nor was it only professional critics who saw it thus. Joy Cameron wrote to *The Scotsman* (2 February 1984: 10) complaining that the enthusiasm for *Jewel* could be readily explained: 'Knocking the British Empire is now a trendy thing to do', while Brigadier Eric Langlands in the *Daily Telegraph* (18 January 1984: 14) considered it 'in parts very anti-British'. (I should like to acknowledge here the presentation to my 1992 MA group by Jeff Crouse and Mikel Kovel on the reception of *The Jewel in the Crown*.)
7 Chief minister to the Nawab of Mirat; Ahmed Kassim is his assistant.
8 Orderly who acts as nurse to Ronald after his disfigurement.
9 Russian woman who runs a sanctuary for the sick and dying at Mayapore.
10 German Jewish émigrée doctor in Mayapore.
11 The Bibighar gardens are next to the house where Daphne lives with Lady Chatterjee and were the property of the white man who built Lady Chatterjee's house. He housed his Indian mistress in the gardens and it was there, as Daphne tells Hari, that he killed his mistress and her Indian lover when he found them making love. It is thus a place of romance and danger to which Daphne introduces Hari.
12 And indeed in the medium, since many have argued that sound dominates over image in television (e.g. Ellis 1982, Altman 1986).
13 This was first pointed out to me by Steven McGrath on a graduate course in which we were studying *Jewel*.
14 This shot was in the serial as originally broadcast, but is not in the retail video set.

6 White death

1 On Robinson, see Harker 1988 and on Cameron, see Hopkinson 1986. On the dead child genre in photography, see Bartram 1985: 151–3.
2 In the edition of *Black Looks* from which this is taken, a printing error makes it look as if this is a quotation from my own writing. Would that it were.
3 The whiteness of *Grand Canyon* is also discussed in Carby 1993 and Giroux 1993.
4 They run through Annette Kuhn's reader (1990) on contemporary science fiction as a key reference point and a reader devoted entirely to *Blade Runner* is in preparation.
5 Are androids ever not white? The idea of a human who isn't human has a very white feel to it. Arnold Schwarzenegger, for a period the top box office star, with a very white, not to say fascist image, repeatedly played androids (*The Terminator* (1984), *Terminator 2* (1991)), someone who might not be human (*Total Recall* (1990)) and a celluloid hero who comes to offscreen life (*The Last Action Hero* (1993)). The eponymous hero of *Robocop* is blond, blue-eyed, mild-mannered, lethal and half-human.
6 Several commentators (e.g. Ruppert 1989: 10–11, Silverman 1991: 114–16) have pointed out that a parallel is suggested between the replicants and African-Americans. When someone refers to the replicants as 'skin jobs', Deckard's voice-over (in the first release version) informs us that this is the equivalent of

saying 'nigger' in an earlier age. The replicant Roy asks Deckard if he knows what it is like to be a slave. The parallel however does not necessarily imply that replicants are African-Americans but that they are in the same position as the latter once were. The replicants are the (skin-identified) oppressed of the future, just as whites fear they may be, or even already are: in the future, what with the teeming hordes and the remorseless march of affirmative action, we shall be the niggers.

7 On the two versions, see Strick 1992.

8 Several of the people interviewed about *Falling Down* by John Gabriel saw this scene as 'decisive' (1996: 141), one, Dave, arguing that 'D-FENS shot [the neo-Nazi] because he saw himself in [him]'; in Dave's words, 'that man brought something out of the Michael Douglas character . . . [D-FENS] couldn't stand to see his reflection in the other bloke' (ibid.: 145).

9 At a seminar at UC Santa Cruz.

10 As Ying-Len Chua, working on a PhD at Warwick University on the representation of lesbians and gay men of colour, has observed, even on the rare occasions when the latter are represented, it is virtually never with the suggestion that they belong to a network or community of other lesbians and gay men of colour and they nearly always have a white lover – the world of homosexuality remains a white one.

Bibliographies

I The matter of whiteness

Alba, Richard D. (1990) *Ethnic Identity: The Transformation of White America*, New Haven: Yale University Press.

Allen, Theodore W. (1994) *The Invention of the White Race* Volume I, London: Verso.

Austen, Jane (1985) *Northanger Abbey*, London: Penguin. (First published 1818.)

Bailey, Cameron (1988) 'Nigger/Lover: the Thin Sheen of Race in *Something Wild*', *Screen* 29(4): 28–40.

Bakshi, Parminder (1994) 'The Politics of Desire: E. M. Forster's Encounters with India' in Davies, Tony and Wood, Nigel (eds) *A Passage to India*, Buckingham: Open University Press, 23–64.

Battersby, Christine (1989) *Gender and Genius: Towards a Feminist Aesthetics*, London: The Women's Press.

Berger, Carl (1966) 'The True North Strong and Free' in Russell, Peter (ed.) *Nationalism in Canada*, Toronto: McGraw-Hill, 3–26.

Berenstein, Rhona J. (1996) 'White Skin, White Masks: Race, Gender, and Monstrosity in Jungle-Horror Cinema' in *Attack of the Leading Ladies: Gender, Sexuality, and Spectatorship in Classic Horror Cinema*, New York: Columbia University Press, 160–204.

Bernal, Martin (1987) *Black Athena: The Afroasiatic Roots of Classical Civilisation*, Volume I: 'The Fabrication of Ancient Greece 1785–1985', London: Free Association Books.

Bhabha, Homi (1983) 'The Other Question: the Stereotype and Colonial Discourse', *Screen* 24(6): 18–36.

Blackburn, Julia (1979) *The White Men: The First Response of Aboriginal People to the White Man*, London: Orbis.

Bogle, Donald (1973) *Toms, Coons, Mulattoes, Mammies and Bucks: An Interpretive History of Blacks in American Films*, New York: Viking Press.

Bonnett, Alastair (1993) 'Forever "White"? Challenges and Alternatives to a "Racial" Monolith', *New Community* 20(1): 173–80.

Bonnett, Alastair (1996) '"White Studies": The Problems and Projects of a New Research Agenda', *Theory, Culture and Society* 13(2): 145–55.

Bruckner, Pascal (1983) *Le sanglot de l'homme blanc: Tiers-Monde, culpabilité, haine de soi*, Paris: Editions du Seuil.

Buscombe, Edward (ed.)(1988) *The BFI Companion to the Western*, London: André Deutsch/BFI Publishing.

Carby, Hazel V. (1992) 'The Multicultural Wars' in Dent, Gina (ed.) *Black Popular Culture*, Seattle: Bay Press, 187–99.

Carby, Hazel (1993) 'Encoding White Resentment: *Grand Canyon* – a Narrative for Our Times' in McCarthy and Crichlow: 236–47.

(charles), Helen (1992) 'Whiteness – the Relevance of Politically Colouring the "Non"' in Hinds, Hilary, Phoenix, Ann and Stacey, Jackie (eds) *Working Out: New Directions for Women's Studies*, London: Falmer, 29–35.

(charles), Helen (1993) '"Queer Nigger": Theorizing "White" Activism' in Bristow, Joseph and Wilson, Angelia R. (eds) *Activating Theory: Lesbian, Gay, Bisexual Politics*, London: Lawrence & Wishart, 97–106.

Cleaver, Eldridge (1969) *Soul on Ice*, London: Jonathan Cape.

Coetzee, J. M. (1988) *White Writing: On the Culture of Letters in South Africa*, New Haven: Yale University Press.

Cumberbatch, Guy and Negrine, Ralph (1992) *Images of Disability on Television*, London: Routledge.

Davy, Kate (1995) 'Outing Whiteness', *Theatre Journal* 47: 189–205.

D'Emilio, John and Freedman, Estelle B. (1988) *Intimate Matters: A History of Sexuality in America*, New York: Harper & Row.

Dines, Gail and Humez, Jean M. (eds) (1995) *Gender, Race and Class in Media*, Thousand Oaks: Sage.

DiPiero, Thomas (1994) 'White Men Aren't', *Camera Obscura* 30: 113–37.

Doane, Mary Anne (1991) 'Dark Continents: Epistemologies of Racial and Sexual Difference in Psychoanalysis and the Cinema' in *Femmes Fatales: Feminism, Film Theory, Psychoanalysis*, New York: Routledge, 209–48.

Dyer, Richard (1988) 'White', *Screen* 29(4): 44–65. (Reprinted in Dyer 1993a: 141–63.)

Dyer, Richard (1993a) *The Matter of Images: Essays on Representations*, London: Routledge.

Dyer, Richard (1993b) 'Seen To Be Believed: Problems in the Representation of Gay People as Typical' in Dyer 1993a: 19–51.

Dyer, Richard (1995) 'Into the Light: The Whiteness of the South in *The Birth of a Nation*' in King, Richard and Taylor, Helen (eds) *Dixie Debates*, London: Pluto, 165–76.

Dyson, Lynda (1995) 'The Return of the Repressed?: Whiteness, Femininity and Colonialism in *The Piano*', *Screen* 36(3): 267–76.

Fanon, Frantz (1967) *The Wretched of the Earth*, Harmondsworth: Penguin. (First published in French in 1961.)

Fanon, Frantz (1970) *Black Skin, White Mask*, London: Paladin. (First published in French in 1952.)

Feagin, Joe R. and Hernán, Vera (1995) *White Racism: The Basics*, New York: Routledge.

Frankenberg, Ruth (1993) *White Women, Race Matters: The Social Construction of Whiteness*, London: Routledge.

Frankenberg, Ruth and Mani, Lata (1993) 'Crosscurrents, crosstalk: race, "post-coloniality" and the politics of location', *Cultural Studies* 7(2): 292–310.

Fredrickson, George M. (1981) *White Supremacy: A Comparative Study in American and South African History*, New York: Oxford University Press.

Frye, Marilyn (1983) 'On Being White: Thinking Toward a Feminist Understanding of Race and Race Supremacy' in *The Politics of Reality: Essays in Feminist Theory*, Trumansburg NY: Crossing Press, 110–27.

Fryer, Peter (1984) *Staying Power: The History of Black People in Britain*, London: Pluto.

Gaines, Jane (1988) 'White Privilege and Looking Relations: Race and Gender in Feminist Film Theory', *Screen* 29(4): 12–27.

Gilman, Sander (1985) *Difference and Pathology: Stereotypes of Sexuality, Race and Madness*, Ithaca: Cornell University Press.

Gossett, Thomas F. (1965) *Race: The History of an Idea in America*, New York: Schocken.

Green, David (1984) 'Classified Subjects: Photography and Anthropology, the Technology of Power', *Ten 8* 14: 30–7.

Green, David (1986) 'Veins of Resemblance: Photography and Eugenics' in Holland, Patricia, Spence, Jo and Watney, Simon (eds) *Photography/Politics: Two*, London: Comedia, 9–21.

Haraway, Donna (1990) 'Reading Buchi Emechta: Contests for Women's Experience in Women's Studies', *Women* 1(3): 240–55.

Harding, Sandra (ed.) (1987) *Feminism and Methodology: Social Science Issues*, Milton Keynes: Open University Press.

Hart, Lynda (1994) *Fatal Women: Lesbian Sexuality and the Mark of Aggression*, London: Routledge.

Hartmann, Paul and Husband, Charles (1974) *Racism and the Mass Media*, London: Davis-Poynter.

Hoch, Paul (1979) *White Hero, Black Beast: Racism, Sexism and the Mask of Masculinity*, London: Pluto.

Hodge, David L. (1975) 'Domination and the Will in Western Thought and Culture' in Hodge, David L., Struckmann, Donald L. and Trost, Lynn Dorland (eds) *Cultural Bases of Racism and Group Oppression*, Berkeley: Two Riders Press, 8–48.

hooks, bell (1991) 'Representing Whiteness: Seeing *Wings of Desire*' in *Yearning: Race, Gender and Cultural Politics*, London: Turnaround, 165–72.

hooks, bell (1992) 'Madonna: Plantation Mistress or Soul Sister?' and 'Representations of Whiteness in the Black Imagination', in *Black Looks: Race and Representation*, Boston: South End Press, 157–64, 165–78.

Horsman, Reginald (1981) *Race and Manifest Destiny: The Origins of Racial Anglo-Saxonism*, Cambridge MA: Harvard University Press.

Ibson, John (1981) 'Virgin Land or Virgin Mary? Studying the Ethnicity of White Americans', *American Quarterly* 33(3): 284–308.

Ignatiev, Noel (interviewee) (1994) 'Treason to Whiteness is Loyalty to Humanity', *Utne Reader*, November/December: 82–6.

JanMohamed, Abdul R. (1985) 'The Economy of Manichean Allegory: The Function of Racial Difference in Colonialist Literature', *Critical Inquiry* 12: 59–87.

Jeater, D. (1992) 'Roast Beef and Reggae Music: The Passing of Whiteness', *New Formations* 18: 107–21.

Jhally, Sut and Lewis, Justin (1992) *Enlightened Racism: 'The Cosby Show', Audiences and the Myth of the American Dream*, Boulder: Westview Press.

Jordan, Winthrop D. (1977) *White over Black: American Attitudes towards the Negro 1550–1812*, New York: Norton. (First published 1968.)

Kaplan, E. Ann (1983) 'Is the Gaze Male?' in *Women and Film: Both Sides of the Camera*, New York: Methuen, 23–35.

Katz, Jackson (1995) 'Advertising and the Construction of Violent White Masculinity' in Dines and Humez: 133–41.

Kealiinohomoku, Joann (1983) 'An Anthropologist Looks at Ballet as a Form of Ethnic Dance' in Copeland, Roger and Cohen, Marshall (eds) *What is Dance?*, Oxford: Oxford University Press, 533–49.

Kovel, Joel (1988) *White Racism: A Psychohistory*, London: Free Association Books. (First published 1970.)

Krajewski, Bruce (1994) 'Wittgenstein's *Remarks on Colour* as Remarks on Racism', *West Coast Line* 28(1–2): 96–108.

Levine, Judith (1994a) 'The Heart of Whiteness: Dismantling the Master's House', *Voice Literary Supplement* 128: 11–16.

Levine, Judith (1994b) 'White Like Me', *Ms.* March–April: 22–4.

Lloyd, David (1991) 'Race under Representation', *Oxford Literary Review* 13(1–2): 62–94.

Lott, Eric (1993) 'White Like Me: Racial Cross-Dressing and the Construction of American Whiteness' in Kaplan, Amy and Pease, Donald (eds) *Cultures of United States Imperialism*, Durham: Duke University Press.

Lovejoy, Arthur O. (1936) *The Great Chain of Being*, Cambridge MA: Harvard University Press.

Lutz, Catherine A. and Collins, Jane L. (1993) *Reading National Geographic*, Chicago: University of Chicago Press.

McCarthy, Cameron and Crichlow, Warren (eds) (1993) *Race, Identity and Representation in Education*, New York: Routledge.

McClintock, Anne (1995) *Imperial Leather: Race, Gender and Sexuality in the Colonial Context*, London: Routledge.

MacDonald, J. F. (1983) *Blacks and White TV: Afro-Americans in Television since 1948*, Chicago: Nelson-Hall.

McIntosh, Peggy (1988) 'White Privilege and Male Privilege: A Personal Account of Coming to See Correspondences through Work in Women's Studies', *Wellesley College Center for Research on Women Working Papers Series* 189. (Reprinted in Andersen, Margaret and Collins, Patricia Hill (eds) *Race, Class, and Gender: An Anthology*, Belmont CA: Wadsworth, 1992, 70–81.)

McNelly, Cleo (1975) 'Natives, Women and Claude Lévi-Strauss: A Reading of *Tristes tropiques* as Myth', *The Massachusetts Review*, Winter: 7–29.

Malbert, Roger and Coates, Julia (1991) *Exotic Europeans*, London: South Bank Centre.

Malcomson, Scott L. (1991) 'Heart of Whiteness', *Voice Literary Supplement* March: 10–14.

Mayne, Judith (1993) 'White Spectatorship and Genre-mixing' in *Cinema and Spectatorship*, London: Routledge, 142–56.

Michaels, Walter Benn (1989) 'The Souls of White Folks' in Scarry, Elaine (ed.) *Literature and the Body*, Baltimore: Johns Hopkins University Press, 185–209.

Miles, Robert and Phizacklea, Annie (1984) *White Man's Country: Racism in British Politics*, London: Pluto.

Morgan, Tracy (1994) 'Pages of Whiteness: Race, Physique Magazines and the Emergence of Gay Public Culture, 1955–1960', *Found Object* 1(4): 108–26.

Morrison, Toni (1992) *Playing in the Dark: Whiteness and the Literary Imagination*, Cambridge, MA: Harvard University Press.

Mosse, George L. (1978) *Towards the Final Solution: A History of European Racism*, London: J. M. Dent.

Mulvey, Laura (1975) 'Visual Pleasure and Narrative Cinema', *Screen* 16(3): 6–18.

Nairn, Tom (1968) 'The Three Dreams of Scottish Nationalism', *New Left Review* 49: 3–18.

Nead, Lynda (1988) *Myths of Sexuality: Representations of Women in Victorian Britain*, Oxford: Blackwell.

Nederveen Pieterse, Jan (1992) *White on Black: Images of Africa and Blacks in Western Popular Culture*, New Haven: Yale University Press.

Norman, Philip (1992) 'The Shock of the Neo', *Weekend Guardian* 30–31 May: 4–6.

O'Kelley, C. G. and Bloomquist, L. E. (1976) 'Women and Blacks on TV', *Journal of Communication* 26, 179–92.

Omi, Michael and Winant, Howard (1986) *Racial Formation in the United States*, New York: Routledge.

Owens, Craig (1983) 'The Discourse of Others: Feminists and Postmodernism' in Foster, Hal (ed.) *The Anti-Aesthetic: Essays on Postmodern Culture*, Port Townsend WA: Bay Press, 57–82.

Parekh, Bikhu (1994) 'Superior People: The Narrowness of Liberalism from Mill to Rawls', *Times Literary Supplement* 4743: 11–13.

Perkins, T. E. (1979) 'Rethinking Stereotypes' in Barrett, Michèle, Corrigan, Philip, Kuhn, Annette and Wolff, Janet (eds) *Ideology and Cultural Production*, London: Croom Helm, 135–59.

Phillips, Mike (1993) 'White Heroes in the Hall of Fame', *Black Film Bulletin* 1(4): 30.

Piper, Adrian (1991) 'Passing for White, Passing for Black', *Transition* 58: 4–32.

Poliakov, Léon (1974) *The Aryan Myth: A History of Racist and Nationalist Ideas in Europe*, London: Heinemann/Sussex University Press.

Rentschler, Eric (1990) 'Mountains and Modernity: Relocating the Bergfilm', *New German Critique* 51: 137–61.

Ridgeway, James (1990) *Blood in the Face: The Ku Klux Klan, Aryan Nations, Nazi Skinheads and the Rise of the New White Culture*, New York: Thunder's Mouth Press.

Robinson, Cedric J. (1983) *Black Marxism: The Making of the Black Radical Tradition*, London: Zed Books.

Roediger, David R. (1991) *The Wages of Whiteness: Race and the Making of the American Working Class*, London: Verso.

Roediger, David R. (1994) *Towards the Abolition of Whiteness: Essays on Race, Politics and Working Class History*, London: Verso.

Roman, Leslie G. (1993) 'White Is a Color! White Defensiveness, Postmodernism, and Anti-racist Pedagogy' in McCarthy and Crichlow: 71–88.

Ross, Karen (1995) *Black and White Media*, Oxford: Polity.

Rouillé, André and Marbot, Bernard (1986) *Le Corps et son image: photographies du dix-huitième siècle*, Paris: Contrejour.

Saïd, Edward (1978) *Orientalism*, London: Routledge & Kegan Paul.

Saïd, Edward (1993) *Culture and Imperialism*, London: Chatto & Windus.

Saxton, Alexander (1990) *The Rise and Fall of the White Republic: Class Politics and Mass Culture in Nineteenth-Century America*, London: Verso.

Scarry, Elaine (1985) *The Body in Pain: The Making and Unmaking of the World*, New York: Oxford University Press.

Seiter, Ellen (1995) 'Different Children, Different Dreams: Racial Representation in Advertising' in Dines and Humez: 99–108.

Sharpe, Jenny (1993) *Allegories of Empire: The Figure of Woman in the Colonial Text*, Minneapolis: University of Minnesota Press.

Shohat, Ella (1991) 'Gender and the Culture of Empire: Toward a Feminist Ethnography of the Cinema', *Quarterly Review of Film and Video* 13(1–2): 45–84.

Shohat, Ella and Stam, Robert (1994) *Unthinking Eurocentrism: Multiculturalism and the Media*, London and New York: Routledge.

Skidmore, Thomas E. (1974) *Black into White: Race and Nationality in Brazilian Thought*, New York: Oxford University Press.

Slotkin, Richard (1973) *Regeneration through Violence: The Mythology of the American Frontier 1600–1860*, Norman: University of Oklahoma Press.

Slotkin, Richard (1988) 'Violence' in Buscombe 1988: 232–6.

Smith, Henry Nash (1950) *Virgin Land: The American West as Symbol and Myth*, New York: Knopf.

Stanley, Liz (1977) 'The Problematic Nature of Sexual Meanings', Manchester: British Sociological Association Sexuality Study Group.

Stollery, Martin (1994) *Alternative Empires: Soviet Montage Cinema, the British Documentary Movement and Colonialism*, University of Warwick PhD thesis.

Taylor, Helen (1989) *Scarlett's Women: 'Gone with The Wind' and its Female Fans*, London: Virago.

Thomas, Deborah (1990) '*Blonde Venus*', *Movie* 34/5: 7–15.

Tompkins, Jane (1992) *West of Everything: The Inner Life of Westerns*, New York: Oxford University Press.

Troyna, Barry (1981) 'Images of Race and Racist Images in the British News Media' in Halloran, J. D. (ed.) *Mass Media and Mass Communications*, Leicester: Leicester University Press.

van Dijk, T. A. (1987) *Communicating Racism*, London: Sage.

Veblen, Thorstein (1899) *The Theory of the Leisure Class: An Economic Study of Institutions*, New York: Macmillan.

Vigarello, Georges (1989) 'The Upward Training of the Body from the Age of Chivalry to Courtly Civility' in Feher, Michael, with Naddaf, Ramona and Tazi, Nadia (eds) *Fragments for a History of the Human Body* Part II, New York: Zone, 148–99.

Village Voice (1993) 'White Like Who?' dossier, 18 May: 24–41.

Ware, Vron (1992) *Beyond the Pale: White Women, Racism and History*, London: Verso.

Weiskel, Thomas (1976) *The Romantic Sublime*, Baltimore: John Hopkins University Press.

Wilson, C. J. and Gutiérrez, F. (1985) *Minorities and Media*, Beverley Hills: Sage.

Young, Lola (1996) *Fear of the Dark: 'Race', Gender and Sexuality in the Cinema*, London: Routledge.

Zimet, S. G. (1976) *Print and Prejudice*, London: Hodder & Stoughton.

2 Coloured white, not coloured

Allen, Louise (1995) '*Salmonberries*: Consuming k d lang' in Wilton 1995: 70–84.

Allen, Theodore W. (1994) *The Invention of the White Race* Volume I: 'Racial Oppression and Social Control', London: Verso.

Angeloglou, Maggie (1970) *A History of Make-up*, London: Studio Vista.

Barthes, Roland (1965) *Le Degré zéro de l'écriture*, Paris: Gonthier. (First published in 1953.)

Bastide, Roger (1967) 'Color, Racism, and Christianity', *Daedalus* 96(2): 312–27.

Bernal, Martin (1987) *Black Athena: The Afroasiatic Roots of Classical Civilisation* Volume I: 'The Fabrication of Ancient Greece 1785–1985', London: Free Association Books.

Bernard, Bruce (1987) *The Queen of Hearts*, London: MacDonald Orbis.

Birren, Faber (1963) *Color: A Survey in Words and Pictures*, New Hyde Park NY: University Books.

Boime, Albert (1990) *The Art of Exclusion: Representing Blacks in the Nineteenth Century*, Washington: Smithsonian Institution Press.

Bonnett, Alistair (1993) 'Forever "White"? Challenges and Alternatives to a "Racial" Monolith', *New Community* 20(1): 173–80.

Bright, Susie (1993) 'White Sex', *Village Voice*, 18 May: 34–5.

Child, Francis James (ed.) (1965) *The English and Scottish Popular Ballads*, New York: Cooper Square Publishers. (First published 1882–4.)

Curtis, Liz (1984) *Nothing But the Same Old Story: The Roots of Anti-Irish Racism*, London: Information on Ireland.

Curtis, L. Perry Jnr. (1971) *Apes and Angels: The Irishman in Victorian Caricature*, Newton Abbot: David & Charles.

Dikötter, Frank (1991) *The Discourse of Race in Modern China*, London: Hurst.

Evarts, Arrah B. (1919) 'Color Symbolism', *Psychoanalytic Review* 6: 129–34.

Foucault, Michel (1975) *Surveiller et punir*, Paris: Gallimard.

Gage, John (1993) *Colour and Culture: Practice and Meaning from Antiquity to Abstraction*, London: Thames & Hudson.

Gaines, Jane (1988) 'White Privilege and Looking Relations: Race and Gender in Feminist Film Theory', *Screen* 29(4): 12–27.

Gergen, Kenneth J. (1967) 'The Significance of Skin Color in Human Relations', *Daedalus* 96(2): 390–406.

Gilman, Sander (1991) *The Jew's Body*, New York: Routledge.

Goethe, Johann Wolfgang von (1840) *Theory of Colour*, London: John Murray. (Translated by Charles Locke Eastlake; first published in German in 1810.)

Goldberg, David Theo (ed.) (1990) *Anatomy of Racism*, Minneapolis: University of Minnesota Press.

Goldberg, David Theo (1993) *Racist Culture: Philosophy and the Politics of Meaning*, Oxford: Blackwell.

Grimes, William (1994) 'The Man Who Rendered Jesus for the Age of Duplication', *New York Times*, 10 September, Section C: 3,18.

Gummere, Francis B. (1889) 'On the Symbolic Use of the Colors Black and White in Germanic Tradition', *Haverford College Studies* 1: 112–62.

Haggard, H. Rider (1958) *King Solomon's Mines*, Harmondsworth: Puffin. (First published 1885.)

Haley, Shelley P. (1994) 'Classical Clichés', *Women's Review of Books* 12(1): 26–7.

Hall, Lesley A. (1991) *Hidden Anxieties: Male Sexuality, 1900–1950*, Cambridge: Polity.

Hamer, Mary (1993) *Signs of Cleopatra: History, Politics, Representation*, London: Routledge.

Hamer, Mary (1996) 'Black *and* White? Viewing Cleopatra in 1862' in West, Shearer (ed.) *The Victorians and Race*, Aldershot: Scolar Press.

Heather, P. J. (1948) 'Colour Symbolism', *Folk Lore* 59: 165–83.

Hodge, John L. (1990) 'Equality: Beyond Dualism and Oppression' in Goldberg 1990: 89–107.

Hodge, John L., Struckmann, Donald L. and Trost, Lynn Dorland (eds) (1975) *Cultural Bases of Racism and Group Oppression*, Berkeley: Two Riders Press.

hooks, bell (1982) *Ain't I a Woman: Black Women and Feminism*, Boston: South End Press.

hooks, bell (1992) 'Representations of Whiteness', in *Black Looks: Race and Representation*, Boston: South End Press, 195–78.

Hughes-Hallett, Lucy (1990) *Cleopatra: Histories, Dreams and Distortions*, London: Bloomsbury.

Jenkyns, Richard (1980) *The Victorians and Ancient Greece*, Oxford: Basil Blackwell.

Jordan, Winthrop (1977) *White over Black: American Attitudes Towards the Negro*

1550–1812, New York: Norton. (First published University of North Carolina Press, 1968.)

Kovachevski, Christo (1991) *The Madonna in Western Painting*, London: Cromwell Editions and Sofia: K & M Publishing.

Kovel, Joel (1988) *White Racism: A Psychohistory*, London: Free Association Books. (First published 1970.)

Lebow, Richard Ned (1976) *White Britain and Black Ireland: The Influence of Stereotypes on Colonial Policy*, Philadelphia: Institute for the Study of Human Issues.

Lerner, Michael (1993) 'Jews Are Not White', *Village Voice*, 18 May: 33–4.

Lowe, Donald M. (1982) *The History of Bourgeois Perception*, Brighton: Harvester.

Malbert, Roger (ed.) (1991) *Exotic Europeans*, London: South Bank Centre.

Maynard, Steven (1994) 'What Color is Your Underwear? Class, Whiteness and Homoerotic Advertising', *Border/Lines* 32: 4–9.

Michaels, Walter Benn (1989) 'The Souls of White Folk' in Scarry, Elaine (ed.) *Literature and the Body*, Baltimore: Johns Hopkins University Press: 185–209.

Miles, Robert (1989) *Racism*, London: Routledge.

Mohanty, Satya P. (1991) 'Drawing the Color Line: Kipling and the Culture of Colonial Rule' in LaCapra, Dominick (ed.) *The Bounds of Race: Perspectives on Hegemony and Resistance*, Ithaca: Cornell University Press, 311–43.

Morrison, Toni (1992) *Playing in the Dark: Whiteness and the Literary Imagination*, Cambridge MA.: Harvard University Press.

Mosse, George (1978) *Toward the Final Solution: A History of European Racism*, London: J.M. Dent.

Poliakov, Léon (1974) *The Aryan Myth: A History of Racist and Nationalist Ideas in Europe*, London: Heinemann/Sussex University Press.

Roediger, David R. (1991) *The Wages of Whiteness: Race and the Making of the American Working Class*, London: Verso.

Sartre, Jean-Paul (1949) 'Orphée noir' in *Situations, III*, Paris: Gallimard, 229–86. (First published as an introduction to Senghor, Léopold Sédar (ed.) *Anthologie de la nouvelle poésie nègre et malagache*, Paris: Presses Universitaires, 1948.)

Saxton, Alexander (1990) *The Rise and Fall of the White Republic: Class Politics and Mass Culture in Nineteenth-Century America*, London: Verso.

Schiller, Gertrud (1971) *Iconography of Christian Art*, London: Lund Humphries. (First published 1966.)

Shaka, Femi (1994) *Colonial and Post-Colonial African Cinema: A Theoretical and Critical Analysis of Discursive Practices*, University of Warwick PhD thesis.

Sloan, Patricia (ed.) (1991) *Primary Sources: Selected Writings on Color from Aristotle to Albers*, New York: Design Press.

Spurgeon, Caroline (1958) *Shakespeare's Imagery and What It Tells Us*, Cambridge: Cambridge University Press.

Stacey, Jackie (1994) *Star Gazing: Hollywood Cinema and Female Spectatorship*, London: Routledge.

Stacey, Jackie (1995) '"If You Don't Play, You Can't Win": *Desert Hearts* and the Lesbian Romance Film' in Wilton 1995: 92–114.

Steinberg, Leo (1983) *The Sexuality of Christ in Renaissance Art and in Modern Oblivion*, New York: Pantheon.

Stowe, Harriet Beecher (1981) *Uncle Tom's Cabin; or, Life Among the Lowly*, Harmondsworth: Penguin. (First published 1852.)

Taylor, Clyde (1988) 'The Master Text and the Jeddi Doctrine', *Screen* 29(4): 96–104.

Trost, Lynn Dorland (1975) 'Western Metaphysical Dualism as an Element in Racism' in Hodge, Struckmann and Trost: 49–89.

Vincendeau, Ginette (1992) 'The Old and the New: Brigitte Bardot in 1950s France', *Paragraph* 15: 73–96.

Wagatsuma, Hiroshi (1967) 'The Social Perception of Skin Color in Japan', *Daedalus* 96(2): 407–43.

Ware, Vron (1992) *Beyond the Pale: White Women, Racism and History*, London: Verso.

Warner, Marina (1976) *Alone of All Her Sex: The Myth and the Cult of the Virgin Mary*, London: Weidenfeld & Nicolson.

Warner, Marina (1994) *From the Beast to the Blonde*, London: Chatto & Windus.

Westmore, Frank and Davidson, Muriel (1976) *The Westmores of Hollywood*, London: W. H. Allen.

Wilton, Tamsin (1995) *Immortal, Invisible: Lesbians and the Moving Image*, London: Routledge.

Young, Lola (1996) *Fear of the Dark: 'Race', Gender and Sexuality in the Cinema*, London: Routledge.

3 The light of the world

Altman, Rick (1984) 'Towards a Theory of the History of Representational Technologies', *Iris* 2(2): 111–24.

Alton, John (1949) *Painting with Light*, New York: Macmillan.

Andrew, Dudley (1981) '*Broken Blossoms*: The Art and the Eros of a Perverse Text', *Quarterly Review of Film Studies* 6(1): 81–90.

Arnheim, Rudolf (1956) *Art and Visual Perception*, London: Faber and Faber.

Arroyo, José (1996) '*Money Train*', *Sight and Sound* 6(6) NS: 46–7.

Barnouw, Erik (1984) 'Torrentius and His Camera', *Studies in Visual Communication* 10(3): 22–9.

Bastide, Roger (1967) 'Colour, Racism and Christianity', *Daedalus* 96(2): 312–27.

Battersby, Christine (1989) 'The Idea of Genius', unpublished lecture at the National Portrait Gallery, London, 20 October.

Baxter, Peter (1975) 'On the History and Ideology of Film Lighting', *Screen* 16(3): 83–106.

Bergman, Gösta M. (1977) *Lighting in the Theatre*, Stockholm: Almqvist & Wiksell International.

Bernal, Martin (1987) *Black Athena: The Afroasiatic Roots of Classical Civilisation*, volume I, London: Free Association Books.

Bordwell, David, Staiger, Janet and Thompson, Kristin (1985) *The Classical Hollywood Cinema: Film Style and Mode of Production to 1960*, New York: Columbia University Press.

Brownlow, Kevin (1968) *The Parade's Gone By*, London: Secker & Warburg.

Bynum, W. F., Brown, E. J. and Porter, Roy (1981) *Dictionary of the History of Science*, London: Macmillan.

Chanan, Michael (1980) *The Dream that Kicks: The Prehistory and Early Years of Cinema in Britain*, London: Routledge & Kegan Paul.

Clair, Jean (ed.) (1994) *L'Âme au corps: arts et sciences 1793–1993*, Paris: Gallimard.

Clarke, Michael (1981) *The Tempting Prospect: A Social History of English Watercolours*, London: British Museum.

Coe, Brian (1981) *The History of Movie Photography*, London: Ash & Grant.

Coleman, A. D. (1985) 'Lentil Soup', *Et cetera* Spring: 19–31.

Coutard, Raoul (1966) 'Light of Day', *Sight and Sound* 35 (1): 9–11.

De Maré, Eric (1970) *Photography*, Harmondsworth: Penguin. (First published 1957.)

Dijkstra, Bram (1986) *Idols of Perversity: Fantasies of Feminine Evil in Fin-de-siècle Culture*, New York: Oxford University Press.

Dyer, Richard (1978) 'Resistance through Charisma: Rita Hayworth and *Gilda*' in Kaplan, E. Ann (ed.) *Women in Film Noir*, London: British Film Institute, 91–9.

Dyer, Richard (1993) 'A White Star', *Sight and Sound* 3(8) NS: 22–5.

Dyer, Richard (1996) 'Into the Light: the Whiteness of the South in *The Birth of a Nation*' in King, Richard H. and Taylor, Helen (eds) *Dixie Debates*, London: Pluto, 165–76.

Dyson, Lynda (1996) 'The Return of the Repressed? Whiteness, Femininity and Colonialism in *The Piano*', *Screen* 36 (3): 267–76.

Edwards, Elizabeth (ed.) (1992) *Anthropology and Photography 1860–1920*, New Haven: Yale University Press.

Factor, M. (1937) 'Standardization of Motion Picture Make-up', *Journal of the Society of Motion Picture Engineers* 28(1): 52–62.

Fanon, Frantz (1970) *Black Skin, White Mask*, London: Paladin. (First published in French in 1952.)

Fielding, Raymond (ed.) (1967) *A Technological History of Motion Pictures and Television*, Berkeley: University of California Press.

Foucault, Michel (1975) *Surveiller et punir. Naissance de la prison*, Paris: Gallimard.

Foucault, Michel (1980) 'The Eye of Power' in Gordon, Colin (ed.) *Power/ Knowledge: Selected Interviews and Other Writings 1972–1977*, New York: Harvester, 146–65.

French, Brandon (1978) *On the Verge of Revolt*, New York: Frederick Ungar.

Frye, Marilyn (1983) 'On Being White: Thinking Toward a Feminist Understanding of Race and Race Supremacy' in *The Politics of Reality: Essays in Feminist Theory*, Trumansburg NY: Crossing Press, 110–27.

Gage, John (1993) *Colour and Culture: Practice and Meaning from Antiquity to Abstraction*, London: Thames & Hudson.

Gaines, Jane (1988) 'White Privilege and Looking Relations: Race and Gender in Feminist Film Theory', *Screen* 29(4): 12–27.

Ginsburg, Madeleine (1981) *Wedding Dress 1740–1970*, London: HMSO.

Gish, Lillian with Pinchot, Anne (1969) *The Movies, Mr. Griffith and Me*, New York: Prentice-Hall.

Green, David (1984) 'Classified Subjects', *Ten:8* 14: 30–7.

Green, David (1986) 'Veins of Resemblance: Photography and Eugenics' in Holland, Patricia, Spence, Jo and Watney, Simon (eds) *Photography/Politics: Two*, London: Comedia, 9–21.

Greenhill, Richard, Murray, Margaret and Spence, Jo (1977) *Photography*, London: Macdonald.

Grover, Jan Zita (1995) 'Visible Lesions: Images of the PWA' in Creekmur, Corey K. and Doty, Alex (eds) *Out in Culture: Gay, Lesbian, and Queer Essays on Popular Culture*, Durham: Duke University Press, 355–81.

Gunning, Tom (1991) *D. W. Griffith and the Origins of American Narrative Cinema*, Urbana/Chicago: University of Illinois Press.

Handley, C. W. (1935) 'Lighting for Technicolor Motion Pictures', *Journal of the Society of Motion Picture Engineers*, 25(5): 423–31.

Handley, C. W (1967) 'History of Motion-Picture Studio Lighting' in Fielding 1967: 120–4. (First published in the *Journal of the Society of Motion Picture and Television Engineers*, October 1954.)

Hansen, Miriam (1991) *Babel and Babylon: Spectatorship in American Silent Film*, Cambridge MA: Harvard University Press.

Happé, L. Bernard (1975) *Basic Motion Picture Technology*, London: Focal Press.

Harrell, Al (1986) 'The Look of *The Color Purple*', *American Cinematographer* February: 51–6.

Henley, Nancy M. (1977) *Body Politics*, Englewood Cliffs, NJ: Prentice-Hall.

Hernton, Calvin C. (1969) *Sex and Racism*, London: André Deutsch.

Higashi, Sumiko (1978) *Virgins, Vamps and Flappers: The American Silent Movie Heroine*, Montreal: Eden Press.

Hills, Paul (1987) *The Light of Early Italian Painting*, New Haven: Yale University Press.

Hoadley, Ray (1939) *How They Make a Motion Picture*, New York: Thomas Y. Crowell.

Hodge, John L., Struckmann, Donald K. and Trost, Lynn Dorland (eds) (1975) *Cultural Bases of Racism and Group Oppression*, Berkeley: Two Riders Press.

Hollander, Anne (1989) *Moving Pictures*, New York: Knopf.

Ihen, Wiard B. and Atwater, D. W. (1925) 'The Artistic Utilization of Light in the Photography of Motion Pictures', *Transactions of the Society of Motion Picture Engineers* 21: 21–37.

Jacobs, Lea (1991) 'Lasky Lighting' in Usai, Paolo Cerchi and Codelli, Lorenzo (eds) *L'eredità De Mille*, Rome: Edizioni Biblioteca dell'Imagine, 250–9.

Jones, Bernard E. (1911) *Cassell's Cyclopaedia of Photography*, London: Cassell.

Jordan, Winthrop D. (1977) *White over Black: American Attitudes towards the Negro, 1550–1812*, New York: Norton.

Kent, Neil (1987) *The Triumph of Light and Nature: Nordic Art 1740–1940*, London: Thames & Hudson.

Kindem, Gorham A. (1979) 'Hollywood's Conversion to Color: The Technological, Economic and Aesthetic Factors', *Journal of the University Film Association* 31(2): 29–36.

Koschatzky, Walter (1970) *Watercolour: History and Technique*, New York/Toronto: McGraw-Hill.

Krauss, Rosalind (1978) 'Tracing Nadar', *October* 5: 29–47.

LaCapra, Dominick (ed.) (1991) *The Bounds of Race: Perspectives on Hegemony and Resistance*, Ithaca: Cornell University Press.

Lalvani, Suren (1993) 'Photography, Epistemology and the Body'', *Cultural Studies* 7(1): 442–65.

Lemagny, Jean-Claude and Rouillé, André (eds) (1987) *A History of Photography: Social and Cultural Perspectives*, Cambridge: Cambridge University Press.

Lesage, Julia (1985) 'Artful Racism, Artful Rape: Griffith's *Broken Blossoms*' in Steven, Peter (ed.) *Jump Cut: Hollywood, Politics and Counter-Cinema*, Toronto: Between the Lines: 247–68.

Liggett, John (1974) *The Human Face*, London: Constable.

Lowe, Donald M. (1982) *The History of Bourgeois Perception*, Brighton: Harvester.

Lynton, L. (1988) '*School Daze* – Black College is Background', *American Cinematographer* 69(2): 67–70, 72.

McBride-Mellinger, Maria (1993) *The Wedding Dress*, New York: Random House.

McDannell, Colleen and Lang, Bernhard (1988) *Heaven: A History*, New Haven: Yale University Press.

Maas, Jeremy (1984) *Holman Hunt and the Light of the World*, Aldershot: Wildwood House.

Maddow, Ben (1977) *Faces: A Narrative History of the Portrait in Photography*, Boston: New York Graphic Society. (Photographs compiled and edited by Constance Sullivan).

Malkiewicz, Kris (1986) *Film Lighting*, New York: Prentice-Hall.

May, Lary (1983) *Screening Out the Past: The Birth of Mass Culture and the Motion Picture Industry*, Chicago: University of Chicago Press.

Medved, Harry and Michael (1984) *The Hollywood Hall of Shame: The Most Expensive Flops in Movie History*, New York: Putnam.

Miles, Robert (1989) *Racism*, London: Routledge.

Millerson, Gerald (1972) *The Technique of Lighting for Television and Motion Pictures*, London: Focal Press.

Mills, Frederick S. (1921) 'Film Lighting as a Fine Art: Explaining Why the Fireplace Glows and Why Films Stars Wear Halos', *Scientific American* 124: 148, 157–8.

Milner, Victor (1930) 'Painting with Light' in Hall, Hal (ed.) *Cinematographic Annual* 1: 91–108.

Mohanty, Satya P. (1991) 'Drawing the Colour Line: Kipling and the Culture of Colonial Rule' in LaCapra: 311–43.

Mulvey, Laura (1975) 'Visual Pleasure and Narrative Cinema', *Screen* 16(1): 6–18.

Nead, Lynda (1988) *Myths of Sexuality: Representations of Women in Victorian Britain*, Oxford: Basil Blackwell.

Neale, Steve (1985) *Cinema and Technology: Image, Sound, Colour*, London: Macmillan/British Film Institute.

O'Dea, William T. (1958) *The Social History of Lighting*, London: Routledge & Kegan Paul.

Owen, David (1993) *Make Better Home Videos*, Slough: Foulsham.

Reid, Francis (1992) *The Stage Lighting Handbook*, London: A & C Black.

Remise, Jac, Remise, Pascale and van de Walle, Regis (1979) *Magie lumineuse: du théâtre d'ombres à la lanterne magique*, Paris: Ballard.

Rentschler, Eric (1990) 'Mountains and Modernity: Relocating the Bergfilm', *New German Critique* 51: 137–63.

Revault d'Allones, Fabrice (1991) *La Lumière au cinéma*, Paris: Seuil/Cahiers du cinéma.

Reynolds, Graham (1971) *A Concise History of Watercolour*, London: Thames & Hudson.

Ronchi, V. (1970) *The Nature of Light: A Historical Survey*, London: Heinemann.

Rosen, Marjorie (1974) *Popcorn Venus: Women, Movies and the American Dream*, New York: Avon Books.

Rouillé, André and Marbot, Bernard (1986) *Le Corps et son image: photographies du dix-neuvième siècle*, Paris: Contrejour.

Russell, Sharon A. (1973) *Semiotics and Lighting: A Study of Six Modern French Cameramen*, Boston: UMI Research Press.

Salt, Barry (1983) *Film Style and Technology: History and Analysis*, London: Starword.

Seiberling, Grace with Bloore, Carolyn (1986) *Amateurs, Photography and the Mid-Victorian Imagination*, Chicago: University of Chicago Press.

Simonson, Lee (1968) 'The Ideas of Adolphe Appia' in Bentley, Eric (ed.) *Theory of the Modern Stage*, Harmondsworth: Penguin, 27–50.

Slive, Seymour (1962) 'Realism and Symbolism in Seventeenth-Century Dutch Painting', *Daedalus* Summer: 469–500.

Stacey, Jackie (1994) *Star Gazing: Hollywood Cinema and Female Spectatorship*, London: Routledge.

Steele, Valerie (1985) *Fashion and Eroticism*, Oxford: Oxford University Press.

Sternberg, Josef von (1955–6) 'More Light', *Sight and Sound* 25(2): 70–5, 109–10.

Stowe, Harriet Beecher (1981) *Uncle Tom's Cabin; or, Life Among the Lowly*, Harmondsworth: Penguin. (First published 1852.)

Stroebel, Leslie and Zakia, Richard (eds) (1993) *The Focal Encylopedia of Photography* (3rd ed), Boston: Focal Press.

Tagg, John (1988) *The Burden of Representation: Essays on Photographies and History*, London: Macmillan.

Tey, Jocelyn (1980) 'Silent Screen Heroines: Idealisations on Film', *American Classic Screen* 5(1): 6–8.

Trachtenberg, Alan (1983) 'Brady's Portraits', *The Yale Review* 73(2): 230–53.

Underhill, James (1995) *Angels*, Shaftesbury, Dorset: Element.

Valentine, Joseph (1939) 'Make-up and Set Painting Aid New Film', *American Cinematographer* February: 54–6, 85.

Vardac, A. Nicholas (1968) *Stage to Screen: Theatrical Method from Garrick to Griffith*, New York: Benjamin Blom. (First published 1949.)

Veblen, Thorstein (1899) *The Theory of the Leisure Class: An Economic Study of Institutions*, New York: Macmillan.

Walker, Joseph B. and Walker, Juanita (1984) *The Light on Her Face*, Hollywood: ASC Press.

Ward, John and Stevenson, Sara (1986) *Printed Light*, Edinburgh: HMSO.

Warner, Marina (1994) *From the Beast to the Blonde*, London: Chatto & Windus.

Williams, Raymond (1974) *Television: Technology and Cultural Form*, London: Fontana.

Wilson, George (1986) *Narration in Light: Studies in Cinematic Point of View*, Baltimore: Johns Hopkins University Press.

Winston, Brian (1985) 'A Whole Technology of Dyeing: A Note on Ideology and the Apparatus of the Chromatic Moving Image', *Daedalus* 114(4): 105–23.

Wright, Basil (1933) 'Shooting in the Tropics', *Cinema Quarterly* 1(4): 227–8.

4 The white man's muscles

Abbruzzese, Alberto (1983) 'Gli uomini forti e le maestre Pedani: Ideologie e pratiche dell'educazione fisica dal risorgimento al fascismo' in Farassino and Sanguineti: 57–65.

Bristow, Joseph (1991) *Empire Boys: Adventures in a Man's World*, London: HarperCollins.

Brunetta, Gian Piero (1975) *Cinema italiano fra le due guerra: Fascismo e politica cinematografica*, Milan: Mursia.

Caldwell, Lesley (1986) 'Reproducers of the Nation: Women and the Family in Fascist Policy' in Forgacs, David (ed.) *Rethinking Italian Fascism*, London: Lawrence & Wishart, 110–41.

Cammarota, Domenico (1987) *Il cinema peplum*, Rome: Fanucci.

Cannella, Mario (1973/4) 'Ideology and Aesthetic Hypotheses in the Criticism of Neorealism', *Screen* 14(4): 5–60.

Chapman, David (1994) *Sandow the Magnificent: Eugen Sandow and the Beginnings of Bodybuilding*, Urbana: University of Illinois Press.

Cohan, Steve (1991) 'Masquerading as the American Male: *Picnic*, William Holden and the Spectacle of Masculinity in Hollywood Film', *Camera Obscura* 25–6: 42–72.

Dalle Vacche, Angela (1992) *The Body in the Mirror: Shapes of History in Italian Cinema*, Princeton: Princeton University Press.

Della Casa, Stefano (1989) 'Il mitologico-peplum' in Salizzato, Claver (ed.) *Prima della rivoluzione: Schermi italiani 1960–1969*, Venezia: Marsilio, 89–94.

Doan, William and Dietz, Craig (1984) *Photoflexion: A History of Bodybuilding Photography*, New York: St Martin's Press.

Dutton, Kenneth R. (1995) *The Perfectible Body*, London: Cassell.

Dyer, Richard (1992) 'The Son of the Sheik' in *Only Entertainment*, London: Routledge, 99–102.

Dyer, Richard and Vincendeau, Ginette (eds) (1992) *Popular European Cinema*, London: Routledge.

Elley, Derek (1984) *The Epic Film*, London: Routledge & Kegan Paul.

Essoe, Gabe (1968) *Tarzan of the Movies*, New York: Citadel.

Fanon, Frantz (1970) *Black Skin, White Mask*, London: Paladin. (First published in French in 1952.)

Farassino, Alberto and Sanguineti, Tatti (1983) *Gli uomini forti*, Milan: Mazzotta.

Felice, Renzo De and Goglia, Luigi (1982) *Storiafotografica del fascismo*, Rome/Bari: Laterza.

Felice, Renzo De and Goglia, Luigi (1983) *Mussolini. Il mito*, Rome/Bari: Laterza.

Fury, David (1994) *Kings of the Jungle: An Illustrated Reference to Tarzan on Screen and Television*, Jefferson NC: McFarland.

Hansen, Miriam (1991) 'Pleasure, ambivalence, fascination: Valentino and female spectatorship' in Gledhill, Christine (ed.) *Stardom: Industry of Desire*, London: British Film Institute, 259–82.

Hay, James (1987) *Popular Cinema in Fascist Italy: The Passing of the Rex*, Bloomington: Indiana University Press.

Holmlund, Christine (1989) 'Visible Difference and Flex Appeal: The Body, Sex, Sexuality, and Race in the *Pumping Iron* films', *Cinema Journal* 28(4): 38–51.

Holmlund, Christine (1993) 'Masculinity as Multiple Masquerade: The "mature" Stallone and the Stallone Clone' in Cohan, Steven and Hark, Ina Rae (eds) *Screening the Male: Exploring Masculinities in Hollywood Cinema*, London: Routledge, 213–29.

Holtsmark, Erling B. (1981) *Tarzan and Tradition: Classical Myth in Popular Literature*, Westport CT: Greenwood Press.

Hunt, Leon (1993) 'What Are Big Boys Made Of?: *Spartacus, El Cid* and the Male Epic' in Kirkham and Thumim: 65–83.

Jeffords, Susan (1994) *Hard Bodies: Hollywood Masculinity in the Reagan Era*, New Brunswick NJ: Rutgers University Press.

Jenkyns, Richard (1980) *The Victorians and Ancient Greece*, Oxford: Basil Blackwell.

Kennedy, Robert (1983) *Beef It! Upping the Muscle Mass*, New York: Sterling.

Kirkham, Pat and Thumim, Janet (eds) (1993) *You Tarzan: Masculinity, Movies and Men*, London: Lawrence & Wishart.

Lacassin, Francis (1982) *Tarzan, ou le Chevalier crispé*, Paris: Veyrier.

Lagny, Michèle (1992) 'Popular Taste: the Peplum' in Dyer and Vincendeau: 163–80.

Leconte, Loredana (1996) 'Fascino Latino: L'invenzione di Rodolfo Valentino' in Malossi, Giannino (ed.) *Latin Lover: A sud della passione*, Milan: Charta, 81–93.

Lott, Tommy L. (1995) 'King Kong Lives: Racist Discourse and the Negro–Ape Metaphor' in Platt, Ron (ed.) *Next of Kin: Looking at the Great Apes*, Cambridge MA: MIT List Visual Arts Center: 37–43.

Milano, Comune di (1982) *Gli annitrenta*, Milan: Mazzotta.

Morton, Walt (1993) 'Tracking the Sign of Tarzan: Trans-media Representation of a Pop-Culture Icon' in Kirkham and Thumim: 106–25.

Nesteby, James R (1982) 'The Tarzan Formula for Racial Stereotyping' in *Black Images in American Films 1896–1954*, New York: University Press of America, 137–47.

Newsinger, John (1986) 'Lord Greystoke and Darkest Africa: the Politics of the Tarzan Stories', *Race and Class* 28(2): 59–71.

Nubret, Serge (1964) 'Rathor parle, ou comment on devient Titan', *Cinéma 64* April: 59–65.

Sandow, Eugen (1904) *Body-building, or Man in the Making: How to Become Healthy and Strong*, London: Gale & Polden.

Sanguineti, Tatti (1983) '"Mitologico, Muscle Man Epic, Peplum' in Farassino and Sanguineti: 87–99.

Segal, Lynne (1990) *Slow Motion: Changing Masculinities Changing Men*, London: Virago.

Siclier, Jacques (1962) 'L'âge du péplum', *Cahiers du cinéma* 22 (131): 26–38.

Studlar, Gaylyn (1989) 'Discourses of Gender and Ethnicity: The Construction and De(con)struction of Rudolph Valentino as Other', *Film Criticism* 13(2): 18–35.

Tasker, Yvonne (1993) *Spectacular Bodies: Gender, Genre and the Action Cinema*, London: Routledge.

Theweleit, Klaus (1987) *Male Fantasies*, Cambridge: Polity.

Torgovnick, Marianna (1990) 'Taking Tarzan Seriously' in *Gone Primitive: Savage Intellects, Modern Lives*, Chicago: University of Chicago Press, 42–72.

Turroni, Giuseppe (1980) *Luxardo: L'italica bellezza*, Milan: Mazzotta.

Valperga, Giuseppe (1983) 'Mitologie popolari dell'uomo forte' in Farassino and Sanguineti: 67–68.

Wagstaff, Christopher (1992) 'A Forkful of Westerns: Industry, Audiences and the Italian Western' in Dyer and Vincendeau: 245–61.

Walkerdine, Valerie (1986) 'Video Replay: Families, Films and Fantasy' in Burgin, Victor, Donald, James and Kaplan, Cora (eds) *Formations of Fantasy*, London: Methuen, 167–89.

Warner, William (1992) 'Spectacular Action: Rambo and the Popular Pleasures of Pain' in Grossberg, Lawrence, Nelson, Cary and Treichler, Paula (eds) *Cultural Studies*, New York: Routledge, 672–88.

Webster, David (1979) *Barbells and Beefcake: An Illustrated History of Bodybuilding*, Irvine (GB): Webster.

Williams, Tony (1990) '*Missing in Action*: The Vietnam Construction of the Movie Star' in Dittmar, Linda and Michaud, Gene (eds) *From Hanoi to Hollywood: the Vietnam War in American Film*, New Brunswick NJ: Rutgers University Press, 129–44.

Wyke, Maria (1996) 'Herculean Muscle!: the Classizing Rhetoric of Bodybuilding', *Arion* 4(3).

5 'There's nothing I can do! Nothing!'

Altman, Rick (1986) 'Television/Sound' in Modleski, Tania (ed.) *Studies in Entertainment: Critical Approaches to Mass Culture*, Bloomington: Indiana University Press, 39–54.

Ballhatchet, Kenneth (1980) *Race, Sex and Class under the Raj*, London: Weidenfeld & Nicolson.

Brandt, George W. (1994) '*The Jewel in the Crown*: The Literary Serial; or the Art of Adaptation' in Brandt, George W. (ed.) *British Television Drama in the 1980s*, London: Cambridge University Press, 196–213.

Brunsdon, Charlotte (1981) '*Crossroads*: Notes on Soap Opera', *Screen* 22(4): 32–7.

Brunsdon, Charlotte (1990) 'Problems with Quality', *Screen* 31(1): 67–90.

Chandavarkar, Rajnaryan (1990) '"Strangers in the Land": India and the British since the Late Nineteenth Century' in Bayley, C. A. (ed.) *The Raj: India and the British 1600–1947*, London: National Portrait Gallery, 368–79.

Donaldson, Laura E. (1992) 'A Passage to "India": Colonialism and Filmic Representation' in *Decolonising Feminisms: Race, Gender and Empire-Building*, London: Routledge, 88–101.

Ellis, John (1982) *Visible Fictions: Cinema, Television, Video*, London: Routledge & Kegan Paul.

Feuer, Jane (1984) 'Melodrama, Serial Form and Television Today', *Screen* 25(1): 4–16.

Geraghty, Christine (1981) 'The Continuous Serial – a Definition' in Dyer, Richard *et al. Coronation Street*, London: British Film Institute, 9–26.

Geraghty, Christine (1991) *Women and Soap Opera*, Cambridge: Polity.

Granada Television (1983) *The Making of 'The Jewel in the Crown'*, London: Granada Publishing.

Greenberger, Allen J. (1969) *The British Image of India: A Study in the Literature of Imperialism 1880–1960*, London: Oxford University Press.

Islam, Shamsul (1979) *Chronicles of the Raj: A Study of Literary Reaction to the Imperial Idea towards the End of the Raj*, Totowa NJ: Rowman & Littlefield.

Midgley, Clare (1992) *Women Against Slavery: The British Campaign 1780–1870*, London: Routledge.

Parry, Benita (1972) *Delusions and Discoveries: Studies on India in the British Imagination 1880–1930*, London: Allen Lane/The Penguin Press.

Robinson, Andrew (1984) '*The Jewel in the Crown*', *Sight and Sound* 53(1): 47–50.

Rushdie, Salman (1991) 'Outside the Whale' in *Imaginary Homelands*, London: Granta, 87–101.

Sharpe, Jenny (1993) *Allegories of Empire: The Figure of Woman in the Colonial Text*, Minneapolis: University of Minneapolis Press.

Ware, Vron (1992) 'Britannia's Other Daughters: Feminism in the Age of Imperialism' in *Beyond The Pale: White Women, Racism and History*, London: Verso, 117–66.

Wollen, Tana (1991) 'Over Our Shoulders: Nostalgic Screen Fictions for the 1980s' in Corner, John and Harvey, Sylvia (eds) *Enterprise and Heritage: Crosscurrents of National Culture*, London: Routledge, 178–93.

6 White death

Bartram, Michael (1985) *The Pre-Raphaelite Camera*, London: Weidenfeld & Nicholson.

Boime, Albert (1990) *The Art of Exclusion: Representing Blacks in the Nineteenth Century*, Washington: Smithsonian Institution Press.

Carby, Hazel (1993) 'Encoding White Resentment: *Grand Canyon* – a Narrative for Our Times' in McCarthy, Cameron and Crichlow, Warren (eds) *Race, Identity and Representation in Education*, New York: Routledge, 236–47.

Clover, Carol (1993) 'White Noise', *Sight and Sound* 3(5) NS: 6–9.

Creed, Barbara (1990) '*Alien* and the Monstrous-Feminine' in Kuhn 1990: 128–41.

Davies, Jude (1995a) '"I'm the Bad Guy?": *Falling Down* and White Masculinity in 1990s Hollywood', *Journal of Gender Studies* 4(2): 145–52.

Davies, Jude (1995b) 'Gender, Ethnicity and Cultural Crisis in *Falling Down* and *Groundhog Day*', *Screen* 36(3): 214–32.

Dijkstra, Bram (1986) *Idols of Perversity: Fantasies of Feminine Evil in Fin-de-Siècle Culture*, New York: Oxford University Press.

DiPiero, Tom (1994) 'White Men Aren't', *Camera Obscura* 30: 112–37.

Doll, Susan and Faller, Greg (1986) '*Blade Runner* and Genre: Film Noir and Science Fiction', *Literature/Film Quarterly* 14(2): 89–100.

Dyer, Richard (1993) 'White' in *The Matter of Images: Essays on Representations*, London: Routledge, 141–63.

Finler, Joel W. (1995) *Hollywood Movie Stills*, London: Batsford.

Gabriel, John (1996) 'What Do You Do When Minority Means You? *Falling Down* and the Construction of "Whiteness"', *Screen* 37(2): 129–151.

Gelder, Ken (1994) *Reading the Vampire*, London: Routledge.

Giroux, Henry (1993) 'Living Dangerously: Identity Politics and the New Cultural Racism: Towards a Critical Pedagogy of Representation', *Cultural Studies* 7(1): 1–27.

Harker, Margaret (1988) *Henry Peach Robinson: Master of Photographic Art 1830–1901*, Oxford: Basil Blackwell.

hooks, bell (1992) 'Representations of Whiteness' in *Black Looks: Race and Representation*, Boston: South End Press, 165–78.

Hopkinson, Amanda (1986) *Julia Margaret Cameron*, London: Virago.

Kennedy, Liam (1996) 'Alien Nation: White Male Paranoia and Imperial Culture in the United States', *Journal of American Studies* 30 (1): 87–100.

Kovel, Joe (1988) *White Racism: A Psychohistory*, London: Free Association Books. (First published 1970.)

Kuhn, Annette (ed.) (1990) *Alien Zone: Cultural Theory and Contemporary Science Fiction Cinema*, London: Verso.

Melville, Herman (1992) *Moby-Dick or, the Whale*, Harmondsworth: Penguin. (First published 1851.)

Newton, Judith (1990) 'Feminism and Anxiety in *Alien*' in Kuhn 1990: 82–7.

Pajaczkowska, Claire and Young, Lola (1992) 'Racism, Representation, Psychoanalysis' in Donald, James and Rattansi, Ali (eds) *'Race', Culture and Difference*, London: Sage, 198–219.

Pater, Walter (1915) *The Renaissance: Studies in Art and Poetry*, London: Macmillan. (First published 1873.)

Pfeil, Fred (1995) *White Guys: Studies in Postmodern Domination and Difference*, London: Verso.

Pratt, Murray (1995) '"Under Construction": Masculine Norms and Family Values in *Falling Down*', *Thamyris* 2(1): 89–114.

Praz, Mario (1933) *The Romantic Agony*, Oxford: Oxford University Press.

Ruppert, Peter (1989) '*Blade Runner*: the Utopian Dialectics of Science Fiction Films', *Cineaste* 17(2): 8–13.

Silverman, Kaja (1991) 'Back to the Future', *Camera Obscura* 27: 109–35.

Sontag, Susan (1979) *Illness as Metaphor*, New York: Vintage.

Stowe, Harriet Beecher (1981) *Uncle Tom's Cabin; or, Life Among the Lowly*, Harmondsworth: Penguin. (First published 1852.)

Strick, Philip (1992) '*Blade Runner*: Telling the Difference', *Sight and Sound* 2(8) NS: 8–9.

Taubin, Amy (1993) 'The 'Alien' Trilogy: From Feminism to Aids' in Cook, Pam and Dodd, Philip (eds) *Women and Film: A Sight and Sound Reader*, London: Scarlet Press, 93–100.

Index

Index

Index

Index